THE ACTOR AS PLAYWRIGHT
IN EARLY MODERN DRAMA

Nora Johnson's study of actors who wrote plays in early modern England uncovers important links between performance and authorship. The book traces the careers of Robert Armin, Nathan Field, Anthony Munday, and Thomas Heywood, actors who were powerfully interested in marketing themselves as authors and celebrities; but Johnson contends that authorship as they constructed it had little to do with modern ideas of control and ownership. Finally, the book repositions Shakespeare in relation to actors, considering his famous silence about his own work as one strategy among many available to writers for the stage. *The Actor as Playwright* provides an alternative to the debate between traditional and materialist readers of early modern dramatic authorship, arguing that both approaches are weakened by a reluctance to look outside the Shakespearean canon for evidence.

Nora Johnson is Associate Professor in the Department of English Literature at Swarthmore College, Pennsylvania. Her essays and reviews, centering on her work on Shakespearean Romance, authorship, and the history of sexuality, have appeared in *Shakespeare Studies*, *English Literary History*, *Theatre Journal*, and *Shakespeare Quarterly*.

THE ACTOR AS PLAYWRIGHT IN EARLY MODERN DRAMA

NORA JOHNSON

Swarthmore College

CAMBRIDGE
UNIVERSITY PRESS

PUBLISHED BY THE PRESS SYNDICATE OF THE UNIVERSITY OF CAMBRIDGE
The Pitt Building, Trumpington Street, Cambridge CB2 1RP, United Kingdom

CAMBRIDGE UNIVERSITY PRESS
The Edinburgh Building, Cambridge, CB2 2RU, UK
40 West 20th Street, New York, NY 10011–4211, USA
477 Williamstown Road, Port Melbourne, VIC 3207, Australia
Ruiz de Alarcón 13, 28014 Madrid, Spain
Dock House, The Waterfront, Cape Town 8001, South Africa

http://www.cambridge.org

First published 2003

Printed in the United Kingdom at the University Press, Cambridge

Typeface Adobe Garamond 11/12.5 pt. *System* LATEX 2$_\varepsilon$ [TB]

A catalogue record for this book is available from the British Library

ISBN 0 521 82416 8 hardback

In memory of my parents, Frank and Eileen Johnson.
Rest in peace.

Contents

List of illustrations *page* viii
Acknowledgments ix

 Introduction: playing author 1

1 Publishing the fool: Robert Armin and the collective
 production of mirth 16

2 The actor-playwright and the true poet: Nathan Field, Ben
 Jonson, and the prerogatives of the author 54

3 Anthony Munday and the spectacle of martyrdom 84

4 "Some zanie with his mimick action": Thomas Heywood and
 the staging of humanist authority 122

 Coda: the Shakespearean silence 152

Notes 168
Select bibliography 194
Index 202

Illustrations

1 The Martyrdom of Richard Atkins: Anthony Munday,
 English Roman Lyfe (London, 1581) unnumbered fold-out page
 Reproduced by permission of The Huntington Library,
 San Marino, California *page* 104
2 Anthony Munday, *A Watch-woord to Englande*
 (London, 1584) p. 46
 Reproduced by permission of The Huntington Library, San
 Marino, California 120

Acknowledgments

There have been times when "Publishing the Fool" threatened to become so much more than just the title of chapter 1. If I've been spared that outcome, it's because of the warm support I've received from many friends, colleagues, and family members. There are numerous friends outside academic life whose contributions are too great to try to list here, but my gratitude is very real. And I want to thank my family in particular for showing me that I can always turn and return to them.

At Berkeley, Janet Adelman went out of her way to make room for me, as she has for so many others in this profession. That was just the beginning of her influence and her friendship; I'm deeply honored to claim both and wish I could live up to her intellectual example. Joel Altman took my work seriously before I did, his kindness and patience matched only by his scholarly depth. Michael Harrawood, Eric Spencer, and Matt Duckworth have remained close friends and colleagues from student days.

Swarthmore College has provided me with a rich environment for teaching and scholarship, including a Becker Faculty Fellowship in 1997–8. Every member of the English Department has contributed something to this book, as have many wonderful colleagues across campus. Abbe Blum, Tom Blackburn, and Nathalie Anderson in particular have commiserated, cajoled, and given feedback. I've shared the tenure process with Patty White, but also much else that's precious. Betsy Bolton and her family are a continual homecoming.

The librarians at Swarthmore and at the rare-book rooms of Bryn Mawr College and the University of Pennsylvania have been kind and enormously helpful. I owe, in addition, a great debt to the librarians at the Folger and Huntington libraries, and to the staff of the Folger Institute. Both institutions provided short-term fellowships that made this study possible. At the Folger, A. R. Braunmuller's seminar on the organization and regulation of the theater companies was a scholarly life raft, as has been the friendship of Heather Hirschfeld. Susan Zimmerman's two colloquia on subjectivity

ix

and sexuality were wonderful experiences, not least because Susan herself maintains such high standards for rigor and collegiality. I'm grateful for the help I received from the members of all three groups, and very much regret that space will not allow me to name them individually. Susan Snyder deepened my appreciation for both Swarthmore and the Folger Library in ways I can't begin to enumerate, and my sorrow for her passing is matched by my gratitude and respect for her as friend and scholar.

At Cambridge University Press, Sarah Stanton, Teresa Sheppard, Alison Powell, and my anonymous readers have provided patient and expert guidance. Susan Beer and Mike Leach were especially helpful as text-editor and indexer. A Shakespeare Association seminar led by Paul Voss, Carole Levin's panel at Kalamazoo, Ohio Shakespeare, the Medieval/Renaissance session at the University of Pennsylvania organized by Owen Williams and James Kearney, Bonnie Gordon's panel at the Renaissance Society of America, and a Swarthmore Faculty Lecture have all enriched this project and helped me identify its shortcomings. Stephen Orgel read an early draft of the book and provided valuable assistance; Bruce Smith has been an encouraging reader and a scholarly resource. Scott Black, Edmund Campos, Jane Hedley, Carolyn Lesjak, Steve Newman, Kristen Poole, Katherine Rowe, Lauren Shohet, Evelyn Tribble, Julian Yates, and all the shorter-term members of our works in progress group have renewed my faith in scholarly work time and again. Their infectious energy and intelligence are priceless. Though the errors in this book are mine, I've greatly enjoyed their attempts at correction. Sharon Ullman and Pieter Judson heard all about it again and again, with great tolerance and good humor.

Leslie Delauter is the reason I wanted to write this book, and the reason I want to finish.

Introduction: playing author

When Robert Armin, the comic actor for the Chamberlain's Men after Will Kemp, wrote *Quips upon Questions* in 1600, he turned collaborative theatrical work into a printed commodity. In what appears to be a kind of transcript of the improvised jesting he did on stage, Armin advertised both his individual wit and his dependence upon audiences. His stage routines, the text suggests, typically began with questions that were posed by others, likely including members of the audience. The poems he invented in response to those questions contain dialogue, what the title page calls "changes upon interrogatories," either multiple parts spoken by Armin himself or exchanges with people in the crowd.[1] Publishing all of these under a stage name, "Clonnico de Curtanio Snuffe," or "Snuff the Clown at the Curtain Theater," Armin thus makes himself up as a writer out of the voices of others, positioning himself not as the origin of the text – the questions come from other people – but as its last word, the one who delivers the witty quip as the closing line of the exchange. Even if the impression of dialogue given by the text is misleading, if Armin managed to perform all of the voices in question, he engages a mode of authorship in *Quips* that renders the notion of a sovereign, individual voice problematic.[2] In fact, though Armin is considered a less collaborative performer than earlier clowns had been, his performances on stage and in print remain striking for their dispersal of agency. Armin's play *Two Maids of More-clacke*, for instance, borrows from one of his other books, *Foole upon foole*. In that text, Armin writes about the life of John in the Hospital, a fool who was well known in London. In *More-clacke*, Armin played both John and Tutch, the play's witty fool. At one point Tutch himself dresses up as and imitates John. In other words, the historical John, Armin's written representation of John, Armin's performances, and Tutch's imitation all blur together in the performed play, rendering the notion of individual agency extremely complex.

It is, as a result, no simple task to classify Armin's relationship to *Quips upon Questions*. Recent scholarship has suggested that the term "author" would be inappropriate, tied as it is to historical innovations such as copyright, Jacobean absolutism, and Romantic subjectivity.[3] Nor is Armin an author in the manner of the classical authority or the Folio persona. In many ways scholarship that restricts authorship to these forms is elucidating the premises set down by Michel Foucault and Roland Barthes, taking up Beckett's question: What does it matter who is speaking?[4] The accepted answer at this point is that it does not matter until notions of private property and subjectivity have made the connection between "the author and the work" appear inevitable. In England before the Statute of Anne, or at very least before the energetic self-promotions of Ben Jonson, such a connection would appear unimaginable. For all the power of Beckett's question, however, this book poses a different one, only partially facetious: What is Snuff? The presence of the stage name on a book suggests that Armin's theatrical celebrity matters. Though Snuff cannot be a figure for individual creation or for access to the mind of a literary genius, he clearly does represent theatrical pleasure for a reading public.[5]

The difficulty of categorizing Armin's relationship to his printed texts is a problem paralleled in the careers of the other performers considered in this book. In a range of ways, Nathan Field, Anthony Munday, and Thomas Heywood register the power of playing to construct forms of authorship that cannot be explained by later notions of literary property or essentialist self-expression. Their roles as authors are perceptible, it seems, only through the lens of these later developments, only as "not the author yet." But to explain them thus, retroactively, is a curiously unsatisfying approach. Armin's fascinating use of the voices of others represents a powerful moment of indeterminacy, a moment in which it is possible for him to speak simultaneously as an individual and a group. As long as we discern in such a moment only the coming of private property, or think of it as a conflict between older and newer modes of describing textual genesis, we lose the ability to imagine Armin as an author who simply exceeds our definitions.[6] If it does not matter to us who is speaking until the speaker becomes an owner, a sovereign, or a subject, we concede the institution of authorship to the regime of private property and interiority.

The nature of that loss becomes clearer in a more detailed analysis of Foucault's author-function. To recapitulate his argument briefly: rather than considering the author as a source of meaning, Foucault describes the author-function as a way of controlling excess meaning. We form a notion of an author on the basis of textual interpretations and biography, which

we then use to determine which textual interpretations – sometimes even which texts – are authentic. In identifying the author as a limiting subjectivity, "a principle of thrift" that enables textual meanings to be fixed, Foucault undoes the idea of the essentialist subject, a principle of autonomy that transcends the constraints of the economic and the social. He counters the practice of identifying authorial subjectivity with what appear to be infinite meanings, all of them constituted by but seemingly never exhausting the possibilities of the author's interiority. Without the quasi-mystical principle of coherence we have been taught to attribute to the author, it seems, we are free to recognize the polysemia of the text.

This is of course a powerful intervention in the study of early modern writing. Unquestionably the modern habit of reading essential subjectivity back into Shakespeare and his peers has given us a poet and a canon that are artificially made coherent, even while they are trumpeted for their power to yield endless variety. The coda of this book will take up the problem of Shakespeare's influence upon our constructions of dramatic authorship. In adopting Foucault's insights, however, we have been too quick to equate our own post-Romantic deployments of the author-function with the possible range of deployments in the period we are studying. Everything we have learned about subjectivity or its related forms in the Renaissance suggests that to imagine an author behind a text in early modern England is a very different process than the one that has produced the Bard.[7] If for us subjectivity is a privileged realm of interior nature that precedes the social and the material, for early modern England that interiority is firmly subordinated to the material and the social. Far from inscribing a perfect circle of human nature that seals the text off from the world, that is, the figure of the early modern author would much more plausibly signal the contingency of textual meaning. If "I am Duchess of Malfi still" can connote a social position rather than an unchanging essence, we should learn to read an author's name as a similarly rich form of engagement with the forces that essentialist subjectivity excludes.[8] In Heywood's view, for instance, the writer who violates decorum, mingling kings with clowns, is simply aligning himself with what pleases his audiences, making himself a name in tandem with their wishes.[9] In a sense Heywood, no less than Armin and the other writers in this book, allows his own name to be constituted by his audiences. In doing so, he suggests possibilities for authorial self-inscription that are not accounted for by our critiques of essentialism. The loss, then, in accepting the subject, the owner, the sovereign, or the elite folio-writer as the constitutive tropes of authorship consists in abandoning the possibility that the proper name or the persona attached to the text

might be a gateway into the exigencies of the social and the material rather than a bulwark against them.

The authors studied in this book are precisely such figures. Their relations to the texts they write defy our tropes of authorship. But to subsume that defiance under "what does it matter" is to miss the rich potential of authorial practice. It is also, of course, to miss the rich potential of theatrical performance.[10] To varying degrees, each of the figures considered in this book was known as an actor as well as a writer. Though this study does not seek to identify a fundamental quality of actorliness that can be traced in the works of these writers, it does trace at length the forms of celebrity and notoriety they cultivated, the forms of reputation that crossed over from performance into print and vice versa. The point of such a study is twofold: it establishes actors as innovators in the construction of authorship, and it highlights the theatricality of authorship itself. On the early modern stage, where the economics, the collaboration, the physicality of theatrical production speak more forcefully than they do in the printed book – where an audience applauds or hisses – authorship takes its proper place: as a relational form, a contest, a negotiation.

Even in the process of exploiting individual fame, an actor almost necessarily wears individuality in a way that complicates our models. Here the work of Robert Weimann, ever the sensitive reader of theatrical practice, is immensely suggestive. In "Laughing with the Audience," an appendix to *Shakespeare and the Popular Tradition*, Weimann considers the subjectivity of the comic actor who addresses his spectators while playing. Contrasting this familiar presence with that of the more purely naturalistic actor who stays in character, Weimann finds in the former a fascinating image of connection between the individual and the culture for which he performs. The famous leave-taking speech of Shakespeare's clown Launce is for Weimann a paradigmatic moment of union in division; actor slips out of character to laugh with his audiences about the stupidity of Launce, but the effect transcends any mere lapse of decorum:

That Launce becomes the clowning object and the laughing subject of his own mirth and that of the audience reveals an astonishing stability in his relations to the social whole. These relations connect the character and the actor, illusion and reality, so that the imaginative flexibility of his relation to the play world has much to do with the security of his relation to real society.[11]

In connecting directly with his audience at the expense of the character he is playing, the actor who performs the role of Launce performs a kind of subjectivity that is both individual and collective. Launce and the actor

who plays him both become permeable entities; the composite figure is linked to the audience by the actor's self-consciousness even while he is kept distinct from the audience by the character's imbecility and fictional status. As a figure whose theatrical roots stretch back centuries, the comic actor evokes precisely the sense of social identity that the author as subject, sovereign, and owner would defend against. He also evokes a responsiveness to audiences that is antithetical to Jonsonian forms of elite self-publication.

Weimann, quoting Hegel, identifies this paradoxical form as the "blessed ease of a subjectivity which, as it is sure of itself, can bear the dissolution of its own ends" (257). But this study makes an additional argument, emphasizing not only the actor's ancient forms of connection with his audience but also the emerging forms of professionalization that blend so richly with Weimann's popular traditions. As aggressive self-promoters, actors in this period cultivated their own individual connection to their audiences almost as a kind of capital. David Wiles, building on the arguments of Clifford Leech, suggests that the role of Launce was created for William Kemp, "an actor whose art is rooted in minstrelsy, and who therefore knows how to dominate a stage without support from plot mechanics."[12] It is as an almost-autonomous professional that Kemp laughs with his audience at his own performance of the character Launce. He thus enacts the old rituals of communal subjectivity at the same time that he enacts new forms of self-possession and self-marketing.[13] In this sense he is surely even further outside the realm of the humanist subject than he would be if we considered him merely to be a complex embodiment of tradition. Kemp as Launce embodies not only the pre-capitalist "stability in his relations to the social whole" but also the profound instability of his relation to the theatrical market; as a semi-autonomous performer, he died, Wiles points out, penniless.[14]

In his lifetime, however, Kemp literally went to great lengths to establish himself as a commodity. His *Nine Daies Wonder* (1600) records the jig he danced from London to Norwich, and the printed book is clearly an effort to make more money from that venture, to capitalize upon his own reputation. Moving from minstrelsy to the professional stage to a commercialized version of carnival and then into print, Kemp enacts a whole range of relations to the social whole, some of which invoke older forms of communal production and selfhood and some of which suggest more individualistic modes of self-presentation. Though it is important to identify the emergent and residual constructs in which a figure like Kemp is bound up, however, it is equally crucial to remember that he embodies the old and the new all at once. When Kemp's name signifies in print, it signifies richly. Like

the figure Kemp-Launce, he has more than one way of being positioned in relation to his culture. It is an effect intensified when the actor is also, like Armin in *Two Maids of More-clacke*, the author of the play in which he appears and the author of the non-dramatic text upon which his role is based.

In such efforts to carry over the complex forms of theatrical subjectivity – the substance of their fame – into print, actors challenge the currently accepted narrative of the emergence of the author. Their enactments of celebrity respond to the economic and social dispensations of early modern England in ways that sometimes encompass but also frequently exceed the boundaries of ownership, sovereignty, or post-Romantic subjectivity. They thus make possible versions of authorship we have largely failed to consider. Nor is this effect limited to the careers of comic actors. Indeed, given the reputations that actors had in the period we are studying it would be re-markable if they could reliably signify anything so respectable as the textual version of bourgeois ownership. If the social positioning of Shakespeare or Alleyn is familiar to us, so too is the mass of writing that describes actors as pariahs. More to the point, of course, is the persistent identification of actors with protean changeability. A "shifting companion" in J. Cocke's formulation, the actor "lives effectually by putting on, and putting off."[15] As wearers of women's apparel, actors trouble the distinctions between men and women. The charges are too well known to be documented another time here.[16] What the antitheatrical literature reinforces, however, is the sense that an actor as an author must at least some of the time appear to be a sign of instability. Foucault's limiting subject is difficult to square with the figure of the professional shape-shifter.

And yet, stage and print alike created new forms of celebrity, and ac-tors were poised to exploit those forms.[17] Focusing upon the actor's self-promotions, then, this book reverses a fundamental assumption of studies of authorship thus far. Scholars have repeatedly turned to the early modern theater companies to look for models of authorship that gain currency more or less explicitly in spite of the presence of actors, in spite of their work as performers, as improvisers, and as owners of theatrical texts. Instead of looking for a kind of authorship that can overcome the participation of actors, however, we should be looking at the notions of authorship that actors themselves developed. If, as Alexandra Halasz argues, printers and booksellers had an interest in commodifying authorship as a way of selling texts, the playing companies who sold them those texts would surely also have had reason at times to promote the writers who produced texts for them, or to make room for a given writer's self-promotions. Having made

such progress in recognizing the power of the playing companies over the writers who worked for them, that is, it would be a mistake to turn over our entire understanding of dramatic authorship to those few writers who presented the illusion of having escaped that power.

Moreover, since this unstable identity is directly connected to the actor's professionalism, since his profit motive is in part what renders him protean, the forms of ownership he practices are themselves unsettling to notions of social place and self. By performing multiple roles on stage while becoming rich, a successful actor wages a two-part war upon traditional values. In earning his status as a gentleman, Shakespeare the upstart would ironically have undermined the very notion of gentility.[18] If textual property is what secures the interiority of the modern author, the early modern actor's commercialism earns him a very different place in his culture. To the extent that ownership is a viable notion for an actor-playwright, that ownership has more to do with the fluidity of the marketplace as Jean-Cristophe Agnew has described it than with the imagined solidity of private property.[19] Moreover, as Margreta de Grazia, Maureen Quilligan, and Peter Stallybrass have recently reminded us, even material objects have a tendency to become insubstantial when they become commodities: "Commodification is...not only the vanishing point of the subject into the commodified object but also of the object into pure exchangeability."[20] If we are to study actors who write, turning their own power to perform into a name that sells texts, we will need to focus on exchange rather than ownership, on circulation rather than possession. We will need to account for the powerful sense of personal presence in a pen name like "Snuff" without imagining that that presence implies ownership, control, or modern subjectivity.

The chapters that follow will accordingly trace models of theatrical authorship that owe their power to theatrical practice itself. Without denying the importance of the folio-author model, and most emphatically without denying the importance of print culture, this study will consider theatrical performance as a factor in the development of theatrical authorship. Even a cursory review of the moments in which authorship is featured in early modern drama serves to underscore the energetic participation of players in the making of that social construct. The First Folio of Shakespeare's works, for all that it has been described as a move away from theatrical realities, is in another sense the production of an actor, Shakespeare, assembled and promoted by fellow actors, Heminges and Condell. The volume, like Jonson's, does clearly instantiate a new text-oriented authority, but it seems worth remembering that that textual authority was created through the

entrepreneurial efforts of actors themselves. Rather than reading these creations of authorship as alien to the playing companies, we should consider them as extending some forms of work already being done on stage and in dramatic quartos.

Thomas Heywood, for example, who performed as a player until about 1619, replied contentiously to the publication of these folios in the preface to *The English Traveller*:

> True it is, that my Playes are not exposed vnto the world in Volumes, to beare the title of Workes, (as others) one reason is, That many of them by shifting and change of Companies, haue beene negligently lost, Others of them are still retained in the hands of some Actors, who thinke it against their peculiar profit to haue them come in Print, and a third, That it neuer was any great ambition in me, to bee in this kind Volumniously read.[21]

In doing so he signals that the folio model of authorship was a less radical innovation than we have previously imagined. His comments suggest not so much that Jonson has created the dramatic author as that he has costumed that author in the trappings of high culture.

Heywood's own textual authority is clearly of strong concern – note that in the lines quoted above he implies that he himself is being read in quarto rather than his texts – but he constructs that authority with different tools. His allegedly casual lack of ambition, for instance, would seem to link quarto publication with manuscript culture, positioning Heywood as a gentlemanly figure who resists the supposed stigma of print like so many humanist writers of the period.[22] At the same time, his references to the actors who alternately hoard and lose his plays establishes Heywood as an author in a more complicated way. On the one hand, he does indeed seem to present theatrical writing as an exercise in writerly anonymity. The players are the authorities here. On the other hand, though, this very anonymity functions as an authorial boast for Heywood. In this same preface, famously, he claims that the *English Traveller* is "one [play] reserued amongst two hundred and twenty, in which I haue had either an entire hand, or at the least a maine finger" (A3). Though the claim may be true, what matters most about it is that we will never know. The missing two hundred plays about which Heywood cannot resist telling his readers constitute a kind of authority more powerful than any number of publications. As all writers know, actual words in print are a form of vulnerability.[23] Imaginary words in the possession of imaginary actors are, on the other hand, proof positive of authorial greatness. Without owning the texts and without being able to claim sole authorship, Heywood nevertheless constructs himself in relation to them.

If this is merely a back formation, a moment of anxious self-invention in response to Jonson's bid for preeminence, it is nevertheless a highly suggestive one.[24] Even if prompted by Jonson to do so, the fact that Heywood can retroactively label his own productions as equivalent to Jonson's implies that Jonson is actually building upon recognizable features of the profession of dramatist as it exists before 1616. Indeed, Heywood's career challenges Jonson in other ways as well, for Heywood managed to claim forms of humanist authority and classical erudition that do not replicate the exclusion of the "low" so basic to Jonson's self-presentation. Heywood happily markets himself as a writer for the ignorant, and while such tactics fail to establish him as a "rare" writer in the manner of Jonson, they nevertheless betoken a solid interest in self-promotion. As this survey of the careers of Armin, Field, Munday, and Heywood will make clear, Jonson's break with his peers comes not because of his interest in promoting himself as an author so much as because he attempts to place himself at the right hand of James I. That position is neither an inevitable one for authorship nor the exclusive expression of a writer's investment in a text.

Indeed, one powerful motive for taking up the question of dramatic authorship from the perspective of performers is the desire to query the automatic equation of authorship with political absolutism. In part because Jonson's efforts to establish his own authorial position are so powerfully connected to the self-representations of James I, the absolutist potential of authorship, the premise that an author is a kind of monarch over his own words, has dominated scholarly discussion.[25] The writers studied here, however, offer a striking range of responses to the notion that authorship is sovereignty. Nathan Field, who came to theatrical work when he was kidnapped as a child and made to be an actor, writes in his prefaces and even in his plays in a manner that emphasizes the distance between his position as a theatrical laborer and the kinds of absolutist prerogative to which a figure like Jonson was carefully laying claim. Field stakes out a very different territory for himself professionally. Indeed, a very different territory is staked out for him by the circumstances of his life, including his eventual fame as a romantic lead. To fail to recognize Field's self-constructions as authorial is *a priori* to mark authorship as elite and court-centered, Jonsonian. Association with classical learning and court culture was one way of promoting authorship in what may have been an anti-authorial milieu, but Field's work makes it clear that there were other modes of self-presentation available to – or even forced upon – theatrical writers. It is possible to imagine Field, and even Heywood, as representatives of the aspects of theatrical work that Jonson worked to overcome in his bid for authorial preeminence. From this perspective, the revelation in Field's work is that those

same aspects of his dramatic labor are the material for Field's own authorial self-inscriptions. Field's writing thus highlights the need for an understanding of authorship that might potentially exceed the political meanings of absolutism.

In many ways, such an assertion borrows from arguments that challenge the early New Historicist reading of the theaters as extensions of state power. Like the performances of kingship enacted on the early modern stage, the performances of authorship undertaken by players need to be imagined as more than straightforward reproductions of official ideology. Especially in a medium as saturated with competing forms of authority as the theater, we ought to expect a transformation of absolutism even when it does appear on stage. As Jean Howard has argued, when we are talking about the stage's ideological impact, we must "attend to more than just theatrical representations *qua* representations, but also to the material practices and conventions of the stage and of theatergoing."[26] Rather than excluding authorship from our theatrical vocabulary, we ought to be looking for ways to explain how the representational density of the stage, its traditions, its actors, and its audiences along with its material aspects, inflect the notions of textual control that might make their way to the theaters from the court.[27] Nor should we look for printed texts to represent authorship as an unproblematic extension of sovereignty into the realm of the literary.[28] Though Jonson took the occasion of print for an opportunity to write out the participation of actors and others, it is of course much more typical for a printed play to borrow the authority of the stage, to advertise the script "as it was played" by the theater companies. Rather than waiting for notions of intellectual property to catch up with Jonson and render the text an authorial possession, we might more profitably consider the rich intersections of print authorship and stage that position the author as something other than a sovereign.

In Louis Montrose's recent formulation, in fact, the author-function has come to signify the dispersal of authority rather than its consolidation:

Within the delimited discursive space of their own printed texts, writing subjects of the Early Modern state might contest, appropriate, or merely evade its semiotic prerogatives. In such circumstances, the author-function may have helped to *disseminate* discursive authority more than it worked to contain it.[29]

Nor, Montrose argues, does such an appropriation simply turn the author into the "absolute ruler of the signifying process" (93). On the contrary, the authority of the sovereign and the writer alike are available in various forms to the printers, booksellers, and even the readers of the texts as they

circulate. Though such a process may ultimately be considered to extend the notion of sovereign power into what becomes the realm of the individual, Montrose's point is worth stressing: authorship can be invoked in ways that militate against the notion of sovereign control.

Certainly Anthony Munday took up a series of authorial stances – whether voluntary or not – that rendered notions of sovereignty and control profoundly problematic. Munday's productions spanned the categories of printed and performed writing in early modern England. A writer of ballads, romances, pastoral poems, translations, histories of London, inspirational tracts, martyrdom pamphlets, anti-Catholic propaganda, guild pageants, and individual and collaborative plays, Munday beautifully exemplifies the ways in which authorship could work against ideological closure as well as for it. Making a name for himself by writing against Edmund Campion and his fellow Jesuits, who were executed in 1582, Munday became the subject of *ad hominem* attacks by Catholic writers anxious to discredit his descriptions of papistical treachery and intrigue. Quite rightly, for instance, Thomas Alfield writes that Munday had himself lived in the Catholic seminary at Rome, appeared to be Catholic, and returned to England ready to report the Jesuits who had befriended him. Anxious to defend himself, Munday responds with *English Roman Lyfe*, a first-person narrative of his time among the Jesuits. Alfield, in other words, invoked Munday as a disreputable author, foreclosing upon the meanings of Munday's writing very much as Foucault would lead us to expect; Alfield used the author-function in this case as a way of limiting Munday's pamphlets to a series of corrupt and misleading formulations. Interestingly, one of Alfield's accusations against Munday was that he had acted (very unsuccessfully) on the stage and had later written (very cynically) against players. Being an actor was, in Alfield's formulation, part of an identifiable authorial meaning; Munday the author equaled bad-faith reporting.

And yet Munday's response to these *ad hominem* attacks links acting and authorship in a much more expansive and paradoxical deployment of the author-function. *English Roman Lyfe* repeatedly emphasizes Munday's personal investment in the text, including of course his first-hand experience of Jesuitical depravity. But the complex strategies of personal justification that Munday uses double back upon one another, ultimately rendering his motives radically unclear and his character profoundly in doubt. He has to explain why he failed to offer himself up as a Protestant martyr while he was in Rome, and what a real martyr is. Munday is the source of the text's meanings, but as a source he seems to generate only epistemological crisis, borne out in the unknowability not just of his own text, but also of

Protestant versus Catholic martyrdom and belief. Standing behind his book as a stigmatized actor and a duplicitous author, Munday becomes a figure for anything but confident English orthodoxy. On the contrary, he is erected as a persona just where religious controversy, the reliability of the medium of print, and the duplicity of acting intersect with one another. In the notoriety that follows Munday for the rest of his career, in fact, these cultural questions remain associated with him. They remain his stock in trade, figuring prominently in the series of martyr plays that he helps to produce for the early modern stage. Munday's performance of authorship positions him as a source of textual meaning, but that positioning is antithetical to Foucault's principle of thrift. In his role as a "shifting companion," Munday, like actors as a class, disables the whole notion of human nature, rendering impossible the project of drawing a closed circle of subjectivity around his works.

Similarly, as suggested above, Robert Armin's authorial practices call the category of the individual into question. If Kemp as Launce occupies more than one position in relation to his audiences and the culture as a whole, Armin, though further removed from folk traditions, is similarly fluid in his self-presentations. It has already been argued that *Quips upon Questions* shows a fascinating use of multiple voices alongside a strong emphasis upon Armin's status as the preeminent quipping voice. Other texts that bear Armin's name also demonstrate an extraordinary authorial permeability. *Foole upon foole* stresses the connections between Armin and the six "real" fools he writes about, playing with the author's simultaneous presence as the subject and the object of his own writing. In *Two Maids of More-clacke*, a play Armin wrote and performed in, he borrows from his own writing about Blue John, a local figure whom his audiences are likely to remember. This figure from the neighborhoods of London who is featured prominently in *Foole upon foole* becomes in the play a kind of local celebrity whom Armin imitates. Not only does he play the role of Blue John, however, he also plays the role of Tutch, the witty fool who at one point also imitates John. On stage and in print alike, Armin appears as author-exploiter, establishing authorship not so much as a privileged form of origin but as an explicit form of borrowing. If, as has recently been argued, ownership is the hallmark of authorship, Armin's free way with the speech and even the performances of others would render him unfit to claim the title. As a star performer and an aggressive self-promoter in the medium of print, however, Armin enacts a powerful celebrity that constructs authorship in a bold new form. We ignore that form at the cost of ignoring historical alternatives to the essentialized author.

There are two ways of thinking about the structure of this book. Each of its chapters takes up an aspect of "authorship as we know it" and explores how actors render our paradigms insufficient. Thus chapter 1 considers the labors of Robert Armin as a stage performer and writer, aiming that discussion at the notion of authorship as a form of owning. As suggested above, Armin establishes himself as an author without using the rhetoric of textual ownership. On the contrary, he emphasizes repeatedly that he is simply the fool clever enough to capitalize upon the folly of others. That process of capitalizing nevertheless bestows upon Armin a powerful charisma that vies with mere ownership as the basis for authorial self-inscription. Chapter 2 reads Nathan Field's writings in light of what we know about his career as an actor. Field had an extraordinarily complicated relationship to Ben Jonson, a relationship highlighted at the moment that *Bartholomew Fair* names Field while he performs before James I. The chapter considers Field's authorial self-inscriptions in relation to Jonson and to the absolutist prerogative that Jonson struggled to claim. Field, this study argues, challenges the equation of authorship with sovereignty.

Chapter 3 considers the tortuous path that Anthony Munday attempted to carve through the epistemological uncertainties that accompanied the Reformation in England. Claiming to offer his audiences and readers the truth about martyrs, Munday inadvertently marked himself as a base commercial panderer. Like the professional actor he was accused of being, Munday made visible the economic bases for his representations. Thus his arguments for conscience are tainted and his certainties are hopelessly impure. Munday offers an insidious alternative to the notion that the author is a limiting subjectivity; his interiority is visibly structured by the very economic and social constraints that humanist subjectivity excludes. Finally, the fourth chapter of this book looks at Thomas Heywood's representations of authorship. Beginning with *Gunaikeion, Or Nine Bookes of Various History Concerninge Women* (1624), the chapter examines Heywood's various juxtapositions of classical erudition and the actor's charisma. In many of Heywood's plays, from the five *Ages* (1611 – 32) to *Rape of Lucrece* (1608), there is a striking insouciance about the difference between popular performance and high forms of cultural production. This easy forgetting of the difference between kings and clowns carries over into other kinds of publication: *Gunaikeion* itself, Heywood's miscellany called *Pleasant Dialogues and Dramma's*, and *Love's Mistress, or the Queen's Masque*. Heywood was an actor at least until 1619; in 1598 Philip Henslowe bound him by contract to play solely with the Lord Admiral's company. Though we know virtually nothing about his playing, Heywood's status as an actor followed him at

least until 1640, when an epigram in *Musarum Deliciae* complains that he is too old to be "groveling on the stage."[30] In the handy imprecision of that expression, we can hear a connection between his playing and his author-ship; it is ostensibly about Heywood's writing of plays that the epigram complains. Ultimately, however, it is the groveling that makes Heywood so important for the present study. As he implies in his preface to *Gunaikeion*, the stage is about pleasing audiences, and pleasing audiences means sell-ing texts. Heywood thus establishes himself as an author who commands classical authority without using that authority to disavow the power of audiences.

There are at least two different sets of reasons for writing about the figures in this book. On the one hand, they bring the social meaning of the actor into our definition of authorship, stressing audience response, protean changeability, a subjectivity constituted in self-division rather than self-possession. In addition to the meanings we might attach to performance in this period, on the other hand, the writers studied here also embrace the commercialism of the theater in a way that makes them particularly important correctives for the biases of "authorship as we know it." Jonsonian eminence depends upon a series of gestures that reject audiences, often constituting a learned reading public at the expense of both players and theatergoers. Armin, Field, Munday and Heywood, on the other hand, are entirely frank in their acknowledgment of the need to sell to a large public. Commercialism and the social significance of performance are overlapping considerations for all of these figures, but the present study uses the two terms as an informal structuring principle. Armin and Field provide the focus for the book's first half, and the concern in those chapters is with acting as a practice that develops specific forms of charisma and celebrity that pertain to print authorship. In Armin's case it is possible to speculate about actual performance styles that establish a persona useful for print; in the chapter on Field a particular performance, his starring role in *Bartholomew Fair*, provides the occasion for speculation about Field's relationship to Jonson and his options as a celebrity writer. Neither chapter can claim to tease out all the rich connections between the craft of acting and the business of authorship; the aim instead is to suggest new sources in theatrical work for the construction of the dramatic author. Turning away from actual performance, however, the second half of this book considers the careers of Anthony Munday and Thomas Heywood. Though it was claimed that Munday performed as a comic actor – and was hissed off stage – scholars remain uncertain about the truth of those allegations. We know that Heywood had a long career on stage, but we know almost nothing about

the shape that career took. For these writers, performance is something like a controlling metaphor, a way of registering the uncertain status of print authorship and theatrical practice alike. Most powerfully, performance is selling for Munday and Heywood, and the higher forms of conscience or classical erudition that they market are always filtered through the need to please an audience. They thus articulate forms of authority that our models of pure interiority or Jonsonian eminence are unable to reach.

Finally, the coda to this book takes up the question of Shakespeare as an actor-author. Though, or perhaps because, Shakespeare said next to nothing about dramatic authorship directly, he has become the lens through which playwriting in early modern England is known to most readers. The effects of Shakespeare's dominance are surprising, influencing both the idealist scholarship that reads him as our universal author and the materialist criticism that would dislodge him from that position. Though the present study began in the impulse to explore writers to whom scholarship has given little attention, its implications reach beyond that limit; to change our sense of Nathan Field or Anthony Munday is ultimately to change our vision of Shakespeare, too.

Publishing the fool: Robert Armin and the collective production of mirth

The modern institution of authorship is, it seems, inseparable from notions of ownership. Following Foucault's influential suggestion that the function of authorship is supported, and even created, by the regime of copyright, a host of scholars has traced the relations between legal concepts of intellectual property and what once seemed to be more purely literary and aesthetic ideas about originality and self-expression. Mark Rose's incisive book, appropriately entitled *Authors and Owners*, opens with the following summary comment: "The distinguishing characteristic of the modern author...is proprietorship; the author is conceived as the originator and therefore the owner of a special kind of commodity, the work."[1] As Rose argues at length, it was through the legal process of defining literary property – a process initiated and sustained by booksellers, seeking to protect their own positions – that notions of the author as an original creative genius achieved currency. Similarly, Joseph Loewenstein has traced the way property rights adhered to stationers long before authors began to exercise legal control over writing.[2]

Locating authorship in notions of property has been especially important for the study of early modern English drama, an institution that clearly privileged performance over composition and often employed authors in anonymous collaborating teams rather than as originating geniuses.[3] Without property rights, it is argued, theatrical writers cannot be said to have practiced authorship as we understand it. As important as it has been to dissociate post-Romantic authorship from early modern theatrical production, however, the emphasis on textual ownership has impoverished our scholarly vocabulary. We have been left with no viable way of talking about the forms of textual appropriation that were clearly being practiced by writers for the stage, even in the absence of copyright. Moreover, as this book argues throughout, we are left without a way to trace connections between performance and authorship, connections that might well change our perceptions of both forms of public address.

A figure like Robert Armin, who wrote numerous pamphlets, ballads, and jestbooks, who is the known author of one play and the likely author of a second, and who performed fool roles with the clown's typical popularity for the Chamberlain's/King's Men after 1599, remains extraordinarily difficult to account for as long as textual ownership or originary genius remain the defining terms of authorship. In fascinating contrast to the post-Romantic ideal, Armin boldly advertised his dependence upon audiences and upon the fools he imitated, locating the source of his authorial productions not in himself but in the culture around him. He was, nevertheless, like other comic actors in this period, a celebrated figure who capitalized upon his celebrity by making incursions into print. As a powerful textual presence in his known play as well as in his non-dramatic writings, Armin establishes a continuity between stage and print, a rhetoric of authorship that challenges our sense of the anonymity of theatrical writing. Perhaps more importantly, he challenges the primacy of ownership and originality in the construct of authorship. Armin's theatrical performances and his published writings alike deploy a paradoxical form of the author-function; neither the originator of his jests nor the owner of them, Armin is nevertheless an individualized figure. And yet he is individualized precisely because he represents communal forms of cultural production. We have not properly understood Armin's charisma, his position at the intersection between the private and the collective, or the power of his reputation to configure strong relationships between print and performance.

PROMISING PLEASURE

In *Foole upon foole*, Armin tells the story of the natural fool Jack Oates, a much-indulged and infinitely troublesome member of Sir William's household. Sir William particularly loves quince pie, and his wife charges the cook with the task of finding quinces out of season so a pie may be had. The cook is unable to do so, but after much searching some preserved quinces are found at an apothecary's, and Sir William agrees that a preserved quince pie is worth eating. He calls together a congenial group of friends in anticipation of the feast. Jack, who has long been at odds with the cook, waits until he is alone in the kitchen and then steals the pie fresh from the oven, and begins devouring it rapidly. He jumps in a moat up to his chest to soothe the burns he has gotten while carrying the pastry, dipping it in the cool water before eating it, fistfull by fistfull. The cook is driven to distraction when he discovers that the pie is missing: "The Cooke comes in, misses the Pye, with all misses Jacke, cries out the Pye: Sir William['s] Pye was gone,

the Author of that feast was gone, and they all were undone."[4] Without placing too much stress on a single word, this chapter will explore what it might mean for Armin to represent a pie as the author of a feast.

Recently the word "author" has been restored to a fuller context than the narrow literary sense can allow. Jeffrey Masten has documented the early theological and political uses of the word, noting that before it came primarily to mean "the writer of a book," "author" referred as well to a progenitor, a prime mover, the instigator of an event or process.[5] Most tellingly, Masten quotes the translator's dedication to the King James Bible, which establishes James as "the principall moouer and Author of the Worke." Within the context of absolutist monarchy, in other words, an author is in line with God, King, and father as an originating force and a powerful authority. As these forms of authorial begetting merge with developing notions of property and genius, the author acquires a right to his or her texts because the author is a quasi-divine creator. The cook's cry of distress, however, suggests a very different approach both to origins and to ownership. In Armin's narrative, almost all of the people mentioned – the cook, Sir William, his wife, Jack, the important guests, the apothecary, the onlookers – can be imagined to possess some degree of agency in the production of the feast, but it is the pie itself, the object they collectively construct, that gets called the "author."

It is an image that resonates powerfully with Armin's career on stage and in print. As both an actor and an author, Armin offers an important counter-fantasy to the one that connects theatrical writing with God and King. Armin's work, building as it does upon the traditions of the fool and the clown, or comic actor, suggests that early modern theater constructs authorship in ways at least partly inimical to absolutist monarchy, inimical to the regime of copyright, sovereign voice, and authorial begetting. It does so in part, clearly, through the figure of the clown. Like that pie, the professional clown is more than a pleasant garnish. He is the essential ingredient of the feast, the focus of its pleasures, the object of longing.

Though the stage practices of the early modern theatrical clown are widely known, they merit review here as a way of stressing the clown's extraordinary power to embody theatrical pleasure.[6] In the theater, he could serve as a catalyst for his audiences, drawing them in with his improvised responses to their own taunts and provocations. We know that the clown in a theater company tended to make a special appearance at the end of a play, prolonging his entrance as long as possible in order to build up anticipation in the audience. Numerous reports emphasize the transformative – not to

say disruptive – pleasure of the clown's initial appearance, as Henry Peacham recalls in 1620:

> As Tarlton when his head was onely seene,
> The Tire-house doore and Tapistrie betweene,
> Set all the multitude in such a laughter,
> They could not hold for scarse an houre after.[7]

Jutting his head out from behind the arras, Tarlton's automatic connection to his audience is enough, even without words, to transform the theatrical environment.

Hamlet worried about the clown's ability to run away with a serious drama, and Sir Philip Sidney wanted them kept away from kings on stage, in part because the performance of a clown effected a virtual change of genre, turning a high tragedy into a low comedy. As David Wiles has documented, some members of the audience arrived at the theater solely for the purpose of witnessing the clown's jigs; they crowded the yard as the play was ending, either having paid admission or having snuck in for free to catch the clown's appearance.[8] Instead of being a diversion at the end of a theatrical event, in other words, the clown often became the audience's focus. Will Kemp built upon his success as a clown on stage by taking his jigs on the road. He performed a Morris dance all the way from London to Norwich, drawing great crowds wherever he went, causing, as in fact traveling theater companies caused, a kind of festival day whenever he arrived. In a very real way, the theatrical clown is the author of an event, the instigator of mirth. When Sir William's cook imagines dessert as the prime mover of a social occasion, then, he is perhaps onto something important, something we might expect the literature of fooling to take as a given: the self-consciously marginal clown, like the pie, is in fact the whole reason for gathering together, at least for those of us willing to admit that our priorities are somewhat misplaced on occasion.

The clown possesses, in other words, by virtue of his pie charisma, an extraordinary measure of agency, an ability to transform the theatrical ex- perience of whole groups of people at once, and to leave diverse audiences satisfied and dazzled. In this sense, his work is analogous to the work we sometimes imagine dramatic authors performing. He is a master manip- ulator of theatrical space, imposing his own vision upon the desires of an expectant crowd, having the last word on stage. He can rewrite a tragedy simply by appearing before an audience. But it is of course important to remember that the clown's performances are not identical with textual au- thorship. They are, instead, more closely linked with the larger, expanded

meanings of "author" in the period. For the clown is the author of an event, not specifically a written text. He initiates a process over which he must then improvise control, manufacturing – often rhyming – responses to the questions or jibes that members of the audience throw out. His relation to the audience is in fact a kind of contest; he pleases them by working with his wit to overcome the series of comic challenges they themselves offer him. Wiles argues that it was an important feature of Tarlton's performances that he let himself seem to be conquered by the jousts of his interlocutors, only turning the jest around at the last minute to triumph by virtue of his own wit (16–17). Clown performances worked in part through delayed gratification, as if to recognize the function of longing and anticipation in the comic, as if to maximize the personal charisma of the performer. Theatrical practice itself, then, created an appetite for individual figures who could, as individuals, promise theatrical pleasure. When the Shakespeare Folio of 1623 constructs the dramatic author as a powerful textual presence, in other words, it is perhaps not simply importing the figure of the author as a construct invented in discourses of absolutist monarchy.[9] It may, rather, be extending the logic of celebrity that performers like Armin had already exploited, merging absolutist sovereignty with forms of personal charisma that clowns were adept at manipulating.

Granted, the performances of a clown are importantly unlike the fantasy of textual control that we generally imagine as belonging to authors. But it is worth remembering that textual control has always been a fantasy, viable to greater and lesser extents in various historical periods. It has been well established that such a fantasy was wildly inappropriate for the early modern stage, with its collaborative writing, its chaotic methods of textual transmission, and its relative empowerment of players at the expense of playwrights. The clown himself has been taken quite rightly as a figure for the dominance of performed improvisation over authorial vision or self-expression. Wiles's own work, the most provocative and furthest-reaching study of the early modern clown to date, is important in part precisely because it dislodges Shakespeare from the pedestal of individual authorship, documenting the influence of clowns as relatively independent theatrical professionals with whom Shakespeare had necessarily to work as he composed his own plays.[10] Shakespeare becomes less of an author because clowns are such powerful performers. But because work on dramatic authorship has so insistently read performance as inimical to authorship, it has been nearly impossible to acknowledge the links between the two, the forms of celebrity that made the stage an important counter to the authorial constructions of the absolutist court, the print shop, or the discourses of private property.

To begin to talk about Armin's authorial practices as a challenge to the author-as-owner paradigm, however, is also to challenge other accepted ideas about authorship. First and foremost, in fact, regarding performance as a source for authorship challenges the model of the "players' theater" versus the "authors' theater." Richard Helgerson has argued that the 1590s saw a gradual consolidation of authorial power and that that power came at the expense of players' freedom to improvise, a freedom most notoriously located in the clown.[11] In keeping with arguments also made by Daryl W. Palmer, Colin MacCabe, and David Wiles, Helgerson points to the banishment of Falstaff, the departure of Will Kemp from the Globe, and the apparent relegation of jigs to the less-prestigious theaters in the north of London as central events in the process of taming players.[12] Thus Armin, the "socially unmarked" fool who replaces the plebeian Tarlton and Kemp, stands in for a move away from the unruly festival elements of theater.[13]

In keeping with this narrative of foreclosure upon popular traditions, Armin is often seen as a more conservative figure than his predecessors. David Wiles reads him as much more obedient to an author's script than Tarlton was, for instance, and much more likely to be reined in at the end of a play than Kemp. He also suggests in a widely accepted argument that Armin did not interact with his audiences in the way the other clowns had, even when he was performing solo rather than taking a scripted role in a play.[14] This chapter will argue that there is only very slight evidence to support the notion that Armin did not collaborate with his audiences, and the coda to this book will begin to address Armin's performances in Shakespeare's plays by scrutinizing the role of Feste in *Twelfth Night*. At this point, however, let it suffice to point out that the political valences of the various positions taken up by Tarlton, Kemp, and Armin are by no means simple to pin down.[15] Tarlton's unruly improvisations, for instance, seem to have been possible in part because of his status as a favorite of Queen Elizabeth's. Strictly speaking, improvisation was illegal; Tarlton enjoyed a kind of immunity from the restrictions. Improvisation thus marks him as potentially more privileged than the authors whose scripts he might have interrupted. He was also very comfortable financially, owning two taverns and letting one out. He performed for the Queen, for various members of the nobility, on stage, and in his own taverns. He was both a Groom of the Chamber and a Master of Fence.[16] He had sources of income that were not directly tied to the success of a particular dramatic production. He represents an extraordinary form of performance authority, a power that fully rivals that of a playwright; in fact he was a playwright, author of

The Seven Deadly Sins, now lost. In this sense, Armin's apparent reduction of improvisation must be understood as a move toward more egalitarian arrangements in the theater company. The players collectively owned the script and could make changes, but the improvisations of a single star performer are radically individualistic gestures. Without Tarlton's power to ignore the law, moreover, an improvising player could put his company at risk.

If Tarlton is an ambiguous figure, of course, so is Kemp. There is a strong tendency to talk about him as having been "expelled" from the Globe, but all we really know is that he left. He said in *Nine Daies Wonder* that he was "dancing his way out of the world," but that hardly gives us enough evidence to document a movement against him by the Chamberlain's company.[17] He may very well have decided on his own to try out other opportunities like his spectacular Morris dance to Norwich, which he followed with a dance to Italy.[18] The alleged comments by Hamlet that condemn him for speaking more than is set down are also very slight evidence that Shakespeare had rejected Kemp's mode of performance. Given that Hamlet himself imitates the clown in the 1603 quarto and that he performs the role of the post-play improviser after *The Mousetrap*, we must at very least allow that the play seems to be making complicated comments about the work of clowning, comments that are not easily turned into historical documentation.[19]

For that matter, the often-noted parallel between the banishment of Falstaff and Kemp's departure from the Chamberlain's Men is a similarly difficult coincidence to read. Even apart from the impossibility of being absolutely certain that Kemp played Falstaff, it is hard to imagine that a playing company would want to stage the rejection of one of its most popular performers *as* a performer.[20] Given Kemp's popularity, it makes much more sense that his performance of Falstaff would render the banishment of the character profoundly unsympathetic. Moreover, though Kemp's departure from the company does seem to mark a shift toward a more naturalistic form of playing, it does not eliminate engagements between the players and their audiences. As Robert Weimann has pointed out, there remain within the neoclassical esthetic as Shakespeare adapted it considerable opportunities for at least a modified platea-style relationship between performer and crowd. In fact, Weimann has suggested a fascinating correlation between a given character's removal from direct relation with the audience and that character's depiction as particularly self-centered or unsympathetic.[21] This is hardly the place to review the modes of performance in Shakespeare's repertory,[22] but consider briefly the effect of Hal's first soliloquy in *I Henry IV*, beginning as it does with "I know you all,

and will a while uphold / The unyok'd humor of your idleness."[23] These lines would be difficult to deliver without addressing an audience directly; they suggest that in the very play in which non-representational mimesis is being rejected, it is also being used to render that rejection problematic. Again, like *Hamlet*, the Henry plays are far too ambiguous to count as solid evidence that Kemp's departure from the Globe was the company's own idea or that it reflected a profound dissatisfaction with what had apparently been a very successful mode of performance.[24]

Finally, it is important to note that whatever move the Chamberlain's company made toward authorship, it was a move that the clowns themselves also appear to have been interested in. Tarlton wrote *The Seven Deadly Sins*, Kemp wrote an account of his dance to Norwich, and Armin had a series of texts appear in print. As the present study has been suggesting, many aspects of the clown's performances are not at all inimical to authorship. Tarlton the privileged improviser was in some ways closer to the fantasy of textual control than Shakespeare. In Armin's case stage performance and print authorship went together, and his successes in one medium are directly linked to his strategies of self-promotion in the other. The very persona that worked in a performance to simulate control over theatrical space could be carried over into print, where it promised buyers both the pleasures of the stage and an experience of Armin's personal talents. If we are not, then, licensed to read Armin's replacement of Kemp as an automatic sign of the former's conservative cultural impact, we find ourselves instead licensed to explore his radical innovations in the construction of authorship. The pages that follow consider ways that a clown's performed charisma could be appropriated for writing, and the ways in which Armin made the transitions between performance and print register the simultaneous importance and impossibility of textual ownership in both media. The concern here is not so much to represent Armin as more subversive than Tarlton or Kemp, or even to establish him as their equal, but rather to bring into our discussion of clowns and fools a sense of their importance for dramatic authorship. Armin in particular demonstrates that our notion of the author as an owner of texts who speaks with a powerfully individual voice is not the only option available to a writer based in performance. On the contrary, Armin manages to emphasize his skill and commodify his name even while speaking as an embodiment of communal pleasures. It is thus difficult to regard Armin as a sign that the player's theater has been left behind and the author's theater, with its implicit logic of private ownership, has taken precedence over the work of actors. Instead, Armin must be considered a figure for the strong continuities between performance and print.

Of course, carrying a persona over from the stage into print is not a simple process. One of the kinds of books that professional clowns could sell easily was the jest book, a collection of gags and exploits that drew either from apocryphal tales or from the actual stage work of comic actors. It is a truism to note that the jests that fill early modern jest books are not particularly funny; David Wiles suggests that "[d]eduction is required if we are to understand from [Tarlton's published] *Jests* why Tarlton was so popular," while J. O. Halliwell admits that "the modern reader will be rather at a loss to discover the merit of many of Tarlton's 'Jests.' "[25] Such observations should be qualified – emphatically – by an admission of historical difference. Early modern audiences should not be expected to laugh in precisely the way "we" laugh, even if we could define "humor as we know it today." Historical adjustments notwithstanding, however, it is instructive to think about why the written records we have of clown performances fail to carry the comic force attributed to them almost universally by contemporary witnesses. What is missing first and foremost, of course, is the clown's body, recognized as crucial not only by today's scholars but by the clowns themselves and by their audiences. Clowns always emphasize their own bodies in some way. Wiles has argued that Armin's scripted theatrical roles often positioned him as the object of some gulling that left him stripped, emphasizing his quasi-dwarfish physique for the audience's pleasure.[26]

As noted earlier, moreover, the mere appearance of the clown on stage – that trademark jutting of the head out from behind an arras – sent audiences into spasms of laughter. The clown is withholding his body here, but the effect is profoundly physical nonetheless, for as Tarlton *withholds*, his audience, in Peacham's words, "*[can] not hold* for scarse an houre after" (emphasis added). Joseph Roach has documented the fears that accompanied acting in this period, demonstrating that players engaged the humors in frighteningly powerful ways, wielding or sometimes improvising control over a contagious fluid that threatened to permeate individual bodies. He summarizes the actor's agency as follows: "First, the actor possessed the power to act on his own body. Second, he possessed the power to act on the physical space around him. Finally, he was able to act on the bodies of the spectators who shared that space with him."[27] Gail Kern Paster, too, has argued that an actor "can offer the image of an affective and physical control so masterful as to quell, if only for a time, the inner turbulence of his own humorality."[28] Those who cannot help laughing at the sight of Tarlton are experiencing a loss of bodily control, and their pleasurable helplessness

in relation to his supreme command of their own humoral dispositions at moments like this does much to explain his status as an embodiment of theatrical pleasure.

But the fool's body and delivery alone are perhaps not enough to account for the overwhelming power of performance versus the relative flatness of a printed version of that performance. The other crucial bodies missing belong to the audience members themselves, and the presence of an audience results in more than just a heightened sense of physicality. For audiences arrive at a theater with expectations, particularly, as noted above, when they are sneaking into a theater at the end of a play on purpose to witness the performance of a favorite clown. What their adulation of the clown obscures, however, is their own role in the production of the humor they come to witness. As Malvolio noted in *Twelfth Night* – and then experienced to his peril – audiences do at least half of the work of clowning. In practice, audience members often thought up the taunts to which a clown responded, and they could also perform the various stock responses to his humor, sometimes – again like Malvolio – leaving the theater in shame, sometimes scoring their own comic "points" at the clown's expense, sometimes joining in the crowd's laughter at them. Though Armin may have performed multiple voices himself, thus perhaps reducing the exchange with audiences that characterized Tarlton's performances, he nevertheless continued to respond to the "themes" they put forward.[29] He continued to blur the distinctions between performer and audience.[30]

Those distinctions are blurred, that is, except when one turns to consider the reputation of the clown himself. For audiences arrive ready to do much of the clown's work, but the results of that shared labor are definitively and passionately labeled "Tarlton" or "Armin." Again and again Tarlton's elegies claim that no one else could be funny in the same way he could. The clown's name tends to stand in for the whole festive occasion he authorizes, even though audiences often initiate the actual jokes, and even though the jokes clowns did perform were usually highly scripted, handed down for generations. Body and performance plus reputation, in other words, add up to humor, which creates more expectations for the next performance – which makes the body and performance funnier the next time around. The clown's name becomes attached to a whole cultural construction, an agreement to make comedy together and to find that comedy funny in part because it bears the name attributed to prior appearances. This helps, perhaps, to explain why jests and published texts were often attributed to Tarlton even after his death. As Alexandra Halasz has argued, other

writers – indeed in her account the print industry as a whole – are in some sense licensed to use his name to sell their own texts.[31]

In fact the crucial analogy here is with Foucault's author function. Neatly reversing the usual humanist assumption that the author is the source of infinite textual meanings, a wellspring of possible interpretations, Foucault has famously argued that authorship works to foreclose upon a text's multiple meanings. Written texts are read for evidence of "characteristic" authorial modes of address, which are then used as information about authorial "essence," which then governs a series of judgments about further texts. The author is a bulwark erected to protect a literary work from what would otherwise be an infinite sea of textual signification. Foucault, then, thinks of the author as a conserving figure; his often-quoted formulation describes the author as "the principle of thrift in the proliferation of meaning."[32] Without denying the importance of the clown's personal performance – any more than we are free to deny the labor of a published author, or imagine that there are no characteristic modes of authorial address – we ought to emphasize the importance of naming in comic performance and literary publication alike. The name "Tarlton" operates socially almost as we would now use the name "Shakespeare": as a principle of thrift in the proliferation of meaning. Both the live clown and the enshrined playwright are authors of events. Both are pie.[33]

We might then reverse our sense that clowns are anti-authors, principles of textual disorder. Critics have traditionally imagined performers as figures for the death of the dramatic author, but in fact the clown demonstrates that the ethic of performance is reconstructed in print, that the actor's power on stage is not absolutely withheld from the author of a book.[34] On the contrary, this form of authorship grows out of theater. The clown reproduces the structures and affective bonds of communal mirth, offering as a commodity the experiences of the fool that originate in the village, the tavern, and the banquet hall. As he does so he acquires authority, the power to license and to guarantee pleasure. At the same time, however, the theatrical clown becomes himself a kind of communal possession, a name invoked for other purposes and other meanings.[35] He embodies the communal for his audiences, which gives him a powerful individual charisma, which then circulates him back into the community as the sign of mirth. He thus becomes a signifier in print; his name means theatrical pleasure. Performance is, as Armin practices it, analogous to the construction of authorship as we now think we know it. In Armin's case, in fact, the charisma of theatrical play and the charisma of print are one and the same.

THE AUTHOR AS PROPERTY

Certainly Tarlton's career, as outlined above, explains how individual rep-
utation comes to represent what is an essentially audience-driven pleasure.
But Tarlton's prominence as a charismatic performer also made him suscep-
tible to a form of pirating. He became an object in circulation. His picture
appeared on alehouse signs and privys alike; at least one fighting cock was
named for him.[36] One of the numerous texts that appropriated Tarlton's
name, the anonymous *Tarlton's News Out of Purgatory*, brings the clown
himself back from the dead. In a play called *Cuck-Queanes and Cuckolds
Errant*, Tarlton appears as prologue to welcome the audience to the Tarlton
Inn, where many of the play's events will unfold. To put words into Tarlton's
mouth and to bring him back to life was to locate in him a powerful textual
authority.[37] As the narrator of *Tarlton's News Out of Purgatory* explains, the
longings of his audiences gave Tarlton a status that rivaled that of classical
oratory:

Sorrowing as most men doe for the death of Richard Tarlton, in that his particular
losse was a generall lament to all that coveted, either to satisfie their eies with his
Clownish gesture, or their eares with his witty iests. The wonted desire to see plaies
left me, in that although I sawe as rare showes, and heard as lofty verse, yet I inioied
not those wonted sports that flowed from him as from a fountain, of pleasing and
merry conceits. For although he was only superficially seene in learning, hauing no
more but a bare insight into the Latine tongue, yet hee had such a prompt witte,
that he seemed to have that *Salem ingenii* which Tullie so highly commends in his
Orator.[38]

In this elegy, Tarlton is a very particular presence, an irreplaceable source
of wit and of pleasure that can only be imagined as his own. No other voice
can equal his. What this particularizing description obscures, however, is
the usefulness of Tarlton's wit as the fountain of the *News* writer's own
conceits. At the moment that Tarlton becomes most himself in print, that
is, he also becomes most emphatically the possession of others.

The case is sometimes made that Robert Armin is the author of *Tarlton's
News*.[39] That argument is ultimately unpersuasive, but it does point to an
important fact: of all the writers who used Tarlton to authorize their own
print performances, Armin is the most deeply indebted. He can be seen not
only as Tarlton's successor on stage but as the heir to Tarlton's authority in
print.[40] And the combination of performed charisma and textual authority
makes Armin a powerful figure for the development of the dramatic author,
a figure positioned to emphasize authorship's now-occluded necessities:
negotiation, manipulation of audience demand, collaboration in the larger

sense if not in the literal one. Certainly the existing story about Armin's association with Tarlton emphasizes both Armin's innate abilities and his need to be recognized by an appreciative audience. As told in *Tarlton's Jests*, Armin is portrayed as the apprentice to a goldsmith who lived in a tavern owned by Tarlton. Charles, the host of the tavern, rented it from Tarlton and was simultaneously deep in debt to Armin's master, the goldsmith. Tarlton visited the tavern frequently and was thus witness to young Armin's repeated attempts, as emissary for the goldsmith, to get money from Charles. One day Armin, in desperation over the host's failure to settle accounts, wrote a poem in which he mocked the host, calling him "Charles the lesser" instead of "Charles the Great." Tarlton, recognizing a fellow comedian, inscribed the following response:

> A wagge thou art, none can prevent thee;
> And thy desert shall content thee.
> Let me divine. As I am,
> So in time thou'lt be the same,
> My adopted sonne therefore be,
> To enjoy my clownes sute after me.
>
> (Feather 23)

The response made Armin love Tarlton, and devote himself to learning the art of the clown. Though, or perhaps because, the story is apocryphal, it speaks loudly for the ways that Armin's career is sculpted for him by audience desire. Tarlton, as representative of the tradition of fooling, responds to Armin's improvisation by identifying in him an essential wit. Though his expertise is clearly shaped by study, the force of Tarlton's recognition, with its language of prophecy and destiny, argues for an almost mystical clown being, an almost essential identity. Like Simeon in the temple, Tarlton embodies the longing of the people of London for their next comic savior. The story exists because there is a prevalent desire to make the representative of mirth something more than well rehearsed. He is a unique individual. He is chosen.[41]

As this chapter has been arguing, however, the flip side of this sense of comic destiny is a strong suggestion that the clown becomes public property when he wins an audience's affection. The above story in *Tarlton's Jests*, for instance, appears to be a version of Tarlton's own myth of origins, as recorded by Robert Fuller.[42] According to that apocryphal tale, Tarlton himself was discovered working in the fields in Shropshire when Robert, Earl of Leicester, stopped to speak with him. The Earl was so taken with what he called Tarlton's "happy unhappy" responses that he brought Tarlton

to the Queen, thus launching his comic career.[43] This story is in turn, apparently, a comic version of a very real economic phenomenon: the "natural" fool could become the ward of anyone who stepped up to take care of him. In the case of the mentally handicapped who possessed property themselves, this policy led to overt exploitation, as "caretakers" acquired the rights to that property by claiming to look after those who seemed unable to care for themselves. As may be expected, there is some evidence that the criteria for mental unfitness could become rather vague when powerful property interests were at stake. The policy also suggests that fools who entertained noblemen may have come to their positions through less than voluntary means.[44] Though it is fairly clear that Armin suffers no such fate in this story – he is after all a witty clown, not a natural fool – the notion of being "discovered" as a clown is inevitably linked in this period to a profound loss of autonomy. The comic performer may be among the most acquisitive and often the most successful entertainers in early modern England, but the narrative of comic discovery also suggests that he is among the most radically dispossessed. And this broad sense that clowns are public property has particular ramifications for Robert Armin's printed work.

Even in the absence of coercion – even though Armin was not a kidnapped natural fool – the structures of indebtedness and apprenticeship in the myth of Armin's origins, in the story of the goldsmith's apprentice, suggest that his improvisations and his comic destiny are accompanied by a series of questions about possession. For the loss of self-possession inherent in the position of the discovered clown is matched by a repeated failure of rhetorical ownership in Armin's written work. At the same time that Armin emphasizes his own witty power to dominate any situation verbally, that is, he also represents himself as speaking with a collective voice. In Armin's writing, the economic conditions under which he labors, the expectations and contributions of audience members with whom he quips, the participation of printers and booksellers in the process of publication, the responses of readers, the presence of live fools whom he impersonates on stage – all become inseparable from his own performance of inherent wit. Like Tarlton before him, when Armin becomes most himself in print, most capable of authorial self-assertion, he simultaneously becomes most obviously the property of others. Again, what this complex logic of possession and dispossession points toward is the development of a kind of author-function that grows out of theatrical work rather than being derived from the absolutist monarch.[45] Armin's particularly powerful careers as a stage performer and a published writer highlight the paradoxes of authorship

in the theatrical milieu: the clown becomes both an individualistic author
and a marker for the communal production of humor. To revise Foucault's
construction, the clown author is both a principle of thrift and a figure for
the theatrical proliferation of meaning.

<div align="center">LOCATING THE QUIPPER IN QUIPS</div>

When Armin publishes *Quips upon Questions*, his version of a jestbook,
he seems at first glance to be transcribing his improvised theatrical perfor-
mances. In fact, however, the text suggests mixed origins. At least one of
the poems it contains conjures up a scene of writing that is removed from
the theater:

> Writing these Embles [i.e. emblems] on an idle time,
> Within my windowe where my house doth stand:
> Looking about, and studying for a Rime,
> I might beholde a Poet weakely man'd.[46]

Elsewhere within this same poem and throughout the others in the collec-
tion, though, *Quips* uses multiple voices. Real or imagined interlocutors
pose questions that vary from "Why barkes that Dogge?" – presumably
a reference to noise in the moment of performance – to "What is light?"
which implies that the interlocutor is himself or herself initiating a riddle
of some kind, thus demonstrating comic prowess that literally and im-
mediately rivals that of the paid performer.[47] Moreover, the poems that
respond to those questions are written in dialogue form, albeit without
speech prefixes.

Presumably, though this is by no means guaranteed, the final quipping
voice that concludes each poem should be imagined as Armin's. But the
real confusion lies in the middle, in the poems themselves. In "What wisht
hee?" for instance, the middle poem appears to be a direct answer by a
first-person speaker, but one or more interlocutors join in, so that six lines
into this composition it becomes difficult to identify the speaking voices at
all:

> *What wisht hee?*
> I know not what he wisht, but I am sure,
> He had his wish, his hartes wish to procure,
> And yet he went without his hartes desier.
> How can this be but thou must be a lyer?
> What is a wish? Why wind, wanting his will.
> To this I yeeld, and yet am simple still. (cv)

The "I" in line six may or may not be the same as the "I" in the opening line. The poem goes on to change speaking voices somewhere between four and seven times in fourteen lines, concluding at one point that the speakers should leave off and agree with one another before erupting into disputation once again. Given such a hopeless mingling of voice, the status of the quipping quatrain at the poem's end is radically unclear:

> *True, but Ile have my wish presently.*
> *He that wisht so, I doe wish hartely,*
> *That as he was a foole to want his will,*
> *So he may nothing loase, but be so still.*
>
> (C2)

This voice may or may not be the same as the one that began answering the initial question, thus raising doubts about whether the "author" here is the primary speaker in the poem, if the poem can be said to have a primary speaker. For a moment, there is even the suggestion that the quipper is the "he" that the question was asked about. In any case the quipping voice becomes linked with the butt of the joke by virtue of the fact that both are wishing and both are fools. The poems posit a triumphant quipper who is presumably Armin, in other words, but the poems themselves are such complicated exercises in attribution that such confidence is ultimately unjustified. All a reader can be sure of is that there is a witty speaker tossing off a last word. Thus verbal preeminence is the whole point of the text, but the preeminent voice is radically unidentifiable.

Such failure of rhetorical possession is in fact advertised by the book's title page:

> QUIPS
> UPON QUESTIONS
> OR
> A Clownes conceite on occasion offered.
> bewraying morrallised metamorphoses of changes
> upon interrogatories: shewing a litle wit, with
> a great deale of will; or in deed, more
> desirous to please in it, then to
> profite by it.
>
> Clapt up by a Clowne of the towne in this last restraint,
> having litle else to doe, to make a litle use of his
> fickle Muse, and carelesse of carping.
> *By Clunnyco de Curtanio Snuffe.* (A)

We are offered the clown's conceits, but they are immediately repackaged as "morrallised metamorphoses of changes upon interrogatories." The very

notion of a sovereign speaker is belied by this tortuous – and apparently accurate – description of textual genesis, in which the clown/author's role is to "betray," or reveal, the quips that he has produced in order to transform comic exchanges that arose in response to interrogations from audience members, which he is writing down "in this last restraint" – because the theater is closed by an order of the Privy Council.[48] Thus the text is literally "Clapt up": it contains jests that have already been applauded on stage, and it is thrown together in a bewilderingly complicated way.

But, as the author's jaunty pen name – "Clunnyco de Curtanio Snuffe," which means "Snuffe the Clown at the Curtain Theater" – suggests, *Quips upon Questions* also betrays a real interest in the figure of the author himself. Alongside his apparent failure of rhetorical possession, that is, this title page and the prefatory materials that follow it also advertise an overwhelming possessiveness, a combative sparring that is very much akin to the desire to have the last word. Just above the printer's device on the title page, for instance, occur two provocative couplets:

> Like as you list, read on and spare not,
> Clownes iudge like Clownes, therefore I care not:
> > *Or thus,*
> Floute me, Ile floute thee; it is my profession,
> To iest at a Iester, in his transgression. (A)

The desire to please that was initially offered gets replaced in these lines by something else altogether: a professional skill at turning reader and audience responses into personal aggrandizement, into individual reputation. It is his *profession* to jest at a jester.

The title page of *Quips* is followed by a series of prefatory pages that contain further statements of authorial prerogative. The epistle "To the Right Worthy Sir Timothie Trvnchion, *Alias* Bastinado" addresses, presumably, the marotte that Armin uses in his stage performances. In it Armin (or more properly, Snuffe) asks "Sweete Sir *Timothie*, kind sir *Timothie*, tough sir *Timothie*" to help him as he walks "from Stationers shop to Stationers shop, to see what entertainement [his] Booke hath; and who so disgrases it enuiously, and not iesting at it gently, at the least bastinado them, that bobbadillo like as they censure, so with him they may receiue reward" (A2–A2v). This is followed by an epistle to the reader, which ranges from deference to violence, offering to let his customers "Glut with gazing, surfet with seeing, and rellish with reading," but also vowing that if they do not use him kindly he will "Let Sir *Timothie* reuenge it" (A3). Finally, a poem is offered as "Incouragement to the Booke": "Goe on, feare none; goe too

and doubt not" (A3v). Though Armin's real name is never used in this text, his interests could hardly be represented more powerfully than they are in the form of Snuffe and Timothie.

David Wiles argues that the poems are likely to represent Armin's performances on stage using multiple voices, speaking all the parts in a dialogue like Feste performing Sir Topas (138–9). But the introductory materials are far too ambiguous to establish Armin's stage practices for us. They say nothing about how he performs as Snuffe, except to indicate that he speaks to his truncheon. Sir Timothy never answers, as one might expect if the point of the introduction were to mimic a routine done with a "speaking" prop. On the contrary, Armin repeatedly uses references to Sir Timothy as a way of threatening readers with cudgeling. There are two references to the truncheon's gift of speech, but they are in indirect discourse. At one moment Snuffe recalls an offer of help: "whereas (kind sir) I sometime slept with thee in the fieldes, wanting a house ore my head; ... at that instant, you assured me to take my part in all dangers" (A2). A few sentences later, Snuffe assures him "you shall in the like commaunde me hereafter" (A2v). The text itself, in other words, gives us no unequivocal help in deciding whether Armin's stage routines are interactive after the initial question is read or called out from the audience.

There are of course other sources of information about Armin that establish him as particularly good at performing multiple voices. Again, the Sir Topas performance in *Twelfth Night* is clearly designed to capitalize upon his skills, and a story to be discussed shortly from Armin's own *Foole upon foole* implies that to imitate Armin is to imitate the performance of several parts at once. Similarly, the role of Carlo Buffone in *Every Man Out Of His Humour*, played by Armin, has him perform the part of two courtiers who fight with one another.[49] But performing multiple voices and interacting with audiences are by no means mutually exclusive arts, and *Quips* itself provides very little information about how it should be read. This is a crucial fact of Armin's work as a performer and writer. On the one hand, he is an aggressive presence, the quipping voice, perhaps a quarrelsome interlocutor, perhaps an energetic mimic of the voices of others. On the other hand, he rarely speaks in an individual voice. Whether in *Quips* he is reporting on his own performances of solo dialogue or reworking actual exchanges with members of his audience, he is insistently dialogic, constituting himself out of the voices of other real or imagined figures. What may seem a position of strength on stage, a power to turn Tarlton-style exchanges into solo performance, becomes in print a radical experiment in uncertain attribution. Particularly as time passes, as Armin gains new

readers who were not present for the original performances, the text of *Quips* establishes him as a complex presence. As an aggressive policer of reader response who will cudgel readers, Armin functions very much as a regulator, a principle of thrift. At the same time, however, the quip format of the text itself establishes Armin as a figure for communal production. Like the myths of comic origin in texts about Armin, Armin's own rhetorical strategies make him a powerfully individual wit at the same time that they make him a publicly owned fool. Whether he is a natural fool who can be begged or stolen, or whether he is a witty fool who becomes an apprentice performer, laying claim to his comic powers means that he himself will be claimed by others, quoted and misquoted by them, and, as in *Quips upon Questions*, spoken through by a crowd.

STEALING THE FOOL

Given the importance and the interdependence of theft, kidnapping, and miraculous recognition in those earlier stories of origin, it becomes especially interesting to consider how Armin makes use of the fools he himself discovers and writes about. In his pamphlet *Foole upon foole, or Six sortes of sottes*, Armin passes on stories about fools he has met or heard of, claiming at once a kind of documentary authority over his subject matter and a fundamental kinship with it.[50] As he himself notes, only the thinnest of lines separates him from the fools he chronicles: "pardon my folly, in writing of folly...Wherefore if my pardon may be purchased then so, if not, the worst is you will say the Author may keep his six fooles company" (F4). Virtually all of the fools Armin describes are themselves casual performers, either because they are maintained in a noble household or because their neighbors sustain them and benefit in turn from their impromptu jests. Moreover, many of the stories in this pamphlet become raw material for Armin's own stage routines. One fool named John in the Hospital becomes the direct source for Armin's performance in the play *Two Maids of More-clacke*, which Armin both wrote and starred in. John's exploits form one of the play's numerous sub-plots, and Armin himself performs the part of John on stage. Armin's relationship to this material is, then, at least partially opportunistic; he mines these stories for their comic potential and then performs them on stage, pamphlet and play-text thus supporting one another and contributing to the popularity of their mutual author. The blurring between Armin as author and the fools he writes about – characteristic of Armin's position as both an individual and a communally formed author – thus once again articulates a familiar authorial position.

In a particularly compelling story from *Foole upon foole*, the story of Jack Miller, Armin revisits implicitly the mythical scene of his own discovery, reworking the terms of that tale to reflect his position as both the imperiled comic commodity-genius and the fool-hunting commodifier. According to Armin's narration, Lord Chandos's Men, a group of traveling players, comes to a town called Esom on the Severn river. In this town there lives a fool named Jack, who loves to perform plays for his neighbors. Jack has given himself a stage name, "Grumball," and has a distinctive playing style much enjoyed by his audiences:

he would imitate playes dooing all himselfe, King, Clowne, Gentleman and all having spoke for one, he would sodainly goe in, and againe returne for the other, and stambring, so beastly as he did, make mighty mirth: to conclude he was aright innocent without any villany at all. (D4v)

Armin reports that when the Lord Chandos's players come to the village, Jack is profoundly drawn to the company's clown, dubbing him "Grumball" and vowing to follow him the world over. This vow causes great concern in the village. In a story that calls to mind the practices of "fool hunting" and the myths of Tarlton's comic "discovery," Jack's neighbors – "they of the towne loath to loose his company" – lock Jack in a closet that has a window in it, so he can watch the players cross the bridge that leads over the river and out of town, but will be unable to run away with them. Though it is never stated in the story, it seems likely that the townspeople were wary about this group of itinerant players, perhaps suspicious that they might bring Jack to Lord Chandos as a kind of human souvenir. Nevertheless, as he witnesses the players' departure, Jack calls to the clown he loves. The narration resumes:

But [Jack] I say seeing [the players] goe by, creepes through the window, and sayde I come to thee Grumball: the Players stood all still to see further, he got downe very daungerously, and makes no more a doe but boldy ventures over the Haven [the river on the edge of town, which is iced over, but not solid] . . . tut hee made nothing of it, but my heart aked to see it, and my eares heard the ice cract all the way: when he was come unto them, I was amazed, and tooke up a brickbat (which there lay by) and threwe it, which no sooner fell upon the Ice but it burst: was not this strange that a foole of thirty yeeres was borne of that Ice which would not indure the fall of a brickbat. (D4v)

There is a crucial unsupplied detail to this story; evidence suggests that Armin himself was the clown traveling with Lord Chandos's men.[51] It is most probably Armin whom Jack loves and with whom he shares his own theatrical name. Though he admits that he is present for these events – indeed

his presence is necessary to establish the truth of this miraculous river-crossing – Armin never admits that he was the charismatic clown who drew the innocent fool across the ice to his evident peril.

Armin's simultaneous presence and absence from this tale makes it a particularly telling representation of an author whose reputation is based in the communal exigencies of comic performance. Once again, Armin is discovered in this story, this time by "a right innocent" whose sense of kinship with the professional performer has the power to carry him over thin ice. This miraculous "suffer the children to come unto me" recognition thus identifies Armin as a comic so gifted and charismatic that he sustains a mystical bond with the harmless innocents he imitates. But as strongly as *Foole upon foole* exploits the connections between Armin and the fools he writes about, it seems both purposeful and uncharacteristic that this narration should omit Armin himself, glossing over his particular role in the story to grant him only an observer's status. In fact, Armin barely manages to perform as a coherent observer in this tale. Instead, he appears almost disintegrated as the narration progresses. If he is initially present in the person both of the traveling clown and of the village natural – as well as the narrating voice – he ends up a virtual collection of body parts scattered along the banks of the icy river. "My heart aked to see [Jack's dangerous crossing]," he interjects, "and my eares heard the ice cract all the way."

Moreover, as culpability becomes an explicit concern in the narration, Armin becomes almost ostentatiously disembodied:

was not this strange that a foole of thirty yeeres was borne of that Ice which would not indure the fall of a brickbat: yes it was wonderfull me though[t] but every one rating him for the deed, telling him it was dangerous: he considered his fault, and knowing faults should be punished, he entreated Grumball the clowne whom he so deerely loved to whip him but with rosemary, for that he thought would not smart: but the Players in iest breecht him till the bloud came, which he tooke laughing: for it was his manner ever to weepe in kindnes, and laugh in extreames, that this is true, my eyes were witnesses being then by. (D4v–E)

Armin is reduced to a pair of eyes passively "being by" – not even looking – precisely at the moment that his implication in Jack's near death is most potentially evident. Rethinking the "wonderfull" charisma that leads the fool across the ice, Jack and Armin seem to realize simultaneously, as though their thought processes were linked, that faults must be punished, that their collective performance is in fact a relationship of potential exploitation and an incitement to vagrancy. And the effort to mitigate the consequences with a joke about rosemary dissolves into a weak textual strategy. "The

Players" (including Armin?) whip Jack "in iest," but the blood is real; Jack laughs but nevertheless bears the brunt of the physical punishment. Armin disguises himself by resorting to an extreme version of the communal identity he has exploited elsewhere, deftly eluding responsibility by hiding behind Jack, Grumball, the narrator, the unspecified players, and his own observing eyes all at once. But no matter how multiple Armin becomes at this moment, no matter how he tries to position himself as audience instead of actor here, we can trace, as presumably some of his early readers could, an individual authorial will in what might otherwise seem to be a neutral act of reporting.[52] Armin wants himself left out of the account. This failure of objectivity constitutes one of the few discernable moments of authorial subjectivity in Armin's otherwise self-less text.

Whether he will or no, Armin is very much the author of this event. His presence is the focus of a comic longing that develops into something painful. Mimesis becomes theft. Even the people whose folly he imitates, even Jack, thinks of the professional performer as the embodiment of fooling, the "Grumball" Jack tries to be when he makes his own reputation as the village fool. Though the narration seems to use Jack to testify to the essential comic charisma of the professional clown, Jack himself seems to use the clown to ratify his own informal comic performances. And because Armin knows how to manipulate this complex set of cultural exchanges – because it is ultimately Armin's representation that will be passed on and that will earn him profit – he stands guilty of a kind of kidnapping. Armin acquires cultural power by becoming more real as a fool than the fool himself is, more Grumball than Grumball. And that means stealing the fool from the village. As author, in other words, Armin reverses the old myth of his own origins, becoming the one who takes the fool away rather than the one who is taken. Armin's disappearance from this text, then, his apparently deliberate self-erasure, must be read as a tacit acknowledgment of authorial power. Once again the connections we draw between individuality, self-possession, and authorship are inadequate to account for Armin's authorial practices. A kind of multiple identity, even a form of textual self-dissolution in this case, is in fact a strong position from which to speak. As Armin employs it here, the multiple voice of the theatrical performer registers his enormous cultural impact. For the pleasures of the village, once mirrored by a professional theatrical company, come to belong to the paid performers who imitate them.[53] When the performer then turns to publication, he cements his hold upon the informal performances of others, changing the affective bonds that sustain the local fool into the price of a pamphlet, that sign of his writing's power to gratify his readers.

Moreover, the prominence of kidnapping as an element of Armin's authorial practice suggests that we might change the terms Foucault has given us for understanding what an author can be. Rather than simply a principle of thrift, Armin was a principle of theft, taking possession of what his audiences first and then his readers were capable of providing one another freely. We are, after Foucault, accustomed to imagining the author as a bulwark against a threatening polysemia. But authorship as Armin practiced it was something else, an institution less concerned with the regulation of textual meaning than with the development of new financial and cultural opportunities, with making money by making a name. The fact that that name comes from the talents of numerous other performers was, at least from the perspective of post-individualist readers, given amazingly frank acknowledgment. Whether Armin is taking responsibility for the comic labor of others or trying to pawn it off, as in the Grumball story, his self-presentations are always connected to communal performance. In portraying himself as a strident individualist who nevertheless speaks with a communal voice, Armin makes possible, and lays the ground rules for, a vision of theatrical authorship that is much more than a derivative of patriarchal absolutism or bourgeois ownership. His career suggests that dramatic authorship is in part intrinsic to dramatic performance. As an institution, the theater created an appetite for pleasure, and part of that pleasure consisted of electing certain individuals to embody communal mirth. Armin's genius consists both in being the pie and in gobbling it up. He functions as an author because he knows how to commit theft in broad daylight, how to make audiences enjoy the process by which he lays claim to mirth, even while they know that mirth is something they themselves have made.[54]

"TOOK NAPPING BY THE WEALE PUBLICK"

As a result, in part, of Armin's exclusion from the realm of important authors, there has been little attention paid to the details of his writing. He has primarily been of interest to scholars who want to trace the history of "the fool" or the traditions of comic acting. And yet it is precisely in the details that his strategies of authorial self-inscription become most unavoidable and most compelling. The representation of fools themselves and the thematics of personal voice outlined so far certainly begin to establish a profound concern with authorship in Armin's writing, but beyond these broader patterns are a host of smaller and even more telling authorial gestures. In prefaces to his texts and in revisions of earlier works, for instance, Armin undertakes a fascinating bid for possession of public pleasure; in doing so,

he speaks with a voice that registers both his individual ambition and his recognition of the communal nature of clown authorship.

Foole upon foole, it has been argued, boasts of Armin's preeminence even while it frankly acknowledges the uniquely collaborative nature of his authorial performance. Interestingly, as if to carry this emphasis upon communal production out to the very margins of the text, Armin goes so far as to focus his readers' attention upon the actual physical artifact of the book, itself, of course, the product of a group effort. In his strikingly unusual preface to the binder and printer of the book, Armin freely acknowledges the collaborative nature of textual transmission, the hands other than his own that have put *Foole upon foole* together. "Let me intreate (or rather for your profit perswade) that you will bee waking when you worke," he asks them, "that you may get good will by your working" (A2). The relations hinted at in this entreaty, ranging from mutual good will to mutual profit, suggest a complex negotiation between a logic of personal ownership and a logic of communal production. Like so much else printed in Armin's name, this preface marks him as a figure for the professionalization and individualization of what might previously have been considered public property.

Armin's dependence upon the good work of others – signaling as it does his lack of control over the book as a physical object, and thus over his own writing – quickly gets subsumed under Armin's usual habit of appropriating the speech of others. "You muse why I greete you thus, blame mee not," he ventriloquizes, and again later, "You'll say if my writing had been better, your printing had had more profit: true so I" (A2). Allowing them to speak only so he can silence them, that is, Armin calls up the voices of his coworker-rivals as though they were fictional characters of his own devising. Moreover, by invoking them as presences here, Armin subtly forces them to speak along with him. It becomes impossible to read this preface without imagining the binder and printer producing the text that binds and prints them, laboring to chastise themselves in print at Armin's behest. The 1605 printer cut this preface, along with some of Armin's introductory poems, apparently in order to save paper; it is tempting to imagine his having done so as a fitting act of revenge upon the author whose comic exuberance stops just short of charging him with incompetence. If Armin can put words into his printer's mouth, perhaps his printer has other more subtle ways of controlling Armin's speech. In fact, this action on the printer's part reminds us of the real power relations that obtain in pamphlet publication. Printers were certainly not just menial laborers; they were with stationers the real owners of the texts they published. Armin conjures up

the printer as a kind of decoration for his text, but as Alexandra Halasz has recently insisted, the pamphlet author is also imaginable as a decoration created by the printer.[55] The questions about ownership are material as well as rhetorical.

But this striking preface goes beyond simply conjuring up the printer and binder in order to make them speak for Armin; it is more than a mechanism for feigning control over the vicissitudes of the material text, more than a rhetorical kidnapping. The preface actually reimagines the whole basis for friendly cooperation, casting it as a particularly invidious form of corporate self-interest:

. . . let us be wise if we can, and ioyne to defend this hard world: . . . the world wil wonder at our good agreeing, no force, I would haue it so: for it's now growne to that passe with all sorts of people aswel the rich as poore, that help me Ile help thee: and so we two liue t'is no matter if all the world dye. (A2)

Not only has Armin taken over the voices of his coworkers, he has replaced idealized "good agreeing" with frank cynicism. Lest the point should be lost upon his readers, he develops it to Swiftian levels of irony by imagining their destruction: "Yet we are not of that minde, for if we two liue and all els dye, what shall the seller doe that bestowes the impression? Nay what shall people doe when none liues to buy his bookes, which hath put him to this charge" (A2). Feigning recoil at the profit motive, Armin has nevertheless clearly replaced universal goodwill with the desire for a paying readership; the death of the entire reading public becomes primarily a tragedy of un-profitable investment in the printing of a book. Like the tale of the fool on the ice, this preface registers the privatization of what might otherwise be considered shared property, and it records that shift by hinting at the dissolution of affection, or at least of fellow-feeling. Armin's appropriation of the speech and labor of others comes along with a surprising affective price tag.

That this should be so makes sense if we consider more carefully the emotional climate of the fool on the ice story. Fools were communal fig-ures, informal performers, signifiers of generosity that got rewarded by nothing but pleasure. Finding their exploits merry, or maintaining them as household entertainers, meant an endless series of occasions in which the household, the lord, the queen, the neighbor, or the town displayed its own magnanimity, its willingness to give away time, food, affection. Fools were on some level a way of naturalizing the bonds of patronage and service. To claim possession of the fool's role as a strategy for selling texts, then, is to connect authorship to the profit motive in an implicitly painful way.

While offering readers an hour's pleasure, as Armin's preface suggests, the fool author is taking away from them the appearance of spontaneous social bonds.

Foole upon foole is a profound record of the privatization of speech, but that process is by no means the only story told by the text, particularly if we consider the revisions Armin undertook in 1608. This was a period of time during which, for reasons it is impossible to identify – though it goes without saying that profit is a strong motivator – Armin seems to have devoted himself to rewriting and reissuing his earlier works.[56] When it came time to rework *Foole upon foole*, interestingly, Armin seems to have considered it expedient to convert the text to a form of allegory. And the nature of that allegory complicates the model we have been building of Armin's encroachment upon the public property of mirth. In a way more in keeping with the deliberately multiple voice of *Quips upon Questions*, the revisions imply that communal authorship remains a powerful position from which to speak.

In the revised text, entitled *Nest of ninnies*, the World, represented as an intemperate woman with a bad hangover, rouses herself to go in search of physic. She arrives at the cell of the cynical philosopher, Sotto, who treats her by showing in his perspective glass the collection of fools that are breeding in her womb. There follows, with minor changes, the text of *Foole upon foole*, each section supplemented by a hasty and wildly unconvincing allegorical reading of the fool stories originally printed in the earlier versions. The story of Jack Oates and the pie, for instance, is said to signify

the deuouring of deuotions dyet, how euer come by yet they will stand up to the arme-pits in daunger rather then to lacke their wils, to slacke or rebate the edge of their appetites: with this the world a little humde and haide, said shee was not pleased that such liued and did promise some amendment, but desired to see further.[57]

What was before a collection of amusing stories is now presented as a series of morally beneficial tales. If an allegory is more literary than a jestbook, Armin has subtly upgraded his status as an author. We might well deem the effort hopeless, but as a literary failure *Nest of ninnies* nevertheless makes the effort usefully obvious.

That upgrading was Armin's goal is suggested by the new text's opening pages. The prefatory materials from the 1600 edition are missing from this new version, and in their place stands an epistle "To the most true and rightly compleat in all good gifts and graces, the generous Gentlemen of Oxenford, Cambridge, and the Innes of Court"; this text is dressed for

a richer audience than Armin's previous offerings had been. Instead of addressing his co-laborers here, Armin aims his work at a University readership. Even in this more rarefied atmosphere, however, and even with the evident pretensions toward literary value inherent in the move to allegory, Armin emphasizes the communal production of his book. For the allegorical structure of the new text makes it clear that, even in his new role as moralizing fool-philosopher, Armin only mirrors back what a world sunk in folly produces on its own. Sotto, speaking much of this text in the first person, has entirely taken over the "I" voice from *Foole upon foole*, thereby establishing himself as a new authorial persona for Armin, becoming a fictional representation of the known author of an earlier text. But his tasks are reduced to representation and interpretation; the actual production of content comes from the drunken female World, who seeks out Sotto with high expectations:

The world wanton sick, as one surfetting on sinne . . . is now leaning on her elbow, devising what Doctour may deliver her, what Phisicke may free her, and what antidotes may antissipate so dangerous a Dolemma . . . out she would, tucks up her trinkets like a Dutch Tannikin sliding to market on the ice and away she flings, and whither thinck you, not to the Law, that was too loud, not to the Church that was too proud, not to the Court, that was too stately, nor to the Cittie, shee was there lately, nor to the Campe, that was too keene, no nor to the Country where seldome seene: she daines her a friendly eye: but of all into a Philosophers cell, who because he was alwayes poking at Fortune with his forefinger, the wise wittely namde him *Sotto* . . . a grumbling sir, one that was wise enough, and fond enough, and solde all for a glasse prospectiue. (A3)

In the World's estimation, no other institution – including some run by Armin's University and Inns of Court readers – can match the salutory effects of Sotto's fond wisdom, and no other consideration – neither beauty, riches, nor security – can keep her from setting out in search of him. Yet Sotto himself has bought his magic powers from someone else, and has gotten his name from "the wise." The World has to rouse him even to get him to perform; he is "tooke napping by the weale publick, who smiles upon him with a wapper eye" (A3).

 In this most sustained representation of his own authorial practice, that is – and in the first full-length work that he signs with his real name – Armin lays claim only to making visible what the world itself breeds and responding to the world's promptings, not to some mystical power of literary begetting. The metaphor of pregnancy and breeding, so typically used to legitimate authorship in the patriarchal-absolutist model, works here to break the connection between organic reproduction and mimesis.[58] It is the

world that does the breeding and producing here, not Sotto. Like the witty improviser who makes a name for himself by manipulating (and publishing) the jests created in part by his audiences, Sotto becomes a satiric moralizer simply by showing the world an image of its own superabundant fertility. And yet it is clear from the revised text and from the prefatory letter that this limited claim, however ironic, nevertheless promises Armin some sort of authorial position, gives him something to offer that no other cultural institution can match. Armin's own work is recognizable – representable – as a kind of literary facilitation. What could look in other contexts like theft or kidnapping is recuperable here as midwifery. In no case is the claim to original inspired utterance made, and yet the evident search for a language of self-description in these disparate works suggests a profound interest in authorship, a real preoccupation on Armin's part with placing himself culturally, negotiating a position from which to speak and to profit. Armin's non-dramatic writings place him variously along the continuum from thief to philosopher, but whether he is overtly taking credit for his skill at reproducing the jests of others or subtly registering the cultural loss involved in his own commercial endeavors, he remains both resolutely self-promoting and resolutely embedded in communal structures of mirth and pleasure. Like the theater that provides him with his most important platform, print authorship helps to make Armin a famous individual whose wit is a kind of personal public property.[59]

THE WORLD'S FOND IDIOT

Print authorship as Armin practices it is a considerably more porous institution than the forms of textual ownership that most commentators have regarded as a cultural innovation well into the eighteenth century. That porousness comes in large measure from the specific kind of notoriety or fame an actor might acquire. Though Ben Jonson could sometimes project a sovereign form of textual control – and that only by making efforts to dissociate himself from the stage – most actors were much better equipped to achieve fame in close proximity to an audience, working with other performers, mouthing words created by another, trading on familiarity or charisma or wit rather than prestige. His fame is, however, as Armin's career suggests, no less personal for the fact of its collaborative genesis. This is not a model of reputation available to or necessary for everyone who writes a play in early modern England; we have to consider an Armin or a Field to be an exceptional figure, outside the bounds of the relative anonymity that accompanies both acting and writing for the stage in the normal course of

events. But their very status as exceptional figures makes them important for the history of authorship. They represent celebrity without the absolute control or prestige projected by a monarch. They also make clear that, for all the collaborative insouciance about textual ownership that we think of as characteristic in the theatrical milieu, reputation was nevertheless powerfully at stake, powerfully driving the efforts of at least some who wrote for the stage.

To look carefully at Armin's dramatic texts necessitates a slight shift of focus. Up to this point the discussion has been about Armin's theft of communal property, his acknowledged appropriation of a plural voice. His play-texts continue this set of concerns, but they also open up a new range of questions about literary value, authorial consistency, and attribution. He is the recognized author of *Two Maids of More-clacke*, and the most likely author of *The Valiant Welshman*, though the terms of that attribution will be dissected carefully below. Our existing models of textual control and individual creation are inadequate ways of accounting for these plays. If we imagine authorship as exclusively a print phenomenon or think of it in terms of sovereign control and textual ownership, we will be unable to read these plays in their proper contexts.

Two Maids of More-clacke is on one level exactly the play one might expect Armin to write. It features John in the Hospital, who was the subject of one of the sections of *Foole upon foole*. Already, then, to feature John in a play is to remind audiences of Armin's earlier printed works. It is also to call up what must by now look like Armin's signature: the candid appropriation of public pleasures in the person of the entertaining fool. In *Foole upon foole*, John is depicted as himself a casual entertainer, a mentally handicapped man maintained by the city and tended by a nurse, who is constantly mentioned as John's companion. He is, in other words, very much the figure for communal generosity and communal bonds. His performances emphasize his privileged position in the community. Outside St. Paul's he imitates the preaching of Dean Nowell, who always gives him a groat:

It is written sayes he in the 3: Chapter of Paul to the Corrinthians brethren you must not sweare (for that was lightly all his text) then thus he begins: Whereas or whereunto it is written, for because you must belieue it: for surely else wee are no Christians: write the Sermond boy sayes he, (as the Hospital boyes doe) and then one must write on his hand with his finger, and he wold goe forward thus: the world is proude, and God is angry if we doe not repent: good friend giue me a pin, or good friend giue me a point as it came in his minde, and so sucking up his driuill and breth together, would pray and make an end: which being done, who

bids me home to dinner now sayes *Iohn*: the boyes that knew his quallities answers, that doe I *Iohn*; thanke ye friend sayes he, and goes home to his owne dwelling at Christes Church. (FV–F2)

John is known by "his qualities," or "in his estate"; he is known by his neighbors not only because they see him around London but because he interacts with them in a series of customary forms, in a relatively fixed social place, with the promise of a particular set of rewards. John performs certain well-rehearsed parts in which the neighboring children participate, and those innocent pleasures are offered by Armin for the interest and delight of his readers. There are countless such stories in the jestbook; they establish the fool as a figure for performance sustained by communal generosity.[60]

Predictably, Armin himself played the role of John in the earliest performances of *More-clacke*. In fact, he played both the role of John and the role of Tutch, the witty fool in the household of Sir William Vergir. To make matters more complex, within the play Tutch dresses up as and imitates John. Armin thus borrows from his earlier writings, which appropriated the performances of a mentally handicapped man, in order to stage a play in which he himself duplicates the known routines of that beloved figure, while also appearing as a witty manipulator who makes his own reputation by imitating that same natural fool. If he lays claim to originality or genius at any point in this process it must consist almost entirely of the dazzling ability to bridge, as a single author-performer, the gap between local pleasures, in a particularly naive form, and professional, institutionalized skill. This is a familiar position to find Armin occupying, taken to a new level by a hall-of-mirrors mimesis that suggests conscious professionalism.

But *More-clacke* also establishes Armin as dramatic author in a more surprising way. In his epistle "To the friendly peruser" he promotes his work while repeatedly devaluing his actual writing:

...I have boldly put into your hands, a Historical discourse, acted by the boyes of the Reuels, which perchaunce in part was sometime acted more naturally in the Citty, if not in the hole. Howsoeuer I commit it into your hands to be scan'd, and you shall find verse, as well blanck, as crancke, yet in the prose let it passe for currant, I would haue againe inacted *Iohn* my selfe, but *Tempora mutantur in illis* & I cannot do as I would, I haue therefore thought good to diuulge him thus being my old acquaintance, *Iack*, whose life I knew, and whose remembrance I presume by appearance likely. Wherein I whilome pleased: and being requested both of Court and Citty, to shew him in priuate, I haue therefore printed him in publike, wishing thus much to euery one, so delighting, I might put life into this

picture, and naturally act him to your better contents; but since it may not be, my entreaty is, that you would accept this dumbe show, and be well wishing to the substance.[61]

The play's performance history is clearly what interests Armin most, and what he expects readers to be most interested in purchasing. They are also, of course, urged to purchase a memory of Blue John or even to purchase John himself, shown in private, and printed in public, commodified for Armin's own purposes as well as the reader's. This is reminiscent of a host of other professional claims that Armin has made.

But two other claims are particularly interesting. First, Armin seems amazingly uninterested in the actual quality of the words he sells. The prose will pass for current, and the verse will be "as well blanck, as crancke"; the written text is in some sense an afterthought. It seems as though in this case print is recognized as a powerful medium in which to establish or extend a reputation – John's as well as Armin's – but the reputation is for appearing on stage rather than performing in print. In this sense, the epistle may be considered a testament to the authorlessness of early modern drama. Moreover, calling the printed text a "dumb show," Armin apologizes for the fact that he himself is absent from the text, unable to perform John for his readers. This is a telling confusion of stage and text; ordinarily, of course, a dumb show is everything but the words of theatrical performance. Though it is apparently meant to mark the distance between a stage event and a printed text, the image actually extends the stage into print, making the book into a body of sorts. Now the published script is itself a kind of show.

The preface to *Two Maids of More-clacke* thus registers the text as an actor's silent performance. Except for the sense of personal charisma that underlies this transformation of the written word, we might consider the preface profoundly anti-verbal, and accordingly anti-author. It is in this sense an actorly rather than a writerly document. But given the investigation of the performer's reputation undertaken thus far, that sense of personal charisma ought to be cause for further reflection before we dismiss *Two Maids of More-clacke* as a sign of the theater's discouragement of authorial self-inscription. For the play's readers are meant to take pleasure in the dumb show and accordingly to "be well wishing" to an unspecified "substance." It seems telling that there should be no real way to identify that substance, which could easily be read as John, as the play in performance, or as Armin. The preface certainly offers the text as a form of access to John, who is "divulged," "shewn," and "printed" by Armin. But Armin also blurs with John as a figure of interest; the engraving on the title page can only be

identified as either John or Armin performing John. If it is Armin who would under better circumstances "give life to" that picture, he is then enmeshed with John in a profound way.

If Armin might be the life and the substance of this text, *More-clacke* might still be regarded as an actorly rather than an authorial document. But the play itself goes on to rely upon Armin and John – only partly individuated figures – as sources for a kind of textual meaning. A look at the play's relation to the prevailing generic modes of its period makes it clear that more than merely Armin's or John's presence is being offered by the text, more than the pleasures of their respective performances. Instead, or in addition, *Two Maids of More-clacke* refers back to Armin as a crafter of plots and to John as something like the key to the genre of comedy. Beyond their professional or amateur improvisations, that is, John and Armin embody the self-referentiality of this play, both in performance and on paper. For all the apparent lack of interest in verbal construction, the play nevertheless highlights its own authorship.

Generically, like so many other works of the period, Armin's play is a puzzling mixture. The James Humil plot, in which a supposed-dead husband returns to find his wife remarrying, so closely resembles the plot of *Hamlet* that some critics have refused to accept the apparent date of the play's composition, arguing instead that it must have been written in response to Shakespeare's tragedy.[62] There are in addition enough verbal echoes of *Lear* and *Macbeth* to suggest a wholesale reevaluation of Shakespearean tragedy in this odd play. And yet there is no extra-textual evidence to support a later date of composition. The best compromise has seemed to be to posit an initial composition date of sometime before 1603, followed by substantial revisions after 1606, which are represented by the printed edition.[63] But in the absence of conclusive evidence, we should hesitate even to adopt this compromise view, or for that matter to attribute Shakespeare's tragedies to Armin's influence.

Even bracketing the possible Shakespearean allusions in this play, though, *Two Maids of More-clacke* is clearly proceeding in response to tragedy in some way. Sir William's speeches are often virtual generic set pieces:

> Who is't that tongue calles man
> That is assured of his wiues condition?
> None, or if any, there the Phoenix liues
> Unfellow'd, be his fate renown'd while mine
> Is mockery, and a Iestiue stock, to
> All that knowes me. O you starres blaze fire,
> Till this abuse be quench'd by my desire.
>
> (xv, 264–70)

Moreover, on both occasions that Tutch makes a pun of his own name, he does so in conjunction with an allusion to that most famous of all early modern plays, Kyd's *Spanish Tragedy*:

> O mistres now am I tri'd on my owne tutch,
> I am true mettall one way, but counterfeit an other:
> O life no life, but messe of publicke wrong,
> Day turne to night for I ha liu'd too long.
>
> <div align="right">(xi, 108–11)</div>

Echoing Hieronymo's famous lines, Tutch seems aimed at tragedy in some way, as though his identity were bound up in a response to Hieronymo.[64]

This odd and perhaps antagonistic relationship between a famous stage clown and a famously hyperbolical tragedy is interestingly reminiscent of the traditional debates about clowns and genre. The pairing of a clown and a tragedy here, of course, produces something Sidney might have pointed to as an especially egregious example of "mungrell tragi-comedy." *More-clacke* ranges from the James Humil love triangle to a comic scheming suitors' plot to the oddly truncated romance scene, in which Mary dies and is buried on a remote island, left by her would-be fiancé, and then dug up and restored to life moments later by a man who just happens to be her uncle. To the extent that this play represents an authorial accomplishment, moreover, that accomplishment lies not in the composition of speeches but in the manipulation of dramatic types. Say what we will about literary value, the play's pleasure is in the simultaneous unfolding of numerous sub-plots. The mongrel generic mix thus becomes a testament to Armin's powers of manipulation, to his ability to scheme. The traditional power of a theatrical fool is converted to an authorial accomplishment, an experiment – successful at least insofar as it produces the required happy ending – in genre.

And the play's happy ending does reinforce the notion that *Two Maids of More-clacke* is among other things a complex reflection on Armin's authorial practice. Playing the role of Tutch, he is the triumphant schemer, present on stage to witness his own play's byzantine denouement, and to comment upon it. Near the end of the play, Tutch presents himself to Sir William and tells all: "I am Tutch your quondam seruant sir, thrust out to thrust them in" (xxii, 262–3). Just thirty lines earlier, reflecting on a turn in the plot, Tutch comes fascinatingly close to speaking as Armin: "I am the author of this shift" (xxii, 235). Still dressed as Blue John at the end of the play, he is a physical testament to his own powers not just as a performer but as an author. For all his evident carelessness about individual speeches,

that is, Armin nevertheless seems to have crafted a dramatic structure that refers not only to other plays and to studies of genre in the period, but to himself as a manipulator of all that and performance too. In a way that the preface does not fully account for, Armin writes himself into the text powerfully.

Nor is John present simply as a London personality and casual performer. As already noted, Tutch dresses up as John and is present on stage at the play's ending. Though he appears at this final scene of comic reconciliation only as the effect of another's performance, however, John dominates the play's conclusion by other means. When Sir William Vergir relinquishes control over his two daughters, he steps forward graciously to accept his lot as the victim of the play's various comic plots. His language is particularly resonant:

> Methinkes I haue a tickling in my blood
> Crosses all anger, malediction hence, hence,
> Thou ill temper'd Feare, this comicall
> Euent seasons the true applause;
> . . .
> I wil be generally laught at,
> Once insooth I will.
> . . .
> Since our fate makes vs the worlds fond Idiot,
> Be it so youth. (xxii, 367)

Sir William's resolution to be "generally laught at" like "the worlds fond idiot" – like John – seems especially important in a play authored by a professional fool. Indeed, Armin would have been on stage as these words were spoken, still playing the part of Tutch in costume as Blue John. John seems to have become something precariously like a subject position at this point, and the unusual form of subjectivity he represents is apparently armed with the power to create comedy where tragedy threatens. In accepting the fact that he will be the play's fool, in other words, Sir William accords fooling, and perhaps accords the figure of John himself, a power that might ordinarily be reserved for Providence or for a comic author. If conversion and communal reconciliation are the expected content of comedy, they are attached here to John and by extension to Armin, so that those two performers become the referent for the genre.

The sign of Sir William's comic conversion, itself a generic convention, is the beloved citizen of London whose informal performances are the basis of Armin's professional triumph as an author and performer. *Two Maids of More-clacke* has, in other words, brought onto the level of plotting and genre

the promise that Armin seems to have been making throughout his career: that he represents the pleasures of daily life commodified. The apparently benign generosity that seemed always to be stressed in early modern representations of the mentally handicapped is reconfigured here as an effect of genre, something reliably produced by comic plotting and characterization. Armin's play, and perhaps festive comedy in general, creates "fond idiots" who make others laugh, even as it creates gracious noblemen who tolerate comic rebellion – even as it creates the two figures in the same character, in Sir William. As performance-oriented as Armin's work is, powerful as might be the claims he makes for himself as an improviser, this play is also pointing toward the more traditionally authorial work he does as a maker of theatrical fictions. Though the individual speeches of the play seem not be the focus of Armin's attention, the play's larger structure is yet another profound boast about his power as a cultural figure, and about the power of the theatrical institution that is the source of his prosperity.[65] Ironically, the play as a printed text shows an extra emphasis on performance, a preface that insists on the superiority of the live event, while the play as performed, with Armin present on stage to remind his audiences of his ability to plot the events they see unfolding, may well have made more powerful claims for Armin as an author.

If Armin's presence in *Two Maids of More-clacke* is an overwhelming fact of the play in print and on stage, Armin's presence in the other play attributed to him is considerably less vivid. *The Valiant Welshman* is printed with "Written by R. A. Gent." on the title page, and though Armin was entitled to sign himself a gentleman by the date of the play's publication in 1615, there is no external evidence to establish him as the author. Critics point out that there were no other known R. A.'s writing for the stage in this period, but that hardly seems conclusive proof of Armin's authorship. As David Wiles has convincingly argued, the role of Sir Morion, listed in the stage directions as the play's "foole" is very like the other roles we know Armin to have played.[66] Most tellingly, as Wiles notes, Armin's roles repeatedly required him to be stripped or in some other way to emphasize his "doglike" physique, and Morion is no exception. Moreover, the play, like *Two Maids of More-clacke*, features stage Welsh. But then, as noted above, clown performers frequently called attention to their bodies, and stage Welsh is certainly no reliable marker of Armin's authorial practice.

The reasons for challenging Armin's authorship of this play are more unsatisfying than the reasons for attributing it to him. Critics have felt, to put it bluntly, that the play is too well written to be Armin's handiwork. It does indeed seem much more coherent than *Two Maids of More-clacke*, and

yet that play may be considered an odd experiment in "blanck as cranke" writing; Armin made a point of lacking interest in the actual words, at least if we are to accept his preface at face value. The dispute over Armin's authorship thus becomes a particularly powerful deployment of the author-function as we know it; we choose to accept the play into the canon if we choose to regard Armin as a literary writer, and we leave the play out if we decide that Armin is merely a figure from popular culture. In either case our evaluation of Armin becomes a self-fulfilling prophecy, since *The Valiant Welshman* must on some level be part of the evidence we use to make this allegedly prior decision about Armin's capacities. In the absence of new evidence about the play, then, we are left with probabilities. In fact, the writer of Armin's entry in the *Dictionary of National Biography* was driven to imagine that the printer or bookseller responsible for *The Valiant Welshman* wanted the text to look as if it had been written by Armin.[67] Given that we have no external evidence, that possibility is as likely as any other.

This question about Armin's claim to the initials "R. A." is a nice irony for a writer and performer who made a career out of appropriating and being appropriated, one whose very power as an authorial presence depends upon his ability to trouble our notions of textual ownership. Moreover, the play itself represents authorship as something far more complicated than a single attribution can account for. The Bardh narrates the events of the Welshman Caradoc's life, but his status as a controlling or originating figure is subordinated to that of the goddess Fortune, who awakes him almost as The World wakes Sotto in Armin's *Nest of ninnies*. It is Fortune who uses the language of creation and sovereignty, and who makes that language specifically theatrical:

> Thus from the high Imperiall Seate of *Ioue*,
> Romes awfull Goddesse, Chaunce, descends to view
> This Stage and Theater of mortall men,
> Whose acts and scenes diuisible by me,
> Sometime present a swelling Tragedy
> Of discontented men; sometimes againe
> My smiles can mould him to a Comicke vayne.[68]

Though she calls the Bardh "Poet Laureat" and presents her desire for the Welshman's story as a request, she is nevertheless the one responsible for what we see (A4v).

Within the play proper, this division of authorship continues. When Caradoc's enemy Gloster wants to defeat him, he enlists the aid of a powerful

(unnamed) Witch and her son Bluso. Gloster calls the Witch "great soule of arte" when asking for her help, and the Witch holds forth for over twenty lines boasting about her own powers and those of her son (E4v). When it comes time for her to act, she turns to Bluso and asks him to call up a spirit "by [his] skill" and make it into a powerful serpent "with [his] Charmes" (F). It is thus somewhat surprising that when Gloster is defeated and the Witch and Bluso captured, Bluso is cleared of wrongdoing:

CARADOC Wert thou the authour? tell upon thy life.
BLUSO No, Prince: for in this horrid Caue There liues my aged mother, deepe in
　　skill Of Magicke Exorcismes, as the art it selfe Exceeds the boundlesse depth
　　of humane wit. With her the Earle conspirde, to draw you hither By this
　　inuention. (G–Gv)

The Witch is burned to death and Bluso devotes his powers to helping the unfortunate. Skill and culpability inhere in the author – however expanded the term's meanings here – but the author is also embedded in a complex system of shared creation.

　　In other words, the play works on a kind of author function that engages questions of attribution, but answers them unpredictably. If we are to take our cue from the text, we will have to imagine the author of *The Valiant Welshman* as a figure who matters both as an individual – the person who owns the initials, the Bardh whose talent and vision set the scene, the witch whose productions are punished – and as part of a larger cultural production. This is the strongest tie between the text and Armin: not the markers of individual style or even of known performance habits, but the persistence of a mode that is both personal and collective. Perhaps we should, when such a model of the writer's authority is invoked, recognize the innovations of Armin in the early modern cultural landscape. Doing so will not allow us to answer questions about attribution, but it may provide us with a way past the assumption of originary genius on the one hand and the prospect of an authorless theater on the other. Those unowned initials matter in part because Armin promoted himself as a figure for the work of others.

While Foucault has argued that "The coming into being of the notion of 'author' constitutes the privileged moment of *individualization* in the history of ideas," Armin reminds us that authorship is also a form of cultural exchange.[69] The founding condition of Armin's singular celebrity is the pointed insistence that he is public property. Moreover, his hold over the material he writes is construed as a form of borrowing or exploiting rather

than formal ownership. Nor can we consider Armin as an author to mark a definitive turning away from the exigencies of performance; on the contrary, he stands as an example of the implications of print and performance for one another, the ways in which the two media worked together in early modern England. In short, Armin's work on stage and in print brings to the fore a set of considerations that are normally occluded in the study of authorship. Like Nathan Field, the subject of chapter 2, Armin as player and writer crosses over what we normally imagine to be the constitutive boundaries of the author. In so doing, he becomes paradigmatic of authorship in a way we have not previously recognized, as one who exposes textual ownership as fantasy and renders vivid the series of performances required to establish that ownership. If we are ourselves willing not to concede authorship entirely to the regime of private property, if we look past the self-presentations of elite authors, we can discern the more properly relational form of authorship in practice long before copyright obscures it.

The actor-playwright and the true poet: Nathan Field, Ben Jonson, and the prerogatives of the author

Ben Jonson appears to be enshrined permanently as an antagonist to the material conditions of early modern dramatic writing. As Stephen Orgel contends, himself taking his cue from Bentley's *Profession of Dramatist in Shakespeare's Time*,

the creation of a play was a collaborative process, with the author by no means at the center of the collaboration. The company commissioned the play, usually stipulated the subject, often provided the plot, often parceled it out, scene by scene, to several playwrights ... the text belonged to the company, and the authority represented by the text ... is that of the company, the owners, not that of the playwright, the author.[1]

But most critics, including Orgel himself, see Jonson as the great exception to the relative authorlessness of early modern drama. By virtue of what Jonas Barish describes as his antitheatricalism, what Richard Helgerson sees as his laureate ambition, what George Rowe thinks of as his efforts at self-distinguishing, and what Joseph Loewenstein labels "the investment of proprietary rhetoric in the author of a printed play," Jonson is felt to have instantiated the notion of the author on the English stage, if not in English literature itself.[2]

Central to these readings of Jonson's career is a recognition of the distinction he himself was always trying to enforce. His productions, even for "the loathed stage," were, he famously insisted, recuperable as high literature, as works, while the contributions of less distinguished playwrights remained popular entertainment, unworthy of a court poet and learned man. Accordingly, Jonson has become a figure for the politics of authorship, broadly defined as absolutist. Jonson functions in criticism as a kind of touchstone for the sovereign author, his efforts to align himself with the court of James I marking him as a powerful innovator in the development of "authorship as we know it."[3] As important as Jonson's claims might be for the history of authorship, however, he ought not to dictate the terms by

which we understand what an author was in the early modern theater. If the study of authorship implicitly recognizes only either Jonson or relative anonymity, it is playing into Jonson's own bifurcated vision too neatly. If the laureate ambition of a playwright is culturally imaginable in this period, perhaps there are alternative forms of "proprietary rhetoric," other paradigms of authorship, discernible in the works of dramatists whose plays have seemed – then and now – popular or derivative.

Rather than emphasizing Jonson's uniqueness, in other words, there may be good reasons to read the works of less self-consciously exalted dramatists with an eye toward their own authorial ambitions. Nathan Field is well known as the dashing leading man for Lady Elizabeth's Men and, after 1616 or so, for the King's Men. He is also noted frequently for his collaborations.[4] But except to find evidence about his writing style that would help to distinguish his lines from those of his collaborators, critics rarely pay attention to Field as a dramatist or to his single-author works, *Woman is a Weathercock* (1609–10) and *Amends for Ladies* (1611).[5] Consideration of Field's career, however, shifts the terms by which we are able to understand both Field as an actor-playwright and Jonson as a uniquely self-promoting (actor) author. Jonson may well have been unique, but that uniqueness was not based primarily on a concern with authorial self-representation. On the contrary, a kind of authorial presence could be scratched out of the conditions of popular dramatic writing, even when the material circumstances of that authorship might suggest otherwise. Moreover, paying attention to Field's proprietary rhetoric makes it possible to detect in his work a telling blend of emulation and critique of the sovereign author. The virtue of recovering Field's complicated relationship to Jonson, in other words, goes beyond whatever the benefits of giving equal time to understudied writers might be.[6] Rather than ranking Field among the elite authors of the period – admittedly a challenging project – this chapter, using *Woman is a Weathercock* and *Amends for Ladies*, works to expand the range of ideological positions that the term "author" might occupy, to uncover modes of dramatic authorial address that do more than simply reinscribe patriarchal absolutism.[7]

In fact, to study Nathan Field is to approach the question of dramatic authorship not from the vantage point of Jonsonian (anxiously maintained) eminence, but from the position of the popular actor. As Jonson's own career indicates, and as critics gesture toward with great frequency, actors and authors were overlapping subsets of the theater population in this period. And yet, as this study contends throughout, it has been singularly difficult to account for that fact in our discussions of authorship. When

actors are considered, they tend to be represented as walking symbols of textual disorder.[8] Actors improvise and thus make impossible any notion of authorial self-expression. They own and sell play texts, thus blocking the possibility of authorial possessiveness. But actors, involved as they were with the mechanics of early modern celebrity, represent more than just the intractability of the theater in the face of the emerging institution of authorship.[9] Instead, especially as actor-playwrights who carry over their onstage popularity into the medium of print, they made possible a kind of authorship that emphasized the very things Jonson worked to disavow, including dependence upon an audience's favor, exclusion from the realm of the properly literary, and the impossibility of speaking with a sovereign, solitary voice. A popular actor who used his reputation in order to sell texts was an anomaly and a paradox: a celebrated individual who spoke with a collective voice, a controller of audiences who was dependent upon them for approval and sustenance, a crafter of words who worked without the assumption of authorial preeminence.

Attending to actors, or to actors-cum-authors, in other words, offers other models for writing than the one Jonson was attempting to put forward. In fact, locating a discussion of authorship in the career of an actor complicates the idea of a dramatic author considerably. In one of the most influential and thoughtful recent studies of theatrical authorship, for instance, Jeffrey Masten has traced a broad shift from a gentlemanly homoerotic ethic of collaboration in the late sixteenth century to an individualistic, patriarchal absolutist model during the course of the seventeenth.[10] But Field was never fully included in either model; indeed, he was situated among his peers in a way that lent itself much more readily to parody and critique of those authorial modes than to appropriation of them. His career – marked as it nevertheless is by a clear interest in himself as an author – thus suggests that alternative descriptions of authorship are and were available.

This is not to suggest that Field's self-representations are somehow ideologically pure, representing a radical break from Jonsonian self-fashioning. On the contrary, Field and Jonson establish themselves as authors in relation to one another. Field's career is intelligible in part because it plays off Jonson's, while Jonson's career is elevated in part because he excludes Field from the realm of authorial prerogative. What this adds up to is neither the dominance of the self-consciously elite author nor the radical novelty of the writer who was known mostly for acting. Instead, it suggests that the proprietary disposition of dramatic writing, however much it parallels and is influenced by absolutist discourse, actually allows Field at some level to intervene in the reproduction of that discourse. Even Jonson, for all

his grasping, was bound up in the collaborative and seemingly undigni-
fied work of theatrical production. As a living sign of that collaboration
and that lack of dignity – and simultaneously as a self-promoting author –
Nathan Field breaks down the distinctions Jonson works so hard to keep
in place. In doing so, he articulates a more properly theatrical notion of
authorship, one that marks the limits of absolutist authorial prerogative
in the confrontation with the figure of the actor. This chapter, then, will
consider Field's placement on stage as an actor, his relationship to Jonson
and the other poets with whom he worked, and his problematic relation-
ship to female audiences. All three factors become part of his authorial
self-inscriptions. Finally, the chapter will turn to Field's later critical repu-
tation, to argue that Jonson's fantasy of the sovereign author has wrongly
shaped our understanding of theatrical work.

PLAYING YOUNG LEANDER

Bartholomew Fair, a play Field himself appeared in as a member of the Lady
Elizabeth's Men, has long been understood as intervening in particularly
powerful ways in the construction of early modern reputations. Patrick
Collinson has argued that Puritans were indelibly shaped by Jonson's repre-
sentation of them in the play. Collinson also notes that Jonson changed his
own position in the world by means of this production, moving up after
this point to writing masques more exclusively for James.[11] Of course, as
many critics have contended, James's sovereignty was actively defined by
the play as well.[12] As impressive as this collection of contested identities
might be, however, perhaps no figure is as compellingly positioned by the
text as its star performer, Nathan Field.

As is often noted by critics, Field received the distinction of having been
named by Jonson in Act 5. When Cokes first encounters the puppets of
Lantern Leatherhead, his inquiries invite comparison between the onstage
"performing object" and the actors playing alongside them:[13]

COK.... What manner of matter is this, Mr. *Littlewit*? What kind of *Actors* ha'
you? Are they good *Actors*?
IOH. Pretty youthes, Sir, all children both old and yong, heer's the Master of
'hem – [14]

As Leatherhead removes them from their baskets, Cokes remarks upon their
size:

COK. These be *Players minors*, indeed. Doe you call these *Players*?
LAN. They are *Actors*, Sir, and as good as any, none disprais'd, for dumb showes:
indeed, I am the mouth of 'hem all!

COK. Thy mouth will hold 'hem all. I thinke, one *Taylor*, would goe neere to beat
 all this company, with a hand bound behinde him . . . Which is your *Burbage*
 now?
LAN. What meane you by that, Sir?
COK. Your best *Actor*. Your *Field*?
IOH. Good ifaith! you are even with me, Sir.
LAN. This is he that acts young *Leander*, Sir. He is extreamely belov'd of the
 womenkind, they doe so affect his action, the green gamesters that come
 here . . . (5.3.75–92)

It is common to note that Jonson praises Field in this scene, associating him
with Burbage as the company's finest actor, and perhaps further mentioning
Joseph Taylor, also of the Lady Elizabeth's company. Youths "old and yong"
may well be a reference to the actual span of ages that were encompassed
by the "boy" companies as they collectively aged. Field himself was twenty-
seven when *Bartholomew Fair* was first performed.

The context for this praise, however, renders it highly dubious. Field is
among the best of them (even though Burbage comes to mind first, and
Taylor is bigger), but they are all essentially wooden blocks who perform
debased versions of *Hero and Leander* for audiences too stupid to under-
stand Marlowe. Moreover, if female audiences fawn over Field, there are
suggestions in this text that the puppet/performers are subject to more than
simply distant admiration. As Cokes "handles" the puppets later, he defends
his actions a bit nervously: "I warrant thee, I will not hurt her, fellow; what
dost think me uncivill? I pray thee be not iealous: I am toward a wife"
(5.4.6–8). Whatever debased acclaim Puppet Field might gain by playing
Leander, were he to play Hero, he might reasonably inspire amorous paw-
ing from his male admirers as well. It may be a compliment to name Field
as the company's best actor, but the strong analogy between actors and toys
takes away much of what the compliment gives.

As intriguing as it is to imagine Field present on stage while his own
name is invoked in morally ambiguous contexts, another passage in this
play, possibly spoken in his absence, names him in an even more complex
fashion. Rejecting Leatherhead's license from the Master of the Revels, Zeal
of the Land Busy holds forth to condemn him:

[T]hy profession is damnable, and in pleading for it, thou dost plead for *Baal*. I
haue long opened my mouth wide, and gaped, I haue gaped as the oyster for the
tide, after thy destruction: but cannot compasse it by sute, or dispute; so that I
looke for a bickering, ere long, and then a battell. (5.5.21–5)

This caricature of Puritan rhetoric takes its force not only from Jonson's
facility with diatribe, but from his use of actual quotation. Keith Sturgess

has identified three sources for Busy's fulminations: a prophecy from Giles Wiggington ("We look for a bickering ere long and then a battle, which we cannot endure"), a Puritan prayer ("Our souls are constantly gaping after thee, O Lord, yea verily, our souls do gape, even as an Oyster"), and Nathan Field's own father, John, a Puritan minister who had been quoted before the Star Chamber in 1591 advocating a dangerously populist approach to the Church of England's seeming intransigence: "Seeing we cannot compass these things by suit or dispute, it is the multitude and people must bring the discipline to pass."[15]

In fact, the senior Field was a well-known preacher who had been imprisoned twice for writing against the Anglican Bishops.[16] Apparently ill after his time in jail, he died just prior to Nathan's birth, leaving behind him a collection of passionate writing that condemned not only the church hierarchy but also the staging of spectacles like the ones his son would eventually appear in. When the Paris Garden collapsed in 1583, John Field made his contribution to the genre of antitheatrical writing, describing in some detail how the audience at that day's bear-baiting had been made to feel the wrath of God's judgement:

Being thus ungodlilie assembled, to so unholy a spectacle and specially considering the time: the yearde, standinges, and Galleries beinge full fraught, being now amiddest their jollitie, when the Dogs and Beare, were in their cheefest battell. Loe the mightie hand of God upon them. This gallerie that was double, and compassed the yarde round about, was so shaken at the foundation, (that it fell as it were in a moment) flat to the ground, without poste or peece, that was left standing, so high as the stake whereunto the Beare was tied.[17]

Though the emphasis in this sermon is above all upon the importance of observing the Sabbath, the dangers of such public entertainments are made clear and immediate: "You have heard that the father bringing his child alive thither carried it home again dead, which came not to pass by chance but by God's providence."[18] In 1614 it was John Field himself who had long since died; his son Nathan was performing on the site of this very theater, the Paris Garden, which had been rebuilt as the Hope Theater a short time before *Bartholomew Fair* opened there.[19]

To call upon Field's father in a play that names Field is clearly to meditate on reputation and fame. To call on Field's father in a play that names Field as a *puppet* is something else again. Moreover, if as seems clear, *Bartholomew Fair* was written with the specific intention of a court performance, Jonson is invoking Field Sr. before an audience that is likely to comprehend his in-jokes.[20] Patrick Collinson calls John Field the "Lenin" of Puritanism.[21] Indeed, he was a driving force in the effort to bring reform about through

an appeal to the people rather than through the official channels of church and state. Though he did much of his work behind the scenes – he was an avid writer of letters to fellow ministers, for instance – he also took a great interest in the publication and translation of reform-oriented writing. He is responsible for preserving and publishing numerous Calvinist texts; when colleagues wrote letters to him privately they were sometimes surprised later to see their personal thoughts on religion in print. Perhaps more importantly for our purposes, the senior Field seems to have left behind him a collection of papers on reform that became the basis for some of the Martin Marprelate tracts. Thus, in ways that may or may not have been known to Jonson, Nathan Field's father played an important role in the development of the stage Puritan, the comic and even grotesque figure for the inversion of social order perfected by the anti-martinist writers (or performers) and epitomized in Jonson's own works, *Bartholomew Fair* not least among them.

Indeed, it is as a figure for the destruction of social hierarchy that Jonson and his audiences were most likely to have known of the senior Field. Jonson seems to have taken his "suit or dispute" quote not directly from the Star Chamber deposition of Thomas Edmunds, where it first appears, but from a later text by Richard Bancroft, who himself quotes Edmunds quoting Field.[22] The 1591 deposition was part of a larger investigation into Puritanism that began with the Marprelate writers and expanded outward, marking a decisive setback for religious interests like Field's, which we might label presbyterian. In 1593, Bancroft, a zealous crusader against reform, wrote *Dangerous Positions and Proceedings*, a vivid description of the threat posed by Puritans, with their secret brotherhoods and leveling ways, to the episcopacy, and thus to the state.[23] He uses as his source not only the records of the Star Chamber, but the register of Puritan writings that Field himself had so carefully assembled. Bancroft clearly considers Field to have been one of the most insidious plotters against the church; he comes back to the "suit or dispute" quote not once but three times, as though Field's statement epitomized for him the turning away from law and hierarchy that made Puritan positions so dangerous. He also establishes Field as a particular menace in *A Survey of the Pretended Holy Discipline*, written that same year, calling him

a great and chiefe man amongst the brethren of London: and one to whome the managing of the discipline (for the outward practice of it) was especially (by the rest) committed. So as all the letters, that were directed from the brethren of other places; to haue this or that referred to the London assemblies, were for the most part directed vnto him.[24]

Moreover, in what may well establish *Dangerous Positions* as a source for *Bartholomew Fair*, Bancroft is similarly taken with Giles Wiggington's "bickering and battle," which he quotes twice.[25]

Though attitudes toward Puritans in England are never straightforward to reconstruct, at court or in the larger popular audience for the play, it seems clear that Bancroft's opinions of Field would have prevailed with at least some of the play's hearers, including James himself. In his lifetime Field had enjoyed the patronage of Leicester, but dissenter and patron had both died in 1588. Bancroft had been Archbishop of Canterbury until his death in 1610. Some of James's attitudes toward reform could be classified as friendly, but he was adamant about the importance of the episcopacy, and had by 1614 presided over the emphatic assertion of the Church's power to discipline its dissenters. In fact, Leah Marcus has described the court's approach toward Puritans as particularly hostile in 1614.[26] If, during the reign of Elizabeth, the threat of John Field's brand of reform lay in its opposition to order, that opposition would have seemed even more intensely aimed at the monarchy when Jonson recalled it before the court of James. As Kenneth Fincham and Peter Lake have argued, James defined as Puritans "those who defied royal authority."[27] In any of the then-current formulations of religious dissent, that is, John Field stands out as a subversive agent, what Albert Peel calls Richard Bancroft's "opposite number."[28]

The personal, religious, political, and professional subtexts of this early performance of *Bartholomew Fair* thus seem almost epic in their scope. The play has the power to construct the ambitious playwright and the potentially humiliated actor, the absolutist monarch and the vanquished Puritan, all in a single performance. For Nathan Field in particular, the power of representation may have seemed enormous. It is, after all, just possible that Thomas Edmunds had lied in his Star Chamber deposition in 1591, that John Field had never uttered the words "suit or dispute," though he was unquestionably capable of ringing rhetoric. Edmunds had been a colleague of Field's, but at this point he was exonerating himself by turning state's witness. Several of his assertions are unreliable.[29] Once Bancroft – himself seemingly crafting a persona to help him rise in the church – picks up Edmunds's story, however, and uses it to epitomize the Puritan threat, Field's alleged speech becomes a powerful tool for Ben Jonson. Jonson quotes Bancroft in *Bartholomew Fair* in an effort to position himself at court, and the zealot described by Edmunds becomes the father with whom Nathan Field must in some fashion contend on stage in 1614. In a very real – or very unreal – way, Nathan Field is the offspring of reputation when the play is performed.

To be the offspring of a reputation shaped by Ben Jonson must be considered a mixed blessing, not least because Jonson names Field as a puppet. In the same play in which Jonson conjures up the senior Field's defeat and posthumous notoriety, that is, he also associates the player with wooden passivity.[30] He thus raises an unanswerable and compelling set of questions about Nathan Field's participation in the drama. What exactly does it mean for an actor to participate in a play that mocks his (virtually martyred) father, while he himself is parodied in a puppet show?[31] What are Field's options as a performer in these moments? To what extent is it possible for him to respond to this representation from within his given role? Either he plays wittily off of Jonson's text, adding a level of irony to his own performance, or Jonson triumphs at Field's expense, and Field becomes the puppet Jonson says he is, made to parody himself and take part in a production that slanders his dead father.[32]

The precise nature of Field's likely response is difficult to determine from the text of *Bartholomew Fair*. It is generally thought that he played either Cokes or Littlewit. If Field played Littlewit, he is specifically prompted to call attention to himself after the Burbage/Field reference in Act 5. Cokes asks Leatherhead to point out "Your best *Actor*. Your *Field*?" and Littlewit chimes in with "Good ifaith! you are even with me, Sir" (5.3.88–9). The response is for our purposes unhelpfully neutral, allowing both for the possibility of gleeful self-promotion and for a sheepish recognition of the low status accorded players in the scene. Moreover, Littlewit is announced as the author of the puppet show to be performed, and that role is similarly marked as a fallen one, as Leatherhead tells Cokes that he has asked Littlewit to "reduce" *Hero and Leander* "to a more familiar straine for our people" (5.3.116–17). Littlewit goes on to list the ludicrous changes he has made, beginning with "for the *Hellespont* I imagine our *Thames* here; and then *Leander*, I make a Diers sonne, about *Puddle-wharfe*" (5.3.122–3). Field as Littlewit would thus identify himself both as the romantic lead (Puppet Leander) and as the people's author, a combination of roles that describes Field accurately but in comically unflattering terms. If Field played Littlewit, he was waiting in the tiring room during Busy's diatribe against the puppet show, present only figuratively in Puppet Leander, incapable of offering any immediate response to the quotation from John Field. Keith Sturgess remarks that "the jokes here work better if [Field] played Cokes" (177). In that case, it is Field who calls himself the company's "best actor," and Littlewit who punctures this moment of self-praise by reminding the audience to consider the source; "You are even with me, Sir," would then be read as "You, Nathan Field, are standing right in front of me." This casting

would heighten the impact of Jonson's parody of John Field, since Cokes is present for Busy's later tirade. Indeed, Cokes responds with some vehemence to Busy. Cokes does speak more lines than anyone else in the play, which would accord with Field's position as leading man, but there are descriptions of Cokes in the text that suggest a younger, taller actor (Sturgess 178). Neither casting choice, finally, tells us what we want to know: whether Field found ways to communicate ironically in the "best actor" scene or elsewhere that compensate for Jonson's poignant use of him, or whether any such playfulness would ultimately have been subsumed, puppet-like, under Jonson's text.

These questions bear strong relationship to the questions surrounding Field's work as a writer, and our reception of that work. Critics have ordinarily understood Field to be something of a puppet, an actor who is able to write plays mostly because he has learned to repeat other writers' words. His collaborations are duly noted, while his original works are scrutinized for borrowings from better playwrights, especially Jonson.[33] But if recent theoretical formulations about authorship have called into question the notion of the solitary genius, perhaps Field is constructing one of our other options. We would in that case profit from thinking seriously about Field as a puppet author, as a writer whose choices are in some measure defined for him by the terms Jonson articulates in *Bartholomew Fair*. Written three years after *Amends for Ladies* was first performed, *Bartholomew Fair* characterizes his fellow playwright in ways that aggrandize Jonson himself while reducing Field to a mere mimic. It is undeniable that Field mimics the writing of the period's leading playwrights, but that lack of an original voice nevertheless allows him his own ironic performances. Moreover, as a reading of Field's work in the context of his career as a player makes clear, Field's performance of authorship and his relation with the self-consciously elite poet Jonson do much to break down the distinction between authorship and performance that Jonson himself would enforce.

"'MONGST THESE UN-AEQUALL'D MEN"

In one sense, Field's presence in *Bartholomew Fair* might be seen as a triumphant defiance of his father's Puritan legacy, a rebellion against paternal prohibition that is abetted by Jonson's own frenzy of ambivalent responses to authority throughout his career.[34] In fact, we have evidence that Field was concerned to defend himself against religious antitheatricality. In 1616, he wrote a letter that chastised his own minister for singling him out – apparently with other players – in church. The text of the original sermon

is lost, but Field's rebuttal demonstrates a powerful concern for public reputation:

> . . . my spiritt is moved, the fire is kindled, and I must speake, and the rather, because yow have not spared in the extraordinary violence of your passion particularly to point att me and some other of my quallity and directly to our faces in the publique assembly to pronounce us dampned, as thoughe you ment to send us alive to hell in the sight of many wittnesses.[35]

Even though *Bartholomew Fair* is itself at least partially antagonistic to theatrical spectacle, its silencing of Busy oddly mirrors Field's adult refusal of the admonitions represented by his father's career. Written in the same year as Jonson's Folio, Field's letter indicates a Jonsonian concern to clear his name from the taint of playing.

A vision of Field that sees his career on stage as an act of rebellion fails to account, however, for all the circumstances that brought that career about, and overestimates the extent to which playing itself could represent autonomy for an actor who entered the theatrical milieu via membership in a boy's playing company.[36] The public theaters seem to have employed boy actors in a system of apprenticeship. Adult players who had guild memberships – like Jonson, who was a bricklayer – were entitled to apprentice boys to work as actors through that guild. As makeshift as such a system might be, though, it was much more humane and orderly than the system apparently used by the boy companies, which based their hiring on the model of the boy choirs.[37] In practice, this could mean resorting to kidnapping, as Nathaniel Giles did in 1600, when he used his authority to impress choristers in order to seize six boys to work as players. One of them was Nathan Field, then thirteen years old and on his way to school.[38] Records of this incident have survived only because one of the boys' fathers complained to the Privy Council about the treatment his son had received. Henry Clifton charged that his child was threatened with physical punishment and was going to be deprived of the education that was supposed to accompany a career as a chorister. Thomas Clifton was let go, but the other five kidnapped boys remained with the company, which indicates that although the council recognized some impropriety in Giles's actions, it was at least provisionally willing to tolerate his methods. Though little is known about how widespread the practice of kidnapping boy players might have been, it seems significant that several years elapsed before the practice was officially prohibited.[39]

So Field's participation in theater can hardly be said to have its roots in a rebellion against paternal prohibitions. On the contrary, playing seems at least initially to have subjected him to an abusive authority from which his

father's intercession might conceivably have saved him. Nor does his adult playing allow him to forget paternal prohibitions. Field's complaints about the minister's treatment of him might as easily have been levied at Jonson, whose own text also points at Field in public and subjects his profession to moral scrutiny. It is not at all clear that Field isn't named by Jonson in order to be damned. In this sense, Jonson stands in league with the ghost of Field's father, neither figure appearing on stage, but both present in the abstract, judging the spectacle of the player with a critical eye.

And there are ways in which Field's relationship to Jonson might have resembled a filial one, pleasant or otherwise. As Bentley has documented, boy players in general seem to have been incorporated into a system that was at least superficially paternalistic.[40] Although Bentley's evidence pertains to the apprenticeship of boys in adult playing companies, Jonson himself suggests that the boy players were objects of affection. He claims to have taught Latin to Field, and his Epitaph on Salathiel Pavy is markedly affectionate.[41] Field seems to have known to resort to a father–son language when he most needed help; he writes to Philip Henslowe requesting financial assistance with the greeting "Father Hinchlow," and signing his letters "loving son."[42] On the other hand, Scott McMillin has found evidence that Field may, in 1609, have "satt up all night" copying out "speeches songes and inscriptions" for Jonson's entertainment at Britain's Burse, honoring James I.[43] Far from representing an escape from filial obedience, theatrical work seems to have imitated familial structures – both of affection and of authority – just as it imitated guild structures and school choirs.

Moreover, Field's adult incorporation into the realm of the theater exposed him to a model of authorship that stressed a quasi-oedipal organization of the power to speak. The prefatory poems he contributed to the works of Fletcher and Jonson indicate that the same kind of deference that worked with Philip Henslowe worked with the group of authors he was attempting to join. His prefatory poem to the 1607 quarto of *Volpone*, for instance, written when he was twenty, stresses his own inadequacy in the face of Jonson's age, talent, and reputation:

> For mee, your *Worke* or you, most worthy Friend,
> ('Mongst these un-aequall'd Men) to dare commend,
> Were damnable presumption; whose weake flame
> Can neither dimme, or light your full grow'n fame[44]

Demonstrating an acute awareness of his own subordination to the community of poets praising Jonson, Field spends the first fifteen lines of the poem issuing disclaimers.

His poem of tribute to John Fletcher in *The Faithful Shepherdess* (1610) begins similarly:

> Can my aproovement (Sir) be worth your thankes?
> Whose unknowne name and muse (in swathing clowtes)
> Is not yet grown to strength.[45]

Field continues by advertising his own idealized identification with this group of writers, declaring that he has always wanted to write a work like Fletcher's *Faithful Shepherdess* and noting that he had always feared public disapproval – which this play had inspired in large quantities – until

> I met a minde
> Whose grave instructions philosophicall,
> Toss'd it like dust upon a March strong winde:
> He shall for ever my example be,
> And his embraced doctrine grow in me.
>
> (26–30)

Critics have tended to identify this "minde" with Jonson, citing their afore-mentioned experiment in pedagogy, but perhaps the phrase's lack of speci-ficity makes this an effective address to the whole group of "un-aequall'd Men" Field courts. What matters here is not the specific relationship to which Field refers, so much as the general sense of homosocial embrace that characterizes the intellectual culture Field is only partially able to enter. When Chapman wrote a poem for Field's printed edition of *Woman is a Weathercock*, he entitled it "To his Loved Sonne, Nat. Field and his Wether-cocke Woman."[46] In spite of the fact that Field is twenty-four years old when this poem is written, Chapman emphasizes the paternalis-tic conditions under which the authorial community will welcome Field's participation.[47]

This filial community, of course, is possible only under certain condi-tions. It depends upon the exclusion of those unworthy of membership, represented here by the ignorant masses who fail to provide "understand-ing" audiences for the plays being commended. It is remarkable that two of Field's three poems appear attached to plays that had been failures on stage, as if the gracious exchange of praise among a select group of authors were to make a new reading public for works that were unable to court popular ac-ceptance. Fletcher himself stresses in his preface to *The Faithful Shepherdess* that his audience had simply failed to understand his experiment in Italian tragicomedy; they thought a pastoral tragicomedy meant "a play of country hired Shepheards, in gray cloakes, with curtaild dogs in strings, sometimes laughing together, and sometimes killing one another" (497).

After providing a rudimentary education in the genre, Fletcher quips "to teach you more for nothing, I do not know that I am in conscience bound." Stressing, then, the exclusive nature of his own writing, Fletcher is maneuvering toward the intellectual high ground in this preface, as Field and his fellow poets do repeatedly in their efforts to praise unpopular plays. One does not achieve the position of father-poet out of love so much as out of competition, and the bonds represented by the language of filial piety are quite obviously meant to establish and enforce an authorial hierarchy. In fact, this hierarchy is the precondition for the atmosphere of brotherly love and mutuality established in the poems. Or, to formulate the problem a different way, Field's point of entry into the constructed realm of elite authorship is exactly at the boundary between homosocial collaboration and oedipal contest. His very presence in the quarto versions of Fletcher's and Jonson's work reveals the limits of homosocial authorial community.[48]

Language belongs to fathers in this poetic community, and Field speaks as a son.[49] The prefatory materials in his own published *Woman is a Weathercocke* gesture toward that status, as will be demonstrated below. But we should first take note of the extraordinary playfulness of his self-presentations here, the habit of calling filial deference into question. Field mocks the expected dedication to an aristocratic patron: "I did determine, not to have Dedicated my Play to any Body, because forty shillings I care not for, and above, few or none will bestowe on these matters, especially falling from so famelesse a pen as mine is yet."[50] He similarly makes fun of the convention of a literary community; no moral or intellectual elite will receive his words as he had received Fletcher's or Jonson's:

Reader, the Sale-man sweares, youle take it very ill, if I say not somewhat to you too. Introth you are a stranger to me; why should I Write to you? you never writ to mee, nor I thinke will not answere my Epistle. I send a Comedie to you heer, as good as I could then make; nor sleight my presentation, because it is a play . . . I have beene vexed with vile playes my selfe, a great while, hearing many, nowe I thought to be even with some, and they shoulde heare mine too. Fare thee well, if thou hast any thing to say to me, thou know'st where to heare of me for a yeare or two, and no more I assure thee. (69)

Mutual understanding between noble authors has vanished in this formulation, to be replaced by a cynical strategy of mutual abuse and revenge. If Field has to receive the work of his fellow playwrights, his own venture into authorship will pay those fellows back. Even his address to the reader is inspired by the demands of the marketplace. Moreover, although the

sentence that closes this epistle is not entirely clear, it may well refer to Field's presence on stage. The exchange that marks authorial community in Jonson's or Fletcher's work is supplanted here by an actor's proximity to his audience. The strategies that protected greater authors from disapproving audiences are in Field's writing replaced by his own vulnerability as a public performer, cast as a playful familiarity.

In many ways, Field's epistle articulates the principles by which Jonsonian authorship is constructed. It is not a noble form of communion among great souls, so much as a competition and a performance, all ultimately undertaken with the end of selling texts. People buy plays in part because they like to imagine themselves included among the elite who understand *The Faithful Shepherdess* or *Catiline*.[51] In fact, it may well have been Field's popularity as an actor that made him worthy to write commendatory poems in the first place, which belies the rejection of audience approval so vaunted in the other prefatory materials these volumes contain. Field's own membership in the self-consciously elite community of authors – especially because of its contingency – marks that community as implicitly pandering to the very audiences it claims to disdain. When Field appears in print, he conjures up images of the sale-man.

Field's self-constructions, it seems, are related to Jonson's elite authorship in complicated ways. Like the puppet-actor whom Jonson will manipulate in *Bartholomew Fair*, Field appears before the public speaking under erasure, excluded from the authorial prerogatives claimed by Jonson or Fletcher, authorized by no aristocratic patronage. At the same time, he retains the potential for an ironic performance of that exclusion, a laying bare of the principles that construct the elite authorial community from which he is excluded. If Jonson's play imagines Field having just two possibilities – either submit to self-ridicule or establish your superiority to the text that mocks you – Field's own performance of authorship goes beyond a grab for satirical preeminence, instead challenging the very notion of a sovereign speaking voice. His particular career as an actor, in other words, makes him much more than an anti-author. It gives him a position from which simultaneously to construct and deconstruct modes of authorial address.

MAKING AMENDS TO LADIES

As one might expect from the implicitly feminizing oedipal logic of the authorial community that surrounds Field – and also from his unique position as an actor whose appeal is directed toward "the green gamesters"

in the theatrical audience – Field's reputation is inseparable from that of the women he writes for.[52] Even the titles of his two solo plays, *Woman is a Weathercock* and *Amends for Ladies*, promise a heightened awareness of female audiences and readers, a certain self-consciousness in relation to his female public. George Chapman, writing a dedicatory poem to *Woman is a Weathercock*, gestures towards this seemingly unavoidable connection between Field and women:

> To his Loued Sonne,
> Nat. Field, and his We-
> ther-cocke Woman.
> To many formes, as well as many waies,
> Thy Actiue Muse, turnes like thy Acted woman:
> In which, disprais'd inconstancie, turnes praise;
> Th'Addition being, and grace of *Homers* Sea-man,
> In this life's rough Seas tost, yet still the same:
> So turns thy wit, Inconstancy to stay,
> And stay t'Inconstancy; And as swift Fame
> Growes as she goes, in Fame so thriue thy Play,
> And thus to standing, turne thy womans fall,
> Wit turn'd to euerie thing, prooues stay in all. (70)

In this rather tortuous description of Field's muse, the weathercock woman he brings to the stage, the play itself, and Fame are all imagined as women that Field must in some way manipulate for the sake of his own reputation. Moreover, his "Active Muse," presumably a muse that produces a great deal and also a muse who is uniquely concerned with acting, practices a kind of incontinency, a salacious turning that Field must convert, through the steady application of his wit, to praise and fame. Moreover, he must convert this female and feminizing inconstancy into what Chapman calls "stay": a form of integrity perhaps like Odysseus's, barely distinguishable from craftiness.[53] It is Field's craft, in other words, both to disparage and to be associated with inconstant women. However Chapman might work to elevate Field by raising him to the level of the epic, the poem suggests that Field's basic task as an author is to convert putative female sexuality into "standing," that neat conjunction of phallic power and communal recognition. As Chapman's affectionate dedication hints, however, the "Loued Sonne's" standing is not as high as his father's. The terms of the praise mark the limits of Field's inclusion among authors who subscribe to a gentlemanly ethic of homosocial communion. At the same time they dictate a certain stance in relation to female audiences.

This emphatic connection between Field and his female audiences extends beyond the prefatory poem and into *Woman is a Weathercock* itself. As a printed work, *Weathercock* makes clear the immediate links between Chapman's poem and Field's work as an author. If we imagine Field in the play's leading role, as we may well be licensed to do, the play becomes fascinatingly self-referential. It is fully possible to read *Woman is a Weathercock* as an attempt to gain standing through the denigration of female chastity. Like *Amends for Ladies*, the play concerns itself with the marital status of three women, in this case sisters. The central plot involves the disillusionment of Scudmore, betrothed by private precontract to Bellafront, who has been coerced by her greedy father into marrying a count. Though it is difficult to be sure that Field appeared in the play, or to know which role he might have taken, the usual assumption at this point in his career is that he played the romantic leads, which in this case would mean playing Scudmore. Interestingly, many of Scudmore's appearances in the play involve lengthy declamations against women, who have all been sullied in Scudmore's estimation by Bellafront's perfidy.

In that disquieting tradition of Renaissance theatrical misogynist diatribe, these speeches tend to have a metatheatrical quality to them, a way of moving from the disparagement of one particular fictional woman to the maligning of the many women present in the audience. Even if Field did not appear in the role of Scudmore, the effect of these lines might position him powerfully as a speaker against female licentiousness:

> Why am I thus rewarded women, women?
> Hee's mad by Heauen, that thinkes you any thing
> But sensuall Monsters, and is neuer wise
> Nor good, but when he hates you, as I now,
> Ile not come neere one, none of your base sex
> Shall know me from this time, for all your Vertues
> Are like the Buzzes, growing in the fields,
> So Weakely fastned te'e, by Natures hand,
> That thus much winde blowes all away at once,
> Ye fillers of the world with Bastardy,
> Worse then Diseases you are subiect too,
> Know I do hate you all, will write against you,
> And fight against you. (2.1.202–14)

The sense of direct address to his female audience combined with the suggestion that writing against women is a vocation aligns itself readily with Chapman's milder hint that Field could make himself a career by turning his muse in tandem with the wiles of feminine sexuality.

Indeed, *Woman is a Weathercock* is riddled with reminders that theater has the power to make or break reputations, an insight that has direct ramifications both for Field and for the women he depicts. In addition to Scudmore's direct addresses to female audience members, which emphasize his power to characterize them, the play relies on explicit references to theatrical production several times, establishing the stage as a major force in the social construction of identities. When Bellafront's sister Kate is wrongly accused of fornication, she demands that her husband-to-be defend her honor, threatening to think as "abiectly" of him

> as any Mongrill
> Bred in the Citty; Such a Cittizen
> As the Playes flout still, and is made the subiect
> Of all the stages. (2.1.274–7)

To be the subject of the stages is clearly to have one's reputation cemented; here, as in the larger context of the production and printing of *Weathercock*, the stage is the real or imagined proving ground both for women and for the men who are engaged in praising and blaming them. In fact, as this subplot resolves itself and Master Strange redeems Kate's honor, he imagines his reward – in addition to getting the girl – as a theatrical triumph:

> I consecrate my deed unto the Cittie,
> And hope to liue my selfe, to see the day,
> It shall be shewne to people in a play.
> (5.2.229–31)

The stage is the final arbiter in questions of honor or status, both for women who are maligned and for the men who establish themselves, like Field, as arbiters of women's reputations.

Within *Woman is a Weathercock*, it seems, Field has positioned himself as an enemy to women, only hinting at the play's end that his female audiences are themselves, as Jonson suggests in *Bartholomew Fair*, a significant force in public opinion. Scudmore's final lines – nearly the last ones spoken in the play – summarize neatly the self-positioning Field engages in in his prefatory materials: "And may all true loue haue like happie end, / Women forgiue me; Men, admire my Friend [i.e. Bellafront]" (5.2.232–3). As Scudmore briefly asks forgiveness of them at the end of the play, he gestures toward a recognition of women that is more fully characteristic of the play in its printed form. Chapman's poem, with its faint-praise logic, its provisional elevation of Field as a recorder of female iniquity, is only one

among several strategic prefaces to the printed edition. The 1612 quarto's dedication and epistle to the reader, already noted for the playfulness with which they position Field, also suggest a fascinating attempt on Field's part to parlay his misogynist satirical persona into an actual alliance with female audiences. The quarto thus represents a significant moment in the evolution of early modern popular culture, in which Field builds a tenuous bridge between the authorial elitism that partially excludes him, and the women in his audiences, who are at least some of the time said to account for his fame.[54]

Field's own descriptions of his standing as an author, like his oddly self-referential treatment of women within *Woman is a Weathercock*, play strikingly with the terms of his exclusion from authorial manhood. In refusing to seek aristocratic patronage for the play, for instance, he combines authorial independence with frank misogyny:

> To any Woman that
> hath beene no Weather-
> Cocke

I did determine, not to haue Dedicated my Play to any Body, because forty shillings I care not for, and aboue, few or none will bestowe on these matters, especially falling from so famelesse a pen as mine is yet. And now I looke up, and finde to whom my Dedication is, I feare I am as good as my determination: notwithstanding I leaue a libertie to any Lady or woman, that dares say she hath been no weather-Cocke, to assume the Title of Patroness to this my Booke. If she haue beene constant, and be so, all I will expect from her for my paynes, is, that she will continue so, but till my next Play be printed, wherein she shall see what amendes I haue made to her, and all the sex, and so I end my Epistle, without a Latine sentence. (68)

On the one hand, this dedication testifies to Field's identification with Jonson and his authorial peers; the joke is the same as the one that structures *Epicoene*, in which Morose finds to his horror that the only silent woman is no woman at all.[55] On the other hand, Field allegedly leaves open the possibility that some woman will qualify to become his patron, and his imagined engagement with this chaste figure is characteristically complex. If a chaste woman becomes his patron, she assumes dominion over a text that denies her existence, in its dedication and title as well as in most of the actual text. If there is no chaste woman, a chaste woman is no one. Moreover, Field expects from her a chastity that continues "but till my next Play be printed"; at the point that he makes amends for attacking women, he assumes, they will once again merit the attack for which he is now projecting an apology. For a woman to act as patron of Field's play,

then, means entering into an implicit contract to speak against herself, to authorize the assertion that women are weathercocks.

As a text, *Amends for Ladies* fulfills the same paradoxical purpose as this ironic dedication. The play opens with a debate between a Maid, a Wife, and a Widow, each of whom asserts that hers is the best condition of life. While the widow and the maid certainly suffer their share of misfortunes, it is the wife, Lady Perfect, who endures deliberate and protracted brutality. Lord Perfect suspects her of unchastity, and convinces his childhood friend Subtle to test her with an attempted seduction. Even at an early stage in this plot, Lord Perfect is astonishing in his cruelty. His initial accusations ("Oh I could kick you now, and teare your face / And eate thy Breasts like udders" 2.2.18–19) give way to what is for him the bottom line of matrimony: "This is cal'd marriage, stop your mouth you whore" (2.2.37). Her husband's insane jealousy might be dismissed as individual pathology, except that when Subtle has no luck seducing Lady Perfect he conspires with Lord Perfect in calculated torture:

> SUBTLE But still I tell you, you must use her roughly,
> Beate her face black and blew, take all her cloth's
> And give them to some Punke, this will be ground
> For me to worke upon.
> HUSBAND All this I have done. (3.1.26–30)

Resistant even to physical violence, Lady Perfect maintains her chastity and praises her husband. The men are stricken with remorse, she accepts their apologies, and the plot moves forward seamlessly. Lady Perfect has no major part to play again until the final scene, when closure dictates a return to the women's contest. The maid and widow are won in marriage by men they love, and Lady Perfect is given a garland to wear like the two new brides. She looks at them and delivers the play's final lines: "Yet mine is now approu'd the happiest life, / Since each of you hath chang'd to be a wife" (5.2.300–1).

It is of course incredibly difficult to take these remarks at face value. Even if Lady Perfect can be played as sincere in this moment – if her bruises have faded and she has gotten her clothes back from her husband's prostitute – her observations about marriage call the whole structure of *Amends for Ladies* into question. What kind of a comedy boasts about its offer of marriage to the maid and widow while scrupulously demonstrating that wives are defenseless victims? This is a play, it seems, that emphasizes its own coercive power. Like the puppet actor who will see his dead father mocked and himself cast in wooden miniature, and like the chaste woman

who becomes patroness of a diatribe against female sexuality, Lady Perfect is made to perform her own marital happiness in an act either of total self-abnegation or of deep irony. This play ends, in other words, in an undecidable contest between authorial sadism and enacted subversion. Either *Amends for Ladies* is a cruel hoax on women, or Lady Perfect performs a kind of ironic mimesis here, paradoxically carving out room for resistance from within her perfect adherence to gender norms.[56] Not knowing who wins the contest – or knowing that every performance of this play might locate itself on some point along a continuum of possible outcomes – allows us exactly the tools we need to talk about Field's authorial self-representations. On the one hand, this resolution is a suggestive indictment of Jonsonian dramatic authorship. Authorship as Jonson conceives of it consists of forcing other people – not only Field in 1614, but puppet Dionysius, Morose, Volpone, and virtually any actor in one of his antitheatrical stage productions – to testify publicly against themselves. The whole logic of constructing elite authorship out of antitheatrical plays requires of players an endless series of self-mocking performances. By demonstrating the brutality of that coercion in his treatment of Lady Perfect, Field critiques the elite authorial community from which he is partially excluded.

Textually, this reading of the play gains support not only from the sufferings of Lady Perfect, but from the play's mockery of male homosocial community. If as noted earlier, playwrights like Jonson, Fletcher, and Chapman established themselves as authors in part by advertising their participation in an elite authorial exchange, and if Field was admitted into this circle rather provisionally, as a son, then two moments in *Amends for Ladies* might be said to reflect upon that provisional acceptance. When Lord Perfect vows to test Lady Perfect, he seals his pact with Subtle by "loues masculine kisse," by their friendship past and future (1.1.467). Instead of the expected celebration of male friendship, however, Perfect's love for Subtle is clearly degraded, a front for their mutual distrust and even hatred, and of course the driving force behind their torture of Perfect's wife. Love's masculine kiss is parodied, moreover, just before Lady Perfect comments upon her wedded bliss. In a truly bizarre plot twist, the foolish Lord Feesimple is dressed as a woman and offered to his pantaloon father in marriage. When Count Feesimple kisses his "bride" and discovers her beard, the son unmasks and protests that they have been "made a couple of fine fooles" (5.2.268–9). If homosocial community is a mark of elite authorship, the savage unveiling of male relations in *Amends for Ladies* renders homosociality highly suspect, even ludicrous.

But the play offers no unambiguous model of exclusion from or resistance to that male community. Before being given to his father in marriage, Lord Feesimple had been on a personal quest to join the group of Roaring Boys who swagger through this play. Brought to them to overcome his fear of swords and knives, Feesimple learns that swaggering consists partly of linguistic bravado. One of the roarers even upbraids him for honing in on the roarer's own characteristic expression:

> [TEARE-CHOPS] Youle pledge me Sir?
> [WELTRIED] Indeed I will not.
> [FEESIMPLE] Dam mee hee shall not then.
> [TEARE-CHOPS] Lord, use your owne words, Dam mee is mine, I
> am knowne by it all the towne o're, d'ee heare?
> [FEESIMPLE] It is as free for mee as you, d'ee here Patch?
>
> (3.4.120–5)

Perhaps it is language that most shows a man, but the Roaring Boys have taken the possession of words to a Jonsonian extreme. In his envy and emulation of the boys, however, Feesimple complicates what might otherwise look like a relatively straightforward parody of the claim to linguistic preeminence. For when he finally assumes his full power to roar, defending himself and his father after their parodic masculine kiss, Feesimple performs a comic and hollow impersonation of a Roaring Boy:

> [FEESIMPLE] . . . marke now what i'le say to 'em, d'ee heare my Masters, Dam-me,
> yee are all the sonne of a whoore, and ye lie, and I will make it good with my
> sword, this is cal'd Roaring Father . . . Has either of you any thing to say to
> me?
> [HUSBAND] Not we Sir.
> [FEESIMPLE] Then have I something to say to you. Have you any thing to say to
> me?
> [BROTHER] Yes marrie have I Sir.
> [FEESIMPLE] Then I have nothing to say to you, for that's the fashion, Father if
> you will come away with your cough, doe. (5.2.271–88)

Able only to imitate "the fashion," Feesimple is caught here between a contentious autonomy and a craven desire for belonging. In fact, he sounds remarkably like Field's epistle to the reader in *Woman is a Weathercock*:

> Introth you are a stranger to me; why should I Write to you? you neuer writ to
> mee, nor I thinke will not answere my Epistle . . . Fare thee well, if thou hast any
> thing to say to me, thou know'st where to heare of me for a yeare or two, and no
> more I assure thee. (69)

That Field's official authorial voice should sound so like his character's attempt to roar suggests a deliberate strategy of self-mocking.[57] From his position on the periphery of authorial community, in other words, Field as a roaring son is able both to parody the fathers and to make fun of his own desire to emulate them.

Field's depictions of himself as an author are, in short, highly paradoxical, especially when combined with the various treatments of verbal sovereignty in *Amends for Ladies*. He displays a contentious desire for authorial autonomy, but his portrait of the Roaring Feesimple suggests that that contentiousness is itself an imitation of an "in" group that has a prior claim to self-aggrandizing speech. Field emphasizes the potential power of his writing to control women, but the power that *Amends* exercises over Lady Perfect seems to imply a sharp critique of Field's own comic project. In each case the desire for a powerful authorial voice is fully established, but also fully undermined, consonant with his status as son to the father-poets.

"[t]HAT'S *HORACE*, THAT'S HE, THAT'S HE, THAT'S HE"

Given the precarious nature of Field's authorial self-positioning, Jonson's treatment of him in *Bartholomew Fair* can seem especially bitter. Almost as if to retaliate for Field's implicit critique, Jonson emphasizes the actor-playwright's subordinate status by comparing him with a puppet; he emphasizes his own claims to paternal preeminence by reviving the memory of Field's defeated father. In the attempt to establish his own greatness before the King, Jonson seems to take away the delicate balance between aggression and emulation that makes it possible for Field to speak as the oedipal son. In fact, if Field is equated with Puppet Leander, that puppet's appearance at the end of the play as

> *our chief Actor, amorous* Leander,
> *With a great deale of cloth, lap'd about him like a Scarfe,*
> *For he yet serues his father, a Dyer at* Puddle *wharfe*
> (5.4.117–19)

would seem to add insult to injury. The prologue ends with an ambiguous promise: "*By and by, you shall see what* Leander *doth lacke*" (5.4.127). When Puppet Dionysius reveals what all puppets lack, finally, the logic of oedipal domination is complete. But even this intensified sense of Jonson's use of Field fails to do justice to the complexity of their engagement with one another. Field is indeed a kind of puppet in this text, but as Scott Shershow has suggested, the status of the contentious puppets in *Bartholomew Fair* is

fascinatingly unclear (102–6). In Shershow's argument, Jonson ultimately recoups his authorial control over the disorderly puppet show by reminding us that Puppet Dionysius speaks by the "inspiration" of Leatherhead. And if Leatherhead is the "mouth" of the puppets, Jonson is the mouth of them all. But perhaps the more remarkable fact is that puppet theater should present such a challenge to authorial sovereignty in the first place. As Leatherhead says of Puppet Cole, "there's no talking to these watermen, they will ha' the last word" (5.4.189–90).

Shershow speculates that Jonson might have begun his own career as a writer for the puppet theaters of early modern London (57). It is true that Dekker's *Satiromastix* (1601) refers to Jonson – thinly disguised in the figure of Horace – as "the puppet-teacher," this just after a query about why Horace ever gave up brick-laying.[58] Dekker's play is also one of the only pieces of evidence that suggests that Jonson had himself been a player.[59] Famously, and somewhat puzzlingly, the play accuses Jonson both of having been a poor (travelling, inferior) actor and of having played in one of the great roles of his day, Hieronimo in Kyd's *Spanish Tragedy*:

... thou putst up a Supplication to be a poore Iorneyman Player, and hadst beene still so, but that thou couldst not set a good face vpon't: thou hast forgot how thou amblest (in leather pilch) by a play-wagon, in the high way, and took'st mad Ieronimoes part, to get seruice among the Mimickes. (4.1.128–32)

Being a puppet-teacher and "running mad" over the loss of a son are especially evocative images for the present study, even occurring as they do thirteen years prior to *Bartholomew Fair*. And in a way, *Satiromastix* gives Jonson's puppet-actors the last word; the play's epilogue features an actor apologizing for an earlier performance that offended: "I recant, beare witnes all you Gentle-folkes . . . that Hereticall Libertine *Horace* taught me so to mouth it" (5–9). The puppets of *Bartholomew Fair*, who speak more than their master Leatherhead sets down for them, are registering a truth about the performer's power – and Jonson's implication in that power – that belies the fantasy of control implied by Jonson's patriarchal authorship.

Through the puppet show, Jonson has in a sense written Field's autonomy into his text and tacitly acknowledged his own relationship to acting and to actors. Even a performing object is able in performance to escape the control of its governing "mouth." As Leah Marcus notes, such a loss of control is typical of Jonson's ambivalent acts of self-representation:

It is characteristic of Jonson to write into his work a meticulous set of discriminations among things that appear similar on the surface but need to be understood as moral opposites. It is equally characteristic of him to fail to sustain the distinctions

he has taken pains to establish – to collapse them uproariously into one another, or at least allow them to contaminate one another to the extent that the playwright's 'authority' over his materials is lost. Considered from the bottom up instead of from the top downward, Jonson's hedges against free interpretation are desperately futile attempts at containing his own ludic impulses along with the populist energies he purported to despise.[60]

A whole series of collapsed distinctions might be accounted for in this way: Jonson vs. Field, Puritan vs. worldly author, distinguished author vs. common player – the list is potentially very long. But the breaking down of distinctions in *Bartholomew Fair* occurs for reasons that are, finally, even more fundamental than Jonson's failure to control his own ludic impulses, reasons implicit in the circumstances of a dramatic author. After all, the theatrical expression of ludic impulses in early modern England emphatically included the making of reputations, whether for popular players, distinguished authors, or subversive Puritans. Once an author inserts himself into a dramatic text, as Jonson does in both the induction for the Hope theater and the dedicatory poem to James I, he becomes a performer in it.[61]

Nor had Jonson been particularly successful at obscuring this inevitable fact of self-promotion.[62] *Satiromastix* mocks Jonson/Horace precisely for his efforts to become known in the playhouse as an elite dramatist, taking him to task in the words of Sir Vaughan:

Moreover, you shall not sit in a Gallery, when your Comedies and Enterludes have entred their Actions, and there make vile and bad faces at everie lyne, to make [G]entlemen have an eye to you, and to make Players afraide to take your part . . . Besides, you must forsweare to venter on the stage, when your Play is ended, and to exchange curtezies, and complements with Gallants in the Lordes roomes, to make all the house rise up in Armes, and to cry that's *Horace*, that's he, that's he, that's he, that pennes and purges Humours and diseases. (5.2.298–307)

Whether Dekker's satire describes Jonson's playhouse practices honestly or not, the image of the dramatist who cannot keep himself from crowding the stage to the cries of the audience is a profoundly damning one for an ostensibly anti-histrionic writer. Dekker highlights the apparent contradictions in Jonson's career; to establish himself as anti-spectacle, Jonson had to make himself a spectacle.[63]

The anti-performance author, in other words, is more than an interestingly conflicted writer; he is a logical impossibility.[64] The position of the serene textual controller is more like the position of the vulnerable, improvising onstage performer than Jonson will readily admit. The similarity is there not merely because Jonson himself is ineluctably associated with the mire of the fair and the improprieties of the theater, but because authorship

is performance, on stage or in print. To court celebrity, is, ultimately, to model oneself after players. Ironically, this realization leaves Jonson doing exactly what he prompted Field to do: testifying against himself. Like Field, Jonson is in the vulnerable position of playing wittily with the terms of his own disadvantage. Even, it seems, a self-styled sovereign playwright must contend with theater, and to do so is to surrender in part the fantasy of sovereign control, relying instead upon a form of improvisation. Jonson constructs authorship by invoking a distinction – particularly disingenuous, given his own history – between dramatist and player, but that distinction itself ignores the prevailing conditions of theatrical celebrity. For a player to become known on stage is to become known for working around the script, playing off of the controlling authority, developing a personal reputation while playing a series of roles devised by others. For a dramatist to achieve a reputation is similarly to work around the authority of the players, establishing a presence in negotiation with them. Moreover, as Field's own career indicates, even audiences can be part of the contest, their own reputations at stake in the witty improvisations of an author-player. What *Bartholomew Fair* may ultimately establish through its vivid contests of representation is not so much the serene authority of the author or the sovereign, but the intermingling of those roles with actors and audiences. In the last analysis, what may matter most is not that authors model themselves upon monarchs but that self-representation per se is fundamentally dominated by the work of the player, by the puppet who speaks from the mouth of another.

"BRILLIANTLY THEATRICAL"

Scholars who narrate Field's career often repeat Richard Flecknoe's nostalgic description of him in *A short discourse of the English stage* (1644), sounding as it does like a reconstruction of the Golden Age of English theater: "In this time were Poets and Actors in their greatest flourish, *Johnson*, *Shakespear*, with *Beaumont* and *Fletcher* their Poets, and Field and Burbidge their Actors."[65] It is of course not surprising that Field is mentioned as a player or that Jonson and Shakespeare should be located so firmly within the realm of authors. To take Flecknoe's description at face value, though, is to gloss over his strikingly hierarchical approach to theatrical work, developed more fully elsewhere in the tract:

A Dramatick Poet is to the Stage as a Pilot to the Ship; and to the Actors, as an Architect to the Builders, or Master to his Schollars: he is to be a good moral Philosopher, but yet more learned in Men then Books. He is to be a wise, as well

as a witty Man, and a good man, as well as a good Poet; and I'de allowe him to be so far a good fellow too, to take a chearful cup to whet his wits, so he take not so much to dull 'um, and whet 'um quite away. (G6)

In its Horatian linking of wisdom and conviviality, Flecknoe's description of the dramatic poet hearkens back emphatically to Ben Jonson, teaching Latin to a young Nathan Field, upholding high standards of erudition and taste, inviting his friends to supper. It also recalls Field's deferential address to his fellow playwrights, the "grave instructions philosophicall" he claims to have received from them in his dedicatory poem to *The Faithful Shepherdess*.

Indeed, Flecknoe invokes this exact pedagogical relationship in another description:

It was the happiness of the Actors of those Times to have such Poets as these to instruct them, and write for them; and no less of those Poets to have such docile and excellent Actors to Act their Playes, as Field and Burbidge; of whom we may say, that he was a delightful Proteus, so wholly transforming himself into his Part, and putting off himself with his Cloathes, as he never (not so much as in the Tyring-house) assum'd himself again until the Play was done. (G6v–G7)

A docile pupil to the master poets, a delightful Proteus, whose identity is malleable in a way that the philosopher-author's is not: the actor in these lines is as carefully defined as the author. What this description of an edenic relationship obscures, of course, is the effort to which a self-constructing author might go to project such an image before a reading and playgoing public. The happiness that Flecknoe looks back on is the fantasy that Johnson and his peers construct carefully for their readers, current and future. In the actual moment of producing *Bartholomew Fair*, however, the relationships are unstable, improvised, dependent upon the inflections given in performance by a player like Field, who is himself capable of much more than docile obedience. In fact, as the puppet show suggests, the brilliance of *Bartholomew Fair* depends in part upon the players' ability to exceed the script.

The power of a description like Flecknoe's is borne out, however, by later scholarly approaches to theatrical work. In choosing a copy text for his 1910 edition of Chapman's *Bussy D'Ambois*, for instance, Thomas Marc Parrott selects what is known as Text A, the first printed edition, rather than Text B, written in 1610–11 and printed in 1641 "Being much corrected and emended by the Author before his death."[66] His reason for doing so bears little resemblance to the logic of multiple texts that has recently caused such a revolution in Shakespearean editing. On the contrary, Parrot rejects the

possibility that the emendations were Chapman's, noting that they seem to him geared toward improving the play for the stage:

With hardly an exception [the emendations] add nothing to the poetic value of the play, but they do in every case add to its stage effects by inserting touches of humour, by linking a scene with what has preceded, or by furnishing a motive for what is to come, and by making the situation clearer to the spectator . . . And when one considers the sublime indifference which Chapman shows in *The Revenge of Bussy* and the *Byron* plays for the requirements of the stage, one feels that he must have had some expert advice before he made so many improvements of this nature, and I know of no one at any time who was so likely to give Chapman advice on this matter as his "son," the actor-playwright Field.[67]

On the face of it, this reading of the B-text revisions seems to offer a pleasing inclusiveness, a recognition that early modern playwrights tended to collaborate and that Field was a powerful presence in the theatrical milieu.

In more subtle ways, however, Parrott invokes a vision of Field's participation in theatrical work that maintains Flecknoe's hierarchical distinctions between philosopher-authors and their lesser friends who act. Chapman's "sublime indifference" to the exigencies of staging contrasts with Field's deafness to "poetic value." It is true that positing Field as a participant in the revisions might explain how the text came to be in the possession of the King's Men, and A. R. Braunmuller has in fact identified some telling verbal echoes of *Bussy* A in *Amends for Ladies*. On the other hand, however, Peter Ure has made a compelling case for reading the revisions as at least mostly Chapman's, and Albert Tricomi has studied the revisions as documents of an increasingly stoic turn in Chapman's work. Interestingly, whether we imagine Chapman as Tricomi's philosophical reviser or Parrott's otherworldly artist, Nathan Field is more or less consistently invoked as a representative of theatrical exigency rather than literary value. Tricomi never suggests that Field might have shared Chapman's stoicism, and Parrott never imagines that Chapman might have cared about the stage.[68] Field is thus allowed to embody, in this debate as in his relationship with Jonson, the desire to place distance between important authors and theatrical work. Chapman represents the settled philosophical authority of the author, while Field stands in for the protean, audience-courting world of the theater.

Field is similarly described by other editors as a lesser poetic light, ostensibly because of his interest in performance. William Peery, editor of his plays, finds his characters "brilliantly theatrical, rather than authentic" (13). In dividing attribution for *The Fatal Dowry*, originally printed as written by

P. M. and N. F., Philip Edwards and Colin Gibson venture to characterize what they believe to be Field's contributions:

The less witty and satirical parts are not really difficult to assign to their authors; the windy pathos of the rhetoric for the funeral in Act II, and for the quarrel in Act III, is not only as distinct from Massinger's style as may be, but is representative of what Field is likely to do in serious writing as shown in the few serious speeches in *Amends for Ladies*; it is not good verse, often irresponsible about the sense and containing ludicrous images, but since it is Field's it cannot lack spirit of a kind.[69]

Gibson and Edwards stop short of making theatrical success uniquely the concern of Field, but surely their attribution of "spirit" to him hearkens back at least as far as Jonson. Field has no taste in imagery, no interest in meaning, nothing but an untutored charisma run rampant. He writes in a merely spirited way that appeals to audiences.

The point here is not to fault editors for drawing conclusions that help them make sense of collaborative work. In the absence of hard information about the working habits of early modern playwrights it may inevitably be tempting to construct notions of style and personality as a way into textual scholarship.[70] Indeed, there is no way to prove that personal style was not important for some early modern playwrights. Perhaps, after all, Field is characterized accurately in these descriptions. But to evaluate Field's position rightly requires a more complicated vision of authorship on the early modern stage. As this chapter has argued, his career suggests that there was in fact an effort among some playwrights to dissociate themselves from players, audiences, and the vicissitudes of performance. But that effort ought not to prevent us from seeing theatrical authorship for what it was: a labor parallel to that of the player, based, like playing, in the work of self-construction before overlapping audiences of viewers and readers.

The position of an antitheatrical playwright, as constructed at least some of the time by Jonson, has indeed come to dominate our understanding of absolutist dramatic authorship. It is, however, by no means the only way that individual authorial careers could be imagined in print and on the early modern stage. On the contrary, Field employed a vocabulary of authorship that acknowledged but also exceeded the terms set out by patriarchal absolutism. Field allowed for affection, admiration, even a family relationship with the figure of the sovereign author, but also performed parody, ironic defiance, and self-deprecation. What he teaches us, finally, is that the notion of the author as a monarch of words was only one possible

form of proprietary rhetoric brought to bear on early modern dramatic texts. A playwright could also speak as a son, as a puppet, as a lover in an unsteady alliance with his female fans. We have tended to dismiss Field as an author because he plays these roles, but in doing so we give Jonson's sometime fantasy of sovereign control a misleadingly uncontested power over early modern audiences and readers.

Anthony Munday and the spectacle of martyrdom

There is no more telling way to introduce Anthony Munday as an early modern theatrical writer than to quote from *A second and third blast of retreat from plaies and theatres*, a text "Set forth by Anglo-phile-Eutheo" in 1580 and often attributed to Munday:

> The writers of our time are so led awaie with vaineglorie, that their onlie endeuor is to pleasure the humor of men; & rather with vanitie to content their mindes, than to profit them with good ensample. The notablest lier is become the best Poet; he that can make the most notorious lie, and disguise falshood in such sort, that he maie passe unperceaued, is held the best writer.[1]

The sentiment is familiar from a long tradition of antitheatrical writings in which the products of human imagination suffer by comparison with truth, cast variously as a Platonic, Christian, or, insofar as verisimilitude and decorum are brought to the fore, a more narrowly literary concern.[2] The *Blast of retreat* writer, however, calls the poet a liar for reasons that touch much more specifically upon the economic structures that support theatrical writing. Produced just four years after the opening of what is sometimes considered the first public theater in England, the treatise shifts between condemning the theaters themselves and condemning the practices of dramatic writing and performance more generally. Its condemnation of theatrical patronage thus seems to stand in for a broader rejection of professional writing:

> But some perhaps wil saie, The Noble man delighteth in such things, whose humors must be contented, partlie for feare, & partlie for commoditie: and if they write matters pleasant, they are best preferred in court among the cunning heads.
> Cunning heads, whose wits are neuer wel exercised, but in the practice of such exploits! But are those things to be suffered and praised, because they please the rich, and content the Noble man, that alwaies liues in ease? not so.
> ...Who writeth for reward, neither regardeth virtue, nor truth; but runs vnto falshood, because he flattereth for commoditie. (108–9)

For most early modern theatrical writers, one might argue, such accusations of falsehood are relatively remote. The theaters managed to coexist with these opinions, at least, until 1642. But for Anthony Munday, the suggestion that writing for reward is a damnable form of lying becomes a problem of the highest order.

The nature of that problem is highlighted by the very controversy over the *Third blast of retreat*'s authorship. Obviously, for a once and former playwright to produce such an attack upon theatrical practice calls up a host of questions about sincerity in writing. We are told in the preface to the reader that, like Stephen Gosson, the writer of the *Third blast* had once been "a great affecter of that vaine art of Plaie making" who vowed to write plays no more after learning how much lascivious behavior occurred on theater grounds (A4). Anglo-phile Eutheo, moreover, boasts that the writer of the *Third blast* had been "as excellent an Autor of those vanities, as who was best" and teases readers with the author's concealed identity: "thou maist coniecture who he was, but I maie not name him at this time for my promise sake" (A5). While attacking the work of the playwright, in other words, the *Third blast* and its prefatory letter simultaneously invest in the playwright as a known and talented producer for the stage, "so famous an Author" as Eutheo calls him (A5).

But the author's fame soon becomes something more like notoriety, and it is at this point that the *Third blast* is tentatively connected to Anthony Munday. Stephen Gosson, writing *Plays confuted in five actions* in 1582, notes that "no man that euer wrote plaies" had also written against them like Gosson himself, "but one, who hath changed his coppy, and turned himself like the dog to his vomite, to plays againe."[3] The reference to the author of the *Third blast* seems clear. Though neither Gosson nor Eutheo ever names this vacillating moralizer, he has by 1582 acquired a reputation for the very disregard of truth he had formerly condemned, a reputation that Munday shares. Thomas Alfield had accused Munday just the year before of returning "home to his first vomite againe," of having been a player, writing a ballad against plays, and then returning to the stage.[4] Though the connection is too weak to make attribution certain, the invitation to conjecture offered by Eutheo's epistle nevertheless suggests that readers did fill in the blanks when authors were described in such veiled references. The unintended consequence of Eutheo's boast about the *Third blast* author's fame is the high likelihood that Munday must have looked at least to some readers like the dog who wandered from stage to antitheatrical treatise and back. It is an appearance that lends credibility neither to Munday nor to the antitheatrical tract.

As this chapter will argue at some length, Munday's penchant for looking like – or indeed for being – a self-serving liar makes him an important figure for the development of authorship in early modern England.[5] More centrally for the purposes of this argument, his reputation for dishonest writing becomes connected to his reputation for being a player. Both forms of performance become notorious precisely when they are used as Munday uses them, to create a reputation for moral seriousness. As a vigorous self-promoter and an equally vigorous supporter of righteous causes, Munday repeatedly invokes his own name to guarantee his texts' trustworthiness. Marketing his name as a sign that he is above the corruptions of the marketplace, Munday necessarily stumbles into a paradoxical version of Foucault's author-function. He becomes a source of textual meaning, but without the sense of coherent subjectivity to which Foucault's post-Romantic author is so firmly attached. On the contrary, for Munday to stand behind his texts as the source of their meaning is to connect his writings not to a pure consciousness but to a performative one. Like the actor he apparently was, Munday is suspected of playing rather than being, of performing for reward the forms of integrity for which he wants to be known. Because his conscience seems so utterly driven by the authorial marketplace, Munday embodies for his readers a set of connections between acting and authorship that render the author at once a powerful figure and a duplicitous one.

These connections emerge most clearly in Munday's writings about martyrdom, most of which were printed in the early 1580s, the years in which his reputation for acting and for writing against the stage was also emerging. Nor should this connection seem surprising. The martyr's resistance offered a powerful opportunity to authors. To celebrate a martyr's triumph or to expose a martyr's fraud is to appropriate for writing a transcendent truth, an ability to define spiritual essences and worldly powers, to confirm or debunk the one on the basis of its interaction with the other. At the same time, however, to enter into the business of representing martyrs is to enter into a competition with other writers, to have one's veracity questioned.[6] Like a martyr, an author could be exposed as a fraudulent performer. This is precisely the contest in which to locate Anthony Munday, who, although he was known as a writer before he began engaging with martyr disputes, achieved something like notoriety by writing a series of tracts about Edmund Campion and his peers. Munday makes visible, often in appalling ways, the stakes of the dispute over martyrdom and martyrology. In particular, he brings to the question of spiritual truth a relentless penchant for economic opportunism, and in doing so he manifests the contradictions inherent in professional writing. Busily appropriating the

spiritual authority of martyrdom on the one hand, he is busy undercutting that authority on the other hand by revealing his commercial motives.

This chapter will consider Munday's writings about martyrs in detail, particularly *English Roman Lyfe*, a tell-all about Catholicism from 1582 that is profoundly puzzling in its approach to the true faith and the honest victim of religious persecution. Clearly, Munday was during these years a figure of some interest to readers, and his various efforts at self-marketing at this time show powerfully the interrelation between religious controversy and a set of anxieties about representation. The author and the actor stand alongside the martyr as figures for a profound epistemological anxiety, occasioned not merely by the overlapping forms of Catholic and Protestant worship but by the competing forms of reputation that could make Edmund Campion, for instance, look like a villain or a hero. But martyrs are not merely the focus of this set of non-dramatic texts; Munday also wrote about martyrdom frequently for the stage. Though the texts in which he treats martyrdom are written collaboratively, they nevertheless reveal a set of preoccupations with playing and martyrdom strikingly similar to those of the non-dramatic writings. After all, Sir John Oldcastle's reputation on the stage was scarcely less malleable than Campion's was in print. Both controversies call attention to the relation between representation and truth, and both produce notions of authorship that challenge Foucault's sense of the author as a limiting subjectivity.

To trace the parallel author functions developed by the martyr pamphlets and the martyr plays alike is not to read Munday's personal consciousness into collaborative theatrical texts. On the contrary, there are two points to be emphasized in these plays: that theatrical work, even when anonymous and/or collaborative, was nevertheless a particularly powerful medium in which to construct authorship; and that the commercial depiction of the martyr's transcendent conscience called up a set of anxieties very like those suggested by Munday's efforts to promote himself through martyrology. To regard Munday's participation in a set of martyr plays as significant is to recast this set of writings. Rather than being simply a set of discourses about execution, as they might appear in a less author-centered account, they become in addition a set of economic opportunities afforded a playwright, working with his peers, to exploit the commercial potential of the martyr.

THE STAGE OF SIR THOMAS MORE

Perhaps no play attributed to Munday calls up the problem of authorial sincerity as powerfully as does *Sir Thomas More*. The editors of the Revels

text suggest that Munday may have come across a manuscript source for his information about More's life as the result of his work with the notorious Catholic-hunter Richard Topcliffe.[7] The extant manuscript of a play that celebrates More and seems primarily to be written in Munday's hand thus establishes theatrical writing as precisely the exercise in duplicity for financial gain that the *Third blast of retreat from plaies* says it is. The purpose of the present study, however, is not to approach authorship from the perspective of textual scholarship; indeed, it would be far beyond the scope of this study to enter into a debate that has been engaged so exhaustively elsewhere.[8] We might instead approach this play in a different way: as a text that, flying in the face of its own famously collaborative composition, thematizes authorship in terms that emphasize individual conscience, the martyr's paradoxical autonomy. Centrally *Sir Thomas More* offers a set of meditations about the poet's place, about whether the poet stands apart from the world of political, social, and economic concerns or whether he is ineluctably engaged with them.

The play thematizes authorship in part by calling repeated attention to the Earl of Surrey's remoteness from the concerns of the world. As commentators have remarked, the Surrey represented in the play seems to be a composite figure for the historical earl, a contemporary of the historical Sir Thomas More, and for the earl's son, the poet Surrey.[9] The younger Surrey was executed in 1547 by Henry VIII for reasons that appear spurious. The strongest motivation for executing the poet, in fact, must have been his lineage; as he boasted in many of his poems, Surrey's birth placed him dangerously close to the throne. Jonathan Crewe has identified what he calls a "suicidal poetics" in Surrey's work, a prevailing mode of self-representation in which Surrey boasts of his poetic prowess while seeming to court disaster. By superimposing the son upon the father, *Sir Thomas More* establishes poetry and poets as especially imperiled, especially vexed in their interactions with a vaguely defined world of affairs.

Surrey's sense of removal from worldliness, almost Romantic in its effects, provides More himself with several opportunities to establish his own vexed relationship to the political realm. Early in the play, Surrey remarks upon his cultural uselessness:

> MORE My noble poet –
> SURREY O my lord, you tax me
> In that word poet of much idleness.
> It is a study that makes poor our fate:
> Poets were ever thought unfit for state.[10]

Though obviously not a starving artist, Surrey nevertheless articulates his disconnection from the political world, which he represents as a realm of profitable action. As wistful as his declaration sounds, it is crucial that we understand his comments to be creating a form of poetic autonomy. In Munday's *John a Kent and John a Cumber*, magicians deploy uselessness as a boast about their magic freedom from the concerns of their patrons; what Surrey expresses with regret and depicts as a weakness, Kent uses as the material for a powerful authorial persona. However apologetically, that is, Surrey implicitly carves out a realm of "idleness" here that belongs only to himself and his poetic peers.

More's initial response identifies him with a very different ethic of poetic production, one that establishes the nobility of the poet in relation to the monarch rather than in his exclusion from a sovereign authority:

> MORE O give not up fair poesy, sweet lord,
> To such contempt. That I may speak my heart,
> It is the sweetest heraldry of art
> That sets a difference 'tween the tough sharp holly
> And tender bay tree.
> SURREY Yet my lord,
> It is become the very lag number
> To all mechanic sciences.
> MORE Why, I'll show the reason.
> This is no age for poets: they should sing
> To the loud cannon *heroica facta*:
> *Qui faciunt reges heroica carmina laudant*;
> And as great subjects of their pen decay,
> Even so unphysicked they do melt away.
>
> (3.1.196–207)

For More, statecraft and poetry are intimately connected. The poet derives his inspiration and subject matter from the heroic deeds of the great, making his poetry virtually a branch of the art of governing. In More's utopian vision, there is an idealized point of connection between the virtue of the monarch and the talent of the poet, at which poetry becomes productive like the mechanic sciences. It becomes a way of working in the political world.

But this is, of course, Sir Thomas More talking; the vision of service he puts forward is intrinsically doomed, guaranteed by history to fail. In fact, as his downfall draws near, More actually reverses his rebuttal of Surrey's poetic uselessness. Arriving at his home after losing his position as Lord Chancellor, More begins what looks to be an epic simile:

> As seamen, having passed a troubled storm,
> Dance on the pleasant shore, so I – O, I could speak
> Now like a poet. Now afore God I am passing light.
> (4.2.51–3)

Oddly, having lost what the world considers to be greatness, More is free to sing his own *heroica facta*. The utopian moment of virtue that empowers poetic speech, is, in other words, like Surrey's idleness, a function of withdrawal from affairs of state. Similarly, in the moment that More is explaining his relative poverty to the lieutenant – on the night before his execution – he is again inclined to identify himself as a Surrey-style poet:

> To think but what acheat the crown shall have
> By my attainder!
> I prithee, if thou beest a gentleman,
> Get but a copy of my inventory.
> That part of poet that was given me
> Made me a very unthrift.
> For this is the disease attends us all:
> Poets were never thrifty, never shall. (5.3.57–64)

More's pun on "escheat" – the crown's confiscation of his goods – and "a cheat" makes it clear that he has nothing to offer to his sovereign.[11] The part he identifies as a poet's renders him impractical, subject to what is almost a contagion of poetic unthrift. More as poet locates himself very far from the description of writing for reward that the author of the *Third blast of retreat from plaies* has given us; he seems, in fact, to be a particularly depressing version of that text's poetic ideal.

But the moments just prior to More's execution establish him as something less neatly defined than the model of doomed poetic agency that Surrey and he embrace. On the scaffold, More merges his poetic powers with those of the improvising player, combining them to suggest a transcendent form of conscience that shapes and reshapes the physical and political vulnerabilities of the martyr:

I confess his majesty hath been ever good to me, and my offence to his highness makes me of a state pleader a stage player (though I am old, and have a bad voice) to act this last scene of my tragedy. I'll send him for my trespass a reverent head, somewhat bald, for it is not requisite any head should stand covered to so high majesty. If that content him not, because I think my body will then do me small pleasure, let him but bury it, and take it. (5.4.71–9)

Though he complains of his utter loss of power in this speech, More is in fact making a bid to control the conditions of his own representation. By naming himself a player, he transforms the scene of his execution, turning the scaffold into a theatrical stage and the crowd of onlookers into a paying audience. By imagining his body as a prop, he asserts control over it, as though he could use it to convey his own meanings to the king even after his death. He thus sidesteps the objectification implicit in the sovereign's use of him as a public sign of royal power, converting that objectification into a form of self-advertising. In addition, by reimagining the scene of his execution as a play, More converts not only the fictive audience at the beheading but also the real audience paying to see the play. They must now imagine themselves as spectators at More's death who imagine themselves to be playgoers; More has hopelessly muddled their ontological status, making it like his own, a function of dramatic imagining in conjunction with physical presence. Like the improvising player, that is, More invokes a scene-setting prerogative that borders on the authorial. The wistful autonomy of the doomed poet combines here with the playwright's and the actor's power over theatrical space. The poet-martyr has emphasized his removal from the world, but here that sense of autonomy is a formidable theatrical talent that transforms both the political realm and the theater itself.

This moment is not the first, however, in which we see More claiming the power to reimagine his surroundings and recreate his audience. While ascending the scaffold, he has delivered a speech equally remarkable for its reconfigurations of both stage and onlookers:

Ye see, though it pleaseth the king to raise me thus high, yet I am not [proud,] for the higher I mount, the better I can see my friends about me. I am now [on a] far voyage, and this strange wooden horse must bear me thither; yet I perceive by your looks you like my bargain so ill, that there's not one of ye all dare venture with me. (Walking) Truly, here's a most sweet gallery, I like the air of it better than my garden at Chelsea. By your patience, good people that have pressed thus into my bedchamber, if you'll not trouble me, I'll take a sound sleep here. (5.4.57–67)

As the stage becomes a metaphor for the king's approval, then a wooden horse, then a gallery, garden, and bedchamber, the audience must imagine itself as a crowd of More's friends, as his potential fellow voyagers, and as visitors to his home. He seizes control of theatrical space in a way reminiscent of Gower in *Pericles*, announcing changes of location that seem dictated almost by authorial whim. Moreover, he seems in his profound autonomy almost prepared to deny his audiences the spectacle they

came to watch; he suggests that he will sleep on stage, a metaphor that replaces the much-awaited scene of his death with a decidedly untheatrical nap.[12]

If the power implicit in such metaphorical reconfigurations is not immediately obvious, it becomes so by the time More finishes the scene. In his stoic efforts to reconfigure the theater of his own death, More repeatedly forges a connection between the ability to reimagine his setting and the ability to defy his audience:

> Stay, is't not
> possible to make a scape from all this strong guard? It is.
> There is a thing within me, that will raise
> And elevate my better part 'bove sight
> Of these same weaker eyes. And, master shrieves,
> For all this troop of steel that tends my death,
> I shall break from you, and fly up to heaven.
> Let's seek the means for this. (5.4.101–8)

If "strong guard" must refer to the king's officers who take More to his death, More's promise that something within him will raise his better part above "sight / Of these same weaker eyes" seems relatively ambiguous. The sight may be his own, and could certainly be the sight of those who guard him, but it seems unavoidable that there should also be a connection between these weak eyes and the eyes of his audience, who will not in fact see him as he walks forward off stage to his death. Like his proposed sleep, that is, the "thing within him" will prove more powerful than his audience's expectations. More's spiritual authority will overpower the physical sight that is his audience's great pleasure and great prerogative, baffling them as they seek a vision of his final defeat.

Poet, player, and martyr thus combine triumphantly at the moment of More's death. The force of conscience blurs with skill at self-staging and both blur with a quasi-authorial ability to dictate the scene; in abjuring state authority – indeed, while being sacrificed to it – More has adopted an extraordinary mixture of theatrical powers. The martyr's testimony to his own truth, a truth which would in fact seem alien to his Protestant audiences, allows him to claim the stage as his own, as martyrs and other victims of execution seem so often to have done during this period. As Katharine Eisaman Maus and Elizabeth Hanson have both argued, corporal punishment was in part a means through which early modern England negotiated questions of interiority;[13] here More seems to answer those questions in favor of his own transcendence of political and religious controversy. He

has answered those questions, in fact, in a way that simultaneously hints at the transcendent powers of theatrical practice.

But however resoundingly this concluding scene establishes theater as a vehicle for transcendent autonomy, elsewhere in the play there have been strong indications that theatrical practice is inimical to transcendence, that playing means being implicated in a range of social and even material imperatives. In yet another scene that unites an interest in playing and theatrical authorship with the specter of More's eventual martyrdom, More as Lord Chancellor hosts the Lord Mayor of London and his wife, entertaining them with an interlude performed by traveling players. More approaches the performance voicing a specific question: "We'll see how master poet plays his part" (3.2.69). That the dramatic poet should be judged before this specific audience, of course, is historically significant. In Munday's era, city officials were involved in ongoing and complex negotiations with the Privy Council over the legitimacy of theater.[14] Producing a moral interlude in the home of the Lord Chancellor when his dinner guests are the Lord Mayor and his wife, then, is for the play's contemporary audience more than just a test of master poet's artistic abilities. It is a test of his ability to provide words that will cement an affinity between the court and the city, resolving not only the political and economic differences that mark their interactions but the differences in moral tone and public style that divide an increasingly Puritan citizenry from an aristocracy convinced of its right to power.

Put another way, that is, *The Marriage of Wit and Wisdom* is about the utility of theatrical work. It promises a performance that will combine the work of the playwright with the demands of his patrons, who are themselves divided about the uses of the stage. The interlude, perhaps like the story of More's own heroic resistance, offers a moral vision of playing to a city corporation that associates it with license and with aristocratic failure to serve the public interest. When More wonders aloud how the poet will fulfill his duties in this interlude, then, he underlines a structural concern of the play, which seems to wonder about the place of theatrical work in the network of alliances and antipathies that marks its audiences. The subtler point here, however, is that the players aim to please. They serve the Cardinal, as More notes, and at this moment they serve More in his efforts to consolidate his relationship with the Lord Mayor. If the execution scene seems to boast of playing as a transcendent ability to reconfigure both the material realm and the powers of the audience, this interlude undercuts that boast by depicting theater as deeply responsive to audiences. In fact More chooses the play they are to present, steps in to play a role, and postpones

the interlude's conclusion – permanently, as it turns out – because dinner and affairs of state get in the way.

If the interlude depicts players as radically dependent upon their audiences, it also configures playing in other ways that contradict the bold assertion of More's power in the moments before his death. As the play's editors note, the interlude is a pastiche of quotations from extant works, many of which are named within the play just prior to the performance. One in that list is particularly surprising. *Lusty Juventus*, written sometime before 1553, is, oddly enough, an anti-Catholic interlude in which a young man is warned away from Abhominable Living by Good Counsel.[15] While on one level Abhominable Living is simply a woman of loose morals, on another she is specifically connected with the Catholic Church. Of course More declines to have the players perform this text in his home, requesting instead that they perform *The Marriage of Wit and Wisdom*. But *Lusty Juventus* shows up anyway, since many of Wit's speeches are lifted more or less verbatim from those of Juventus himself. In a moment of deep irony, More steps in to improvise the part of Good Counsel, and in so doing he performs, through the magic of intertextuality, his own condemnation. In warning Wit against Lady Vanity, *Wit and Wisdom's* version of Abhominable Living, that is, More also plays in *Lusty Juventus*, in which he warns youth away from the seductions related to Catholicism.

If the execution scene combines the poet, the player, and the martyr as triumphantly autonomous speakers, this interlude calls both the autonomy and the triumph into question. Either More is speaking against himself here or the author of *Lusty Juventus* is. Or more insidiously, the authors of this section of *Sir Thomas More* have set their eponymous hero up to play a joke upon himself.[16] Why does More have an anti-Catholic interlude committed to memory? Should we believe that he "naturally" improvises a set of lines that happen to condemn him, that the anti-Catholic truth emanates somehow from More's own consciousness? Perhaps the authors of *Sir Thomas More* have managed to wink at the learned members, at least, of their audiences, conveying to them a good Protestant sentiment while ostensibly celebrating a Catholic hero. But were such a rarefied joke possible, it would surely reflect as well upon the Protestant authors themselves. As consoling as it might be to imagine More speaking against Rome, the spectacle of his self-division must be overshadowed by the spectacle of the play's authors speaking everywhere else in the play, however discretely, against Henry VIII.[17]

In the interlude, in other words, the forms of agency attributable to theater are riven by the sense that theatrical performance and theatrical

writing alike are forms of self-division. Even the manipulation of theatrical props, something More claims he can do after death, when he will send his head to the King, becomes in the interlude an exercise in radically dispersed agency. From their first introduction the players bring with them a sense of endless logistical negotiation; More begins his discussion with them by inquiring about their casting arrangements, noting the difficulty of production in a small company (3.2.72–7). The sense that performance depends upon a series of material exigencies is intensified when the character who plays "Inclination the Vice" enters to make his apologies. Wit requires a beard, and one of the players, named Luggins, is sent to fetch it. He must go to Ogle's shop. As Gabrieli and Melchiori explain, Ogle was a well-known purveyor of wigs and theatrical properties; his introduction here connects the interlude solidly to the mechanics of real-life staging.[18] The delay allows More to step in and improvise, taking over Luggins's part of Good Counsel until the beard can be fetched. But in an otherwise pointless complication of the plot, Luggins returns without the beard, explaining that Ogle was out of the shop, and his wife unwilling to part with it in her husband's absence. More approaches the interlude with the specific intention of testing its author: "We'll see how master poet plays his part" (3.2.69). But what starts out to be a test of the poet ends up depending upon the good will of the beard-maker's wife; the exigencies of theatrical production are almost literally allowed to run away with the plot. More, apparently tiring even of his own participation in the interlude, interrupts the performance with the rather vague assertion that "by this time I am sure our banquet's ready" (3.2.283). Affairs of state prevent the party from returning to the performance after eating. Somehow the interlude is no longer of interest once the logistics are settled. The poet-player-martyr who will with such confidence reshape the scaffold and the theater itself in the play's concluding moments is shown here to be entrenched in a web of material and social constraints that render his performance profoundly self-contradictory.

The conflicting views of martyrdom, playing, and authorship in *Sir Thomas More* suggest an unfinished experiment in the cultural history of forms. On the one hand each term relies upon the others for legitimation; More is a more appealing martyr because of his repeated theatrical acts, while master poet can be tested only through the work of the players and the whole interlude gains cultural authority through the patronage and direct participation of a famous martyr. On the other hand, of course, while the poet, the martyr and the player each wield a form of power, those powers are undercut by the obvious constraints under which each is shown

to operate. More's most triumphant playing takes place on the scaffold, while Surrey's articulation of poetic autonomy depends upon his present uselessness and his future demise.

This experiment in the mutually implicated forms of interiority that might be attributed to writing, playing, and testifying to one's conscience is connected to issues of profound significance in early modern England. Beyond the pages of the *Book of Sir Thomas More*, martyrs figured not only in the obvious political and spiritual controversies of the day, but in a second, quieter debate about representation. The press and the stage both reflect and shape the struggle to secure the hegemony of English forms of belief and government, but they are themselves institutions struggling to consolidate their powers in this culture. Doubtless the gravity of the spiritual and political issues at stake here would dictate a primary emphasis upon martyrs themselves, but it is possible to make a more surprising claim: that we can read representations of martyrs as a way of uncovering the place of the actor and the author. *Sir Thomas More* is perhaps the most famous theatrical example of the martyr's status as a legitimating figure, an embodiment not only of compelling religious questions but of compelling professional ones. But many of the other works in which Munday had a hand are also troubled by questions about the ethics of professional representation, and those questions are articulated in the handling of martyrs. Because of the relentlessness with which Munday pursued martyrs, both as the subject of his writings, theatrical and non-theatrical, and as the literal focus of his work as a pursuivant for the Catholic-hunter Richard Topcliffe, he becomes a kind of touchstone for the mutually legitimating powers of the scaffold, the stage, and the printing press in this period. Or to state the matter in a less flattering way: because he approached the topic of martyrdom with such obviously commercial intentions, Munday became a lightning rod for the anxieties about duplicity that accompanied martyrdom, professional writing, and professional playing alike. Because his own conscience was so manifestly governed by opportunism, Munday forced a small crisis of legitimacy for authorship even as he helped to ensconce the professional author as a figure of importance in early modern England.

WHEN IN ROME

As argued throughout this book, actors were profoundly engaged with the mechanics of early modern celebrity and notoriety, and their work as writers demonstrates that engagement, positioning print authorship as a performance before an audience. Robert Armin capitalized directly upon his

fame as a clown, publishing texts under the name of "Clunnyco del Mondo Snuff" or Snuff the Clown at the Globe Theater. Nathan Field played off of his fame as an actor by telling his readers that if they had anything to say to him, they would "know where to reach him," presumably on stage. Anthony Munday's reputation as a player, however, is considerably more ambiguous, and its ambiguity is of a piece with his authorial endeavors. Best known now as a writer of pamphlets, romances, plays, antitheatrical tracts, city pageants, pastoral poems (under the beguiling name of "Shepherd Tony"), and meandering histories, Munday was remarkable in his own lifetime not only because he seems to have been a dismal stage actor but because his various appearances in print struck many readers as sham performances, as acting in the worst sense of the word.

As mentioned above, the only actual reference we have to Munday as a player was written by one of his detractors, whose invective, while it raises questions about historical accuracy, nevertheless crystallizes the problems of reputation that follow Munday throughout his career. Munday had written *A Breefe discourse of the taking of Edmund Campion and divers other papists* in 1581, which had inspired a bitter response.[19] In *A True reporte of the death... of M. Campion Jesuite*, written in 1582, the Catholic writer Thomas Alfield complains that the *Discovery of Edmund Campion*, also written that year, is

nowe deliuered out by munday, who first was a stage player (no doubt a calling of some creditt) [marginal notation: Northbrookes booke against plaiers] after an aprentise which tyme he wel feined with deceauing of his master then wandring towardes Italy, by his owne report became a coosener in his iourney. Comming to Rome, in his short abode there, was charitably relieued, but neuer admitted in the seminary as he pleseth to lye in the title of his booke, and being wery of well doing, returned home to his first vomite againe. I omite to declare howe this scholler new come out of Italy did play extempore, those gentlemen and others whiche were present, can best giue witnes of his dexterity, who being wery of his folly, hissed him from his stage. Then being thereby discouraged, he set forth a balet against playes, but yet (O constant youth) he now beginnes againe to ruffle vpon the stage.[20]

Munday's work as an actor – even his inconstant commitment to that profession – establishes him as what J. Cocke calls all actors: "shifting companions," duplicitous figures who move from one role to the next, discarding identities and trades for implicitly sinister reasons.[21] And Munday's response to these accusations is particularly telling.[22] In *A breefe Aunswer Made unto two seditious Pamphlets* (1582), he takes the unusual step of publishing a letter from his former master, testifying that Munday had in fact fulfilled his term of apprenticeship (D3v). Munday never addresses the

attacks upon him as a player, never denies that he was (apparently a very bad) actor, never claims that acting is a noble profession. He seems to have been resigned to the fact that he would appear both on stage and in print as a humiliated performer, and that his work on stage would powerfully undercut his claims to reliability as a writer. If authorship is a performance, Munday clearly had to contend with hostile audiences.[23]

But *A True Report*'s attack and Munday's response establish more than just Munday's reputation as a debased player. They also highlight the urgency of authorship in a culture that is witnessing both an expanding print market and a religious crisis. For while pamphlets and books are essential tools in the war of propaganda that shapes and reshapes the deaths of Catholic martyrs in this period, they invite twin forms of skepticism, as both the martyr and the writer of the pamphlet about the martyr are held up for scrutiny and read for signs of duplicity. Indeed, Alfield had openly wondered whether Munday or "some macheuillian in mundayes name" had written the *Discovery of M. Campion* (D4v). The interchange that culminates in the testimony of Munday's master is, in other words, an exercise in attribution and even spurious attribution, a contest not only over the spiritual authority of the martyrs themselves but over the narrative authority of those who describe their lives and deaths. Munday's *A breefe and true reporte, of the Execution of certaine Traytours at Tiborne* (1582) makes this problem particularly clear, with its epistle devoted to Munday's own reputation, its repeated narrations of the accusations made by the executed Catholics against Munday himself, and its concluding promise that readers can hear more in the forthcoming *English Roman Lyfe*.[24] Like the martyr, the author is called upon to testify in public about the gravest spiritual truths, but that testimony will immediately put in motion a chain of interpretations that will render its truth value hopelessly elastic. What acting, authorship, and martyrdom have in common in the wake of the Campion execution is the prevailing sense of fraud, of reversible identity, of sham performance.

It makes sense, then, that while Munday's *English Roman Lyfe*, written in 1582, is itself about the interpretation of martyrs, it is also on some level about Munday as an author. Designed as an exposé of recusant Catholicism abroad, the text depends upon the power of first-person testimony; the title page advertises its author as "A. M., sometime the Popes Scholler in the Seminarie among them." *The Lyfe* nevertheless calls its own narrative authority powerfully into question. In it, Munday explains how he came to live among the recusant Catholics in Rheims, finally moving to the Jesuit seminary in Rome, where he remained for an unspecified length of time before returning to England. It is difficult to take his explanation at face

value: he went to France because his patron the Earl of Oxford felt Munday needed to improve his French. He was robbed, turned to the nearest English speakers for help, and found himself caught up in a community of Catholics who aided him with the more or less explicit stipulation that he convert and enter the seminary. It seems especially suspicious that he should have thought from the beginning to use an assumed name among them, and that the name he chose should lead the recusants to believe that he was the son of a known English Catholic.[25] Whatever the actual reason for his travel, in other words, it is difficult to read *English Roman Lyfe* without imagining that Munday went to France with the intention of spying on seminarians, especially given that he turned against the very Catholics who had helped him and eventually went to work as a pursuivant for Richard Topcliffe. Munday also leaves himself open to what would in fact have been a more damning charge, however: that he honestly flirted with Catholicism, only recanting later and turning against the Jesuits who had aided him.[26]

In other words, Munday's participation in seminary life and his subsequent decision to tell all make for a peculiarly difficult authorial self-presentation. While keeping the focus on the evil Jesuits, Munday must nevertheless answer a set of questions about his own conduct. Nowhere do these questions become more acute than in Munday's discussions of martyrdom. Following, as *English Roman Lyfe* does, on the heels of Munday's vicious campaign of pamphlet writing against Campion, the book is designed to capitalize upon Munday's reputation as a Catholic-baiter. Accordingly, the book goes to great lengths to demystify martyrdom itself, dwelling for most of a chapter on the superstitious practices of martyr-worship. In paragraph after paragraph, Munday describes Catholic reliquaries in Rome, punctuating each description of a martyr's bones or a saint's garment with a wry comment: "This is a holy and very precious relic" (1518–19). Munday's straightforward rejection of the practices of Catholic martyrdom will, however, become increasingly difficult to maintain as the narrative progresses.

In a particularly telling passage, Munday dwells upon the practices of self-flagellation in the Jesuit seminaries, emphasizing the perverted pleasure the seminarians take in debasing and injuring themselves while venerating icons:

One of the Jesuits, because they could never get me to whip myself... took me once with him into his chamber, saying I should see (because I was so fearful) what he would inflict upon his own body...

In these and suchlike acclamations, he continued whipping himself almost the space of half an hour, bleeding so sore as it grieved me very much to see him. Afterward, he willed me to try it once, and I should not find any pain in it but

rather a pleasure...I desired him to bear with me a while, for I was not endued with that strength and fortitude as to abide and suffer the pains he did, but yet in time I doubted not to fulfil anything on my body he would command me. My answer pleased him indifferently, so I left him in his chamber and went down, lamenting to see a spectacle of so great folly. (1006–63)

The evasion Munday practices here is absolutely characteristic of the work as a whole. While lying to the Jesuit, that is, Munday must simultaneously convince his readers that he would not lie to us. But his feigned intimacy with his host leaves him implicated in too many ways to be redeemed by anti-Catholic sentiment. Difficult as it is to read intentions in this description, at least two inferences are possible. Either the Jesuit is deeply sincere in his practices and Munday is the epitome of the glozing temporizer, or the Jesuit is engaging in a sadistic spiritual seduction and Munday understands every move he makes. It is just possible, after all, that at the time he witnessed Jesuit life in Rome he was already picturing the executions that might result from the evidence he could provide back home. Whatever his original motivations, in writing this scene – be it real or fictional – after the death of Campion and his peers, Munday would look forward not to the fulfillment of the Jesuit's commands on Munday's body, but to the fulfillment of the Privy Council's demands on the bodies of the English Catholics. His readers would be well aware of that fulfillment. In this sense it is difficult for Munday to extricate himself from the scene of Jesuit masochism with polite stalling tactics.

But Munday is implicated in the martyrdom he witnesses in an even more damning way, and one that gets us to the heart of his problems as an author of this text. Having provided example after example of Catholics who died for their faith or who longed to do so, Munday is left having to explain why it was so easy for him to sidestep the opportunity himself:

And because my adversaries object against me, that I went to mass, and helped the priest myself to say mass, so that (say they) who is worst, I am as evil as he. I answer, I did so indeed, for he that is in Rome, especially in the College among the scholars, must live as he may, not as he will; favour comes by conformity, and death by obstinacy. (1834–42)

It works, perhaps, for a spy to hide his moral convictions, but since Munday either is not a spy or is not admitting that he is one, such explanations become deeply problematic. Munday's very survival of the seminary experience stands as testimony that he is unfit to condemn it. As if in acknowledgment that his reputation will not be redeemed by commonplaces like

"favour comes by conformity," Munday lashes out a paragraph later at some of his imagined readers:

These rash heads being in England would do many goodly matters at Rome, they would tell the Pope of his lascivious and unchristian life, the cardinals of their sodomitical sins, the friars of their secret juggling with the nuns, and the priests of their painted Purgatory, their wafer God, and their counterfeit blood in the chalice; all this they would do, now they are in England. But I doubt if they were at Rome, and beheld the merciless tyranny executed on the members of Christ, God having not endued them with the spirit of perseverance, so suffer and abide the like (for what can this frail carcase endure, if God do not say, 'I will that thou shalt suffer this'?), I fear me, they would be as ready to do anything for the safeguard of their lives as I was. (1843–59)

Tucked away behind the praise of God's sustaining power is the assertion that God simply failed to choose Munday to be a martyr.

Having shifted the onus of his wrongdoing onto unspecified rash heads and an inscrutable God, Munday can safely change the subject. He goes on, fascinatingly, to condemn Campion, Shert, Kirby, and Cottam for daring to usurp the title of "martyr": "Yet they would die in a bravery, to be accounted martyrs at Rome, and in the midst of their bravery, all the world might note their false and faint hearts" (1863–7). Like the braggarts who claim they would disobey the Pope in Rome, the English Catholics are engaging in vain performance, laying false claim to the status of martyr. Munday alleges that he saw signs of fear among them at the hour of their executions:

Sherwood, he ran down the ladder when death should arrest him...Campion, their glorious captain, he looked dead in the face so soon as he saw the place of execution, and remained quaking and trembling unto the death...These are the martyrs of the Romish Church, not one of them patient, penitent, nor endued with courage to the extremity of death, but dismaying, trembling and fearful, as the eyewitnesses can bear me record. (1868–85)

The difficulty of reading Munday in *English Roman Lyfe* gets shifted here onto the necessity of reading the Catholic martyrs with care. Munday critiques the performances of the English priests in order to deflect attention away from his own ambiguous performance as an author. Tellingly, however, Munday uses the same language to condemn these false martyrs ("nor endued with courage to the extremity of death") that he had used to describe the spiritual condition of the "rash heads": "I doubt if they were at Rome, and beheld the merciless tyranny executed on the members of Christ, God having not endued them with the spirit of perseverance, so suffer and abide

the like . . . I fear me, they would be as ready to do anything for the safeguard of their lives as I was" (1851–9). Munday momentarily allies himself both with the rash heads and with the false martyrs in these passages, since he is implicitly among the number of believers not endued with the qualities required for a proper martyr.

Munday has even more trouble positioning himself in relation to real and false martyrs later on. It is necessary, in this text and in Protestant England generally, to affirm the existence of real, chosen, godly martyrs, and Munday provides a pair of examples:

> We may therefore well know that a good cause doth animate the martyr, which belonging to God, let Rome, Hell, and all the devils set themselves against us, they can touch us no farther than God will suffer them. As St. Laurence being broiled on the gridiron, to witness the invincible courage wherewith God endued him, he said, 'Thou tyrant, this side is now roasted enough, turn the other.' And St. Isidore likewise said to the tyrant, 'I know thou hast no further power over me, than my God will suffer thee from above.' (1885–96)

This recuperation of martyrdom is important for several reasons. Though the emphasis upon serene transcendence is familiar from most martyrologies, Munday's choice of St. Lawrence as a first example hints at the troubling level of performance required to signify that serenity; the joking victim comes very close to dying "in a bravery," as Munday says false martyrs do. He dies, in other words, looking something like a comic actor. To add to the confusion about who is and isn't properly called to martyrdom, this praise of St. Lawrence occurs just twelve pages after Munday's exposé of the shrine at the church of St. Lawrence. Earlier in the chapter, that is, St. Lawrence was a sign of papistical superstition.

But the most interesting problem with Munday's defense of martyrdom – at least for the purposes of the present argument – is subtler. Having just opined that he himself was not chosen by God to suffer religious execution, Munday slips into a rhetorical stance in this passage that marks him as a rash head. "Let Rome, Hell, and all the devils set themselves against *us*," he volunteers, "they can touch *us* no farther than God will suffer them" [emphasis mine]. In this quiet pronoun shift Munday practically ventriloquizes St. Isidore: "I know thou has no further power over me, than my God will suffer thee from above." Though the Christian solidarity may seem justified to an early modern Protestant, it nevertheless threatens to undo all the careful distinctions Munday has been trying to set up between those who are called and those who are not, those who bluster and perform and those who boast legitimately in their faith. Standing among the

chosen martyrs is a rhetorical luxury that Munday both desires and cannot afford.

As it turns out, however, Munday's sleight of hand here is related to a larger strategy in *English Roman Lyfe*. The title page promises more than just a record of his own experiences in the seminary: "*The English Romayne Lyfe*. Discovering: The liues of the Englishmen at *Roome*: the orders of the English Semi*minarie* [sic] ... *There vnto is added, the cruell tiranny*, vsed on an English man at Roome, his Christian suffering and notable Martirdome ... Written by A. M. sometime the Popes Scholler." The notable martyr discussed in the book's last chapter is Richard Atkins, an Englishman who was executed for desecrating the sacrament and speaking against the church in Rome. He himself is a complicated figure; the Italians thought this stranger to be mad, but Munday reworks the potential signs of imbalance to present him as a manly, plain-speaking representative of his nation and faith. Moreover, ending the book with the story of a proper English martyr seems to be a way of capturing the rhetorical force that Munday's equivocation about his own survival loses him elsewhere. Though Atkins is not Munday, Atkins is clearly the idealized image behind which Munday hides. As long as a chosen Protestant dies for his beliefs, the author of this account need not do so. Even on the level of the material book, Atkins seems to envelope Munday's story of compromise and betrayal; the original edition contains a large woodcut of Atkins's bravery and subsequent death (see fig. 1). Stitched in as an oversized foldout page just after signature A4, the tableau of Atkins's martyrdom unfolds to cover the rest of the text. In it Atkins strides manfully through Rome, knocking the sacrament out of a priest's hands and facing execution bare-chested and confident. His virility is striking. It covers a multitude of Munday's failures.

Anthony Munday appears in *The English Roman Lyfe*, that is, dressed as Richard Atkins, borrowing the authority of a real martyr to bolster his performance in print. His having done so underlines the connections between acting, authorship, and martyrdom in the wake of the Campion execution. Both Protestants and Catholics take it as a given that there is an ideal form of testimony, martyrdom, in which an ineffable fidelity to God's truth is made manifest.[27] At the same time, both sides in this dispute are adept at reinterpreting the signs of that martyrdom, making it resignify as a debased performance, an expression of heresy.[28] The books and pamphlets intended to solidify the martyr's reputation take their places alongside the writings of detractors, potentially reducing the martyr to a set of signs that can be read in mutually conflicting ways. The truth of the martyr thus comes to depend upon the truth of the author, the reliability of the one who

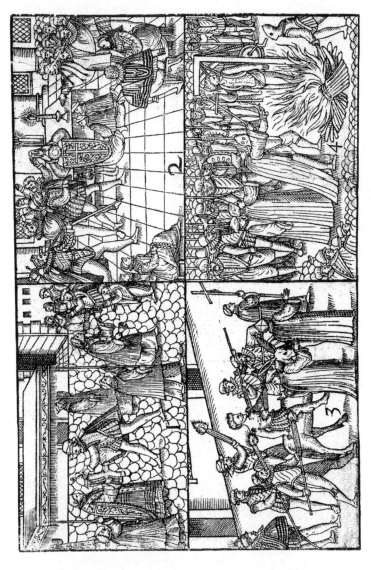

1 The Martyrdom of Richard Atkins: Anthony Munday, *English Roman Lyfe* (London, 1581) unnumbered fold-out page.

gives his interpretation in print. But, as Munday's reputation makes clear, the author also becomes a duplicitous figure when the pamphlets circulate. In Munday's case, the very possession of knowledge about Catholicism suggests the author's unreliability. The author's reputation is at stake along with the martyr's, and Munday's solution is telling; effectively dressing himself up in print as Richard Atkins, he attempts to stand among God's elect as the author of an anti-Catholic text. But, dressed in the costume of an actual martyr, he ends up looking like what *A True Report* called him, what in fact he was: a bad actor whose sham performances register the epistemological uncertainties of martyrdom and authorship alike.

Given the theatricality of martyrdom itself and the level of performance Munday made visible in the process of writing about martyrs, it should come as no surprise that the subject should accompany him to the play-house. Even a quick survey of Munday's surviving plays marks him as a purveyor of martyrs to the early modern stage. In addition to his apparent work on *Sir Thomas More*, he collaborated on the *Sir John Oldcastle* plays. *The Downfall* and *The Death of Robert Earl of Huntingdon* detail the process through which Robin Hood and Maid Marion, along with other innocent parties, succumb to treachery and torture. Even *John a Kent and John a Cumber* has some affinity with the controversies surrounding the execution of martyrs, depicting as it does a struggle between two magicians to manipulate spiritual presences in a way that will gain them professional stature. Moreover, again and again the plays that Munday wrote all or part of return to figures analogous to the author, represented in the person of Skelton in the Huntington plays, Surrey in *Sir Thomas More*, More himself, and the competing magicians in *John a Kent*. Munday's theatrical career is structured around the questions that structure *Sir Thomas More* and *English Roman Lyfe*: whether authorship is an autonomous force, whether writing for reward is commensurate with the truth claims that make the martyr such a compelling figure. In spite of the fact that, like *Sir Thomas More*, many of the works to which Munday's name is attached were written collaboratively and appeared anonymously, it is nevertheless possible to trace in them the same set of questions we have traced in Munday's non-dramatic prose. We should take this as a sign of the centrality of the issues Munday confronts as a writer about martyrs. The accusation that Munday was a player has a kind of validity beyond whatever its factual truth might be; his performances in print beg questions that are central to theatrical practice in this period. The author on stage and the author in print are mutually informing constructions, and in the figure of the martyr both forms of authorship are measured against the standards of the autonomous conscience. Ultimately, like the

authorial representations he helps to produce for the stage, Munday works as an author figure not because he can match the martyr's pure conscience but because he consistently reveals that ideal to be a commodity that sells. Munday thus crystalizes problems of professional authorship that haunt both the stage and the printing press. He functions as an author, that is, not because he represents the kind of limiting subjectivity that Foucault invokes as a form of textual closure, but because he reveals text and author alike as forms that are firmly embedded in the commercial and the social.

MARKETING THE MARTYR

The problems that cling to Munday throughout *English Roman Lyfe* are epitomized in the text's dedication to the Privy Council. On the one hand, he claims, he is guided by nothing but "certeintie and knowledge"; on the other hand, he indicates that his perfect honesty is strategic:

> so when I had fully finished [the text], and done the uttermost of my endeavour therin, I considered with myself, I was to present the same to such personages of honour, wisdom, and gravity, as, did malice rule me, they could quickly espy it, or affecting my self to any, they would soon discern it; then would honour reprove me for the one, and their noble nature reprehend me in the other.
>
> To discharge my selfe of both these and purchase the favour wherewith your Honours are continually adorned, I directed my compass by truth, persuading myself, that albeit in some, *veritas odium parit*, yet in your Honours, *magna est veritas et prevalet*. (1–2)

While literally stating only that he found the courage to dedicate *English Roman Lyfe* to the Privy Council after reflecting upon their integrity, Munday's statement implicitly calls his own honor into question along with theirs. Having finished the book, he suggests, he had a moment of hesitation about revealing his experiences. He resolved that hesitation by considering that any malice or bias he might convey in the text would not appeal to his readers. Thus, determined to "purchase the favour" that "adorns" the Privy Council – and we should note the implication that honor is a saleable commodity, like a garment – Munday stood by his truth. Although some people might prefer him to lie, he suggests helpfully, the Councilors would be offended.

Were this dedication attached to a text that described less outright temporizing it might pass unremarked, but coming as it does at the beginning of a narrative devoted to the notion that favor comes by conformity, it sounds remarkably incriminating. Even were we to overlook the fact that the Privy Council's honor is at least mildly compromised by the content of the book

itself as a tribute, since it is exercise in duplicity, there would remain the dedication's problematic paraphrase: "I might lie to some people, but never to you." The letter thus encapsulates a set of problems that follow Munday throughout his career. Munday reveals his truths, time and again, to be contingent upon his economic and social constraints. Just as we see him assuring the Jesuit flagellist that he will be glad to try penance some other day, or telling us that he did not think it expedient to die for his faith, we see in his work that personal integrity is situational, a performance calculated to appeal to a particular audience. Though Munday may not be the author of the *Third blast of retreat*, he is clearly an embodiment of its complaints about writing for reward.

Even the suggestion that personal conscience is a performance might not be overwhelmingly problematic were it not for a fascinating double bind that situates Munday in the authorial marketplace. The integrity he impugns by performing and selling is, it turns out, exactly the kind of integrity that sells best. Many observers have noted the popularity of martyr stories for the merchant audiences of London during this period; in becoming, as Richard Helgerson has remarked, the author or part-author of a series of plays that all focus on individual conscience, often explicitly in the context of martyrdom, Munday established himself as a merchant of integrity, a profferer of heroic martyrdom to the early modern stage.[29] The Campion controversy was doubtless his most public venture, the context in which his personal name was most often mentioned in connection with his writing, but his theatrical works, too, return to the same successful strategy of emphasizing personal conviction and heroism.

Such a strategy associates Munday with the values of the marketplace in a complex way. He writes, apparently, for city audiences invested in the notion of conscience, and in doing so he embodies a paradox implicit in their values. The emergent structures of exchange that make London prosper in this period, it has been much argued, favor an unsettling social fluidity, a sense precisely that identity is performed.[30] These are the very structures that help the theater companies to flourish. On the other hand, the logic of private property, powerfully entwined with religious conviction, balks at such fluidity, favoring notions of personal solidity and incipient forms of interiority. Munday's audiences, it would seem, want to buy the fiction of not selling, even while they are fascinated by the power of the salesman. As partial as such a description must be, it goes some of the way toward accounting for Munday's long and successful career as a despised figure, and perhaps as well for the odd consistency of the themes to which he returns as a writer. We may be unable to locate internal coherence in

Munday himself, but a close look at his work reveals what he consistently relies upon his audiences to buy: a mingling of integrity and marketing, the promise that people who hold on to their truths are heroes combined with the suggestion that truth sells.

In later eras, as Mark Rose and others have argued, authorship would itself be categorized variously as a form of property and as an expression of interiority.[31] For the late sixteenth and early seventeenth centuries in England, however, when textual ownership did not characterize authorial practice and when interiority was, by our standards, firmly subordinated to structures of rank and social place, a figure like Munday opens up a key set of questions about the positions authors might take up in relation to their texts.[32] It has been suggested above that Munday the public figure performed in ways that expand Foucault's sense of the author function as a principle of thrift; the pages that follow develop that notion specifically for the theater, tracing in Munday's plays a persistent representation of authorship in contest with the martyr's ideal autonomous conscience.

The First Part of Sir John Oldcastle presents no author other than the collaborative "we" who speaks the preface to the 1600 quarto. In fact, the author on the title page of the 1619 quarto is, astonishingly, William Shakespeare. The astonishment comes not from the fact of misattribution, which is part and parcel of theatrical publication at this time, but from the particularly galling association of Shakespeare's name with a play that is specifically aimed at correcting his work.[33] As the play's Prologue famously contends, *Sir John Oldcastle* exists in order to set the record straight on the life of the fifteenth-century Lollard martyr: "It is no pampered glutton we present, / Nor agèd counsellor to youthful sins; / But one whose virtues shone above the rest."[34] The record needs to be corrected because of the great success of the Henry plays for the King's Men. As is well known, their depiction of Oldcastle in the person of Falstaff had apparently offended Protestant sensibility enough to provide a large audience for a counter-portrayal, one aimed at celebrating Oldcastle as an obedient subject and true believer. To publish this revisionist text under the name of Shakespeare, then, is to depict the King's Men's playwright as something like Munday himself, a temporizing mercenary who fabricates images of true martyrs in order to profit from their popularity. In fact, Munday had, like Shakespeare, written an anti-Oldcastle account. In *A Watch-Woord To Englande To Beware of Traytours and Treacherous Practises* (1584), Munday follows Stow's version of Oldcastle's life, in which the martyr is represented as a traitor. In that sense, the accidents of textual transmission would seem to have underscored Munday's insincerity; as an anonymous collaborator on *Sir John Oldcastle*,

Munday was once again writing in self-compromising ways about a figure who did not compromise himself.

But Munday as a personality cannot be the focus of this play. With its anonymity, its collaboration, its obvious dependence upon theatrical trends, and even its automatic commissioning in two parts, the Admiral's Men's production must be considered not as a particular form of authorial self-expression, but as a sign that the authors' consciences are collectively defined by their audiences, their readers, their company. In fact, as the collaborating "we" presents the play in print, the contingency of its dramatic truths stands out sharply. Sir John Oldcastle is, according to the preface,

> A valiant martyr and a virtuous peer,
> In whose true faith and loyalty expressed
> To his true sovereign and his country's weal
> We strive to pay that tribute of our love
> Your favors merit. (9–13)

The virtue of the martyr consists not only of his faith but of his loyalty to a true king; in fact the lines imply that the faith is itself faith in the king. Moreover, his faith and loyalty are made manifest in the tribute paid to him in this play, and that act of making manifest is simultaneously a payment to the company's audiences and readers. The Admiral's Men need Oldcastle to pay their audiences, and Oldcastle needs the Admiral's Men to express his loyalty to Henry V, which was, after all, a matter of some historical debate.[35] The tangle of allegiances and tributes here is profound, the martyr's pure conscience bound up in a string of alliances that stretches forward in history, passing on its way through the political and the commercial.

If we consider further the entanglements of the Admiral's Men offering this play in competition with the King's Men, its moral content begins to seem even more emphatically market-driven. The presence of Sir John of Wrotham, whose character closely parallels that of Falstaff, the presence of Doll, so reminiscent of Doll Tearsheet, the allusions to a past that seems to come from Shakespeare's plays, all point to a pervasive fraud in the play's composition.[36] It is both designed to refute Shakespeare's play and to capitalize upon that theatrical success.[37] Though this play demonstrates no particular interest in the figure of the author, the preface with its strong denial of a family resemblance surely suggests a collective desire to look like the King's Men. And that desire suggests that the powerful interest in Oldcastle as a man of the people and a man of conscience is itself in part a commercial venture. Like Munday's complex self-positioning in *English Roman Lyfe*, the position of the Admiral's Men here is deeply compromised.

Their martyr is not Falstaff in something like the way that Shakespeare's Falstaff is not Oldcastle: because the players say "this is not the man."

What may be most interesting in this story of unsavory theatrical competition, however, is the massive figure it enshrines: the relentlessly self-serving, cowardly Sir John who looks just like the worthy martyr, and with whom the martyr must compete for an audience. Like the martyrs Munday writes about in the 1580s, Oldcastle is forever on the verge of becoming a comic improviser, a sham player. Kristen Poole and David Scott Kastan have both argued forcefully that Falstaff is recognizable as a mainstream Protestant caricature of the radical Puritan, but perhaps we might add another term to the equation: Falstaff's humbug performance also borrows from the sense of fraud that accompanies martyrdom in this period, at least when that martyrdom is understood in the context of a polemical war that renders signs of conscience and faith distressingly reversible.[38] It is in that sense, perhaps, that the radical Puritan and the comic actor coalesce most powerfully. The much-valued emphasis upon autonomy of conscience is a contentious issue in this period, one compromised from its inception by the very modes of representation that guarantee its popularity. Especially in performance, when the opportunities to please an audience are especially rich, the martyr is almost necessarily accompanied by his playing double, by some conduit for the bad faith that attends upon the commercial display of the martyr's conscience. Oldcastle is somehow incomplete as a theatrical spectacle without the false Sir John of Wrotham beside him. To sell an audience the commodity of the true martyr, Wrotham implicitly reminds us, is to perform the part of the martyr's scandalous double.

AUTHORING THE MARTYR'S TALE

As I have noted, the surviving Oldcastle play evinces very little interest in the figure of the author. Moreover, beyond its usefulness as a sign of the ideological tensions that structure his career, *Sir John Oldcastle* offers very little that pertains explicitly to Anthony Munday. In *The Downfall* and *The Death of Robert Earl of Huntingdon*, however, Munday does become part of a collaborating team that represents authorship directly.[39] The entire first play and a section of the second are framed by the presence of John Skelton, imagined as the author of the plays, working with the other players – Skelton himself is imagined as an actor-playwright – to present Huntingdon's life to Henry VIII. It is of course significant that the plays imagine Skelton's authorship in relation to stories about martyrs. The plays are reworkings of the popular Robin Hood legends, famous for establishing Robin Hood

as an aristocrat rather than a yeoman.[40] In *The Downfall*, Huntingdon is outlawed for debt, in part because of the efforts of his own uncle and steward. Donning the name Robin Hood, Huntingdon takes up residence in the woods with the predictable set of allies, including Mathilda, daughter of the Earl of Fitzwater, who is for at least part of the series known as Maid Marion. Though Huntingdon himself dies at the hands of his enemies in the second play, the explicit focus on martyrdom centers more predictably upon the protracted demise of Mathilda, a virgin imperiled by the lust of the King, sworn to chastity in memory of Robin Hood but doomed to pay for her devotion with a spectacular death.

Though the specific details of his collaboration with Henry Chettle on these plays are notoriously difficult to pin down, it is known from Henslowe's diary that Munday was paid to write the first part originally, and Chettle to revise for court. That has led some critics to assume that Chettle wrote the authorial frame, the depiction of Skelton's involvement. But John Carney Meagher has effectively demonstrated how unlikely such a narrative of composition must be.[41] Thus the easier and more recognizable narrative about authorship, that Skelton is created as a way of elevating the play for a court performance, must be cast aside. However tempting it seems to imagine the author as more suited to the court than to the theater, it appears in fact that Skelton was created specifically for public theater audiences. Similarly, because *The Death of Robert Earl of Huntingdon*, part two of the series, quickly abandons Huntingdon in favor of his fiancée Mathilda, it has been tempting to imagine that Chettle tacked on a play about Mathilda to the remains of Munday's work on Huntingdon. But again Meagher has shown that this narrative of composition, relying as it does upon a notion of consistent authorial design, will not stand up to scrutiny. What we are left with, then, is the very strong likelihood that Munday wrote most of both plays, with additions by Chettle. In other words, there is no "pure" form of this text separable from its depicted fantasies about authorship and martyrdom, nor are these fantasies separable from one another. They need to be considered as a unit.

In many ways, Skelton as an authorial presence seems to suggest that authorship and autonomy of conscience are inimical to one another. Skelton is, after all, in service at the court of Henry VIII, and the production for which he is responsible is explicitly designed to please the King. Moreover, Skelton's composition is in some unspecified way also attributed to Sir John Eltham, who tells us that he has, at the king's behest, taken a break from surveying maps of the New World to see that the play will go on. Eltham serves repeatedly to undermine the authorial autonomy of Skelton.

He chooses the role of Little John in the play; Skelton has to ask him what part he wants.[42] When Skelton delivers a long oration on the inferiority of contemporary poets, Eltham interrupts him: "Stoppe master *Skelton*: whither will you r[u]nne?" (tln. 890). Eltham also reminds Skelton that Henry is likely to want more of the conventional "iests of *Robin Hoode*" than the play has offered (tln. 2210). These moments imply that the author may in fact be an unlikely figure on the early modern stage, that theatrical practice and authorship are inimical to one another.

But Skelton is simultaneously powerful in ways that make it harder to produce him as an example of the theater's unsuitability to the figure of the author. He manifests, for instance, a strong characteristic style of speaking – Skeltonics, of course – as if to suggest that the voice of a poet could be showcased in a play rather than subordinated.[43] Moreover, since he is at once the author of the play, an actor in the role of Friar Tuck, and the narrator, he seems, as Armin and Field sometimes also seem, more than usually present within his own dramatic text. At times, in fact, Skelton the author becomes strangely manifest in Tuck the character. The previously mentioned oration on poetry that Eltham interrupts is delivered spontaneously, in Skeltonics, while Skelton is in character as Tuck. In fact Tuck breaks into Skeltonics several times, as though the historical poet, the fictional author, the stage narrator, and the actor who plays Tuck had a tendency to merge into one overwhelmingly verbal figure. When Eltham calls Skelton's attention to this lapse, the response is instructive:

> IOHN One thing beside; you fall into your vaine,
> Of ribble rabble rimes, *Skeltonicall*,
> So oft, and stand so long, that you offend.
> FRI It is a fault I hardly can amend
> O how I champe my tongue to talke these tearmes,
> I doe forget oft times my Friers part:
> But pull mee by the sleeue when I exceede,
> And you shall see mee mend that fault indeede.
> Wherefore still sit you, doth *Skelton* intreat you,
> While he *facetè* wil breefely repeate you, the history al,
> And tale tragical, by whose treachery, and base iniury,
> *Robin* the good, calde *Robin Hood*, died in *Sherewodde*
> (tln. 2234–45)

In other words, like the apologetic but autonomous Earl of Surrey, Skelton is simply unable to keep himself from being out of sync. He means to try iambic pentameter (and seems to have no trouble doing so elsewhere), but all he can muster here are a few lines before the "ribble rabble rimes" take

over again. He just has to be Skelton. As Skelton, moreover, he has power over the audience and Eltham alike, who must patiently listen to the next Skeltonic narration.

At times Skelton even seems hesitant about respecting the wishes of his royal patron. When Eltham complains above that the play lacks morris dances and other Robin Hood "jeasts," Skelton makes an astonishing comment:

> JOH. Pray God this Play of ours may haue good lucke,
> And the kings Maiestie mislike it not.
> FRI. And if he doe, what can we doe to that?
> I promist him a Play of *Robin Hoode*,
> His honorable life, in merry Sherewod;
> His Maiestie himselfe survaid the plat,
> And bad me boldly write it, it was good,
> For merry ieasts, they haue bene showne before
>
> (tln. 2214–21)

Though he goes on to say that if his audience dislikes the play it will not be shown to the King, Skelton implies here that the King will have to accept what he agreed to originally. Difficult though it may be to imagine the historical Henry VIII being held to his word by a court poet, Skelton seems to consider it a viable option.[44] Moreover, because the absence of traditional Robin Hood merriment is a defining feature of the play as a whole, it is just possible to hear in this self-defense a defiance of the theatrical audience's expectations.[45] It is as if Skelton, and perhaps Munday and Chettle, were defending the play against audience disapproval by accepting with equanimity the suggestion that the King himself may not like this version of the story.

In light of Skelton's extraordinary freedom within the evident constraints of courtly service, in other words, it seems too simple to say that he represents authorship as an inappropriate construct for the early modern stage. On the contrary, Skelton, like Field, Armin, Heywood, and Munday himself, suggests instead that the conjunction of performance and authorship is of considerable interest to early modern theatrical audiences. Moreover, that conjunction is imagined in *The Downfall* very much as it is imagined in many of the other writings in which Munday had a part. Skelton is clearly the figure to whom the play returns as a source, but when we consider him as a source, we find that, like Munday, Skelton opens the door to a network of social and broadly economic structures that render him much more fluid than Foucault's notion of a limiting subjectivity can account for. Predictably, in this culture that does not fully distinguish between

individual interiority and social and economic embeddedness, to imagine
an author behind a text is not to draw a circle of pure subjectivity around
it. It is instead to call up a host of constraints and enablements that are
nevertheless not conceived as inimical to authorship. Skelton is both au-
tonomous and dependent; the contradictory truths about authorship are
here contained within a single pleasing fantasy of insouciance.

It is perhaps for this reason that when Skelton is virtually pushed off the
stage in *The Death*, he leaves without making much of a fuss. He enters
that play already busy with something else, the hunt that he participates
in as Friar Tuck. In fact, though he continues in Skeltonics for this first
appearance, he is named in the texts as "Friar," and never appears as Skelton
again. It is as though something else were taking over from the Skelton we
knew in *The Downfall*; this new narrator even forgets momentarily how
the story goes.[46] The play nevertheless takes up the thread of the plot from
The Downfall, and dispatches with Robin Hood in five scenes. When Tuck
reappears to mourn Huntingdon's death, he also appears ready to end the
play:

> Here dothe the Frier leaue with grieuance:
> *Robin* is deade, that grac't his entrance:
> And being dead he craues his audience,
> With this short play, they would haue patience.
>
> (860–3)

When the Earl of Chester tells Tuck he must continue the play so that
Mathilda's death can be depicted, the last vestiges of Skelton's presence
vanish. There is no Friar Tuck role in Mathilda's tragedy, so after narrating
the transition to the Mathilda story Tuck never appears on stage again. The
brief moment of narration that will conclude the play is spoken by King
John.

In light of the conflicts traced throughout this chapter between the
power of the martyr's conscience and the exigencies of professional author-
ship, it seems especially noteworthy that Skelton should be replaced by
Mathilda, a figure whose demise is specifically categorized within the play
as martyrdom. In the interests of narrating a story that revolves around
Mathilda's heroic resistance to the sexual advances of a depraved King, the
play shifts gears entirely. When the martyr arrives on the scene, the fantasy
located in Skelton, a fantasy in which authorial autonomy coexists magi-
cally with the constraints of patronage and the expectations of audiences,
is no longer appropriate. The play adopts a sharper sense of purity at this
point, an emphasis on Mathilda's absolute virtue. The play's authorship is

correspondingly restructured with considerably less power to intrude upon the play itself. The King's final speech, shifting as it does into a formal epilogue, makes this reassessment of authorship explicit:

> Goe forward maids: on with *Matildaes* herse,
> And on her Toombe see you ingraue this verse;
> > *Within this Marble monument, doth lye*
> Matilda *martyrde, for her chastitie.* *Exeunt.*
> > Epilogus.
> *Thus is* Matildaes *story showne in act,*
> *And rough heauen out by an vncunning hand;*
> *Being of the most materiall points compackt,*
> *That with the certainst state of truth doe stand.*
>
> (3045–53)

It is hard to imagine Skelton, with his runaway verse and carefree attitude, making such claims for the truth value of what is after all strictly fiction. As if under the influence of Mathilda's honesty, however, the authorship imagined in this closing scene comes close to eliding the act of representation altogether.[47] Like the stonecutter who will tell Mathilda's story – she was chaste and martyred, period – in two lines on her monument, the imagined author of the play will simply hew the facts out without cunning, in keeping with the "certainst state of truth."

To replace Skelton with Mathilda, in other words, is to substitute an image of absolute integrity for an image of integrity lightly grasped. While Skelton vanishes without complaint, Mathilda's very different demise is necessarily a matter of tremendous pathos. It is, moreover, capable of re-forming onlookers; King John is converted instantly by the spectacle of her death. Doubtless the depiction of this tale confers unsurpassed legitimacy upon the players presenting her tragedy. But this legitimacy, as it turns out, is a surprisingly complicated thing. There are suggestions within the play that the presentation of Mathilda's story "showne in act" is itself tainted by its commercial presentation. What replaces Skelton's imagined insouciance is not merely the martyr's virtue; it is the contest between the martyr's virtue and the sullying force of the play in which that virtue is depicted.

The strongest sign of this split between the truth of martyrdom and the tainted reality of the theatrical marketplace comes not directly from the Mathilda narrative but from a companion martyr plot, the death of Lady Bruce and her son. As part of King John's campaign of tyranny, he demands possession of the young boy as a kind of hostage. After putting up a valiant defense, Lady Bruce finally agrees to yield her younger son to the King, with the understanding that she will accompany him into captivity.

In a development for which the direct culprit is never fully identified, Lady Bruce and her son are locked into a tower and starved to death. The older Bruce son reveals the bodies of his mother and sibling, highlighting the resemblance to a religious persecution: "[Here] sits my mother martyrde by her selfe, / Hoping to saue her childe from martyrdome" (tln. 2868–9). In a manner typical of disputes between Protestants and Catholics over the validity of martyrdom, the signs of the mother–son demise are read obsessively for evidence about the intentions of the deceased:

> my mothers teeth and chin
> Are bloudy with the sauage cookery,
> Which her soft heart, through pittie of her sonne,
> Respectlesse, made her practice on her selfe:
> And her right hand, with offring it the child,
> Is with her owne pure bloud staind and defilde.
> My little brothers lips and chin, alone,
> Are tainted with the bloud; but his eauen teeth,
> Like orient pearle, or snowe-white yuory,
> Haue not one touch of bloud, one little spot:
> Which is an argument the boy would not
> Once stir his lips, to taste that bloudy foode,
> Our cruell gentle mother ministred. (2872–84)

This extraordinarily graphic description of what must have been an extraordinarily disturbing spectacle raises a whole host of questions about the relation between the ethics of theatrical representation and the truth of the martyr's conscience.[48]

On the one hand, this scene insists upon its own moral force. The King begs Bruce to stop speaking, protesting that his heart has flooded his eyes with tears. Lester, making the evangelistic power of the martyr's appearance explicit, informs the King that his tears are a sign of the spectacle's efficacy, calling them "euen as good, / As raine in haruest, or a swelling floode" (2905–6). Theater, forever castigated for its display of the body, reverses that stigma in this case to offer precise physical evidence for its moral value. That value, in fact, is doubly emphasized when Mathilda's body is brought on stage immediately after Lester speaks, accompanied by a spectacular procession and laid next to those of Lady Bruce and her son. The concrete vision of wronged innocence, so powerfully designed for the stage, completes the King's conversion from a life of sexual depravity. The vision thus dramatizes the educational efficacy of such horrific spectacles.

For all its powers of theatrical legitimation, however, this display of virtuous bodies is accompanied by surprising suggestions that it is an illicit spectacle. We are only able to see Lady Bruce and her son because the older Bruce son, in order to clear his mother from the imputation of self-chosen starvation, has excavated a hole in the tower where she was confined. His comments upon unveiling the corpses suggest that he is a reluctant broker of martyrdom:

> How now my Lords: were ye last night so pleasd
> With the beholding of that propertie,
> Which *Iohn* and other murderers haue wrought,
> Upon my starued mother and her sonne:
> That you are come againe? Shall I againe
> Set open shop, shew my dead ware, deare bought,
> Of a relentlesse merchant that doth trade
> On the red sea, swolne mightie with the bloud
> Of noble, vertuous, harmelesse innocents?
>
> (2737–45)

The sense of violation and guilt here is matched only by the shocking language of the marketplace. It is as if in the space between the necessary use of forensic evidence and the current demand for a repeat performance, he had been meditating upon the ethics of theatrical violence. Suddenly what had been an edifying spectacle has become a crass commercial transaction, with moral legitimacy itself seeming equivalent to pandering.

This surprising outburst has, moreover, a subtle echo in the Mathilda plot. In her desperate struggle to evade the grasp of the lecherous king, she had ultimately gone to a convent, where she intended to take vows and live a life of contemplation and devotion to God and Robin Hood. What she finds there, however, is a comic scene of Catholic depravity ill suited not only to Mathilda's purposes but to the ostensible purposes of the play itself. In a scene perhaps too successful at Protestant satire of monastic life, Mathilda encounters the archetypal evil monk and nun, both secretly determined to offer her up to King John. The nun explains that she has nightly visions of the devil in the form of "yon reuerend Monke," which she can only dispel if she will "coniure him, / That the foule fiend hath no more powre to stand" (2476–7). In a series of bawdy jokes, in other words, the evil monastics convey their true intentions first to the audience and only eventually to the uncomprehending Mathilda. The audience enjoys a few laughs at the scene of Mathilda's final defeat, joining in a bond of sexual knowledge over the head of the innocent victim. If Bruce registers the implicit corruption of the sale of martyrdom, this scene surely

suggests an even less flattering set of possibilities: that the ennobling vision of Mathilda's suffering and resistance is in some sense interchangeable with bawdry; that the desire to give audiences one more moment of theatrical pleasure has proven commercially irresistible, superseding the demands of moral edification.

Another way to put this is to draw a parallel with *English Roman Lyfe*. Once again, it seems, the truth of martyrdom is in an uncomfortably close relationship to the demands of writing for reward. For all the play's emphasis on personal will and personal conscience, there is also a strong current of salesmanship running through both printed text and staged performance. In the person of Skelton, perhaps, it is possible to represent both a transcendent authorial voice and a comfortable sense of economic and social embeddedness, but when that idealizing vision is removed, a more powerful split between personal will and the constraints of employment comes to the fore. Skelton is an image of authorial incoherence as pleasure; the narration of martyrdom that sweeps him from the stage comes much closer to touching upon authorship as the cynical practice of selling personal will, an incoherence more radical and damning than the Skelton persona can account for.

And it is this practice of selling personal will that comes closest to Munday himself. As argued above, Munday's career, from his earliest public moments as an authority on martyrdom, marks him as the champion of conscience while simultaneously marking him as the champion of economic opportunism. There thus attaches to his name a set of author functions that are beyond the sights of Foucault's formulation. Munday functions as a source of textual meaning, but as a limiting subjectivity he is a baffling figure. He stands in for epistemological uncertainty, and for a set of cultural questions about personal will and private property. Moreover, the force of these questions and their link to the ongoing problem of interpreting the martyr's performance carries over from pamphlet controversy to the stage. Munday's participation in a set of pamphlet debates about martyrs brings the ethics of authorship for reward into sharp focus, and those debates are cast in language heavily suggestive of the stage. When we turn to the actual plays that Munday helped to produce, it becomes clear that writing for the theater also lent itself to a meditation on authorship, in spite of the seeming gap between the material conditions of production – including collaboration and anonymity – and the discourses of authorship we are used to recognizing.

This is because there were other powerful forces at work in the theater that supported notions of authorship. Collaborative writing and anonymity

certainly helped to shape theatrical representations of the author, but so did the tremendous economic potential occasioned by professional theatrical work. The plays in which Munday had a hand seem strongly drawn to selling the martyr, to reaping the profits available for those who knew how to exploit the performance of pure conscience. But performing pure conscience seems necessarily to raise questions about the ethics of such exploitation. When Mathilda appears on stage, Skelton's easy compromise between serving his various audiences and speaking autonomously – a precondition for veracity, according to the *Third blast of retreat* – can hardly help but vanish. The professional opportunity provided by the compelling spectacle of martyrdom brings with it a heightened sense of self-consciousness, an imperative to consider the source. Like Munday the author of *English Roman Lyfe*, the anonymous and collaborating writer of a martyr play is virtually driven to answer questions about representation, questions that adhere to writing for reward. Reward was, after all, one of the most prominent features of work for the professional playing companies, one of the radical innovations that the institution of the theater helped to foster in early modern England.

We are accustomed to think of the author as a function of ownership, a function of copyright and developing notions of literary property. Munday and the martyr together, however, point us toward a very different possibility: that the author is imagined on stage and in print not so much because he is the owner of the text as because he is the property of his audiences, his patrons, and his playing company. He owes them truth, but the circumstances of that owing render his truths profoundly compromised. As the author of the *Third blast of retreat* suggests, he flatters for commodity, and thus becomes a troublesome presence in his own text. In fact, when an unknown contemporary of Munday's picked up the copy of his *Watchwoord to Englande To beware of traytours* (1584) now in the possession of the Huntington Library, he or she registered just such an awareness. Near the end of this pamphlet, Munday makes two moves that are typical of him. The first is commercial. Munday explains that he is about to publish a book called *The Court of Conscience,* in which he will set forward even more tales of crime and danger: "And I dare awarrant thee," he says, "that thou neuer readst not such a Booke in all thy life" (N2v). The second move is apparently pious; Munday invites his readers "tyll [the next book] come, that thou thy selfe mayst iudge of it, I will breeselie desire thee to ioyne in prayer with me" for the protection of England from traitors and other dooers of bad deeds. Apparently vexed by the close conjunction of piety with the profit motive, Munday's unknown reader carefully inscribed in the

A Watch-woord

lous néede to looke vnto : but becaufe J entended this pꝛe-
fent purpofe in this Watchwoord, J referre the reſt to
my other Booke called the Court of Confcience, which
thou ſhalt ſhoꝛtlie receyue from me . And J dare awar-
rant thée, that thou neuer readſt not fuch a Booke in all thy
life, both foꝛ the circumſtances of the matter, and the woꝛ-
thineſſe of the whole in generall : but tyll it come, that
thou thy felfe mayſt iudge of it , J will bꝛéefelie deſire thée
to ioyne in pꝛayer with me , foꝛ the good ſucceſſe of all hap-
pineſſe, that may pleafe God to fend thée.

 Let vs pꝛaye , that we may fée when thofe that ſhall
wꝛeſt oꝛ pꝛocure to chaunge Lawe, to erect the courage
of any daungerous Uiper to fuch endes , oꝛ to any afpi-
ring hope of pꝛeuenting and vndermining , vnder what
couller , name , pꝛetence, oꝛ otherwife, oꝛ to the fafegarde
of their perfons that haue fo attempted : that they maye
be declared, and erecuted as enimies to the ſtate, and to the
Quéenes fafetie.

 Let vs pꝛaye , that we may fée fuch Lawes pꝛouided
foꝛ her Highneſſe pꝛeſeruation, and the fame fo erecuted
without reſtraint oꝛ ſlackeneſſe foꝛ any refpect : as the
hope of Papiſtes , fuch as be enimies to God, the Quéene
and the Realme , may (if they repent not) be cutte off foꝛ
euer.

 Let vs pꝛaye to liue to fée, that none may haue place,
Office, oꝛ acceſſe into her Maieſties Court noꝛ houſehold,
no , noꝛ once into her pꝛefence : that ſhall not be knowne
to fauour both God and her, fo farre as any circumfpection
oꝛ policie can pꝛouide it.

 Let vs pꝛaye, that no Office of dignitie , Lawe oꝛ Iu-
ſtice, may be in their handes, who do not fauour the Lawe
of God, and acknowledge her Maieſties right, that is head
of Lawe and Iuſtice in this Realme.

 Let vs pꝛaye , that her Maieſtie and her Councell may
haue fuch particular knowledge of men , that thofe that
haue well deferued , yea , haue and yet do hazard their
liues

Marginal notes:

A Booke called
the Court of
Confcience,
which I entend
(God aiding me)
to publiſh verie
ſhortly.

Mundaye the
errant and
palpable Enga-
lie of Englande

God graunt that
fuch Papiſtes as
be enimies to
her Maieſtie and
the Realme, may
be quickly cutte
off.

2 Anthony Munday, *A Watch-woord to Englande* (London, 1584), p. 46.

left-hand margin at this point, "Munday the errant and palpable knaue of Englande" (see fig. 2). Troublesome, duplicitous, self-promoting, and ultimately incoherent, the author on stage and in print speaks of martyrdom and ultimately renders himself the object of his discourse. Just as Robert Armin challenges the notion that a well-developed ethic of private property is the *sine qua non* of authorship, and just as Nathan Field suggests vivid alternatives to the author as an absolute monarch over his words, Munday reminds us that the essentialist subject is not the only form of authorial presence imaginable. On the contrary, Munday was a compelling presence exactly because he occupied the marginal position of the shape-shifting, duplicitous player.

CHAPTER 4

"Some zanie with his mimick action": Thomas Heywood and the staging of humanist authority

Speaking of the low status of actors at the end of the seventeenth century, Robert Weimann notes that "this Restoration disdain for performers was at least in part anticipated in the theatre of George Chapman, Ben Jonson, John Marston and Francis Beaumont."[1] "Looking at these dramatists," he goes on to say, "we cannot seriously doubt that, beginning at the turn of the century, the circulation of authority among poets and players (as well as audiences) could be effectively contested" (35–6). However inexorable the coming separation of elite authorship and the exigencies of popular drama might have been, however, much of the interest in Weimann's account, and in the theater of this period more generally, comes from rich admixtures of high and low like the ones he is able to identify in plays like *Hamlet*. For although "high" humanist authorship with its antitheatrical bias came eventually to set the terms in which dramatic writing could be described, there were other compelling vocabularies in play throughout the period. As late as 1624, for instance, in *Gunaikeion*, Heywood could defend his own authorial practice in ways that utterly mangle the humanist paradigms against which "low" culture and popular traditions in the theater were increasingly being defined. Whether hapless or purposeful, this mangling deserves attention, for as the previous chapters have argued, it is precisely in such experimental forms of authorial engagement that early modern theater offers its most profound challenges to "authorship as we know it."

On the one hand, writing *Gunaikeion: or Nine Bookes of Various History Concerninge Women* is clearly a bid for authorial preeminence. Printed in folio format, it includes a gorgeous engraving of the nine Muses, a dedicatory epistle to the Earl of Worcester, and a long survey of classical, biblical, and fictional women noted for virtue and/or vice. Curiously, though, it also contains a fair amount of folk narrative, including stories like "A tricke of an English Skould, &c." that appear out of place in a learned treatise (235). Heywood's defense of their inclusion is remarkable for its configurations both of print and of performance:

It may be likewise obiected, Why amongst sad and graue Histories, I haue here and there inserted fabulous Jeasts and Tales, sauouring of Lightnesse? I answer, I haue therein imitated our Historicall and Comicall Poets, that write to the Stage; who least the Auditorie should be dulled with serious courses (which are meerely weightie and materiall) in euerie Act present some Zanie with his Mimick action, to breed in the lesse capable, mirth and laughter. (A4v)

Placed alongside the various execrations of "the loathed stage" with which we typically associate humanist authority in this period, Heywood's self-justification marks a radical departure. Sounding as though no one had ever complained about the mingling of kings and clowns, Heywood blithely refers his readers to theatrical practice as a way of legitimating his lapses of writerly decorum. In doing so, he relocates the source of writerly authority; it is the stage and the marketplace that set the precedents here, the popular dramatist who is to be imitated, if classical scholarship is to meet with public acceptance. Rather than constructing authorship out of the elite rejection of audiences and actors, Heywood grounds his work in their commercial successes.[2]

Nevertheless, Heywood associates the desire for mirth with "the lesse capable"; the preface betrays some partial lack of confidence in the cultural authority of the comic performer. We know, of course, that in 1633 Heywood claimed to have had "either an entire hand, or at the least a maine finger" in no fewer than two hundred and twenty plays.[3] To claim in 1624, then, that he is *imitating* "our" dramatic writers when he compiles *Gunaikeion* suggests a subtle recognition of the low position in which theatrical practice is more commonly held. The preface continues in this mixed vein, drawing parallels between performance and print that are as remarkable for their embrace of theatrical practice as for their mild invocation of learned disapproval:

I haue therein imitated our Historicall and Comicall Poets, that write to the Stage; who least the Auditorie should be dulled with serious courses...in euerie Act present some Zanie with his Mimick action, to breed in the lesse capable, mirth and laughter: For they that write to all, must strive to please all. And as such fashion themselves to a multitude, consisting of spectators seuerally addicted; so I, to an uniuersalitie of Readers, diuersly disposed. (A4v)

The "such" who "fashion themselves to a multitude" are literally the dramatic writers here, but they are teasingly connected to the actors they write for in their appearance before a crowd. Writers are seemingly engaged in the same work as the players in this passage. Even though Heywood is lifting himself slightly above "their" level – fashioning himself to an eerily

prophetic "universality of readers" instead of the unruly "spectators severally addicted" – he is nevertheless establishing a continuum that stretches from the clown who pleases his audiences to the dramatist who supports that performance to the learned compiler of classical lore who wants his work to sell. The playwright himself appears almost to be on stage in Heywood's description.

Here, then, Heywood encapsulates the cultural tensions that structure the present study: in the face of an increasing, Jonsonian, pressure to define authorship, even dramatic authorship, as anti-commercial, anti-histrionic, some writers for the stage were nevertheless tapping explicitly into the tremendous power of the professional actor. To read Heywood's career in this context is to recast the terms of his importance in the history of authorship. For while Heywood has received some critical attention for his repeated commentary on publication in dramatic prefaces and epistles to the reader, his career tells us about much more than the vicissitudes of print for a dramatic author. Rather, we should view Heywood as he appears in the preface to *Gunaikeion*, taking a stance that is repeated implicitly or explicitly throughout his career: as a figure whose involvement in both print and performance positions him to articulate surprising connections between these media. Though he was an actor himself at least as late as 1619, it is not, as in the case of Armin or Field, his personal celebrity as a performer that figures prominently in his authorship.[4] Nor is Heywood notorious in the way that we must consider Munday to be. Instead, Heywood uses the actor's general popularity as a source of legitimation, either directly, as in *Gunaikeion*, or implicitly, as in several of the texts to be discussed below. Moreover, in his insistence upon bringing classical material to Red Bull audiences, Heywood resituates humanist authorship, exposing its ripeness for commercial exploitation in ways that proper humanist rhetoric rarely does.[5]

The pages that follow will trace some of Heywood's attempts to command classical authority, in and out of the theatrical marketplace. From among his many writings, this chapter will focus on two particular dramatic experiments: the Age plays, a series of mythological dramas produced between 1611 and 1632, and *Rape of Lucrece*, a tragedy whose deployments of actorly charisma are problematic in the extreme. As *Gunaikeion* would suggest, however, the pleasures of the stage figure not only in Heywood's writing for the public theaters, but in a surprising number of his other publications as well. Ultimately, Heywood's willingness to relax the strictures of learned decorum, including the antitheatrical bias, while insisting upon his own preeminence, places him at the center of the period's negotiation of

authorial prerogative. Once again, in the case of Heywood as in the cases of Armin, Field, and Munday, to read early modern theater as a realm without authors – or to see the construction of authorship only in the exclusive gestures of Jonson and his peers – is unnecessarily to surrender the institution of authorship to its later and more elitist incarnations. The construction of authorship was a contest, not between Jonsonian self-promotion on the one hand and inchoate forms of writerly engagement on the other, but between multiple forms of authorial self-inscription, sometimes overlapping, sometimes sharply contrasted, and sometimes, as in Heywood's case, grounded in a more or less explicit attempt to combine humanist authority with actorly charisma.

THE APT AND THE DULL

As Heywood rose to a position of some eminence in 1634, he was privileged to present *Love's Mistress, or the Queen's Masque*, which as the title page boasts was "three times presented before both their two Excellent MAIESTIES, with-in the space of eight dayes."[6] The masque is clearly Heywood's great moment of authorial prestige, and its acceptance by Henrietta Maria – the masque came to be known as the "Queen's Masque" from the time that she called for it to be played on Charles's birthday – was an occasion for triumph. In the printed preface to the "Generous Reader," Heywood strikes what is for him a tone of unprecedented self-congratulation: "For this dramatic poem I need not much apology, it having passed so many tests of approbation; yet for commendable custom's sake I follow the tradition of all or most authors, who were never deficient in this kind of complement" (3). The dedication to the Earl of Dorset, though far more obsequious, borrows similarly from the authority of the Queen:

> It having pleased Her Most Excellent Majesty to grace this, though unworthy, poem so often with her royal presence, I was emboldened the rather, though I dare not commend, yet to commit it to your noble patronage; neither are dramas of this nature so despicable as to be held unworthy the countenance of great men, when there is frequent precedent that the like have been dedicated to and entertained by emperors and the most potent princes of their times. (2)

As Raymond Shady remarks, "for one dizzy week [Heywood] was a favourite court poet."[7] In many ways Heywood uses this opportunity to construct himself as a Jonsonian author, as the court's own producer of flattering elite spectacles.

The masque itself, however, takes an interesting turn toward inclusiveness.[8] As the story of Cupid and Psyche plays out its familiar pattern,

Heywood frames the action with a series of dialogues between Apuleius, who has just recovered from being transformed into an ass because of his intellectual curiosity, and Midas, in his post-enchantment status as the humbled king of beasts. It is Apuleius's task to present the story of Psyche; Midas owns that he

> know[s] no Muses,
> No Muses' hill, no Aganippes' spring;
> And which is more, [he] care[s] for no such toys.
>
> (1.1.36–8)

Having established that their interchanges will take the form of a contention between Art and Ignorance, Apuleius invites the audience to judge the winner of "this banquet academical" (1.1.84). The stage is, as it were, set for the triumph of art to be validated by the aristocratic viewers, eager to repudiate whatever secret sympathies they might share with the ignorant Midas.

But Midas proves far too valuable to the audience, and to the masque as a whole, for such repudiation to succeed. It is Midas who occasions the periodic breaks in the masque's actions that allow for elucidation of its allegorical meanings. Repeatedly, Apuleius explains that Psyche is the soul, tragically misguided in its attempts to see God, and that the masque's various turns of plot serve the purposes of spiritual allegory. The benefit to the audience is clear: they are able to receive Heywood's teachings as though to do so were simply a way of humoring the dull-witted.[9] Moreover, Midas's short attention span makes him the ideal spectator for a masque by *Gunaikeion*'s author, as he cries out for anti-masques of various kinds, to provide relief from the story of Psyche's mistakes. Apuleius graciously consents to such diversion, since, as he admits, "Art sometimes must give way to Ignorance" (2.5.9). Ultimately, Cupid steps in to save the audience from having to decide who wins the contest:

> I by the favour of these gentlemen
> Will arbitrate this strife. One seeks to advance
> His Art, the other stands for Ignorance.
> Both hope, and both shall have their merits full:
> Here's meed for either, both the apt and dull.
> Pleased or displeased, this censure I allow:
> Keep thou the ass's ears, the laurel thou.
>
> (5.3.135–41)

Cupid's easy acceptance of all the desires brought to a performance of a masque simply renders unnecessary the elitist gestures familiar to readers

of Jonson. As in the preface to *Gunaikeion*, Heywood emphasizes not the great chasm that increasingly divides high and low culture but the relatively congenial relations that might obtain between them. He thus establishes himself as an author without the strong ethic of exclusion that Jonson – and much contemporary scholarship – read as essential to authorial self-promotion.

In fact, one could argue that Heywood's deployment of masque in the service of authorial ambition was distinctly anti-Jonsonian. In light of Jonson's much-discussed rivalry with Inigo Jones, for instance, the following remarks from the masque's letter to the reader serve notice that Heywood occupies a vastly different authorial universe:

So much for the subject itself, but for the rare decorements which new apparelled it when it came the second time to the royal view (Her Gracious Majesty then entertaining His Highness at Denmark House, upon his birthday), I cannot pretermit to give a due character to that admirable artist, Master Inigo Jones, Master Surveyor of the King's Work, &c., who to every act, nay almost to every scene, by his excellent inventions gave such an extraordinary lustre, upon every occasion changing the stage, to the admiration of all the spectators, that, as I must ingenuously confess, it was above my apprehension to conceive, so too their sacred Majesties, and the rest of the auditory. It gave so general a content, that I presume they never parted from any object presented in that kind, better pleased, or more plenally satisfied. (3)

"So much for the subject": a gesture of self-dismissal only possible, it seems, for a writer who wants his readers to believe theatrical spectacle is entirely unthreatening to his own stature. In contrast with the preface to *The Masque of Blackness*, the gesture sounds almost pointedly aimed at Jonson, a possibility enhanced by the fact that, as Arthur Clarke points out, Jonson's conflict with Jones was still under way when *Love's Mistress* was produced.[10] *The Masque of Blackness* finishes a fifty-line description of Jones's design with "So much for the bodily part."[11] Or again, in *Hymenaei*, Jonson turns from lambasting those who prefer spectacle to contemplating what he calls "my better subject" (76). Nor does it worry Heywood much to admit that Jones functions at a level, as he says, "above my apprehension." In making such a confession he simply takes his seat next to "their sacred Majesties, and the rest of the auditory." Were this a Jonsonian preface we would have license to read an implicit critique here: Jones's designs were too obscure for the audience to understand. But Heywood assures us that incomprehension is a form of satisfaction.

It would be easy to miss the complex forms of authority that Heywood is constructing; by rejecting Jonson's (already ambivalent) rejection of Jones,

Heywood is not simply failing to invoke the set of antitheatrical anxieties we have learned to label "authorial." Nor, for that matter, is Heywood operating without precedent. *Love's Mistress* may show the influence of Lyly's *Midas*, published first in 1592 and printed for a second time just two years before Heywood's masque.[12] Though that play is less interested in physical spectacle than Heywood's masque is, it does seem to confirm Heywood's embrace of "low" pleasures in high places. The play tells the story of Midas's failure to judge correctly in a singing contest between Apollo and Pan. As David Bevington notes, Midas's preference for the songs of Pan is a "distinction of 'folk' versus court."[13] Pan's music is referred to as "minstrelsy" (4.1.124), associated with broadly popular taste in Apollo's pun on Pan's name: "thou art Pan and all, all Pan and tinkerly" (4.1.67–8). Though Apollo gives him asses' ears in punishment, however, Midas is ultimately forgiven after he confesses his mistake.[14]

Like the audience for *Love's Mistress*, Lyly's Midas can be allowed his low tastes. And this forgiveness appears to be connected with the play's own generic choices. Lyly's play makes use of a low comic subplot, and is prefaced by a familiar justification for its indecorous elements: "what heretofore hath been served in several dishes for a feast is now minced in a charger for a gallimaufry. If we present a mingle-mangle, our fault is to be excused, because the whole world is become an hodgepodge" (Prologue in Paul's 18–22). Though Lyly's presentation is unquestionably prestigious, this prologue bears a family resemblance to *Gunaikeion's* attempts to please the multitudes. Following in Lyly's footsteps by creating an elite spectacle that includes the "lesse capable," Heywood implies that authorial preeminence can be separated from exclusive judgment. And yet the title page of Lyly's *Six Court Comedies*, in which *Midas* appeared in 1632, promises comic pleasure in the figure of a highly respected author: "By the onely Rare Poet of that Time, The Witie, Comicall, *Facetiously-Quicke* and vnparalelld: IOHN LILLY, Master of Arts." Similarly, the dedicatory epistle by Edward Blount seems calculated to assuage whatever anxieties Midas's choice might raise: "It can be no dishonor, to listen to this Poet's Musike . . . For this Poet, sat at the *Sunne's* Table" (A3–A3v). Though there are forms of humanist authority that shun the music of Pan, Heywood's apparent interest in Lyly suggests a different set of authorial strategies.

Like Nathan Field, in other words, Heywood takes up the very features of staged performance that Jonson claims to reject in order to establish his stature as an author. The sharp division of high from low appears in this masque to be an optional facet of courtly writing. For critics accustomed to assuming that theatrical spectacle competes with authorship, that

it introduces unwelcome collaboration and distracts audiences from the excellence of an author's composition, Heywood's masque opens up less obvious possibilities: that spectacle could be seen to legitimate authorship, that a writer could brag about keeping company with an elite designer, that the relation between print and performance could be mutually reinforcing. What emerges from consideration of Heywood as a masque author, then, is the conviction that we have overlooked forms of authorship in this period in part because we have listened too attentively to Ben Jonson.[15] Jonson's constructions of authorship are noteworthy not because they are the only instances in which a dramatic writer claims the prerogatives of the author, but because they foreclose upon the many viable alternatives imagined by his fellow players who wrote.

"TO MAKE A POCKET BOOKE"

Among the alternatives to folio publication practiced by Heywood is the generally ignored *Pleasant Dialogues and Dramma's*, an octavo volume published in 1637. As Heywood himself notes in his dedication to the Earl of Dover, the smaller format has its own merits, distinct from the grandeur of the folio:

Elaborate Poems have ever aym'd at learned Patrons, who valued Books as your best Lapidaries praise Iewels, not by their greatnesse, but their goodnesse. This is a small Cabinet of many and choyse, of which none better than your Noble selfe can judge . . . (A3)

Here exclusive judgment is turned back against folio-style preeminence. Interestingly, reflection upon the size of the book is a strategy Heywood also practices in other volumes to very different effect. In part one of his *Fair Maid of the West*, six years earlier, Heywood had noted that his plays had "not beene exposed to the publike view of the world in numerous sheets, and a large volume; but singly (as thou seest) with great modesty, and small noise" (A4). Similarly, Heywood's *Life of Merlin* (1641) reflects upon its own size as a kind of convenience. Noting that everything one needs to know from the English annals is contained in his book, he highlights the usefulness of the condensed version:

For in the steed of a large study book, and huge voluminous Tractate, able to take up a whole yeare in reading, and to load and tyre a Porter in carrying, thou hast here a small Manuel, containing all the pith and marrow of the greater, made portable for thee (if thou so please) to bear in thy pocket, so that thou may'st say, that in this small compendium or abstract, thou has *Hollinshed, Polichronicon, Fabian, Speed*, or any of the rest of more Giantlike bulke or binding. (¶4v)

Obviously, it would be a mistake to take Heywood's various authorial claims at face value, as a sincere statement of belief in the virtues of small-volume publishing. Instead, what bears emphasizing in these statements is the variety of forms that lend themselves to authorial self-aggrandizement. Because scholars have tended to emphasize the way folio publication constructs authors, it has been difficult to credit the broad range of ways that authorship can be attached to texts. Even if Heywood's claims here are, like his claims in *The English Traveller*, merely self-justifying, we ought not to wait for folio publication to signal a dramatist's investment in authorial status.

Once the small size of the volume has ceased to be an objection, *Pleasant Dialogues and Dramma's* becomes a very interesting record of the connections between stage and print. As Douglas Brooks has noted, the title page seems calculated both to appeal to lovers of theater and to disappoint them. The volume's full title is very full indeed:

Pleasant Dialogues and Dramma's, selected out of Lucian, Erasmus, Textor, Ovid, &c. With sundry Emblems *extracted from the most elegant* Iacobus Catsius. *As also certaine* Elegies, Epitaphs, *and* Epithalamions *or* Nuptiall Songs; Anagrams *and* Acrosticks; *With divers Speeches (upon severall occasions) spoken to their most Excellent Majesties, King* CHARLES *and Queen* MARY. *With other* Fancies *translated from* BEZA, BUCANAN, *and sundry Italian Poets.* (A2)

Apparently the intention was to leave nothing out. But there are exclusions, including a prologue and epilogue for *Richard III* once presented at the Red Bull, and "A Prologue to the Play of Queene *Elizabeth* as it was last revived at the Cock-pit" (248), which has been identified almost certainly as pertaining to Heywood's *If You Know Not Me, You Know Nobody*.[16] Apparently, these count neither as the "Dramma's" promised in the book's title nor as the "diverse Speeches," which were given before the King and Queen. They are, however, grouped with prologues and epilogues from masques given for the Earl of Dover and at court, the volume as a whole prefaced with several commendatory poems that establish Heywood's importance. Thus Heywood's dramatic speeches take their place among more obviously prestigious monuments to his cultural significance. The presence of strictly dramatic writing does, however, seem to cause a small crisis of nomenclature. "Dramma's" on the title page suggests to us plays and/or masques, but refers instead to some brief adaptations of Ovid.[17] Heywood troubles the definition again in his preface to "the Generous Reader": "For such as delight in Stage-poetry," he says, sounding as though he is about to mention the Red Bull, "here are also divers *Dramma's*, never before published: Which though some may condemne for their shortnesse, others againe will commend for their sweetnesse" (A4). This appears again to refer to the

Ovidian pieces, which while they are too short to stand on their own as offerings for the public stage, do use stage directions and speech headings, and do resemble Heywood's other attempts to stage classical mythology for public audiences. There appears to be no reason to call the prologues and epilogues "short," a term not applied to the masque speeches that are reprinted beside them.

Categorically, then, the speeches reprinted here from public theater seem troublingly out of place, since virtually everything else in the book is recuperable as aristocratic pastime, learned imitation, translation, or tribute to a patron. If the volume itself is a hopeful construction of authorial preeminence, however, we should consider that the speeches belong to it precisely because they are theatrical, because of the extraordinary connections they draw between print and the stage. What Heywood and his printer had some trouble explaining in the prefatory pages of *Pleasant Dialogues*, Heywood and his fellow-actors had no difficulty delivering in person. The speech from *Richard III* is remarkable for borrowing the language of print to explain a theatrical expediency. It is captioned "A young witty Lad playing the part of *Richard* the third: at the Red Bull: the Author because hee was interested in the Play to incourage him, wrot him this Prologue and Epilogue. The Boy the Speaker" (247). What follows is an exercise in actorly charisma, precisely the kind of self-fashioning before a multitude that Heywood associates elsewhere with dramatic authorship:[18]

> If any wonder by what magick charme,
> *Richard* the third is shrunke up like his arme:
> And where in fulnesse you expected him
> You see me onely crawling, like a limme
>
> (247)

Next comes a list of small things that are as valid as large ones, including an example drawn from pages very like the one we are reading in *Pleasant Dialogues*:

> [H]ave you never read
> Large folio Sheets which Printers over-looke,
> And cast in small, to make a pocket booke?
> So *Richard* is transform'd: if this disguise
> Show me so small a letter for your eyes,
> You cannot in this letter read me plaine,
> Hee'l next appeare, in texted hand againe.
>
> (247–8)

Sounding remarkably like the various claims Heywood has made for his non-folio publications, the boy actor proudly proclaims his legitimacy as a

representation of Richard. Or if the performance is inadequate, the sugges-
tion goes, it can be amended next time. The exact next time being promised
"in texted hand" is richly ambiguous: the return of the adult performer, the
printed version of the play, or even figuratively a return to the handwritten
manuscript that the printer had originally made into a pocket book.

The presence of lines spoken by a witty boy actor making slightly fac-
etious claims about how small is good suggests a powerful moment of
experimentation in the history of dramatic authorship. Though the volume
itself reflects some consternation about the status of theatrical writing, the
moment in performance is a testament to the audacity of actors, their
imaginative power over both audience and text. "Little Richard," as he
is called in the epilogue, deserves to appear in a volume with masque
speeches that address the King and Queen – and those are deeply Jonsonian,
profoundly allied with sovereign authority – because on some level the
work of actors is also a formidable power in this culture. While asking for
audience approval, that is, the boy is also demonstrating his wit, challenging
his audience through the force of his own ironic self-promotions. Moreover,
as that challenge to the audience becomes a print commodity, it becomes
firmly linked to Heywood as author. Performed charisma claims a certain
power over writing here, and that charisma makes its way, acknowledged or
not, into a volume that does not quite know how to categorize it. This is in
miniature a dramatization of the contest that shapes Heywood's unshapely
career. Theatrical practice provides numerous moments of pleasure and
cultural authority that carry over logically into print, where they sometimes
resonate with elite forms of authorship and sometimes clash with them.

It has been a structuring premise of this study that the forms of authority
enacted on stage are neither reducible to absolutism nor dependent upon
copyright and the various regimes of subjectivity. As Robert Armin's career
makes evident, though, there are powerful forms of control wielded by
actors, even as they declare and experience a profound dependence upon
audience approval. The boy playing Richard demonstrates this complex
performance power, emphasizing both his need to apologize for a perceived
inadequacy and his triumph as a child monarch. Performance is, as *Pleasant
Dialogues* acknowledges, a difficult thing to categorize. And nowhere is
the complexity of performance – and the attendant richness of dramatic
authorship as a cultural form – better signified than in the second theatrical
offering in Heywood's volume. Just after the speech for the child who
plays Richard, Heywood presents his prologue and epilogue to "the play of
Queene *Elizabeth*." As Brooks has argued, it constitutes a milestone in the
history of Heywood's dramatic publications.[19] Rather than attaching yet

another preface to a published play that complains about his mistreatment at the hands of actors, printers, his fellow writers, or ungenerous readers, Heywood seizes this performance in the Cockpit to use acting as a medium for authorial control:

> Plays have a fate in their conception lent,
> Some so short liv'd, no sooner show'd, than spent;
> But borne to day, to morrow buried, and
> Though taught to speake, neither to goe nor stand.
> This: (by what fate I know not) sure no merit,
> That it disclaimes, may for the age inherit.
> Writing 'bove one and twenty; but ill nurst,
> And yet receiv'd, as well perform'd at first,
> Grac't and frequented, for the cradle age,
> Did throng the Seates, the Boxes, and the Stage
> So much; that some by Stenography drew
> The plot: put it in print: (scarce one word trew:)
> And in that lamenesse it hath limp't so long,
> The Author now to vindicate that wrong
> Hath tooke the paines, upright upon its feete
> To teach it walke, so please you sit, and see't.
>
> (248–9)

Brooks has suggested that this prologue is about "the perils of publication," which is certainly true, but for our purpose its interest lies even more in the way that Heywood mingles print and performance, actor and author. For publication's dangers are rooted in the playhouse, in audience betrayal. The presence of those mysterious Stenographers suggests that print, with its power to lame a text, is an aspect of audience reception. Even the most gracious response to a performance is potentially an exercise in lost control, and the most extreme loss of control is, ironically, publication.

What follows the speech can never be recovered; the anxious request that the audience "sit, and see't," is followed by no report about the play's latter-day reception, or for that matter, about its faithful reproduction by the actors at the Cockpit on that occasion. The introduction to the present study made much of Heywood's claim to have written some two hundred plays that had mostly been lost by playing companies; the strong suggestion in lines like the ones quoted here is that authorship as Heywood practiced it virtually always rested in the hands of actors. Sometimes they could be imagined as cooperating with a fantasy of authorial control, and sometimes, as in the preface to *Gunaikeion*, their very antic behaviors could be said to complete Heywood's authorial practice. Each of these possible relationships begs to be read as authorial, promising not merely an expansion of the

list of writers who "count," but a certain reversal of terms, as authorship becomes a theatrical effect rather than an inherently antitheatrical endeavor. It is ultimately the turbulent relationship between writing, performance, spectatorship and publication that Heywood offers in *Pleasant Dialogues and Dramma's* as a delight commensurate with more aristocratic pleasures like the masque.

These two distinctly ambiguous theatrical moments – the witty request for favor of a boy actor doing his best to imitate a sovereign, and the bold efforts of a playwright to establish the stage as his own – italicize the combinations of vulnerability and self-assertion that characterize performance authority. They are included in Heywood's volume with his masque prologues because the forms of authority invoked and exchanged in theatrical practice offer a compelling and powerful model for cultural production, one that rivals the absolutist model favored by Jonson and his peers. That theatrical model of authorship, one that acknowledges and negotiates with audiences and actors even while stressing the power of the writer, shapes Heywood's career. His compulsion to remark upon the circumstances of his various publications, his curious forgetting of the contradictions between elite self-display and commercial selling, his easy use of comic pleasure in all the wrong places, all mark him as a writer whose roots in the theater lead him to make experiments in both print and performance that exceed the categories we have recognized for authorship in early modern England. Like the composer of the title page for *Pleasant Dialogues and Dramma's*, we have emphasized authorship's connection to prestigious cultural forms in the period without fully recognizing the theatrical pleasures that could also be a source of authorship's power. The pages that follow will examine two of Heywood's specifically theatrical experiments: the Age plays and *The Rape of Lucrece*. The first is tedious and the second frankly deplorable. In both cases, however, the very difficulty of recovering these plays now suggests that Heywood articulates forms of authorship that cannot be accounted for by our models, forms marked by a distinctly early modern encounter between actors and classical authority.

WRITING IN THE BRAZEN AGE

Though Heywood's Age plays are not centrally located in most studies of early modern English literature, they have recently attracted some critical attention for their portrayal of authorship. Heywood published the series – *The Golden Age*, *The Silver Age*, *The Brazen Age*, and *The Iron Age*, parts one and two – between 1611 and 1632. The first three plays are narrated,

Pericles-style, by Homer, who asserts himself as a particularly lofty example of writerly authority:

> What hath not *Homer* done, to make his name
> Live to eternity? I was the man
> That flourish'd in the worlds first infancy:
> When it was yong, and knew not how to speake,
> I taught it speech, and vnderstanding both
> Euen in the Cradle.[20]

Claiming authority over language itself, Homer opens *The Golden Age* with a vision of authorship that has little to do with the exigencies of theatrical production or early modern textual transmission. On the contrary, as Jeffrey Masten has argued, Homer seems to be a fantasy of sovereign textual control, even deploying the parental language that Masten links so compellingly to patriarchal absolutist models of authorship in the reign of James I.[21] But as in the prologue to *If You Know Not Me* discussed above, authorship in the Age plays proves a much livelier contest than Homer's early boast admits. We ought to read these lines not as a disembodied example of the discourses of absolutism, but as a strategy adopted by an author writing for actors. Reading Homer as Heywood's strategy mandates that we consider these lines in relation to the series of plays from which they were taken, and that we further consider Heywood's larger project of print publication. Doing so makes clear that Homer is both more and less than an absolutist author. He is instead, like the living author who wrote his lines, involved in complex relationships with audiences, with other texts, and even with the classical authority he seems to be bringing to the stage.

Homer begins to lose his control over *The Golden Age* in the play's first act.[22] Act I depicts the mythical struggle between Tytan and Saturne to succeed Vranus, which of course culminates when Saturne, the younger brother, takes the "throne" (all of the questions of succession and rule play out in distinctly human, distinctly Renaissance terms) from Tytan only on the condition that Saturne remain without an heir. This means killing male children at birth, a strategy decried by various members of Saturne's court, most notably including his queen Sibilla. From the margins of the court, from the Clown and Nurse, comes a trenchant analysis of Saturne's bargain:

> CLOWN ... the worst newes is, that if the King haue a young
> Prince, hee is tide to kill it by oath: but if his maiesty went
> drunke to bed, and got a gyrle, she hath leaue to liue till she
> dye, and dye when she can liue no longer.

NURS. That couenant was the most vnnaturall
 That euer father made: one louely boy
 Hath felt the rigor of that strict decree,
 And if this second likewise be a sonne,
 There is no way but death. (B3v)

Though these lines take for granted the "natural" role of the patriarch, they do at very least charge Saturne with failing to play that role. If we can take it as a given that the equation of paternity and sovereignty was fundamental to James's reign, and if authorship in this period is linked to both of those institutions, then surely the conjunction of Homer the author with Saturne the anti-paternal king makes this play more than an assertion of absolutist prerogative. Moreover, as Sibilla and Saturne's mother Vesta conspire with the nurse to hide all the male heirs, paternity itself begins to look like a process that works against sovereign control.

 The sense of upheaval that comes with the source material in this play might well signal on its own a threat to the kind of imperial paternity that Homer claims at the play's opening. But Homer's appearance in Act 2, just after Sibilla's plot to defy Saturne has been formulated, makes the connections between Saturne's rule and Homer's own authority unavoidable. Vesta's last words in Act I are menacing: "About our taskes; you some choyce friend to finde, / I with my feigned teares the King to blinde" (c4). Homer enters immediately after, a very different figure than he was an act before:

What cannot womens wits? they wonders can
 When they intend to blinde the eyes of man.
 Oh lend me what old *Homer* wants, your eyes,
 To see th'euent of what these Queenes deuise.
 The doombe shew, found (c4)

Strikingly, Homer's blindness seems here like a wound inflicted by Sibilla, who will with her mother go on to "deuise" the next part of the plot without Saturne's knowledge.[23] Adding insult to injury, in fact, the next part is a dumb show, a spectacle that Homer cannot see. Homer is as helpless to narrate as the King, ignorant of his wife's scheme, is to rule.

 In fact, many features of this speech suggest that Homer has undergone a sea change over the course of the first act. Initially he had asked rhetorically about his own authorial prowess ("What hath not Homer done, to make his name / Liue to eternity?"). Now he asks wistfully about the devious power of a woman's wit, a power that exceeds his own. More significantly, perhaps, it is only here in Act 2 that Homer fully acknowledges his blindness. What had seemed like an offhand remark in Act I ("I was the Muses Patron,

learnings spring, / And you shall once more heare blinde *Homer* sing" BV)
has been replaced by a much more radical sense of physical limitation. As
Homer reminds us, virtually every member of the audience can see what
remains hidden to him. It is not only the queens who can claim superior
sight. Homer seemed, in Act I, almost able to gaze upon his audience:

> The Gods of *Greece*, whose deities I rais'd
> Out of the earth, gaue them diuinity,
> The attributes of Sacrifice and Prayer
> Haue giuen old *Homer* leaue to view the world
> And make his owne presentment. (B)

But the apparent instability of Saturne's paternity and rule brings with it
a palpable diminishment of Homer's authorial stature, a privileging of the
seeing audience along with the threatening female forces within the play.
Interestingly, and all the more troublingly for Homer's authority, the Age
plays are famously visual rather than poetic productions; Andrew Gurr calls
them "that peak of spectacle."[24] For all that Homer asserts his triumphant
way with language, *The Golden Age* itself is decidedly more effective as action
than as poetry. The last set of stage directions, for example, reads as follows:
"Sound. *Pluto* drawes hell: the Fates put upon him a burning Roabe, and
present him with a Mace, and burning crowne" (K2v).[25] This occurs after
Jupiter has ascended upon an eagle and Aeolus has been presented with
"the 4 winds in a chaine" (K2v). The inability to see is, in other words, a
genuine liability at many moments in these plays, and Homer's stance as
the ur-author only partially compensates for his handicap.

In fact, our sense of how great a liability such blindness is grows more
emphatic when we consider these plays in the greater context of Heywood's
career. In an often-quoted passage from his *Apology for Actors*, for instance,
Heywood bases the moral efficacy of playing in visuality:

Description is only a shadow receiued by the eare but not perceiued by the eye:
so liuely portrature is meerely a forme seene by the eye, but can neither shew
action, passion, motions or any other gesture, to moove the spirits of the beholder
to admiration: but to see a soldier shap'd like a soldier, walke, speake, act like a
souldier; to see a Hector all besmeared in blood . . . Oh there were sights to make
an Alexander.[26]

Vision and words alike are crucial to the theater's power.[27] Presumably
Homer does not require the edification that his audience will receive
from these plays, but the strong links between his blindness and Saturne's
shortcomings suggest that greatness without vision is a limited source of

authority. Homer further reminds his audience before leaving the stage in Act 2 that they have a power he lacks:

> My iournie's long, and I my eye-sight want.
> Courteous spectators, lest blind *Homer* stray,
> Lend me your hands to guide me on your way.
>
> (c4v)

Unable to follow the course of his own story without the audience's help, Homer here cedes control over the narrative in a way that surpasses the usual deference of an applause-courting chorus. He needs help to tell a tale that he now identifies as belonging to the spectators: "Lend me your hands to guide me on *your* way."[28]

And in a very real sense this narrative does belong to Homer's audience. It seems to have been adapted carefully for the stage. Heywood had written about the rule of Saturne before in *Troia Britanica, or Great Britaine's Troy* (1609), a long verse treatment of the mythical prehistory of Trojan England; in that poem, Saturne and Sibilla (Ops) are very different figures, poised in a very different relation to one another.[29] The poem presents Saturne as far less culpable, initially committed to celibacy but overcome with love for his sister Ops. As the narrator puts it: "He feeles his soft thoughts in his bosom melt: / (Needs must he yeild whom such faire lookes assailed)."[30] Though Ops is not depicted as a knowing partner in the production of sacrificial offspring, she is at least given the standard power of the alluring object, and to the extent that her beauty lures Saturne, he is less brutally culpable for the intended murder of his sons. In *The Golden Age*, however, Saturne makes his deal with Titan while already married to Sibilla. The force of his desire thus impels him toward dominance, toward both political rule and despotic marital authority. The divisions between Saturne the despotic husband and Sibilla the plotting wife are thus much stronger in the staged version, and Sibilla's resistance is both more threatening and more powerfully motivated. In fact, *Troia Britanica* devotes several stanzas to a scene of feminine doting that makes the women's plot seem not a sign of forceful rebellion but instead a clear sign of their weakness:

> When they behold the beauty of the Lad,
> They vow within themselues his life to saue,
> But then the kings Iniunction makes them sad,
> And straight (alas) they doome it to the graue;
> Now with their blades in hand, like Beldams mad,
> They menace death; then smiles the pretty knaue,
> Then fall their kniues, then name they the kings will,
> And then againe they threat the babe to kill. (1.59)

The power in this description belongs to the smiling infant Jupiter and the king's will; whatever threat these women enact is ultimately contained by their feminine submission to the charms of the notoriously charismatic thunder god. By contrast, it is the staged version of the story – the one that belongs not to the patriarchal author but to the all-seeing audience – that allows the women to defy Saturne's authority while simultaneously breaking the narrative frame and wounding Homer. No case can be made that theatrical writing is automatically less patriarchal than print; the point here is simply that in staging these events Heywood has increased their dramatic value by intensifying conflict. The version of the story that Heywood presents to his theatrical audiences is, as it turns out, particularly undermining to the forms of authority that Homer and Saturne share.[31]

And yet this questioning of literary and political paternity is not unrelated to Heywood's larger project of staging and publishing classical mythology. If Jonson's folio model of preeminent authorship – like his use of a Horatian persona – involves identification with classical writers, a borrowing of their authority, Heywood presents his own work, and in some contexts presents himself, with an important difference. Rather than establishing himself as equivalent to classical writers, he establishes himself as a writer who has access to their works but not to their stature. In fact, making a name for himself is something he does quite explicitly in opposition to the golden age of authorship. In *Hierarchie of the blessed Angells*, he spends several pages digressing on the subject of poetry. He notes that the authors of "Past Ages" were given special names to indicate the esteem in which they were held by patrons or by the public:

> *Publius Ouidius Naso* had th'ostent
> Of *Sulmonensis* added, and did giue
> The Dorpe a name, by which it still doth liue.
> *Publius Virgilius* likewise had th'addition
> Of *Maro*, to express his full condition.[32]

In a strategically charming break in tone, the poem then switches to a consideration of the names of poets in contemporary England:

> *Tom. Nash* (in his time of no small esteeme)
> Could not a second syllable redeeme.
> Excellent Bewmont, in the formost ranke
> Of the rar'st Wits, was neuer more than *Franck*.
> (206)

Poets now, the poem implies, are much less exalted, much more mundane presences.

What Renaissance poets lack in stature, and perhaps in syllables, however, they make up for in accessibility. Heywood positions himself among them:

> I for my part
> (Thinke others what they please) accept that heart
> Which courts my loue in most familiar phrase;
> And that it takes not from my paines or praise.
> If any one to me so bluntly com,
> I hold he loues me best that calls me Tom. (206)

Like all the other Toms who write for his readers, that is – and Heywood volunteers "Ben" for this cozy position, too, in spite of "Ben's" inevitable discomfort – Heywood is only about half the size of his distinguished predecessors.[33] What authority Tom, and even Ben, can muster is based upon their accessibility. It depends upon relation to an audience. Like the diminutive *Pleasant Dialogues and Dramma's* with its charismatic Little Richard, *Hierarchie* configures authorship as powerful precisely in its lack of stature.

This sense of Heywood's lesser stature and the audience's corresponding power is also manifest in the Age plays. It is important to note that Homer asserts his authority at *The Golden Age*'s opening, but it seems equally crucial, given what the Age plays are offering their audiences and readers, that the plays partially undo that authority.[34] Like Saturne, whose rule is precarious at best, and like the oddly human Jupiter, Homer is an authority in the process of unraveling. In fact this sense of Homer's accessibility increases in *The Silver Age*. Homer enters the play noting that modern authors have already told over modern history, so that anyone who can read "Can poynt before we speake, how, where, and when / We have no purpose."[35] The odd syntax here suggests that if an audience knows a story already, the author has no importance, which shows a puzzling lack of confidence in an era when most plays were based on familiar sources. Redefining his classical authority, that is, as a simple choice he has made in order to avoid redundancy or competition, Homer goes on to offer what he can to his audience:

> Homer old and blinde
> Of eld, by the best iudgements tearm'd diuine,
> That in his former labours found you kinde,
> Is come the ruder censures to refine:
> And to vnlocke the Casket long time shut,
> Of which none but the learned keepe the key,
> Where the rich Iewell (*Poesie*) was put.
> She that first search't the Heauens, Earth, Ayre, and Sea.

> (B)

Homer, and by extension Heywood, refuses to hoard as exclusively his property the jewel of poesie, becoming instead a mediating figure between the divine, originary power of poetry, accessible only to the learned, and the "ruder judgements" he imagines in his audiences.[36] Perhaps advertising one's preeminence in the model of the classical folio author is an effective strategy for Ben Jonson, but for Heywood classical authority is something to play against in part. Heywood makes a name for himself as an author who steals secrets from Homer and brings them to the stage. In this commercial sense it seems utterly plausible that Heywood does not care "to be volumniously read." He means to be seen. As Homer puts it,

> We therefore begge, that since so many eyes,
> And seuerall iudging wits must taste our stile,
> The learn'd will grace, the ruder not despise:
> Since what we do, we for their vse compile.
>
> (B)

Again, the lines seem in the context of Heywood's larger authorial project to be considerably more than a gracious denial of literary ambition. On the contrary, they sound like a frank evaluation of the Age plays' location on the literary and dramatic map of early modern England.

In fact, Heywood's career as a handy compiler of erudition for "the ruder" sort of readers and playgoers stretches beyond his series of Age plays. Clearly he meant them to be one of his major projects, published in one volume, "with an Explanation of all the difficulties, and an Historicall Comment of euery hard name, which may appear obscure or intricate to such as are not frequent in Poetry."[37] But the widespread sharing of abstruse knowledge is a business that occupied Heywood several times, on stage and off. The manuscript of *The Escapes of Jupiter* shows him at work on yet another staged version of the gods' exploits, this time emphasizing Jupiter's encounters with Calisto, Danae, Semele, and Alcmena. *Pleasant Dialogues* offers "Annotations and obseruations of all such things as may appeare difficult or forreigne to the ignorant Reader" (A4r). *Troia Britanica* includes explanations at the end of each canto, "because it may not seeme intricate to the lesse capable" (24). Each book of *Hierarchie of the blessed Angells* is followed by "Obseruations," so that "nothing in these short Tractates may appeare difficult to the Ignorant" (31). Even *The Four Prentices*, strangely enough, promises access to a story that is only available in manuscript.[38] The various meditations on friendly classicism in the Age plays, then, speak not only to Heywood's immediate purposes but to a central component of his reputation.

Of course the position of mediator does bring with it a kind of ped-agogical authority, and Homer claims that power explicitly in *The Silver Age*:

> Why should not *Homer*, he that taught in *Greece*,
> Vnto this judging Nation lend like skill.
> And into *England* bring that golden Fleece,
> For which his country is renowned still. (B–Bv)

Like the Homer who "flourish'd in the worlds first infancy" and taught it to speak, this teaching figure seems poised to launch Heywood's project of popularizing classical texts into the realm of distinguished literary en-deavor (*Golden Age* B–Bv). And indeed the notion of Homer (and implicitly Heywood) bringing the golden fleece to England establishes the narration of this play as a heroic feat, one that *The Brazen Age* will celebrate in terms that link writing with alchemical powers.[39] But that pedagogical stance is emphatically undercut by Heywood's presentation of it in the printed ver-sion of *The Brazen Age*. After having implied in *The Silver Age* that Homer the great teacher was a hero on the scale of Jason, Heywood writes a preface to the next play in the series that reads like a curious non sequitur:

yet this is my comfort, that whatever imperfection [*The Brazen Age*] haue, hauing a brazen face it cannot blush; much like a Pedant about this Towne, who, when all trades fail'd, turn'd *Pedagogue*, & once insinuating with me, borrowed from me cer-taine Translations of *Ouid* ... [which] his most brazen face hath most impudently challenged as his own ... [but] they were things which out of my juniority and want of judgement, I committed to the view of some private friends, but with no purpose of publishing, or further communicating them. Therefore I wold entreate that *Austin*, for so his name is, to acknowledge his wrong to me in showing them, & his owne impudence, & ignorance in challenging them. But courteous Reader, I can only excuse him in this, that this is the *Brazen Age*. (A2)

This preface calls several of the strategies used within the Age plays them-selves into question. Pedagogy, a central reason for the existence of the plays in the first place, gets recast here as a grubby business to which Heywood's enemies turn when they fail to succeed in commerce. Sharing access to clas-sical works becomes a similarly shabby exercise in defending one's rights to a translation; the gracious exchange of texts among learned friends looks at this point more like an invitation to plagiarism.[40] Perhaps most surprisingly, Heywood's own play, which has as he says a "brazen face," is linked to the wrongdoing of the brazen Austin. Presumably Heywood's authorship and Austin's pirated translation alike are only possible in a fallen world. Even though Heywood elevates the play to the level of alchemy and pedagogy and

the sharing of texts, in the print version he resolutely un-idealizes pedagogy and the power of the classics. They become material, about literary property. Authors themselves – not just audiences, with their ruder judgments – are located firmly in the brazen age.

Authorship as Heywood presents it here is, in other words, anything but a neutral conduit for absolutist authority. On the contrary, authorship is an institution that spans the full range of ages. There is a golden form of authorship, somewhat problematically claimed by Homer, but that form is in contest with the brazen activities of writers like Heywood himself, who fashion themselves in print, in performance, in communities of authors, through and against plagiarism, for money. The writer who engages with the stage is not simply reproducing absolutist forms of authority, but neither is he simply subject to the whims of an acting company. Nor will the dichotomy between aggressive self-promotion in print on the one hand and powerlessness over the process of publication on the other account for all the forms of authorship we can see Heywood practicing here. All at once, Heywood takes up all of these stances: property and owner, sovereign and subject, principle of thrift and point of entry for material and social constraint. Moreover, these many forms of authorship are epitomized in the work of the actor. Such authority as Heywood claims has everything to do with actorly moments of self-fashioning, of gratifying an audience's desires, of negotiation and charisma. The final pages of this chapter turn to what is in some ways Heywood's most bathetic experiment in dramatic writing, *The Rape of Lucrece*. Though critics have long expressed bewilderment over the principles of composition Heywood used to write this play, its apparent success in print and on stage points toward Heywood's astute deployment of the mixed authority to which he had been laying claim throughout his career. Moreover, because the play would seem to push the contradictions between acting and authorship to the brink of incoherence, it rewards us with a particularly keen sense of the actor's place in early modern England.

"TRANSESHAPT TO A MEERE BALLATER"

The play's 1608 title page promises *The Rape of Lucrece. A True Roman Tragedy. With the seuerall Songes in their apt places, by Valerius, the merrie Lord amongst the Roman Peeres. Acted by her Maiesties Seruants at the Red Bull, neere Clarken-well. Written by Thomas Heywood*. The word "apt" in the title might be taken to indicate some uneasiness about the very presence of a merry lord singing songs in the Rome of Collatine and Tarquin, but in fact the word appears to be addressing an entirely different set of concerns.

Rather than explaining away the presence of comedy with a promise that it will only appear in inoffensive forms, that is, the title seeks to reassure potential buyers that they will find the songs just where they ought to be, that the text has been printed with an eye toward the authentic reproduction of the Red Bull performances. The songs appear not randomly throughout the play but exactly as the actor first performed them. That this is the title page's purpose is confirmed by a second address "To the Reader" at the end of the printed text:

Because we would not that any mans expectation should be deceived in the ample printing of this booke: Lo, (Gentle Reader) we have inserted these few songs, which were added by the stranger that lately acted *Valerius* his part in forme following. (K2)

The expectations that the printed text promises to meet are expectations not about decorum – much less about the author's artistic vision – but about a reader's access to that delightful music.

The play was printed five times between 1608 and 1638; the fourth edition (1630) adds four songs to the original thirteen, and the fifth (1638) weighs in with an impressive twenty-two opportunities for singing. Moreover, in the early editions (1608–30) the songs are carefully numbered, as if to emphasize their importance entirely apart from the content of the play. In the fifth impression (1638), new songs are clearly advertised as novelties; "She that denies me, I would have" in the 1638 edition, for instance, is printed as "The first new Song" (D3v). Clearly, the abiding pleasure of this text over thirty years is as a kind of musical miscellany, framed by an ostensibly edifying story. In fact, the title page of the 1638 impression offers *The Rape of Lvcrece, A true Roman Tragedy. With the severall Songs in their apt places, by* Valerius *the merry Lord among the Roman Peeres. The Copy revised, and sundry Songs before omitted, now inserted in their right places.* However chaotic the textual transmission of early modern drama tended to be, there was clearly great interest in getting the music right.

This growing musical incursion upon a "true Roman Tragedy" might be explained by the author's loss of control over the printed version of his text. Perhaps this is our expected narrative: that unscrupulous printers in collusion with a charismatic actor simply ignored Heywood's "literary" ambitions – more and more as the years went by – and used his writing as an excuse for publishing a songbook.[41] But such an expectation is thwarted by what little evidence we have about the source of the songs in the play. For it is not until the fifth printed version in 1638 that we can begin to be sure that we are reading one of Heywood's own lyrical compositions.

Editors have identified most of the songs from the previous editions as versions of tunes already popular in early modern England, but the fourth impression (1630) includes "Packe clouds away," a song Heywood used in *Pleasant Dialogues and Dramma's* as an epithalamion for William Waade. It also includes "The Spaniard loves his ancient slop," which appears in Heywood's *Challenge for Beauty*.[42] Of all the lyrics offered by the play's several printed editions, that is, neither of the two most likely to have been composed by Heywood himself appears before the fourth impression. Thus we are unable automatically to construe the print history of *Rape of Lucrece* as the story of a text mishandled by printers or players; instead we must be willing at least to consider the possibility that Heywood welcomed and/or participated in the addition of nine additional songs to a play already, by our standards, marred by its use as a springboard for musical delights.[43]

The play itself treats Valerius's lapse into song as the by-product of his high tragic interiority. Like Hamlet putting on an antic disposition to conceal his stratagems, Valerius takes on music as a crafty-mad expression of his discontent with the Tarquins. The play notes the oddity of his choice; when the lords gather to discuss the state of Rome, they marvel at Valerius's transformation:

> HORA. Nay can his thought shape ought but melancholly
> 　　To see these dangerous passages of state,
> 　　How is he tempered noble *Collatine*?
> COLLA. Strangely, he is all song, hee's ditty all,
> 　　Note that: *Valerius* hath given up the Court
> 　　And weand himselfe from the Kings consistory
> 　　In which his sweet harmonious tongue grew harsh,
> 　　Whether it be that he is discontent,
> 　　Yet would not so appeare before the King,
> 　　Or whether in applause of these new edicts,
> 　　Which so distaste the people, or what cause
> 　　I know not, but now hee's all musicall.
> 　　Vnto the Counsell chamber he goes singing,
> 　　And whil'st the King his willfull edicts makes,
> 　　In which nones tongue is powerfull save the Kings,
> 　　Hee's in a corner relishing strange aires.
> 　　Conclusively hee's from a toward hopefull Gentlemen,
> 　　Transeshapt to a meere Ballater, none knowing
> 　　Whence should proceed this transmutation.　　(525–42)

Like Hamlet and also like Livy's Brutus, who feigns idiocy to protect himself, Heywood's Valerius conceals some method behind his madness. Indeed, Valerius's singing may be at least partially recuperable as an effort

to temper melancholy.[44] But it is difficult to miss the sense of particular wonder occasioned by Valerius in the lines above. He has become not just a madcap but an actual balladeer, who sings wildly anachronistic and bathetic songs like the Scottish "Weele gang into the Kirk" (595–8) and a "Dutch" hit that features the refrain "Skerry merry, runke ede bunk ede hoore was drunke a" (1435). He sings them not in brief outbursts of apparent distraction, but in full-length, spotlight-hogging, crowd-pleasing performances. He is mixing, as Sidney would complain, "hornpipes and funerals."[45]

Acting less like Hamlet, that is, and more like Bottom, who wants to make *Pyramus and Thisbe* "more gracious" by singing his own ballad at the time of Thisbe's death, Valerius performs at moments of what should be high dramatic seriousness.[46] After debating among themselves how best to respond to the tyranny of the Tarquins, Brutus, Horatius, Valerius, Collatine, and Scevola reach something like a consensus that it is best, as Collatine says, "That what they cannot mend, seeme not to mind," rather than yielding publicly to the intensity of their feelings (986). Scevola admits that he has traded the wenching house for the statehouse, about which Valerius remarks "The more his safety, and the lesse his feare" (1008). The play having thus framed bawdry as a stoic response to oppression, Valerius then sings "The first new Song," the aforementioned "She that denies me, I would have," a ditty that expounds upon the joys of making love to women who resist. On the one hand, the rape logic of the song seems a parody of the wrongdoing that we all know Tarquin will soon commit. On the other hand, of course, the possibility that the song will please audiences in and of itself, without what used to be called "redeeming social value," is a real danger to the play's ostensible purpose.[47] As the title "The first new Song" indicates, there is every chance that readers will turn to the play because they want the lyrics, not because they are interested in subtle commentary on the misuse of force.

Not shying at all away from this apparent danger, the play pushes its own contradictions as far as possible. Just a page after the previous example, Valerius sings a song that lists representative women and evaluates them as possible conquests:

> *Oh the cherry lips of* Nelly
> *They are red and soft as jelly,*
> *But too well she loves her belly.*
> *Therefore ile have none of* Nelly.
> (1047–50)

Brutus's response is striking: "what hurt's in this *Horatius*? is it not better to sing with our heads on, then to bleed with our heads off?...come

Valerius, weel run over all the wenches of *Rome*, from the community of lascivious *Flora* to the chastity of divine *Lucrece*, come good *Horatius*" (1072–7). That Brutus should underscore the rapacious nature of Valerius's song, claiming it as a fit response to tyranny, becomes especially troubling when we consider that he has already figuratively placed Lucrece in the position of violated-spouse-turned-mythical-figure, on a par with Flora. In fact, immediately after Brutus speaks these lines the scene changes and Lucrece enters, cautioning her maid against loose behavior as if to confirm her status as a byword. Valerius's songs have already made Lucrece into the praiseworthy victim that Tarquin will later appear to create.

The disturbing parallels between Tarquin's crime and the lords' resistance reach their lowest point just before Lucrece reveals that the attack has taken place. Lucrece's clown has been sent to bring Collatine back from the camp, and has sworn not to reveal Lucrece's secret before she does. Horatius and Valerius nevertheless coax him to share the news:

VAL. If thou wilt not say thy minde I prethee sing thy minde, and then thou maist save thine oath.
CLO. Indeed I was not sworne to that, I may either laugh out my newes or sing em, and so I may save mine oath to my Lady. (2282–6)

The result of this clever logic is one of the more astonishing moments on the early modern stage. Valerius, the Clown, and Horatius sing together a catch that narrates comically what Lucrece has forbidden the clown to say:

VAL. *Did he take faire Lucrece by the toe man?*
HOR. *Toe man.*
VAL. *I man.*
CLOW. *Ha ha ha ha ha man.*
HORA. *And further did he strive to go man?*
CLOW. *Goe man.*
HOR. *I man.*
CLOW. *Ha ha ha ha man, fa derry derry downe ha fa derry dino.*
VAL. *Did he take faire Lucrece by the heele man?* (2296–305)

Beginning at her feet, the song moves metonymically toward rape, which it describes in a stanza that begins "*But did he do the tother thing man?*" and ends with "*And at the same had he a fling man*" (2337–41). Following this performance, as the stage directions tell us, the scene changes: "*A Table and a Chaire covered with blacke. / Lucrece and her Maid*" (2344–5).

Though Heywood has made numerous efforts to incorporate the purported musical pleasures of the balladeer into his text, all strategies would seem to break down at this moment. The clown, after all, has precious

little interest in the quasi-stoical framing that validated Valerius's earlier attempts at musical comedy. His participation is purely for the sake of gossip, a motive that threatens to make the play itself appear to be a guilty pleasure and calls into question the tragedy's efforts to legitimate Valerius's music. Work on the early modern culture of rape in England and the rest of Europe supports the notion that rape could be presented as comic or simply trivial in this period, a hypothesis that would at least begin to account for Heywood's willingness to align his play with Tarquin's brutality.[48] But those paradigms emphasize the class difference that structures the period's representations of sexual violence; this is Lucrece, after all, and she can be expected to merit more concern than common women did.[49] Even if a "low" perspective is being brought into contrast with high tragic chastity here, the discord is solidly jarring. There is of course a tradition of representing Lucrece comically, as described by Ian Donaldson.[50] Heywood himself translates an epigram from Beza that is critical of Lucrece at the end of *Pleasant Dialogues and Dramma's*.[51] Nevertheless, to bring that comic reading of her story within a few lines of Lucrece's private mourning is a view-shifting gesture for which the play never really accounts. And it is precisely this failure to be troubled about its own contradictions, ultimately, that makes *Rape of Lucrece* paradigmatic for Heywood's career and for early modern drama more generally. As demonstrated in the preface to *Gunaikeion*, in *Pleasant Dialogues and Dramma's*, in the relative weakness of Homer on stage, there is something about theatrical pleasure – and particularly something about the charisma of actors – that Heywood cannot keep himself from engaging, even when good taste dictates that he should distance himself from the popular and the histrionic.

In fact, the ease with which Heywood foregrounds theatrical pleasure in *Rape of Lucrece* is something like the ease with which his *Apology for Actors* makes claims for the dignity of theater that we might now consider irrational.[52] Writing that defense against a backdrop of cultural anxiety about the drama as a form of idolatry, for instance, Heywood blithely celebrates the "ancient dignity" of actors thus: "Tragedies had their first names from the oblations due to *Bacchus*."[53] I.G., in his *Refutation*, has an easy rebuttal: "[Plays] were first instituted amongst the fabulous Heathen Greekes . . . in honour of their Divell-Gods" (D). More amazingly, Heywood points out that Julius Ceasar was so taken with playing that he became an actor himself, becoming "so extremely carried away with the violence of his practiced fury, and by the perfect shape of the madnesse of Hercules, to which he had fashioned all his actiue spirits, that he slew him dead at his foot" (E3v). Idolatry, murder, and villainy are acceptable to Heywood

because the stage is its own legitimating force. Though *Rape of Lucrece* poses an insoluble problem of theatrical legitimation, that is, it does so in a way recognizable from Heywood's more conscious attempts to assert the dignity of playing. The difference is that *Lucrece* makes this appeal so problematic for modern readers that it challenges us to an explanation. Thus the final pages of this chapter will revisit the question of an actor's success before an audience; ultimately this is the great pleasure out of which Heywood creates authorship, a popularity that easily rivals the power of print to consolidate authorial prestige.

At various moments in this study, it has been crucial to try to imagine an actor's divided consciousness: the bond Nathan Field might have made with his audiences as he responds to the taunting he receives in *Bartholomew Fair*; Robert Armin's self-display as he performs the part of the witty fool who plays the natural in *Two Maides of More-clacke*; even the fictional representation of Sir Thomas More improvising an anti-Catholic part from *Lusty Juventus*. In each of these moments, Robert Weimann's foundational work on the subjectivity of the performer, discussed in the introduction to this book, has been an implicit guide to negotiating theatrical charisma. Speaking of the clown Launce in *Two Gentlemen of Verona*, Weimann notes:

His, indeed, is what Hegel called the "blessed ease of a subjectivity which, as it is sure of itself, can bear the dissolution of its own ends." For the comic tension between the ridiculousness of the object and the hilarity of the *Subjekt* of [Launce's leave-taking] speech is remarkable, and it points to the dramatic quality of its comic achievement.[54]

For Weimann, the remarkable feature of this comic performance is the comfort with which the actor playing Launce can become "the clowning object and the laughing subject of his own mirth and that of the audience" (p. 257). But what connection does the actor playing Valerius manage in this play, especially at the moment that he joins voices with the clown? How does he perform comic pleasure at Lucrece's devastation while registering on some level his position in a "True Roman Tragedy"? What might be the form of his subjectivity, blessed or otherwise? Somehow, his performance captivates his audiences so thoroughly that they will be paying for the written version of his act for another thirty years. Moreover, Heywood apparently fails to perceive any contradiction between this actor's astonishing work and his own grasping after classical authority in the presentation of *Lucrece*. Unlike Shakespeare's comic tour de force in *Two Gentlemen*, Valerius's performance is scripted in a way that gives us no reassuring "comic achievement," suggests

no masterful author in firm control of a charismatic actor's rapport with the audience.

We are, of course, free to imagine Red Bull audiences liking the songs of Valerius because they are stupidly funny, Heywood approving of their inclusion because they would make the play sell. This is, after all, Heywood's own explanation for the mingling of kings and clowns in *Gunaikeion*: some of his audiences like that sort of thing ("For they that write to all, must striue to please all" A4v). But we should finally say more about the audience's desires than Heywood does. "It sells" is, in the last analysis, an admission that the play taps into its culture in some unexplained way. We should, perhaps, imagine spectators who do not know why that song amuses them, who are themselves uncertain about the nature of the pleasure they derive from Valerius's presence. It is in considering this second possibility that we come closest to understanding the power of performance in early modern England, and thus to understanding the work that Heywood and his peers did so energetically in that culture. This is how we can begin to think about the singing actor and the humanist author wielding collateral forms of cultural authority. Such an understanding begins in the recognition that performance authority is in some ways ineffable. This study has argued, for instance, that Nathan Field's participation in *Bartholomew Fair* involves him in a subtle contest with Ben Jonson, one determined in part by Jonson's mockery of Field's father. Watching the play, however, some spectators will be unaware that Field's family history matters at all. Some will read the negotiation wrong. Field may behave in ways that are not legible to himself, much less to us, to Jonson, or to their audiences. And all of these factors may vary every time Field steps on stage to perform. There are traditions of performance that help to set the parameters for improvisation, but as actors and again as authors, Field and Jonson are working with a highly volatile substance, making exchanges for which they themselves can never fully account. No one discourse of authorship is enough to contain the multiple energies of performance.

Surely the point to notice is that early modern England was addicted to such undecidable contests. Audiences returned day after day to the theaters hungry not only for plots and poetry, not only for costumes, music and dance, but for the improvisations, the bodily dispositions, the tones of voice, that register an actor's relation to a play. They returned, among other reasons, to witness the rehearsal of agency in what appeared to be an open-ended contest. What they actually witnessed was in fact a deeply traditional practice, with plots, characters, styles of oration, and modes of improvisation that preceded the Renaissance, sometimes by many centuries.[55] But

to the extent that the self-referential performer appeared to be breaking the rules, speaking out of turn, crafting a play for himself, he allowed his audiences to witness the forces at work shaping their culture in a period of extraordinary mobility. Significantly, however, the pleasure that drew audiences to the early modern stage was not solely an impulse toward individualism. Clearly, audiences also returned to the theater to experience their own desires as shaping forces in an actor's improvisations, to watch the actor call attention to himself in tandem with their collective will. The transitional subjectivity embodied by a Robert Armin, the sense that he is simultaneously an individual celebrity and a communal figure, is the performance of a transition that was being undertaken by an entire culture as much as it was the work of a single comic actor.

But even as actors played out their relationships to scripts, even as audiences returned again and again to watch them, the twin media of print and performance were spelling out a partial resolution to the problem of cultural change. The logic of commodity – of self-possession, of private property – would come historically to dominate questions of agency. That logic found one of its origins in the impulse to purchase a seat in the theater, England's early capitalist enterprise, and it stretched out to encompass the desire for a printed souvenir of the actor's work. As has been argued throughout these chapters, however, we should read dramatic authorship not from the endpoint of this process of commodification, not from the point at which selling is naturalized as self-expression, genius, ownership, or sovereignty, but from within the process, while the forms of authorial engagement are being negotiated. Authors like Heywood were poised between the commodity and the contest, poised, that is, to speak with forms of authority we must labor to recover.

Coda: the Shakespearean silence

In *William Shakespeare: The Invention of the Human*, Harold Bloom provides a succinct explanation for his choice of authors: "The answer to the question 'Why Shakespeare?' must be 'Who else is there?' "[1] It is a tactic not easily adopted for a book on four unloved playwrights. Taken on their own, in fact, Bloom's comments could serve as sufficient cause for the present study, though not because the figures discussed in these pages have been at work inventing human nature. Quite the contrary: they were at work selling texts and performances that can help us dislodge the automatic association of authorship with idealist, ahistorical constructions of subjectivity. "Who else is there?" marks a determination to seal writing off from certain forms of the collective, the commercial, the performative, and the material, a determination against which this book is firmly aimed. Though the writers studied here are chosen in part for their ability to widen the horizons of scholarship on early modern drama, however, they constitute only a partial answer to Bloom's question. Even if we were to limit the sample to writers who were, or just might have been, actors, the theater of the period has much more to tell us about authorship.

To continue to read dramatic authorship in terms of performance might lead one to a figure like Robert Wilson, a professional clown whose allegorical plays show an extraordinary self-consciousness. In *Three Lords and Three Ladies of London*, Wilson writes about the recently deceased Tarlton; Wit, Will and Wealth discuss their relation to the famous player.[2] Like Wilson, William Rowley was also a comic actor, though he was much better known than Wilson for writing plays, both alone and in collaboration. In a prolific career, two moments of actorly self-representation stand out. In 1620, Rowley collaborates with Middleton on *The World Tost at Tennis*. The masque depicts the origins of monarchical authority, but it is Simplicity the clown, Rowley's part, who "had first possession" of the world.[3] After Middleton's dedicatory epistle in the printed version, Rowley adds an epistle to the reader, which he signs in character, as "Simplicity."[4] What

does it mean for Rowley as character, actor, and collaborating author to be depicted as the ground against which authority is derived? Is this a simple act of submission to James or a vertiginous meditation upon the relationships between sovereignty and performance? And what does it mean when Rowley's *All's Lost by Lust* (London, 1633) appears in print with a dramatis personae that identifies the clown role as "personated by the Poet" (AV)? Such a description suggests tantalizing possibilities for reading Rowley's clowns in light of his authorship. One might begin by considering Roger the clown in *A Woman Never Vext*, a figure who suggests repeatedly that he has misgivings about the heroine's predilection for suffering – and thus that he is out of sympathy with Rowley's entire plot.

One might, additionally, investigate authorship as constructed by yet another of the alleged subordinates against whom Ben Jonson positions himself, Richard Brome.[5] Like Field and Munday, Brome had the dubious distinction of being represented in one of Jonson's plays; he is the author's "man" described as lingering off stage in the Induction to *Bartholomew Fair*, listening in on the stage-keeper's speech.[6] The evidence about whether Brome was an actor is inconclusive, but Jonson's Induction does at least imply that he was known to theatrical audiences before he began writing plays himself. The facts of Brome's career are, like Rowley's, well known, but they need still to be analyzed as they pertain specifically to the construction of authorship in relation to performance. Such analysis might include Jonson's apparent pique at Brome's success as a playwright, his extraordinarily condescending "I taught you everything you know" poem of reconciliation in 1632, and Brome's own series of emphatically humble self-inscriptions, including this from the Prologue to *The Damoiselle*:

> Readers and Audients make good Playes or books,
> Tis appetite makes Dishes, tis not Cooks.
> But let me tell you, though you have the power,
> To kill or save; They're Tyrants that devoure,
> And Princes that preserve: He does not ayme,
> So much at praise, as pardon; nor does claime
> Lawrell, but Money.[7]

Like Armin, Brome consciously grants his audiences and readers a form of ownership over his texts, even while he admits his desire for profit. There is a clear interest in self-inscription, here, and, as in the works of Nathan Field, a determination to play against Jonsonian vocabulary. The prologue begins by referring to "Our Playmaker (for yet he won't be calld / Author, or Poet) nor beg to be installd / Sir Lawreat)" (A2).

Jonson himself, in a moment of classic aggression, plays with the pronunciation of Brome's name to link him to the cleaning implement. In the "Ode to Himself," appended to the 1640 edition of Jonson's *New Inn*, Jonson uses Brome as an emblem of debased attitudes in the theater, complaining that "Broomes sweepings doe as well / Thear as his Masters Meale."[8] We have paid too little attention to these descriptions of the author, as a graciously self-effacing, actively self-promoting, speaking broom, less exalted than Jonson but just as good in the theater. In Jonson's reading, and indeed often in Brome's own, he is a tool rather than an agent, a servant rather than a master, and a student rather than a teacher. All of the writers mentioned here can be seen to negotiate the theater's power in relation to the vicissitudes of print authorship; all of them defy the investment in authorial greatness that drives the question "Who else is there?"[9]

Bloom's question may on its own provide ample reason for looking at the neglected playwrights of the period, but we can also answer him by looking at a different Shakespeare from the one we have generally been given. Such a figure has in fact been taking shape in these pages even while his more aggressive peers have taken center stage. In fact, he has taken shape most clearly in relation to his famously aggressive fellow actors, the professional clowns. In the absence of direct statements from Shakespeare in prefaces or prologues, critics have turned to reading his use of the professional clown as some indicator of his authorial self-positioning, some way of hearing information in the Shakespearean silence. Shakespeare's apparent foreclosures upon popular tradition have seemed, in this line of reasoning, tacit attempts to make the dramatic author a sovereign controller of theatrical space, owner of his own words. Or, at very least, his texts are said to move the Chamberlain's Men away from clowning, toward respectability.[10] Shakespeare as antagonist to the improvising actor thus implicitly joins forces with Jonson the antitheatrical playwright, both reconceptualizing dramatic writing as an act increasingly amenable to absolutist authority and/or capitalist ownership. As noted in chapter 1, however, much of the evidence for Shakespeare's apparent rejection of unruly theatrical practices rests on a particular reading of Robert Armin's replacement of Will Kemp as company clown.[11] That change and its associated phenomena – the rejection of Falstaff (as played by Kemp), Hamlet's conservative articulation of the purpose of playing, Armin's more generally cerebral style of performance – give the appearance of a growing anti-histrionic bias in Shakespeare's writing. The present study has argued that Armin's written record cannot support the assertion that he avoided improvisation or direct address to the audience. Moreover,

both *Hamlet* and the Henriad have been found far too ambivalent in their handling of the clown's popularity to give us any kind of certainty about the dawning of a new author-centered theatrical esthetic.[12]

Rather than making an absolute claim for the opposite possibility, that Shakespeare was a clown-friendly writer and thus not interested in authorship, this book has opted for a two-fold response to such arguments. While stressing the ambivalence of the existing evidence for what Richard Helgerson has called a developing "authors' theater" in the 1590s, that is, the present study has also endeavored to take seriously the authorial potential in comic performance, proposing an alternative to the very actor/author split that structures the debate.[13] Thus the evidence that counted most in chapter I was evidence about Armin's own work as a writer and performer, not the evidence about whether Shakespeare was able to control him, or even interested in controlling him, on stage. At this juncture, however, to turn to Shakespeare's use of Armin in a more detailed way offers a chance to reconceptualize Shakespearean authorship as something more than, or different from, a Jonsonian move away from the necessary collaborations of the stage. Surrounded as he was by author-actors like Kemp and Armin, it would be surprising if Shakespeare had no models of authorial engagement available to him other than Jonson's.

Though it must be remembered that Shakespeare's silence is a real silence, unlikely to answer our various questions about authorship, Shakespeare's deployments of Armin do offer some tempting opportunities for speculation. Feste has, for instance, been spoken of as a character in *Twelfth Night* rather than a semi-autonomous, self-presenting performer.[14] It is true that Feste, like Touchstone, has a recognizable project, a narrative reason for interacting with the play's other characters, and what we might call a characteristic mode of address. It is also true that the conventions that govern the construction of character in early modern drama are elastic and difficult to reproduce. These considerations notwithstanding, some of the problems of Feste's characterization are ripe for reconsideration in light of recent work. Alan Sinfield has argued that character as we might recognize it is founded upon two structural principles: the suggestion of interior depth, often construed as the capacity to withhold information or the necessity of choosing between two dominant ideologies; and some unspecified measure of continuity, the sense that a character's interiority is not wantonly sacrificed in the interests of, say, comic expediency or an overwhelming need in the play for ideological closure.[15] Without asking Feste to meet the requirements of full-blown character criticism, we might nevertheless consider some of the discontinuities built into his role.

Twelfth Night makes much of Feste's unexplained absences. Orsino has to have him hunted down when he wants to hear "Come away, come away, death"; Olivia wants him taken away because he has failed to attend upon her household.[16] His response to Viola/Cesario's question about his place of residence has seemed to some critics to promise untold depths of subjectivity: "Foolery, sir, does walk about the orb like the sun; it shines everywhere" (3.1.30–1). As C. L. Barber puts it, "He never tells where he has been, gives no details. But he has an air of knowing more of life than anyone else – too much in fact."[17] But compare Barber's statement with David Wiles's description of Will Kemp in the role of Launcelet from *Merchant of Venice*: "There is no way of telling what Launcelet 'really' thinks and feels."[18] Wiles is describing a mixture of clever acting and the representation of folly, while Barber is reading depth into the character of Feste. But the distinction between clown as character (Armin) and clown as charismatic actor (Kemp) may ultimately be very slight. It is, after all, difficult to explain why the sense of subjective depth, if there is one, in Feste's remarks about folly should not be read as cultivation of the Armin mystique rather than construction of something we could recognize as character on stage. Feste's absences are characteristic, but not necessarily developed in a way that clearly distinguishes character from performer.

More problematically, Feste's absence from the famous letter-reading scene has caused critics to wonder whether the introduction of Fabian at that juncture is evidence of some kind of authorial revision or error. Stranger still, Feste appears in the play's final scene quoting speeches of Malvolio's that have been spoken in his absence (5.1.349–54). Such problems of continuity are of course not unusual in Shakespeare's plays, but two decades of critique in Shakespeare studies ought to make us pause before following Barber's lead and subsuming Feste's various appearances under the unifying rubric of character. The point here is emphatically not to rule out character or interiority as terms for analysis of early modern drama, but rather to ask whether we can define them well enough to read Shakespeare's use of Armin as a marker of historical or institutional change. There is enough unexplained work for Feste in *Twelfth Night* to suggest that charisma in the moment – his or Armin's – may overwhelm any pull toward continuous interiority.

Nor is it entirely correct to argue that Shakespeare's plot controls Feste more powerfully than previous comic roles controlled their interpreters. The gulling of Malvolio in the Sir Topas scene is a more intellectual exercise than Launce's famous "this shoe is my mother" routine in *Two Gentlemen of Verona*, but the fundamental sense of a comic performer's autonomous *act*

remains. Neither text mandates actorial improvisation; nor does either one preclude it. The Sir Topas scene is, as Maria points out, a superfluous action undertaken mostly for Feste's own pleasure, not driven by the exigencies of plot. If it appears tame within the context of *Twelfth Night*, that appearance derives not so much from Robert Armin's certain obedience to Shakespeare's text, but from the presence of Toby Belch and Andrew Aguecheek in the play, who supply whatever vulgarity Feste lacks. We might say, by analogy with Petruchio's famous attempt at controlling Kate: if *Twelfth Night* tames one comic actor it unleashes two more. Bawdy humor is ultimately out of sync with the Viola–Olivia–Orsino plot, but there is a difference between marking bawdry as out of place and avoiding its use as a form of theatrical pleasure. *Twelfth Night*, whatever its ultimate assessments of rough humor, maintains a clear investment in its comic figures as uncontrolled and un-controllable. Armin's intellectualism, especially given that it observes no more sense of decorum than Sir Toby's drinking, should not be taken on its own as a sign that the clown has been forced to obey the sovereign author.

One of the most compelling arguments made for the narrowing of comic autonomy in Shakespeare's plays is the absence, after Kemp's departure from the company, of a performer who would take over the stage to present a jig, which had a rough plot all its own and an esthetic not easily assimi-lated into respectable drama. David Wiles has demonstrated that the roles associated with Kemp tended to leave him out of the final scenes of comic reconciliation or dramatic closure, freeing him to return at the play's closing and begin his own bawdy dramatic project.[19] Surely such an appearance would have given Kemp an authority that rivaled Shakespeare's text; Feste's song at the end of *Twelfth Night* has nothing on the level of sheer spectacle that can compete with it. But before accepting Feste's scripted participa-tion in the ending of the play as evidence for a particular stand toward clowns in Shakespeare's later work, we ought to consider the manifest sense of incongruity the clown brings to this final scene. Precisely because he is not outside the script, Feste opens up possibilities within authorship as Shakespeare practiced it that speak loudly of the need to negotiate charis-matic performance.

In some ways the ending of *Twelfth Night* does look like a shutting-down of comic opportunity. While taking gleeful revenge against Malvolio, Feste has fallen out of step with the other characters in the play's second half. By the time Olivia asks to hear Malvolio's letter read in Act 5, Feste has become entirely unable to adjust himself to the comic needs of the moment. He reads the letter in his "mad" voice, which instead of pleasing his audience results in Olivia's exasperated demand that Fabian take over the job of

reading. Later Fabian confesses to his part in the scheme with the sober hope that

> no quarrel, nor no brawl to come,
> Taint the condition of this present hour,
> Which I have wondered at. (5.1.335–7)

The reconciliation of Viola and Sebastian has, Fabian suggests, rendered vulgar comedy distasteful. Feste demonstrates famously, however, that he suffers no such compunctions:

Why, "Some are born great, some achieve greatness, and some have greatness thrown upon them." I was one, sir, in this interlude, one Sir Topas, sir, but that's all one. "By the Lord, fool, I am not mad." But do you remember? "Madam, why laugh you at such a barren rascal? An you smile not, he's gagged." And thus the whirligig of time brings in his revenges. (5.1.349–54)

Quoting more of Malvolio's speech than he has heard, strangely determined to be "one" in a play – indeed in a career – that stresses his ability to be multiple, Feste/Armin is oddly out of step with the aura of wonder that Fabian seems to respect naturally.

If Feste's self-aggrandizing performances are out of step with his onstage audience, however, we should not assume that they are unhappily so. What looks like a lapse in Feste's comic judgment, or like an implicit critique of comic performance on the part of the text, may read equally well as a moment in which the clown engages his theatrical audience over the heads, as it were, of his fellow players. This would not be the first such moment in the play. When Malvolio chastises Olivia for enjoying Feste's routines, he calls attention to a two-part dynamic that is typical of Feste's major appearances (1.5.65–70). True, as Malvolio notes, "Unless you laugh and minister occasion to him, he is gagged" (1.5.67–8). But we might add, noting Malvolio's function in that very moment as an adjunct to Feste's appeal, Feste seems to need the assistance not only of a receptive audience but of an onstage adversary as well. Olivia appreciates Feste's humor at Malvolio's expense, articulating her own graciousness – "to be generous, guiltless, and of free disposition" – by condemning his condemnation of the clown's techniques (1.5.72). Perhaps this is a key to the audience's own reception of Armin's humor. When Feste performs as Sir Topas, his audience's delight is once again threatened, this time by Maria's observation that it was unnecessary for Feste to dress up: "Thou mightst have done this without thy beard and gown. He sees thee not" (4.2.48–9). In these moments, Feste's connection with an audience (the paying audience in the latter case, and the

paying audience plus Olivia in the former), appears to depend upon the threat of devaluation. When Olivia fails to appreciate Feste's mad reading of Malvolio's letter at the play's end, or when the other characters on stage are unable to share his brash spirit of self-promotion, Feste may not be failing as a comic; he may instead be consolidating a form of comic authority that has relied upon adversity from its first moments in *Twelfth Night*.

The reasons for this mixed form of comic pleasure must be more complex than a single theory of actor–author relations can establish. Like *Hamlet*, this play does seem to be negotiating a duel dramatic esthetic. If Hamlet's instructions to the players are oddly out of step with many of that play's own best moments, so too in *Twelfth Night* the logic of the romance plot is not the same as the logic of the clown performance. To acknowledge this split, as Robert Weimann has shown in his work on *Hamlet*, is not automatically to read Shakespeare's text as rejecting the pleasures of unruly acting.[20] On the contrary, it is to recognize what Weimann and others argue is a sense of open negotiation between high and low cultures on the early modern stage.[21] Though Olivia is no Prince Hamlet – there is no high tragic mode at stake here – *Twelfth Night* is nevertheless engaged in mixing romance with clowning, and Armin's complex power to please while courting displeasure is perhaps an effect of that experiment in dramatic forms. It bears repeating that this is a live contest, not a predetermined victory for elitism. But there are also aspects of clown performance more generally that can account for the adversarial structure of Feste's humor. As David Wiles has carefully documented, clowns often win audiences precisely through the cultivation of a threat to their comic powers; Tarlton loved to perform in jests that initially positioned him as a loser, and of course Armin specialized in "quips" and "interrogatories," building his wit out of the tension that comes with potential defeat.[22] Finally, we might pause to remember Foucault's assertion that "[t]exts, books, and discourses really began to have authors...to the extent that authors became subject to punishment, that is, to the extent that discourses could be transgressive."[23] If Armin is, as this study has contended, creating a form of authority analogous to that of the author, the resemblance between his embattled comic triumphs and Foucault's endangered writer are powerful ones.

There are, in short, many reasons to question previous descriptions of Armin as a clown brought under the control of Shakespeare's text. He is not the radically subversive figure that Kemp could sometimes be – though he appears at least once to have played Dogberry, which is assumed to be Kemp's role – but he may retain the clown's emphasis upon star performance at the expense of theatrical character.[24] His performances, moreover, follow

a kind of adversarial logic that makes it very difficult to tell the difference between an attack on clowning and a building-up of the clown's comic authority. But perhaps the most telling feature of Shakespeare's use of Armin in *Twelfth Night* has to do with what happens when Armin is not on stage. For the funniest performance in the play belongs not to Feste/Armin, but to the actor who plays Malvolio, who enters 3.4 with a comic build-up that would suit any theatrical clown. We know what his act will be (wooing Olivia ineptly), and how he will be dressed for the part (yellow stockings, cross-gartered). If anticipation is a key feature of clown performance, this play clearly sets up the actor who plays Malvolio to win an audience in the time-honored traditions of Tarlton and his peers.

Consider Joseph Hall's complaint in *Virgidemiarum* about the clown who "laughs, and grins, and frames his mimic face" in performance, courting the audience by stopping the action of the play to "show his teeth in double rotten row, / For laughter at his self-resembled show."[25] Perhaps Malvolio's teeth are in better shape, but very few actors play this scene, even today, without presenting the painful, crabbed, pathetically hopeful trademark Malvolio smile to an audience beside itself with laughter.[26] The comment about how cross-gartering causes "some obstruction in the blood" may be addressed to Olivia, but surely not without a misguided "insider's wink" to the paying spectators (3.4.19–21). Granted, Hall's disgust with theatrical display had to do in part with the clown's base physicality being juxtaposed with a representation of kings, while in some sense it is the goal of this scene to mock Malvolio's fantasy of mingling with his betters. But here, in a figure who stands for the end of festive mirth, is a wildly effective revival of what Weimann has famously called "laughing with the audience."[27] The "blessed" form of subjectivity that Weimann associates with such moments, in which the actor who plays the role unites with audiences at the expense of the character he plays, takes on a particularly powerful resonance when performed by Malvolio. For the traditions of clowning, with their gleeful breaking of the frame of realistic performance, are invoked here to bolster the performance authority of the comic actor who stages their very chastening.

Such moments in *Twelfth Night* can never account for all the ways that Shakespearean drama may or may not position itself in relation to the popular traditions of playing. It is of course well beyond the ambition of the present study to do so. But reconsideration of clowning in the play does provide a crucial reminder that the narrative of Shakespeare as a sanitizer of early modern drama has to answer to the hardy successes he scripts for the self-staging performer, even after Robert Armin has replaced Will Kemp

as the comic star. Comic authority can withstand even direct attacks like Malvolio's. It may require them. Comedy does a great deal more than survive in the mixed atmosphere of detraction and celebration that typifies *Twelfth Night*. After all, even after Feste has appeared to alienate Olivia and much of his onstage audience, the play still uses him as the spokesperson for the playing company.[28] The closing song positions Feste, against whom men "shut their gate," and who can "never thrive" by "swaggering," as the enduring principle of pleasure in the play and in the company more broadly (5.1.366–85). Both single, a loner, and able to speak for the collective "we" who will "strive to please," Armin/Feste marks a change in performance styles that is far too ambivalent – and handled far too ambivalently – to establish Shakespeare as even an implicitly actor-taming author. There is no jig at the end of this play, but neither Feste nor Malvolio is ready to give up the contest of mutual antagonism that has provided audiences with so much pleasure. Feste will strive to please us every day in the future, and Malvolio will be revenged on "the whole pack" (5.1.355). Who knows when Viola will get her dress from the sea captain?

Of course this brief treatment of Shakespeare raises more questions than it can answer, and there is still no real way of filling in his silence about authorship, no substitute for Heywood's loquacity or Field's self-promotions. Surely Shakespeare could have courted some form of personal celebrity; early in the 1590s he was handed an opportunity by Robert Greene and/or Henry Chettle, who singled him out as a "*Tygers hart wrapt in a Players hyde*," well launched in an upstart career as an actor-author.[29] After all, if Anthony Munday is any fair indication, bad press was no reason to abandon the profession of famous playwright. Shakespeare himself did not play that role, however he may have helped construct it for a player like Robert Armin. Perhaps, as Richard Dutton has recently argued, Shakespeare's failure to pursue fame as an author had to do with his simultaneous commitments to the "corporate ethos" of the Chamberlain's Men, the circulation of plays in manuscript, and aristocratic forms of anonymity in print.[30] What we can say with certainty is that when Shakespeare did at last get constructed as a kind of author we might recognize, his becoming so was not an individualistic gesture, nor did it exclude the concerns of the marketplace. It was, like so much of what Robert Armin did, a collective investment in individuality: the joint production of *Mr. William Shakespeares Comedies, Histories & Tragedies*, by his brother actors, Heminges and Condell.

The project of re-reading Shakespeare's plays in light of Armin's autonomy is, however, only a very partial response to the Shakespeare industry and its constructions of authorship. The larger problem remains; Bloom's

forgetting of everyone else is sometimes sadly mirrored by critics who would never align their politics with his. Whatever contributions the present study can make toward championing an interest in forgotten playwrights, perhaps it also offers a perspective from which to address the effect of Shakespeare's dominance. For though it may be Shakespeare's popularity that directs so much academic energy and so many resources toward the early modern drama, it is also Shakespeare's popularity that shapes the use of those resources. In the question of authorship, the influence has been particularly unhelpful. One last consideration of the uses of Shakespeare's silence is, then, a fit conclusion to a project determined to look elsewhere for its information about theatrical authorship in Renaissance England.

George Bernard Shaw wrote of the "seven ages of man" speech that in essence Shakespeare had hold of a brilliant notion: "Nothing is more significant than the statement that 'all the world's a stage.' The whole world *is* ruled by theatrical illusion."[31] In Shaw's view, however, Shakespeare, "with his usual incapacity for pursuing any idea, wanders off into a grandmotherly Elizabethan edition of the advertisement of Cassell's Popular Educator" (268). *As You Like It* creates a moment of theatrical self-consciousness, that is, but fails to move beyond sentimental abstractions. Obviously others have found more to recommend in Shakespeare's handling of the theatrical metaphor – and we could certainly point to Rosalind's epilogue as the source of some pointed observations about playing – but, as the previous pages have suggested, there is something to Shaw's cranky objection that can be taken seriously. It bears saying again: Shakespeare is astonishingly more anonymous and less specific in his references to theatricality than the other figures considered here. Where Armin would call attention to his own theatrical talents as the fool-author of the text that serves as the source for the fool-role that he plays – in fact this is too simple a description of Armin's presence in *Two Maids of More-clacke* – Shakespeare appears content to tell us that life is like a play. The heightened consciousness about theatricality in Shakespeare's plays calls attention to the fact of stage-playing, perhaps with the end of glorifying the Chamberlain/King's company, certainly with the effect of producing sophisticated metatheater. But we would be hard pressed to think of such moments in Shakespeare's writing as a direct form of self-promotion.

Famously, Shakespeare's dramatic texts, as distinct from his poetry, offer no prefaces, no epistle from the author, no Jonsonian contract with the audience. We have instead abstractions of theatrical production: vices and plotters, Gower, Prospero, choruses, mechanicals, the idea of the play, the

thematization of writing. Granted, if we knew with certainty which roles Shakespeare performed we might uncover some pattern of self-referentiality, but even the relative absence of such information indicates that Shakespeare never cultivated a star persona, never exploited the relationship between print and performance in the ways that Field or Armin did. To approach Shakespeare after studying the writers who figure prominently in this book, then, is to confront a striking paradox. Thus far it has been argued that the energetic self-promotions of actor-playwrights helped to construct a form of authorship grounded in performance, one that rivals the notion of the author as sovereign, subject, or owner. Capitalizing upon print as a form of publicity, these writers sought to make names for themselves. Yet for all the vigor with which Anthony Munday or Nathan Field pursued the project of celebrity authorship, they are virtually anonymous now. Critics can still struggle to get Nathan Field's name right, and yet the adjectival form of "Shakespeare" can stand in for the entire period in which these writers worked. The players who cultivated celebrity have been entirely upstaged by the player who appears to have avoided it.

No one would suggest that *Amends for Ladies* is a better play than *Hamlet*, but surely the disappearance of these so-called "minor" playwrights can be attributed to more than relative levels of talent. They are not Shakespeare, but they are also, emphatically, not uninteresting to study. In fact, it may be precisely because these writers are interesting and interested – because professional, economic, religious and political concerns mark their participation in literary culture so profoundly – that they have been excluded from later constructions of authorship. As authorship has become subsumed historically under the various rubrics of private and/or self-expressive subjectivity, the silent Shakespeare has provided opportunities for ideological cathexis that cannot be matched by his more aggressive colleagues. It is more than unnecessary to rehearse the long history of Shakespeare's rise to the status of silent icon here, but that history does present us with a particular challenge that needs to be addressed. For Shakespeare's avoidance of celebrity continues to exert an undue influence upon our thinking about dramatic authorship. In particular, Shakespeare's silence on the subject of his own career seems to have prompted, or at very least been particularly friendly to, the development of essentialist notions of authorial subjectivity. If essentialist subjectivity is on the one hand the ideology of the individual, it is also true, as Alan Sinfield notes, that "the counterpart of the individual is the universal; so while [traditional] characters are supposed to be essentially themselves, they end up reduced to an essential human nature – to *man*."[32] Or to shift Sinfield's terms onto the terrain of authorship: a

critic looking for high, post-romantic subjectivity in Shakespeare's career has no reason to be discouraged by lack of evidence. Indeed, Shakespeare's lack of specificity makes him a ready embodiment of self-expression in the abstract, a locus of human nature in its noblest form, with no Jonsonian signs of ambitious self-construction to mar the picture.

One moment from the earliest days of Shakespeare's career as an icon crystallizes the logic of his reputation in the centuries after his death; the terms it sets up are surprisingly apt for Shakespeare studies today. In *The Making of the National Poet*, Michael Dobson has documented a particularly striking instance of Shakespeare's silent adaptability as a figure of noble (and abstracted) authorial greatness. In response to a campaign that enlisted Alexander Pope, among others, a monument to Shakespeare was erected in Westminster Abbey in 1741, "conceived," Dobson explains, "by its sponsors as an affirmation of the national poet's resistance to ministerial corruption, but variously treated by contemporaries as a monument to Jacobite nostalgia, to female patronage, and to the supremacy of the study over the theatre."[33] When the statue was first unveiled it consisted of a gentrified and pensive Shakespeare leaning against a kind of pillar that held what appears to be Rowe's edition of his works, and pointing to a prominent unrolled scroll. The scroll was originally left blank, as though the great poet's most profound statement were in fact a wordless confirmation of the attitudes brought to Westminster Abbey by the beholder.

Apparently, the spectacle of a Shakespeare so plainly ready to give his assent to any and all ideological projects was too much for his devotees to bear, so that the blank scroll became, in printed engravings of the monument that appeared in various periodicals, the locus of witty poems that alternately bemoaned the statue's failure to make a specific statement or expressed plainly the anti-Walpole stance of the statue's original sponsors. Fearing, Dobson speculates, that the statue would become a "focus for sedition," the dean of Westminster ultimately had it engraved with some misquoted lines from *The Tempest*:

> The Cloud cupt Tow'rs,
> The Gorgeous Palaces,
> The Great Globe itself
> Yea all which it Inherit,
> Shall Dissolve;
> And like the baseless Fabrick of a Vision
> Leave not a wreck behind. (145–6)

It is particularly telling that the inscription finally chosen should cover over the potential for dissension with a reference to one of Shakespeare's

metatheatrical moments. Though Dobson argues importantly that Shakespeare figured for the eighteenth century in ways that are not reducible to a conservative agenda or to the workings of state power, we must note that the tendency to abstract from the plays their blandest sentiments about the theater confirms him as a figure for a shared English nobility. In fact, though these lines as spoken by Prospero provide a rich commentary on the physicality of actors, when taken unproblematically as Shakespeare's own musings they lose that force. "If you can't say nothing," Shakespeare seems to say, "tell them all the world's a stage." The effect of undiscriminating legitimation is furthered when, as Dobson tells us, the monument is reproduced as a perfume bottle and as a design for the twenty-pound note.[34] Early on in his career as a figure for human greatness, Shakespeare's silences and his meditations on the theatrical are virtually interchangeable.

Whether or not the absence of direct self-promotion is deliberate in Shakespeare's writings, it makes him the ideal candidate both for ideological contest and for the putative universality that covers that contest over. The effect is very close to Michael Bristol's reading of essentialist humanism:

Humanism actually specifies a content for the generic human condition that Shakespeare's plays reveal; the human condition is an ambiguous one and therefore the most sophisticated cognitive strategies are those that transcend partisan interests of every kind. In its weaker variants this celebrates a profound indecisiveness, even vacuousness, discovering in Shakespeare orientations to experience that are politically neutralized and culturally innocuous.[35]

In this sense, the process Dobson traces, which leads from controversy to blankness to commodification, seems almost a necessary way of confirming the function of the universal author. Even the briefest survey of Shakespeare's reputation in the centuries after his death upholds this reading of the impact of Shakespeare's silence, as a long parade of intellectuals – and a whole host of anti-Stratfordians – have all taken their turns paying homage to an ineffable core at the center of Shakespeare's works. As Marjorie Garber puts it, "'Shakespeare' is present as an absence – which is to say, as a ghost. Shakespeare as an author is the person who, were he more completely known, would not be the Shakespeare we know."[36]

But the history of the Shakespeare Monument tells us more than just the story of a figure whose brand of metatheatrical rumination provided a platform for later constructions of the essentialist author. On the contrary, that monument also comprises a warning for those who would rush to deconstruct authorship as we know it. In moving toward anti-essentialist critiques of authorship, that is, we have generally failed to recognize that essentialism is only half the problem. The other problem is Shakespeare.

If Shakespeare's relative silence about authorship has tended to feed the construction of the humanist subject and its various permutations, that same silence has also made it much too easy to dismiss authorship as an anti-dramatic phenomenon. There is, it seems, a deep and unacknowledged connection between Shakespeare's prominence in early modern studies and our failure to grasp authorship as some of the dramatists of the period constructed it.

Addressing the "Shakespeare myth" in the preface to a book by that name, Graham Holderness makes a claim that illustrates the problem of trying to understand early modern dramatic authorship through the lens of Shakespeare's later prominence:

The true content of that myth, which can be decoded from a long history of intellectual struggle around the problem of identity, is that the concept of individual authorship on which most Shakespeare criticism is based is a misleading way of addressing the work of an Elizabethan/Jacobean dramatist; perhaps, following Foucault, a mythical concept in itself.[37]

Of course the mythical notion of authorship that has dominated the Shakespeare industry is wildly misleading as a tool for analyzing the drama of the sixteenth and seventeenth centuries, but note the easy slide here from a Shakespeare-centered fallacy to an implicit dismissal of individual authors in Renaissance drama *per se*. In no way should we discount the important work done in recent decades to emphasize the inherent collaborative nature of early modern dramatic writing, but as the preceding chapters have argued, particular forms of personal celebrity developed on stage in this period did in fact carry over into print authorship. The notion of the individual author may indeed be "mythical," then as now, but early modern England was no more immune than we are to the creation of myths. The material conditions of the stage and of print publication – however powerful they may be when aimed at idealist versions of authorial production – are never entirely constitutive of the discourses of authorship.

We must, then, leave room for constructions of the author that reconfigure the collaborative stage in order to make room for developing forms of personal charisma. Granted, it does seem clear that the kinds of top-down models cultivated by Ben Jonson or the University Wits have at least a tactical antitheatricality at their rhetorical core, and it is similarly clear that the collaborative systems of dramatic production and publication militate against an absolutist sense of authorial control. But the admittedly urgent need to critique Shakespeare as humanist author has led to a curious impasse. As long as we focus on Shakespeare, we are prompted to see

the options for dramatic authorship in early modern England as a kind of great subject/no subject binary. Having agreed that an immortal, mysterious Shakespeare is the creation of later epochs – however that creation might build on suggestions given (or withheld) by Shakespeare himself – we have tended to focus again on Shakespeare's silence as our counter-evidence. Thus studies of authorship have often moved from assertions that the essentialist Shakespeare is anachronistic to blanket statements about the absence of authorial self-inscription in Renaissance drama.[38] To the extent that such studies overlook the bold forms of self-display practiced with shameless ingenuity by Shakespeare's colleagues, they must inevitably reproduce the very dominance of Shakespearean silence that they set out to undermine. Our task as scholars, finally, should be something more than the endless reinscription of Shakespeare's monument, even if we intend our message to be iconoclastic. We have done well to recognize the death of the author; now we need to acknowledge that his remains, like those of the historical Shakespeare, lie outside the gates of Westminster Abbey.

Notes

INTRODUCTION: PLAYING AUTHOR

1 See David Wiles, *Shakespeare's Clown: Actor and Text in the Elizabethan Playhouse* (Cambridge University Press, 1987), pp. 136–44.

2 Wiles notes initially that we can imagine the poems in *Quips* either as collaborative or as spoken entirely by Armin, but he then goes on to describe the book's preface in ways that support the notion of Armin's solo performance (*Shakespeare's Clown*, pp. 138–9).

3 See for instance, among the many studies on this subject: Joseph Loewenstein, "The Script in the Marketplace," *Representations* 12 (1985), 101–14, and "For a History of Literary Property: John Wolfe's Reformation," *English Literary Renaissance* 18 (1988), 389–412; Jeffrey Masten, *Textual Intercourse: Collaboration, Authorship, and Sexualities in Renaissance Drama* (Cambridge: Cambridge University Press, 1997); Mark Rose, *Authors and Owners* (Cambridge, MA: Harvard University Press, 1993); Martha Woodmansee, *The Author, Art, and the Market: Rereading the History of Aesthetics* (New York: Columbia University Press, 1994); and the essays in Martha Woodmansee and Peter Jaszi, eds. *The Construction of Authorship: Textual Appropriation in Law and Literature* (Durham: Duke University Press, 1994). In tracing the development of authorship alongside changes in the Stationers' Company, particularly with regard to patents and royal authority, Loewenstein's latest work richly anticipates the desire expressed in the current study to talk about authorship before the Statute of Anne. I regret that his extensive contributions appear too late for a full response in these pages. See *The Author's Due: Printing and the Prehistory of Copyright* (University of Chicago Press, 2002) and *Ben Jonson and Possessive Authorship* (Cambridge University Press, 2002).

4 Foucault, "What is an Author?" in *The Foucault Reader*, ed. Paul Rabinow (New York: Pantheon Books, 1984), pp. 101–20; p. 101; Barthes, "The Death of the Author," in *The Rustle of Language*, trans. Richard Howard (New York: Hill and Wang, 1986), pp. 49–55.

5 Alexandra Halasz has done path-breaking work on this subject, studying the ways in which Tarlton's name circulated in print. See " 'So beloved that men use his picture for their signs': Richard Tarlton and the Uses of Sixteenth-Century Celebrity," *Shakespeare Studies* 23 (1995), 19–38, and *The Marketplace of Print:*

Pamphlets and the Public Sphere in Early Modern England (Cambridge University Press, 1997), pp. 65–70.

6 Margreta de Grazia's remarks on *Lear* are very helpful here: "There is a way in which seeing the Renaissance as the Early-Now commits itself to the very universalizing tendency that historicizing set out to avoid in the first place" ("The Ideology of Superfluous Things: *King Lear* as Period Piece" in *Subject and Object in Renaissance Culture*, eds. Margreta de Grazia, Maureen Quilligan, and Peter Stallybrass (Cambridge University Press, 1996), pp. 17–42; p. 21).

7 See for example Catherine Belsey, *The Subject of Tragedy: Identity and Difference in Renaissance Drama* (London: Methuen, 1985). In *The Tremulous Private Body: Essays on Subjection,* Francis Barker states the matter succinctly: "Pre-bourgeois subjection does not properly involve subjectivity at all, but a condition of dependent membership" [(London: Methuen, 1984), p. 31].

8 In Belsey's well-known reading, *The Duchess of Malfi* registers a "not-yet fully differentiated" sense of subjectivity (*Subject of Tragedy*, p. 39). I am inclined to agree with Alan Sinfield that "Belsey is slightly too insistent on banishing agency and meaning from the dramatis personae of early modern plays" [*Faultlines: Cultural Materialism and the Politics of Dissident Reading* (Berkeley: University of California Press, 1992), p. 60].

9 "To the Reader," *Gunaikeion: Or Nine Bookes of Various History Concerning Women: Inscribed by the names of the Nine Muses* (1624), A4v.

10 In *Shakespeare the Actor and the Purposes of Playing*, Meredith Skura forges powerful connections between acting and authorship (University of Chicago Press, 1993).

11 *Shakespeare and the Popular Tradition in the Theater: Studies in the Social Dimension of Dramatic Form and Function*, ed. Robert Schwartz (Baltimore: Johns Hopkins University Press, 1978), p. 257.

12 Wiles, *Shakespeare's Clown*, p. 74. Weimann also discusses Kemp as the performer here, mostly insofar as he represents a more profound degree of incorporation into Shakespeare's dramatic structure than in the clown tradition generally (*Shakespeare*, p. 258). In "Performing at the Frontiers of Representation: Epilogue and Post-Scriptural Future in Shakespeare's Plays," Weimann considers Kemp's difficult relationship with the Lord Chamberlain's company [*The Arts of Performance in Elizabethan and Early Stuart Drama: Essays for George Hunter*, ed. Murray Biggs, Philip Edwards, Inga-Stina Ewbank, and Eugene M. Waith (Edinburgh: Edinburgh University Press, 1991), pp. 96–112; p. 107]. See also "Bifold Authority in Shakespeare's Theatre," *Shakespeare Quarterly* 39:4 (1998), 401–17; 405–6.

13 See Max W. Thomas, *"Kemps Nine Daies Wonder*: Dancing Carnival into Market" for a discussion of Kemp's commodification of his own performances [*PMLA* 107 (3), 511–23].

14 In his poverty Kemp is something of an exception to the rule of the comic actor's prosperity (Wiles, *Shakespeare's Clown*, p. 41).

15 "A common Player" (1615), in E. K. Chambers, *The Elizabethan Stage*, 4 vols. (Oxford: Clarendon Press, 1923), vol. 4, p. 257.

16 Some of the many works to take up the reputations of actors in this period are Jonas Barish, *The Antitheatrical Prejudice* (Berkeley: University of California Press, 1981); Muriel C. Bradbrook, *The Rise of the Common Player* (Cambridge MA: Harvard University Press, 1962); Laura Levine, *Men in Women's Clothing: Anti-Theatricality and Effeminization, 1579–1642* (Cambridge University Press, 1994); Louis Montrose, *The Purpose of Playing: Shakespeare and the Cultural Politics of the Elizabethan Theatre* (University of Chicago Press, 1996); Joseph R. Roach, *The Player's Passion: Studies in the Science of Acting* (Ann Arbor: University of Michigan Press, 1993); Skura, *Shakespeare the Actor*, esp. chapter 2; William B. Worthen, *The Idea of the Actor: Drama and the Ethics of Performance* (Princeton University Press, 1984).

17 In addition to the work of Halasz and Thomas cited above, see Leo Braudy, *The Frenzy of Renown: Fame and its History* (Oxford University Press, 1986), pp. 315–61; Rosemary J. Coombe, "Author/izing the Celebrity: Publicity Rights, Postmodern Politics, and Unauthorized Genders," in Woodmansee and Jaszi, eds., *The Construction of Authorship*, pp. 101–32.

18 For a trenchant analysis of these issues, see Donald E. Wayne, "*Drama and Society in the Age of Jonson*: An Alternative View," *Renaissance Drama* 13 (1982), 103–29.

19 *Worlds Apart: The Market and the Theater in Anglo-American Thought, 1550–1750* (Cambridge University Press, 1986), esp. chapters 1 and 2.

20 *Subject and Object*, p. 4.

21 Amsterdam: Da Capo Press (1973), A3.

22 On the stigma of print, see J. W. Saunders, "The Stigma of Print," *Essays in Criticism* 1 (1951), 139–64; Arthur Marotti, *Manuscript, Print, and the English Renaissance Lyric* (Ithaca: Cornell University Press, 1995); Wendy Wall, *The Imprint of Gender: Authorship and Publication in the English Renaissance* (Ithaca: Cornell University Press, 1993).

23 Among many others, see Abbe Blum, "The Author's Authority: *Areopagitica* and the Labour of Licensing," in *Re-Membering Milton: Essays on the Texts and Traditions*, ed. Mary Nyquist and Margaret W. Ferguson (New York: Methuen, 1987), pp. 74–96; and Annabel Patterson, *Censorship and Interpretation: The Conditions of Writing in Early Modern England* (Madison: University of Wisconsin Press, 1984).

24 Douglas Brooks reads Heywood's comments in something like this fashion, and I would agree that Heywood is often taking aim at Jonson. See below, p. 187 [Douglas Brooks, *From Playhouse to Printing House: Drama and Authorship in Early Modern England* (Cambridge University Press, 2000), pp. 201–3]. See also Heather Hirschfeld, "Collaborating across Generations: Thomas Heywood, Richard Brome, and the Production of *The Late Lancashire Witches*," *Journal of Medieval and Early Modern Studies* 30:2 (2000), 339–74; 347.

25 See for example Jonathan Goldberg, *James I and the Politics of Literature: Jonson, Shakespeare, Donne and their Contemporaries* (Stanford University Press, 1989), and Masten, *Textual Intercourse*.

26 *The Stage and Social Struggle in Early Modern England* (London: Routledge, 1994), p. 83.

27 See the works of Weimann cited above for a very rich working out of the relations between stage practices and authority.

28 In many ways, this argument is in accord with the one made by Jeffrey Masten in *Textual Intercourse*. Even as Masten argues that the absolutist author began to appear on stage and in print in the early years of the reign of James I, he positions that figure in relation to a theatrical milieu and a print medium that in many ways resist the formulation. See especially chapter 3, "Representing Authority."

29 "Spenser's Domestic Domain: Poetry, Property, and the Early Modern Subject," in *Subject and Object*, de Grazia, Quilligan, and Stallybrass, eds., pp. 83–103; p. 93.

30 Quoted in Edwin Nungezer, *A Dictionary of Actors and of Other Persons Associated with the Public Representation of Plays in England before 1642* (New Haven: Yale University Press, 1929), p. 191.

I PUBLISHING THE FOOL

1 Mark Rose, *Authors and Owners*, p. 1.

2 Joseph Loewenstein, "For a History," and "The Script." See also Martha Woodmansee's *The Author*.

3 Gerald Eades Bentley, *The Profession of Dramatist in Shakespeare's Time, 1590–1642* (Princeton University Press, 1971); Loewenstein, "The Script"; Jeffrey Masten, *Textual Intercourse*; Stephen Orgel, "What is a Text?" in *Staging the Renaissance: Reinterpretations of Elizabethan and Jacobean Drama*, ed. David Scott Kastan and Peter Stallybrass (New York: Routledge, 1991), pp. 83–7; p. 84.

4 B2v. All references to *Foole upon foole* are taken from J. P. Feather, *The Collected Works of Robert Armin* (New York: Johnson Reprint Corporation, 1972).

5 Masten, *Textual Intercourse*, p. 64.

6 I am of course deeply indebted to the research of David Wiles at this moment and throughout my discussion of Armin (*Shakespeare's Clown*, esp. pp. 136–63).

7 *Thalia's Banquet*, 1620. Quoted in Edwin Nungezer, *A Dictionary*, pp. 362–3. See also David Mann, *Elizabethan Player*, p. 56.

8 "[W]hether they paid, stamped their way in, or entered freely is still unclear" (p. 47). The nature of the clown's performance after the play varies from Tarlton's extemporizing to Kemp's jigs, and presumably Armin's quips (Wiles, *Shakespeare's Clown*, p. 43). Wiles also contends that Armin, who seems not to have danced, was a less autonomous presence than Kemp at the end of a typical play, but as Wiles's own observations about *Quips upon Questions* make clear, he also engaged in extensive improvising with his audiences in the tradition of Tarlton at one stage in his career (pp. 55–6, 138).

9 See Margreta de Grazia, *Shakespeare Verbatim: The Reproduction of Authenticity and the 1790 Apparatus* (Oxford: Clarendon Press, 1991), pp. 14–48, for a

discussion of the 1623 Folio as a construction of Shakespeare. See also Leah S. Marcus, *Puzzling Shakespeare: Local Reading and Its Discontents* (Berkeley: University of California Press, 1988), pp. 1–25.

10 See for example Wiles's assertion that "While the idea that a performer's art could shape Shakespeare's writing has long run against the grain of the literary critical tradition, the idea that Armin was an intellectual influence has found a ready welcome." Wiles does go on to note that "Because he set himself up as a writer, Armin did not perceive that there was any necessary tension between the purposes of the dramatist and the purposes of the actor/clown" (*Shakespeare's Clown*, p. 136).

11 *Forms of Nationhood: The Elizabethan Writing of England* (University of Chicago Press, 1992), p. 199 and chapter 5 throughout.

12 MacCabe, "Abusing Self and Others: Puritan Accounts of the Shakespearian Stage," *Critical Quarterly* 30:3 (1988), 3–17; Palmer, "William Kemp's *Nine Daies Wonder* and the Transmission of Performance Culture," *Journal of Dramatic Theory and Criticism* 5:2 (1991), 33–47; Wiles, *Shakespeare's Clown*, pp. 35–6, pp. 116–35.

13 Helgerson refers to Armin's fool in these terms (*Forms of Nationhood*, p. 223).

14 Wiles, *Shakespeare's Clown*, pp. 53–7, pp. 38–9.

15 Nor is the lack of class indicators in Armin's performances a definite sign of his company's solidarity with the wealthy. As has often been noted, Tarlton and Kemp could inspire laughter at rustics even while they played rustics (Helgerson, *Forms of Nationhood*, pp. 216–18; Wiles, *Shakespeare's Clown*, pp. 70–2).

16 Wiles, *Shakespeare's Clown*, pp. 12–16. Wiles also notes that although Tarlton always represented himself as impoverished, his mother brought a complaint after his death that £700 was assigned incorrectly in his will (p. 12).

17 Expulsion is all but implied in most accounts, but the term is actually used in MacCabe, "Self and Others," p. 13. See Richard Dutton's analysis of Kemp's departure in *Licensing, Censorship and Authorship in Early Modern England: Buggeswords* (Houndmills: Palgrave, 2000), pp. 34–5. Dutton reads Armin's "allowed fool" roles as reflections of the Chamberlain's Men's relationship to official censorship.

18 See Max W. Thomas, "Kemps Nine Daies," for a discussion of Kemp's commodification of his own performances [*PMLA* 107:3 (1992), 511–23].

19 Wiles, *Shakespeare's Clown*, pp. vii–x. Helgerson appears to read Hamlet's instructions as unironic (*Forms of Nationhood*, p. 223). See Robert Weimann's meditations upon the complexities of this scene in *Author's Pen and Actor's Voice: Playing and Writing in Shakespeare's Theatre* (Cambridge University Press, 2000), ch. 6. See also David Mann's study of the enduring importance of unruly clowns well into the seventeenth century (*Elizabethan Player*, p. 58).

20 See T. J. King's skeptical review of Wiles's suggestion that Kemp must have played Falstaff in *Shakespeare's Clown: Actor and Text in the Elizabethan Playhouse* (review), *Shakespeare Quarterly* 39:4 (1988), 518–19.

21 Robert Weimann, *Shakespeare and the Popular Tradition*, ed. Robert Schwartz (Baltimore: Johns Hopkins University Press, 1978), p. 237.

22 We ought, of course, to be considering the Chamberlain's/King's entire reper-
tory here, but because Shakespeare is generally billed as the chief cause and/or
beneficiary of Kemp's expulsion, I focus briefly upon his drama.

23 *The Riverside Shakespeare*, ed. G. Blakemore Evans (Boston: Houghton
Mifflin, 1974), 1.2.195–6. See Janet Hill's careful study of what she calls "open
address" in the history plays and in Shakespeare's career more generally [*Stages
and Playgoers: From Guild Plays to Shakespeare* (Montreal and Kingston: McGill-
Queen's University Press, 2002), pp. 109–60 and throughout].

24 See David Mann's important resistance to reading Armin as "evidence of some
general tendency" [*The Elizabethan Player: Contemporary Stage Representations*
(London and New York: Routledge, 1991), p. 58].

25 Wiles, *Shakespeare's Clown*, p. 16; Halliwell, ed. *Tarlton's Jests and News Out of
Purgatory* (London: Shakespeare Society, 1844), p. xxvi.

26 Wiles, *Shakespeare's Clown*, pp. 147–50. See also Sandra Billington, *A Social
History of the Fool* (New York: St. Martin's Press, 1984), pp. 4–5).

27 *The Player's Passion* (Ann Arbor: University of Michigan Press, 1993), p. 27.

28 *The Body Embarrassed: Drama and the Disciplines of Shame in Early Modern
England* (Ithaca: Cornell University Press, 1993), p. 20.

29 For a fascinating study of the fool's power to speak in multiple voices, see
William Willeford, *The Fool and His Scepter* (Chicago: Northwestern University
Press, 1969), esp. chapter 3, "The Fool and Mimesis."

30 To the extent that Armin keeps the boundaries between himself and his audi-
ences fluid, he maintains what Michael D. Bristol describes as a property of
carnival, the habit of "[eliminating] the social boundary or proscenium that
separates performer from onlooker" [*Carnival and Theater: Plebeian Culture
and the Structure of Authority in Renaissance England* (New York: Methuen,
1985), p. 65].

31 See Halasz's important article, " 'So beloved,' " to which my discussion of clowns
as authors is indebted throughout. Halasz also sees the clown's name as standing
in for a form of cultural production, though the emphasis in her argument is
on the circulation of Tarlton's name by the book trade after his death. Tarlton
is for Halasz a particularly powerful conserving figure in the expanding print
market. Armin is fascinatingly unlike Tarlton, however, in his manipulation of
his own name, during his lifetime, to represent a tradition of live performance
which he also unabashedly represents as collaborative.

32 Michel Foucault, "What is an Author?" pp. 101–20; p. 118.

33 David Wiles quotes an account of fooling from Kenilworth in 1575 that is par-
ticularly interesting for the argument I am developing here: "Hereat everyone
laughed agood, save the minstrel; that though the fool were made privy all was
but for sport, yet to see himself thus crossed with a country cue that he looked
not for, would straight have given over all, waxed very wayward, eager and sour.
How be it, last, by some entreaty and many fair words, with sack and sugar, we
sweetened him again, and after he came as merry as a pie" (*Shakespeare's Clown*,
pp. 19–20).

34 See for example, Olive Mary Busby, *Studies in the Development of the Fool in the
Elizabethan Drama*: "As higher dramatic ideals began to prevail, the dramatists

seem to have realized that the only way to prevent the clown from spoiling their plays was to develop his part more fully themselves, and to connect it as closely as possible with the main action" [(London: Oxford University Press, 1923, reprinted 1973), p. 26].

35 See Halasz, " 'So beloved' "; see Thomas, "Kemps Nine Daies," 521, on the relations between carnival and the marketplace.

36 On celebrity, see Halasz, " 'So beloved' " and Rosemary J. Coombe, "Author/izing the Celebrity."

37 See Halasz, " 'So beloved,' " throughout, and also Muriel Bradbrook's survey of Tarlton's career in *The Rise of the Common Player*, pp. 162–77.

38 (B) in Feather, *Collected Works of Robert Armin*, vol. 1. Halasz; " 'So beloved,' " pp. 23–8.

39 See Feather's introduction to *Tarlton's News*.

40 Though Kemp was referred to as "Iestmonger and Vice-gerent generall to the Ghost of Dicke Tarlton" in the dedication to *An Almond for a Parrat*, as a clown-author, Armin's celebrity too is in part constructed for him by the functioning of Tarlton's name in the medium of print [*The Works of Thomas Nashe*, ed. Ronald B. McKerrow (Oxford: Basil Blackwell, 1958), vol. 3, 341]. Dana E. Aspinall sees in Armin's work a tendency to distance himself from Tarlton, but the evidence she gives from *Quips upon Questions* is partial. The full text of "Where is Tarlton" suggests a stronger tribute than the two lines Aspinall quotes ["Robert Armin" in *Fools and Jesters in Literature, Art, and History: A Bio-Bibliographical Sourcebook*, ed. Vicki K. Janik (Westport, Connecticut: Greenwood Press, 1998), p. 43].

41 See Enid Welsford, *The Fool: His Social and Literary History*, for a discussion of the fool as wielding special powers (London: Faber and Faber, 1935), pp. 76–112 and throughout. For a discussion of "the characterology of 'genius,' " see Ernst Kris, *Psychoanalytic Explorations in Art* (New York: International Universities Press, 1952), p. 64. I am indebted to Meredith Skura for this reference.

42 Billington, *Social History*, pp. 32–6.

43 Welsford, *The Fool*, p. 282.

44 Billington, *Social History*, pp. 32–6.

45 Though I have been reading Armin's form of authority as implicitly a challenge to absolutist authorship, much could be said about the fine line between Armin's shared individuality and the "vile participation" that Joel Altman identifies in *Henry V* [" 'Vile Participation': The Amplification of Violence in the Theater of *Henry V*," *Shakespeare Quarterly* 42 (1991), 1–32]. See also Anthony Dawson's quasi-liturgical use of the term in Paul Yachnin and Anthony Dawson, *The Culture of Playgoing in Shakespeare's England: A Collaborative Debate* (Cambridge University Press, 2001), pp. 20–9.

46 C. All references to *Quips upon Questions* come from the Feather *Collected Works*.

47 See Wiles, *Shakespeare's Clown*, p. 139, and Muriel Bradbrook, "Robert Armin and *Twelfth Night*," in *Shakespeare, Twelfth Night: A Casebook*, ed. D. J. Palmer (London: Macmillan, 1972), pp. 222–43.

48 Wiles, *Shakespeare's Clown*, p. 138.

49 Ibid., pp. 144–58.

50 *Foole upon foole* was printed in 1600 and again in 1605. Armin revised the pamphlet as *A nest of ninnies* in 1608.

51 Aspinall, "Robert Armin," p. 44; Alexander Liddie, *An Old-Spelling, Critical Edition of The History of the Two Maids of More-Clacke* (New York: Garland Publishing, 1979), pp. 5–7; Wiles, *Shakespeare's Clown*, p. 137.

52 Armin was mentioned by Nashe and Harvey as a prominent pamphlet writer (see Aspinall, "Robert Armin," p. 42), and in the dedication to his *True Discourse of the Practices of Elizabeth Caldwell* (London, 1604) he mentions his service to Lord Chandos.

53 In many ways the logic of Armin's appropriation of Jack resembles the logic of enclosure, the making private of what was once public. See Bradbrook, *Rise of the Common Player* (pp. 17–115). See also Robert Weimann, *Shakespeare and the Popular Tradition*, pp. 53–4, however, on professional playing as itself a response to the enclosure of land. See also Michael Bristol, *Carnival and Theater*, pp. 3–7, pp. 200–4.

54 One of the poems in *Quips upon Questions* seems to reach toward this model of authorship. "A Poet Pawnde" conjurs up a vision of Armin himself, "Writing these Embles [sic] on an idle time" (cited above p. 30). While writing, the Armin persona meditates upon the ethics of a poet's having pawned his wit (c–cv).

55 See Halasz, " 'So beloved,' " and Masten, *Textual Intercourse*, p. 93.

56 Wiles reviews this period, in which *Foole upon foole*, *Two Maids*, and Armin's poem *The Italian Tailor and his Boy* all seem to be repackaged as bids for aristocratic patronage (*Shakespeare's Clown*, pp. 140–4).

57 B4v. All references to *Nest of ninnies* are from the Feather *Collected Works*.

58 See Masten for the ways in which this language is more constitutive of absolutist authorship than the term "metaphor" can convey (*Textual Intercourse*, pp. 63–73). See Rose, *Authors and Owners*, p. 41, for a discussion of the eventual conflict between notions of authorial property and notions of authorial begetting.

59 Max W. Thomas describes early modern literary property more generally as a kind of self-conscious theft ["Eschewing Credit: Heywood, Shakespeare, and Plagiarism before Copyright," *New Literary History* 31:2 (2000), 277–93; see also Loewenstein, *Ben Jonson*, pp. 74–84.

60 See Aspinall, "Robert Armin," p. 47 for a discussion of the affection between fools and aristocrats in Armin's work.

61 104. All references to *Two Maids* are taken from Liddie's edition. See Mary Bly's important argument about the genesis of this text in *Queer Virgins and Virgin Queans on the Early Modern Stage* (Oxford: Oxford University Press, 2000), pp. 47–52. See also Loewenstein, *Ben Jonson*, p. 49.

62 See, for instance, John Middleton Murry, "Notes on Shakespeare," in *The New Adelphi* (March 1928), 251–3.

63 See Liddie, *Two Maids*, pp. 13–24.

64 Oh eyes! no eyes, but fountains fraught with tears;
 Oh life! no life, but lively form of death;
 Oh world! no world, but mass of public wrongs,
 Confused and filled with murder and misdeeds.

[The Spanish Comedy, *or*] The First Part of Hieronimo *and* The Spanish
Tragedy [*or* Hierinomo is Mad Again] ed. Andrew S. Cairncross (Lincoln:
University of Nebraska Press, 1967), 3.2.1–4. Noted in Liddie, *Two Maids*,
p. 271. See also *Two Maids*, scene xxi, in which Tutch again quotes Hieronymo
in conjunction with his own name: "Ile fit ye sir, tis here, I am tutch right, hic
& vbique, euery where" (*Two Maids*, 79–80; *Spanish Tragedy*, 4.1.70). Noted
in Liddie, *Two Maids*, p. 202.

65 Wiles suggests that Armin may have revised the text of the play for printing, in
 which case the lack of interest in the actual language is all the more remarkable
 (*Shakespeare's Clown*, p. 143).

66 Wiles, *Shakespeare's Clown*, pp. 143–4.

67 Dutton Cook, "Robert Armin," *Dictionary of National Biography*, ed. Leslie
 Stephen and Sidney Lee, vol. 1 (New York: Macmillan, 1908), p. 559.

68 A4. References to *The Valiant Welshman* are from John S. Farmer, ed., Tudor
 Facsimile Texts (New York: AMS Press, 1913).

69 "What is an Author?" p. 101.

2 THE ACTOR-PLAYWRIGHT AND THE TRUE POET

1 "What is a Text?" pp. 83–7; pp. 83–4.

2 Barish, *The Antitheatrical Prejudice*, pp. 132–54; Helgerson, *Self-Crowned
 Laureates: Spenser, Jonson, Milton, and the Literary System* (Berkeley: University
 of California Press, 1983), pp. 101–84; Rowe, *Distinguishing Jonson: Imitation,
 Rivalry, and the Direction of a Dramatic Career* (Lincoln: University of
 Nebraska Press, 1988), esp. chapter 1; Loewenstein, "The Script," p. 273; see also
 Loewenstein, *Ben Jonson*, for a rethinking of these issues.

3 See the above-mentioned critics, n.2, and also Jonathan Goldberg, *James I*. In
 Forms of Nationhood, Richard Helgerson suggests that high dramatic author-
 ship is linked to the efforts of individual playwrights to cater to monarchs,
 and that such catering ultimately produces an "authors' theater" in the 1590s
 (pp. 199–204). See, however, Louis Montrose, *The Purpose of Playing*, pp. 77–8.

4 William Peery lists Field's acknowledged collaborations, *The Jeweler of
 Amsterdam* (1617, lost), and *The Fatal Dowry*, with Massinger (1617). He also
 lists attributed collaborations as follows: *Four Plays* (1612), *The Honest Man's
 Fortune* (1613), *The Queen of Corinth* (1617), and *The Knight of Malta* (1618)
 [*The Plays of Nathan Field* (Austin: University of Texas Press, 1950), pp. 322–3].
 As discussed below, there has also been some debate about Field's possible
 participation in the revised *Bussy D'Ambois*.

5 Some notable exceptions include Anthony B. Dawson, "Mistress Hic and
 Haec: Representations of Moll Frith," *Studies in English Literature* 33:2 (1993),

385–404); Suzanne Gossett " 'Best men are molded out of faults': Marrying the Rapist in Jacobean Drama," *English Literary Renaissance* 14:3 (1984), 305–27; Donald Hedrick, " 'Be Rough With Me': The Collaborative Arenas of *The Two Noble Kinsmen*," in *Shakespeare, Fletcher, and* The Two Noble Kinsmen, ed. Charles H. Frey (Columbia: University of Missouri Press, 1989), pp. 45–77; Theodore Leinwand, *The City Staged: Jacobean Comedy, 1603–13* (Madison: University of Wisconsin Press, 1986), pp. 183–4. See also Kathleen McLuskie's reading of Field's dedicatory prefaces in "The Poets' Royal Exchange: Patronage and Commerce in Early Modern Drama," *Yearbook of English Studies* 21 (1991), 53–62.

6 Nevertheless, we should consider Field understudied. The Modern Language Association cd-rom bibliography lists his name as "Nathaniel," which as Florence Brinkley pointed out in 1924 is the name of Nathan Field's brother [*Nathan Field, the Actor-Playwright* (New Haven: Yale University Press, 1924), pp. 10–14]. One still sees incorrect references to Nathaniel Field in contemporary criticism.

7 Alan Sinfield has recently argued that Jonson himself, at least in *Poetaster*, is inscribing a "critical authorial function" ("*Poetaster*, The Author, and the Perils of Cultural Production," *Renaissance Drama* 27 (1996), 3–18; 8). In so arguing Sinfield is implicitly building on the logic of earlier arguments, notably including Don E. Wayne, *Penshurst: The Semiotics of Place and the Poetics of History* (Madison: University of Wisconsin Press, 1984). See also Martin Elsky, *Authorizing Words: Speech, Writing, and Print in the English Renaissance* (Ithaca: Cornell University Press, 1989), pp. 81–109.

8 David Wiles has used this vision of actors to re-examine Shakespearean authorship in very useful ways (*Shakespeare's Clown*), as has Stephen Orgel in "What is a Text?" For a sustained analysis of the relationships between performance and texts in the modern era, see W. B. Worthen, *Shakespeare and the Authority of Performance* (Cambridge University Press, 1997).

9 Important work has been done on comic actors in relation to print authorship. In addition to Wiles, *Shakespeare's Clown*, see Alexandra Halasz, " 'So beloved,' " and *The Marketplace of Print*. See also Max W. Thomas, "*Kemps Nine Daies*."

10 See *Textual Intercourse*, especially chapter 2, "Between Gentlemen."

11 "The Theatre Constructs Puritanism," in *The Theatrical City: Culture, Theatre and Politics in London, 1576–1649*, eds. David L. Smith, Richard Strier and David Bevington (Cambridge University Press, 1995), pp. 157–69; p. 163. See also Graham Perry, "The Politics of the Jacobean Masque," in *Theatre and Government under the Early Stuarts*, ed. J. R. Mulryne and Margaret Shewring (Cambridge University Press, 1993), pp. 87–117; p. 107.

12 See Leah Marcus, *The Politics of Mirth: Jonson, Herrick, Milton, Marvell, and the Defense of Old Holiday Pastimes* (University of Chicago Press, 1986), pp. 38–63. See also her important revision of these arguments in "Of Mire and Authorship," in Smith, Strier and Bevington, eds., *The Theatrical City*, pp. 170–81.

13 The phrase is taken from Scott Cutler Shershow, *Puppets and Popular Culture* (Ithaca: Cornell University Press, 1995).

14 Herford, C. H., and Simpson, Percy and Evelyn, eds., *Ben Jonson*, 11 vols. (Oxford: Clarendon Press, 1938), vol. 6, 5.3.48–52. All further references to the play are taken from this edition and appear parenthetically in the text.

15 Keith Sturgess, *Jacobean Private Theatre* (London: Routledge, 1987), p. 173.

16 Roberta Florence Brinkley, *Nathan Field, the Actor-Playwright* (New Haven: Yale University Press, 1924), pp. 1–8; Patrick Collinson, "John Field and Elizabethan Puritanism," in *Godly People: Essays on English Protestantism and Puritanism* (London: The Hambledon Press, 1983), pp. 335–70; H. C. Porter, *Puritanism in Tudor England* (London: Macmillan and Co., 1970), pp. 115–21.

17 John Field, *A Godly Exhortation* (London, 1583) cv. See also John Field's letter to the Earl of Leicester in 1581: "And I humblie beseech yor honor to take heede howe yow gyve yor hande either in euill cawses, or in the behalfe of euill men as of late yow did for players to the greate griefe of all the Godly" (reprinted in Brinkley, *Nathan Field*, pp. 148–50).

18 This passage was brought to my attention by Bryan Crockett, *The Play of Paradox: Stage and Sermon in Renaissance England* (Philadelphia: University of Pennsylvania Press, 1995), p. 103. See Collinson, "John Field and Elizabethan Puritanism," and "The Theatre Constructs Puritanism." See also Kristen Poole, *Radical Religion from Shakespeare to Milton: Figures of Nonconformity in Early Modern England* for a detailed analysis of the process by which the stage came to caricature reformers (Cambridge University Press, 2000), esp. chapters 1–3.

19 Peery, *Plays of Nathan Field*, p. 3.

20 See Kathleen Lynch on the "calendar and geographic places of the paired initial performances of this play" ["The Dramatic Festivity of *Bartholomew Fair*," *Medieval and Renaissance Drama in England* 8 (1991), 128–45; 128].

21 Smith et al., eds., *Theatrical City*, p. 160. Elsewhere, Collinson stresses Field's anonymity, but clearly after 1593 Field's work for reform was well documented ("John Field and Elizabethan Puritanism," p. 335).

22 See Collinson's many references to Richard Bancroft in *The Elizabethan Puritan Movement* (Berkeley: University of California Press, 1967). See also Stuart Barton Babbage, *Puritanism and Richard Bancroft* (London: SPCK, 1962) and Albert Peele, *Tracts Ascribed to Richard Bancroft* (Cambridge University Press, 1953).

23 *Dangerous Positions and Proceedings*, 1593 (Netherlands: Theatrum Orbis Terrarum, 1972).

24 *Survay of the Pretended Holy Discipline* (London, 1593), p. 369.

25 Sturgess gives no reference for the quote from John Field, and Herford and Simpson do not mention John Field at all in connection with Busy's speech. Note that Bancroft consistently translates the Latin in his text, which indicates that he intended it for the widest possible audience.

26 Marcus, *Politics of Mirth*, p. 28.

27 "The Ecclesiastical Policies of James I and Charles I," in *The Early Stuart Church, 1603–1642*, ed. Kenneth Fincham (Stanford University Press, 1993), p. 27.

28 Peele, *Texts Ascribed*, p. xxix.

29 Collinson notes that Edmunds was an unreliable witness (*Elizabethan Puritan Movement*, p. 426).

30 I have been unable to find explicit contemporary references to the familial relationship between John Field and Nathan Field. As a family, however, the Fields seem to have been unusually well known; not only are John Field Sr. and Nathan Field public figures, but another son, Theophilus, became Bishop of Hereford in 1635 (a development that adds to the bizarre irony of the Field family saga). Theophilus is mentioned as "Field the player's brother" in a letter by Thomas Larkin in 1619 [James Birch, *The Court and Times of James I*, 2 vols. (London, 1848), vol. 2, p. 167]. He had become chaplain to James in 1609. It seems likely that the family connections of a rising cleric might have been known, perhaps even by Richard Bancroft. Finally, given that the names of the brothers other than Theophilus were John, Jonathan, Nathan, and Nathaniel, their family connections may have been singularly difficult to disavow in the relatively close-knit societies of the stage or the church.

31 See Sturgess, *Jacobean Private Theatre*, pp. 177–8, and Peery, *Plays of Nathan Field*, p. 19, for a discussion of Field's actual role in the play.

32 What is at stake for Field in this theatrical moment is what Robert Weimann has called the "relations to the social whole." In *Shakespeare and the Popular Tradition*, Weimann argues that the actor who is able to call attention to himself as an actor while staying in character is performing a supremely comfortable subjectivity, one able to contemplate its own dissolution (p. 257). In the contest between ironic performance and self-damnation that Jonson demands of Field in *Bartholomew Fair*, abjection and secure celebrity are doing battle.

33 See for example Brinkley, *Nathan Field*, pp. 71–80. Peery works at establishing that Field is less derivative than other critics accuse him of being (*Plays*, pp. 34–46).

34 See Collinson's interesting speculations about the possibility that Jonson's own father was a minister (Smith et al., eds., *Theatrical City*, pp. 159–60). See also David Riggs, *Ben Jonson, A Life* (Cambridge, MA: Harvard University Press, 1989), p. 9.

35 *The Remonstrance of Nathan Field*, ed. J. O. Halliwell-Phillipps (London, 1865), p. 8.

36 Dympna Callaghan has discussed the potential for abuse in the boy companies in *Shakespeare Without Women: Representing Gender and Race on the Renaissance Stage* (New York: Routledge, 2000), pp. 49–74.

37 See Stephen Orgel, *Impersonations: The Performance of Gender in Shakespeare's England* (Cambridge University Press, 1996), pp. 64–8; Gerald Eades Bentley, *The Profession of Player*, pp. 113–46.

38 See Brinkley, *Nathan Field*, pp. 18–22; Orgel, *Impersonations*, pp. 66–7; Harold Newcomb Hillebrand, *The Child Actors: a Chapter in Elizabethan Stage History* (Urbana: University of Illinois Press, 1926), pp. 160–3.

39 See Hillebrand, *Child Actors*, p. 160, for the details of the Clifton suit.

40 Bentley, *Profession of Player*, pp. 129–34.

41 David Lee Miller traces the logic of father–son relationships in Jonson's "On my First Sonne," *Freud's Interpretation of Dreams*, and Lacan's *Four Fundamental Concepts*. Anne Barton, cited in Miller, notes Jonson's preoccupation with sons and with children in general, referring strikingly to the Cary-Morison ode and the additions to the *Spanish Tragedy* that she attributes to Jonson ["Writing the Specular Son: Jonson, Freud, Lacan and the K(not) of Masculinity," in *Desire in the Renaissance: Psychoanalysis and Literature*, eds. Valeria Finucci and Regina Schwartz (Princeton University Press, 1994), pp. 233–60]. See also Miller, "Writing," p. 237 and David Riggs, *Ben Jonson*, pp. 91–2, on the relation between kidnapping and death in the Pavy epitaph.

42 Brinkley, *Nathan Field*, pp. 21–2, p. 39. Peery describes Field as the "leader and official representative of his company" at the time *Bartholomew Fair* was first performed (*Plays of Nathan Field*, p. 19). See also E. K. Chambers, *The Elizabethan Stage*, vol. 2, pp. 316–18.

43 "Jonson's Early Entertainments: New Information from Hatfield House," *Renaissance Drama* 1 (1968), 153–66; 161.

44 *Ben Jonson's* Volpone *or* The Fox, ed. Henry De Voght from the Quarto of 1607 (Louvain: Librairie Universitaire, 1937), pp. 350–3.

45 *The Faithful Shepherdess*, ed. Cyrus Hoy, in *The Dramatic Works in the Beaumont and Fletcher Canon*, gen. ed. Fredson Bowers, 10 vols. (Cambridge University Press, 1976), vol. 3, pp. 1–3.

46 Peery, *Plays*, p. 70.

47 A. R. Braunmuller notes that Field may have been revising Chapman's *Bussy D'Ambois* near the time that he wrote *Amends for Ladies* ["Chapman's *Bussy D'Ambois* and Field's *Amends for Ladies*," *Notes and Queries* 26, 5 (1979), 401–3]. See Heather Hirschfeld's discussion of mentoring relationships that appear to have obtained among playwrights in "Collaboration across Generations," p. 341 and throughout.

48 In this sense, Field seems to me to offer a challenge to Jeffrey Masten's sense of homoerotic collaboration in the early modern theatrical milieu. Seen from the vantage point of Field, the bonds of gentlemanly friendship that characterize the authorial community are in fact strictly hierarchical, scarcely less so than Jonson's more properly absolutist and individualistic formulations (*Textual Intercourse*, esp. chapter 1).

49 For an extended working-out of the Freudian dynamics of Jonson's poetic circle, see Victoria Silver, "Totem and Taboo in the Tribe of Ben: The Duplicity of Gender and Jonson's Satires," *ELH* 62 (1995), 729–57.

50 Peery, *Plays*, p. 68.

51 Wendy Wall has studied the implicit offer of membership in elite poetic circles that accompanies the purchase of a poetic miscellany, and I see some such logic working here as well. See especially her chapter 1, "Turning Sonnet."

52 Field's complicated relationship to the women in his audiences resonates with his status as a kind of puppet; Scott Shershow has argued that "puppets frequently evoke figural associations of femininity or effeminacy" (*Puppets and Popular Culture*, p. 105, pp. 66–86).

53 There is of course the possibility that Field played women's roles as a boy actor, but since he was part of a boy company, that possibility is by no means certain. Malone's assertion, unsupported by evidence, seems to be the source of most claims that he did so. See Peery, *Plays of Nathan Field*, p. 8, n. 53, for a summary of the positions taken by critics and editors.

54 We know, of course, that women were an important part of the audience for the plays of this period, but we have no specific factual information about the percentage of women who counted themselves among Field's fans. As interesting as Field's apparent connection to female audiences is, I want to leave open the possibility that his appeal was to male and female viewers and readers alike, and that he was characterized as "for women" by writers like Jonson and Chapman who cultivated elite reputations. See Dympna Callaghan's important argument about the early modern habit of ascribing audience credulity to women (*Shakespeare Without Women*, pp. 139–65). See Jean Howard, *The Stage and Social Struggle*, for analysis of the presence of women in audiences, esp. chapter 4.

55 *Epicoene* was written in 1609; Field appears on the actors' list for the play (Peery, *Plays*, p. 14).

56 The concept of mimeticism is derived from Luce Irigaray: "To play with mimesis is... for a woman to try to recover the place of her exploitation by discourse, without allowing herself to be simply reduced to it. It means to resubmit herself... to 'ideas,' in particular to ideas about herself, that are elaborated in/by a masculine logic, but so as to make 'visible,' by an effect of playful repetition, what was supposed to remain invisible" [*This Sex Which is Not One*, trans. Catherine Porter with Carolyn Burke (Ithaca: Cornell University Press, 1985), p. 76]. See also Karen Newman's adaptation of Irigaray to *Taming of the Shrew* in *Fashioning Femininity and English Renaissance Drama* (University of Chicago Press, 1991), pp. 46–8. Whatever Lady Perfect's motives in this particular scene, we do know from her earlier actions (especially in 2.2) that she is capable of feigning affection for her husband in public. She also seems possessed of an extraordinary metatheatrical insight: "Oh men! what are you? why is our poore sexe / Still made the disgrac't subiects, in these plaies?" (2.2.106–7).

57 Field's dedication of *Woman is a Weathercock* suggests, as does external evidence, that *Amends for Ladies* was already written and performed when *Weathercock* was first printed, even though *Amends* itself did not appear in print until 1618. See Peery, *Plays*, pp. 143–5.

58 *The Dramatic Works of Thomas Dekker*, ed. Fredson Bowers, 4 vols. (Cambridge University Press, 1962), 4.3.174. Further references are to this edition, appearing parenthetically in the text.

59 See Fredson Bowers, "Ben Jonson the Actor," *Studies in Philology* 34 (1937), 352–406.

60 "Of Mire and Authorship," p. 177.

61 Robert C. Evans reads Jonson's vulnerability in the plays in *Ben Jonson and the Poetics of Patronage* [(Lewisburg: Bucknell University Press, 1989), pp. 246–68].

62 See Paul Yachnin's account of Jonson's implication in performance and commercialism in *Stage-Wrights: Shakespeare, Jonson, Middleton, and the Making of Theatrical Value* (Philadelphia: University of Pennsylvania Press, 1997), pp. 48–51.

63 Certainly the "apologeticall Dialogue" to *Poetaster*, featuring "the Author," and the Induction to *Bartholomew Fair*, which mentions the presence of "the Poet" or of his "man," Richard Brome, extend the logic I have been developing here (C. H. Herford and Percy and Evelyn Simpson, eds., *Ben Jonson*, vol. 4, pp. 317–24, and vol. 6, p. 13).

64 For an interesting response by theater practitioners to the notion of Jonson as antitheatrical, see *Ben Jonson and Theatre: Performance, Practice and Theory*, ed. Richard Cave, Elizabeth Schafer, and Brian Woolland (London: Routledge, 1999). See also Richard Helgerson's discussion of the parallels between acting and authorship in Jonson's *Every Man Out of His Humor* (*Self-Crowned Laureates*, pp. 138–9).

65 G4v. In *Historia histrionica an historical account of the English stage by James Wright 1699. A short discourse of the English stage by Richard Flecknoe 1644.* Introductory notes by Peter Davison (New York: Johnson Reprint Corporation, 1972).

66 Thanks to Katherine Rowe for bringing this debate to my attention. See George Parrott, *The Plays of George Chapman*, 2 vols. (New York: Russell and Russell, 1910), vol. 1, p. 541. See Rowe's discussion in "Memory and Revision in Chapman's *Bussy* Plays," *Renaissance Drama* 31 (2002), 125–52.

67 "The Date of Chapman's *Bussy D'Ambois*," *Modern Language Review* 3 (1908), 137.

68 The key texts in this debate are Parrott, *Plays of George Chapman*; Thomas Marc Parrot, "The Date of Chapman's *Bussy D'Ambois*"; Peter Ure, "Chapman's 'Tragedy of Bussy D'Ambois': Problems of the Revised Quarto," *Modern Language Review* 48 (1953), 257–69; Nicholas Brook, ed. *Bussy D'Ambois* (London: Methuen, 1964), pp. lx–lxxxiv; Albert H. Tricomi, "The Revised Version of Chapman's *Bussy D'Ambois*: A Shift in Point of View," *Studies in Philology* 70 (1973), 288–305, "The Revised *Bussy D'Ambois* and *The Revenge of Bussy D'Ambois*: Joint Performance in Thematic Counterpoint," *English Language Notes* 9 (1972), 253–62; A. R. Braunmuller, "Chapman's 'Bussy D'Ambois' and Field's 'Amends for Ladies' [*Notes and Queries* 26 (1979), 401–3]. As Tricomi points out, Brooks's suggestion that Field had a major part in the revised *Bussy* seems to overlook Ure's persuasive argument. Braunmuller notes Field's possible engagement with the intellectual content of Chapman's play.

69 *The Plays and Poems of Philip Massinger*, 5 vols. (Oxford: Clarendon Press, 1976), vol. 1, p. 1.

70 Of course Masten's important challenge to attribution studies should be remembered here, as well as his insistence that collaboration be central to our vision of early modern dramatic authorship (*Textual Intercourse*, esp. chapter 2).

3 ANTHONY MUNDAY AND THE SPECTACLE OF MARTYRDOM

1 *A second and third blast of retreat from plaies and theatres* (1580), p. 104. William Ringler argues that the tract was "quite certainly" authored by Munday [*Stephen Gosson: A Biographical and Critical Study* (Princeton University Press, 1942), pp. 26–8, p. 71].

2 Among the many discussions of these issues, see Jonas Barish, *The Antitheatrical Prejudice*.

3 Stephen Gosson, *Plays confuted in five actions* (1582) G3v.

4 Thomas Alfield, *A True reporte of the death... of M. Campion Jesuite* (1582), E.

5 There is no shortage of evidence to suggest that Munday did in fact deserve his reputation for duplicity. Among other telling documents, see his will, in which he confesses that he had lied to his wife about the condition of his estate when marrying her [Celeste Turner, *Anthony Munday: An Elizabethan Man of Letters* (Berkeley: University of California Press, 1928), pp. 170–1]. See also Philip J. Ayres, *Anthony Munday: The English Roman Life* (Oxford: Clarendon Press, 1980), p. xvii, n. 9.

6 See Robert Weimann, *Authority and Representation in Early Modern Discourse*, regarding the new forms of authority that the Reformation generally made available to early modern writers [ed. David Hillman (Baltimore: Johns Hopkins University Press, 1996), pp. 4–5 and throughout].

7 Sir Thomas More, *A Play by Anthony Munday and Others. Revised by Henry Chettle, Thomas Dekker, Thomas Heywood and William Shakespeare*, ed. Vittorio Gabrieli and Giorgio Melchiori (Manchester: Manchester University Press, 1990), p. 8. Gabrieli and Melchiori characterize those who oppose the attribution of the majority of the play to Munday as "a few extravagant exceptions."

8 To begin a survey of the debates over authorship of this text, see Peter Blayney, "*The Booke of Sir Thomas Moore* Re-examined," *Studies in Philology* 69 (1972), 167–91; Scott McMillin, *The Elizabethan Theatre and the Book of Sir Thomas More* (Ithaca: Cornell University Press, 1987); and the essays in *Shakespeare and 'Sir Thomas More': Essays on the Play and its Shakespearean Interest*, ed. Trevor Howard-Hill (Cambridge University Press, 1989).

9 Gabrieli and Melchiori, *Sir Thomas More*, p. 31; Crewe, *Trials of Authorship*, ch. 2.

10 (3.1.192–5). References to *Sir Thomas More* are taken from Gabrieli and Melchiori, and will appear parenthetically in the text.

11 Gabrieli and Melchiori, *Sir Thomas More*, p. 196.

12 On the staging of this play in general and the manipulation of theatrical space in this scene in particular, see McMillin, *Elizabethan Theatre*, pp. 103–5. See also Charles R. Forker and Joseph Candido, "Wit, Wisdom, and Theatricality in *The Book of Sir Thomas More*," *Shakespeare Studies* 13 (1980), 85–104.

13 See Michel Foucault, *Discipline and Punish: The Birth of the Prison*, trans. Alan Sheridan [(New York: Random House, 1979), pp. 32–69]; Elizabeth Hanson, *Discovering the Subject in Renaissance England* (Cambridge University Press, 1998), pp. 24–54; Katharine Eisaman Maus, *Inwardness and Theater*

in the English Renaissance (University of Chicago Press, 1995), pp. 78–81. See Weimann, *Authority and Representation*, pp. 83–9 on the power of conscience in this period. See Molly Smith, *Breaking Boundaries: Politics and Play in the Drama of Shakespeare and his Contemporaries* (Aldershot: Ashgate Publishing, 1998) on the mutual implications of corporal punishment and theatrical practice during this period (pp. 7–14).

14 For a summary of the relationship between city and court, see Louis Montrose, *The Purpose of Playing*, pp. 53–65. See also E. K. Chambers, *The Elizabethan Stage*, vol. 1, pp. 269–307 and vol. 4, pp. 259–345; Scott McMillin and Sally-Beth MacLean, *The Queen's Men and their Plays* (Cambridge University Press, 1998), pp. 8–10.

15 Gabrieli and Melchiori, *Sir Thomas More*, pp. 143, 150. See also Forker and Candido, "Wit, Wisdom and Theatricality," pp. 86–9.

16 See Gabrieli and Melchiori, *Sir Thomas More*, for the attribution of 3.2 primarily to Hand M, with additions and deletions by Hands B and C (pp. 38–9).

17 As Forker and Candido point out, More's assumption of the role of Good Counsel is also an ironic comment on his relation to Henry VIII ("Wit, Wisdom, and Theatricality," p. 87).

18 Gabrieli and Melchiori, *Sir Thomas More*, p. 147. See also David Mann's reading of the scene's "remarkable literalness" about the material facts of playing (*Elizabethan Player*, p. 29).

19 In fact, Munday's work inspired bitter responses from an anti-Catholic writer as well; George Ellyot's *Very true report of the Apprehension of Edmond Campion* (1581) states on its title page that it is a refutation of Munday's account.

20 (D4v–E). See Alison Shell's discussion of this pamphlet in "Campion's Dramas" [*The Reckoned Expense: Edmund Campion and the Early English Jesuits*, ed. Thomas McCoog S. J. (Woodbridge, Suffolk: The Boydell Press, 1996), pp. 103–18; p. 113]. There are of course questions to be asked about its veracity. It has been established, for instance, that Munday did enroll in the seminary at Rome. Nevertheless, as Celeste Turner points out, Munday took great pains to respond to the allegation that he had run away from his apprenticeship while leaving the accusation that he was a player unanswered, and that suggests that there was no point in trying to live down his career on stage (*Anthony Munday*, pp. 59–60).

21 Cocke's language is particularly striking in its dual application to actors in general and to Munday in particular as an actor-author: "Take him [the actor] at the best, he is but a shifting companion; for hee lives effectually by putting on, and putting off... His own [profession] ... is compounded of all Natures, all humours, all professions" [*A Common Player* (1615), excerpted in E. K. Chambers, *The Elizabethan Stage*, vol. 4, p. 257.]

22 For a summary of the pamphlet controversy surrounding Campion's execution, see Helen C. White, *Tudor Books of Saints and Martyrs* (Madison: University of Wisconsin Press, 1963), pp. 196–239; see Owen Williams, *Trials of Conscience: The Criminalization of Religious Belief* (Dissertation, University of

Pennsylvania, forthcoming 2003), especially chapter 1, "Manifest Dissimulation: The Jesuit Conscience on Trial."

23 See Arthur Marotti, "Southwell's Remains: Catholicism and Anti-Catholicism in Early Modern England," on the extraordinary sympathy that Campion inspired even in Protestants [*Texts and Cultural Change in Early Modern England*, ed. Cedric C. Brown and Arthur F. Marotti (London: Macmillan, 1997), pp. 37–65]. See also Ayres, *Anthony Munday*, on Munday's bad reputation (pp. xv–xix).

24 See A2–A2v, B3v, B4v–C2, C4.

25 In his 1980 edition of the text, Ayres notes that the name was almost certainly Hawley. Munday claims that the Catholics in Paris somehow took him for the son of a gentleman "whom I here refuse to name," and that he therefore thought it expedient to use that name in the rest of his travels. He never explains how or why the community in Paris made their assumption, though (*Anthony Munday*, pp. 19–20, line 477n. See also p. xx). Line numbers from *English Roman Lyfe* are taken from Ayres and appear parenthetically within the text.

26 Ayres argues that "little credence attaches" to Munday's claims at the trial of Campion (*Anthony Munday*, pp. xiv–xv).

27 Elizabeth Hanson, *Discovering the Subject*, pp. 44–5 and chapter 2 throughout. See also Brad S. Gregory, *Salvation at Stake: Christian Martyrdom in Early Modern Europe* (Cambridge, MA: Harvard University Press, 2001), pp. 315–39 and throughout.

28 In one such pamphlet, an anonymous Protestant writer simply reproduces a Catholic writer's description of the Atkins incident, accompanying it with comments about the reliability of a Catholic source and some very suggestive remarks about the need for relics in a Protestant community [*The Copy of a Dovble Letter sent by an Englishe Gentilman from beyond the seas* (1581) A2–A3].

29 See Richard Helgerson, *Forms of Nationhood*, on the interest in plays about those who suffer generally at the hands of the powerful (pp. 230–8); Gabrieli and Melchiori, *Sir Thomas More*, pp. 15–16; Tessa Watt, *Cheap Print and Popular Piety 1550–1640* (Cambridge University Press, 1991), ch. 2. On the Oldcastle plays as questioning state authority within certain prescribed limits, see Larry S. Champion, " 'Havoc in the Commonwealth'; Perspective, Political Ideology, and Dramatic Strategy in *Sir John Oldcastle* and the English Chronicle Plays," *Medieval and Renaissance Drama in England: An Annual Gathering of Research, Criticism, and Reviews* v (1991), 165–79.

30 Jean-Christophe Agnew, *Worlds Apart*, ch. 2 and throughout; David Hawkes, "Idolatry and Commodity Fetishism in the Antitheatrical Controversy," *Studies in English Literature 1500–1900* 39:2 (1999), 25–8; Jean E. Howard, *The Stage and Social Struggle*, pp. 23–6.

31 Among the many writers on this topic, see Mark Rose, *Authors and Owners*; Joseph Loewenstein, "The Script," and "For a History," and David Saunders, *Authorship and Copyright* (London: Routledge, 1992).

32 See for example Catherine Belsey, *The Subject of Tragedy*, and Francis Barker, *The Tremulous Private Body*.

33 The 1619 quarto, famously, was printed by Jaggard for Thomas Pavier as written "By William Shakespeare," and dated 1600. See Peter Corbin and Douglas Sedge for this effort to "anticipate the newly-planned Shakespeare folio" [eds., *The Oldcastle Controversy:* Sir John Oldcastle, Part I *and* The Famous Victories of Henry V (Manchester: Manchester University Press, 1991), p. 34].

34 Prologue 6–14. All references to *Sir John Oldcastle* will be taken from Corbin and Sedge.

35 David Scott Kastan, " 'Killed with Hard Opinions': Oldcastle and Falstaff and the Reformed Text of *1 Henry IV*," in *Shakespeare after Theory* (New York and London: Routledge, 1999), pp. 93–106; Kristen Poole, *Radical Religion*, chapters 1–3; Alice-Lyle Scoufus, *Shakespeare's Typological Satire: A Study of the Falstaff-Oldcastle Problem* (Athens: University of Ohio Press, 1978).

36 Corbin and Sedge, *Oldcastle*, pp. 13–18.

37 David Wiles speculates that Will Kemp may have played the part of Wrotham after leaving the Chamberlain's Men, thus increasing the play's highly commercial resemblance to the Henry plays (*Shakespeare's Clown*, pp. 134–5).

38 Kastan, "Killed"; Poole, *Radical Religion*, pp. 16–43.

39 For a reading of the play in terms of its collaborative authorship and its structure, see John C. Meagher, "Hackwriting and the Huntingdon Plays," in *Elizabethan Theatre*, Stratford-Upon-Avon Studies, 9 (New York: St. Martin's Press, 1967), pp. 197–219.

40 On the novelty of this depiction of Robin Hood, see Jeffrey L. Singman, "Munday's Unruly Earl," in *Playing Robin Hood: The Legend as Performance in Five Centuries* (Newark: University of Delaware Press, 1998), pp. 63–76. See also John Bellamy, *Robin Hood: An Historical Enquiry* (Bloomington: Indiana University Press, 1985); R. B. Dobson and J. Taylor, *Rymes of Robyn Hood: An Introduction to the English Outlaw* (Pittsburgh: University of Pittsburgh Press, 1976); and Malcolm A. Nelson, *The Robin Hood Tradition in the English Renaissance* (Salzburg: Institut für Englische Sprache und Literatur, 1973).

41 See *The Downfall and The Death of Robert, Earl of Huntingdon*, ed. John C. Meagher (dissertation, University of London, 1961), Introduction; M. A. Nelson, "The Earl of Huntington: The Renaissance Plays," in *Robin Hood: An Anthology of Scholarship and Criticism*, ed. Stephen Knight (Cambridge: D.S. Brewer, 1999), pp. 99–121.

42 *The Downfall of Robert Earl of Huntingdon*, ed. John C. Meagher (Oxford: Malone Society, 1965), tln. 22–4. All further references to this edition appear parenthetically within the text.

43 The choice of Skelton to narrate these plays is striking. He has no known relation to the Robin Hood story, but it seems to me that, beyond his status as an "old" author of merry tales, Skelton is also strangely appropriate to the plays because of his complex historical relationship to patronage and self-assertion. See Richard Halpern, "The Twittering Machine: John Skelton's Ornithology of the Early Tudor State," in *The Poetics of Primitive Accumulation: English Renaissance*

Culture and the Genealogy of Capital (Ithaca: Cornell University Press, 1991). See also William Nelson, *John Skelton, Laureate* (New York: Columbia University Press, 1939), and Ian A. Gordon, *John Skelton: Poet Laureate* (Melbourne University Press, 1943). On Skelton's influence upon clowning, see Muriel C. Bradbrook, *The Rise of the Common Player*, pp. 164–5.

44 Again, such affrontery was well within the historical Skelton's grasp. See Halpern, "Twittering Machine," on Skelton as "a more recognizably modern figure – self-promoting, dissatisfied with his duties in a rural parish, lacking strong convictions or social allegiances, willing to use his literary talents in any way that will serve his own ambitions" (p. 106).

45 See Jeffrey Singman, "Munday's Unruly Earl," on the plays' allusions to aspects of the Robin Hood tradition that they do not make use of (pp. 66–9).

46 *The Death of Robert Earl of Huntingdon*, ed. John C. Meagher (Oxford: Malone Society, 1964), tln. 1–13. All further references to this edition appear parenthetically within the text.

47 See Frances E. Dolan, " 'Gentlemen, I have one thing more to say': Women on Scaffolds in England, 1563–1680," for a discussion of the opportunity for public speech that comes along with public execution and martyrdom for women (*Modern Philology* 92:2 [1994], 157–78).

48 Dolan suggests that the executions of women were generally described in ways that elided the actual bodies of the victims (" 'Gentlemen,' " 157–68).

4 "SOME ZANIE WITH HIS MIMICK ACTION"

1 *Author's Pen*, p. 35.

2 See Kathleen McLuskie's *Dekker and Heywood: Professional Dramatists* (New York: St. Martin's Press, 1993). See also Alan B. Farmer and Zachary Lesser, "Vile Arts: The Marketing of English Printed Drama, 1512–1660," *Research Opportunities in Renaissance Drama* 39 (2000), 77–109.

3 Preface to *The English Traveller*, London, 1633 (Amsterdam, Da Capo Press, 1973), A3. See the discussion of this text on pp. 8–9 and p. 170 above.

4 See the discussion of Heywood's career in the introduction to the present study, pp. 8–9 and 13–14. See also Arthur Melville Clark, *Thomas Heywood, Playwright and Miscellanist* (Oxford: Basil Blackwell, 1931).

5 See Bruce R. Smith on Heywood's reworkings of classical material in his comedies [*Ancient Scripts and Modern Experience on the English Stage, 1500–1700* (Princeton University Press, 1988) pp. 177–83].

6 *Love's Mistress, Or The Queen's Masque*, ed. Raymond C. Shady (Salzburg: Institut für Englische Sprache und Literatur, 1977) p. 1. Further reference to the masque are to this addition, appearing parenthetically within the text.

7 Shady, *Love's Mistress*, p. xxix. See also Clark, *Thomas Heywood*, p. 131.

8 McLuskie, *Dekker and Heywood*, pp. 168–73.

9 See Shady's discussion of the conflict between Midas and Apuleius as a reflection upon the traditions of *prodesse* and *delectare* (*Love's Mistress*, pp. lxix–lxxvii).

10 See Hirschfeld, "Collaborating across Generations," for further discussion of Heywood's relationship to Jonson's authorial project (347); see Loewenstein, *Ben Jonson*, pp. 202–3. See also Clark's conjecture that the masque was staged at the Phoenix in Drury Lane soon after it was finished at court, possibly with some of Inigo Jones's sets. This would have made it one of the first plays to be performed with elaborate scenery in early modern England (Clark, *Thomas Heywood*, p. 131, discussed in Shady, *Love's Mistress*, p. xxix). Andrew Gurr argues that such staging is highly unlikely [*The Shakespearean Stage 1574–1642* (Cambridge University Press, 1992) pp. 200–2].

11 *Ben Jonson: The Complete Masques*, ed. Stephen Orgel (New Haven: Yale University Press, 1969), p. 50. Further references to Jonson's masques are to this edition, and appear parenthetically in the text.

12 I am grateful to Edmund Campos for this suggestion. See Clark, *Thomas Heywood*, p. 130.

13 John Lyly, *Galatea*, ed. George K. Hunter, *Midas*, ed. David Bevington (Manchester University Press, 2000), p. 128.

14 Midas is also associated with tyranny and conquest, which he must renounce in order to shed his asses' ears. See Bevington, *Midas*, pp. 126–30.

15 For a parallel argument, see Lauren Shohet, "Interpreting *The Irish Masque* at Court and in Print," *Journal for Early Modern Cultural Studies* 1,2 (Fall/Winter 2001), 42–65.

16 ed. Madelein Doran (Oxford: Malone Society, 1934) pp. xi–xvi.

17 The table of contents lists "*A Drama from* Ovid, *called* Iupiter *and* Io," "*A second from* Ovid *called* Apollo *and* Daphne," and "*A Pastorall Drama called* Amphrisa, or the Forsaken Shepheardesse" (A6v). Heywood uses the term "drama" to refer to *Love's Mistress* in the masque's dedication to the Earl of Dorset, quoted above p. 125. The OED gives only a handful of citations for "drama" and its related forms in this period. See also Clark, *Thomas Heywood*, pp. 158–64.

18 This speech is mistakenly listed in *Pleasant Dialogues and Dramma's* as an epilogue (pp. 247–8).

19 For Douglas Brooks, this moment in *Pleasant Dialogues and Dramma's* is the place where "author and authority finally converge" for Heywood, but I would suggest that Heywood's career looks slightly different if his non-dramatic publications are considered (*From Playhouse to Printing House*, p. 220); see Loewenstein, *Ben Jonson*, pp. 24–5.

20 *The Golden Age. Or the lives of* Jupiter *and* Saturne, *with the defining of the Heathen Gods* (London, 1611), b–bv.

21 Masten acknowledges that patriarchal authorship does not simply install itself uncontested in the theatrical milieu, but his brief discussion of Heywood's Age series misses the complex working out and undercutting of Homer's authority that I describe below [*Textual Intercourse*, pp. 74–5].

22 McLuskie argues that Homer becomes "more apologetic and less confident" as the Age plays progress (*Dekker and Heywood*, pp. 21–2).

23 Homer's blindness could be invoked in a range of ways in this period. See Barbara Mowat on Arthur Hall's construction of Homer as "a poor blinde

soule" ["Constructing the Author" in *Elizabethan Theater: Essays in Honor of S. Schoenbaum*, ed. R. B. Parker and S. P. Zitner (Newark: University of Delaware Press, 1996), pp. 97–110; pp. 97–8]. Also see Mowat throughout on the paternity trope in this period.

24 Gurr, *The Shakespearean Stage*, p. 67.

25 For a study of the props and technical skill required by these plays, see George Fullmer Reynolds, *The Staging of Elizabethan Plays At the Red Bull Theater 1605–1625* (New York: Modern Language Association, 1940).

26 *An Apology for Actors (1612) by Thomas Heywood, A Refutation of the Apology for Actors (1615) by I. G.*, Ed. Richard H. Perkinson (New York: Scholars' Facsimiles, 1941), B4–5. Barbara Baines also cites these lines in relation to the spectacle of the Age plays [*Thomas Heywood* (Boston: Twayne Publishers, 1984), p. 139].

27 In the Prologue to *The English Traveller* (1633), it is announced that "We vse no Drum, nor Trumpet, nor Dumbe show" to "bumbaste out a Play" (A3v). Nevertheless, the Prologue goes on to assert that "these all [are] good, and still in frequent vse / With our best Poets," (A3v). This is decidedly not a Jonsonian boast about the decision not to pander to audiences.

28 Homer betrays similar limitations in Act 5, remarking on Saturne's "blind ambition" as he makes his entrance (G3). Presumably Homer's own blindness is most notable to audiences at moments when he enters or exits.

29 Allan Holaday downplays the importance of *Troia Britanica* in the Age plays, but makes an exception in the case of *The Golden Age* ["Heywood's *Troia Britannica* and the Ages," *Journal of English and Germanic Philology* 45 (1946), 430–9].

30 *Troia Britanica, or Great Britaines Troy* (London, 1609), Canto 1, stanza 30.

31 In a play as episodic as *The Golden Age*, however, it is difficult to make general-izations about the forms of agency attributable to women or about authority in the abstract. See Valerie Traub, "The (In)Significance of 'Lesbian' Desire," in *Queering the Renaissance*, ed. Jonathan Goldberg (Durham: Duke University Press, 1994), pp. 62–83; pp. 73–5.

32 *The Hierarchie of the blessed Angells* (London, 1635), p. 205.

33 Heather Hirschfeld's reading of Heywood's strategy in this text anticipates mine in many ways ("Collaborating across Generations," pp. 343–5).

34 Mowat argues that classical authors were used in this period "with charac-teristics of [their] own that emerged as the construct of the classical Author was appropriated by current cultural needs and desires" ("Constructing the Author," p. 95).

35 *The Silver Age* (1613), B.

36 Interestingly, these plays seem to have reached an unusually large cross-section of theatrical audiences. As Heywood himself states in the preface to Part I of *The Iron Age* (1623), the plays were "Publickely Acted by two Companies, uppon one Stage at once," and "sundry times thronged three seuerall Theaters" (A4v). See Baines, *Thomas Heywood*, p. 140, for a survey of the venues in which the plays were performed, which range from the Red Bull to the court.

37 *The Second Part of the Iron Age* (1632), A4r. Brooks argues that Heywood's plans for the Age plays were central to his campaign for "bibliographical prestige," and although this is clearly the case, there are, as I have been arguing, also other forms of authorial preeminence available to Heywood (*Playhouse*, pp. 196–203).

38 *The Four Prentices* (London, 1615), A4v.

39 *The Brazen Age* (London, 1613), G4.

40 See Max W. Thomas, "Eschewing Credit," for a reading of Heywood's relationship to plagiarism here and in the *Passionate Pilgrim* episode. See Loewenstein, *Ben Jonson*, pp. 74–84.

41 In fact, in an otherwise compelling attempt at historical recovery to which I am indebted, Alan Holaday has argued that the actor Robert Browne performed in the role of Valerius. In Holaday's view, Heywood can be expected to corrupt his own play with musical entertainment only because Browne, a personal friend, had fallen on hard times and badly needed the career boost this play offered him [*Thomas Heywood's* The Rape of Lucrece (Urbana: University of Illinois Press, 1950), pp. 5–19]. Unless otherwise indicated, quotations from *Rape of Lucrece* are from this edition. Through line numbers appear parenthetically in the text.

42 Holaday, *Lucrece*, pp. 33–4.

43 Heywood's address to the Reader does claim that many of his plays have "accidentally come into the Printers hands, and therefore so corrupt and mangled, (copied only by the eare) that I have beene as unable to know them, as ashamed to challenge them." But he goes on to add that "This [ie. *Lucrece*] therefore I was the willinger to furnish out in his native habit" (Holaday, *Lucrece*, p. 46).

44 I am grateful to Katherine Rowe for this suggestion.

45 *An Apology for Poetry*, ed. Forrest G. Robinson (Indianapolis: Bobbs-Merrill, 1970), p. 78.

46 William Shakespeare, *A Midsummer Night's Dream*, ed. Harold F. Brooks (London: Methuen, 1979), 4.1.212–17.

47 See Andrew Gurr's reference to the anonymous pamphlet *Ratsey's Ghost* (1616), in which the famous highwayman admits "I have often gone to plaies more for musicke sake, then for action" (*Shakespearean Stage*, p. 80).

48 See Kathryn Gravdal on the medieval French *pastourelle* and its echoes in rape law [*Ravishing Maidens: Writing Rape in Medieval French Literature and Law* (Philadelphia: University of Pennsylvania Press, 1991) see especially chapters 4 and 5]. In *Sexual Violence on the Jacobean Stage*, Karen Bamford argues that this handling of song in *Lucrece* "reveals an ambivalence about rape characteristic not just of Heywood's play, but of social attitudes in a patriarchal society" (New York: St. Martin's Press, 2000), p. 73.

49 See Cynthia B. Herrup on the place of Lucretia in the complex and contradictory attitudes about rape in this period [*A House in Gross Disorder: Sex, Law, and the Second Earl of Castlehaven* (Oxford University Press, 1999), pp. 26–32]. See also Stephanie Jed on the uses of the Lucrece story in humanist culture [*Chaste Thinking: The Rape of Lucretia and the Birth of Humanism* (Bloomington: Indiana University Press, 1989)].

50 Donaldson traces "parodies and inversions" of Lucrece's story [*The Rapes of Lucretia: A Myth and its Transformations* (Oxford: Clarendon Press, 1982), p. 100]. He finds Heywood's version seemingly accidental in its dismantling of the legend (pp. 86–7).

51 "If to thy bed the adulterer welcome came,/O *Lucrece*, then thy death deserves no fame./If force were offred, give true reason why,/Being cleare thy selfe thou for his fault wouldst dye?/Therefore in vaine thou seekst thy fame to cherish,/Since mad thou fal'st, or for thy sinne dost perish" (*Pleasant Dialogues and Dramma's*, p. 268). Of course, as McLuskie points out, the Age plays too make frequent reference to rape as comic (*Dekker and Heywood*, p. 19). Clearly it is no more true to say of *Lucrece* than it was to say of the Age plays that Heywood constructs authorship as an anti-patriarchal undertaking. But the patriarchalism deployed here is not the same as the patriarchalism we associate with high absolutist authority. This is low comic misogyny.

52 See David Mann, *Elizabethan Player*, on the *Apology*'s odd logic (p. 191). See also Barish, who notes that the *Apology* posits the Rape of the Sabines as the "prime instance of the power and glory of the stage" (*Antitheatrical Prejudice*, pp. 117–18).

53 Perkinson, *Thomas Heywood*, DV.

54 *Shakespeare and the Popular Tradition*, p. 257.

55 Among the numerous studies, see J. L. Styan, *Shakespeare's Stagecraft* (Cambridge University Press, 1967); Weimann, *Shakespeare and the Popular Tradition*; Peter Thomson, "Rogues and Rhetoricians: Acting Styles in Early English Drama," in *A New History of Early English Drama*, ed. John D. Cox and David Scott Kastan (New York: Columbia University Press, 1997), pp. 321–36.

CODA: THE SHAKESPEAREAN SILENCE

1 (New York: Riverhead Books, 1998), p. 1. I am grateful to Gabriel Hankins for calling this moment to my attention.

2 Scott McMillin and Sally-Beth MacLean have recently considered Wilson's writing in relation to the Queen's Men's repertory (*The Queen's Men*, pp. 121–8).

3 *The World Tost at Tennis*, in *The Works of Thomas Middleton*, ed. A. H. Bullen, 8 vols. (Boston: Houghton Mifflin, 1936), vol. 7, line 416.

4 Bullen, ed., *Works of Thomas Middleton*, vol. 7, p. 144.

5 Heather Hirschfeld has conducted an exemplary study of Brome's peculiar forms of authority in "Collaborating across Generations"; see also Loewenstein, *Ben Jonson*, pp. 106–11.

6 C. H. Herford and Percy and Evelyn Simpson, eds., *Ben Jonson*, 11 vols. (Oxford: Clarendon Press, 1938), vol. 6, Induction 8.

7 *Five New Plays, By Richard Brome* (London, 1653), A2.

8 *The New Inn or The Light Heart*, ed. G. B. Tennant (New Haven: Yale University Press, 1908). In the original 1631 version of the play, these lines read "There, sweepings do as well / As the best order'd meale."

9 There are of course other writers who might figure in a study like the present one. John Webster may or may not have been an actor; see Margaret Loftus

Ranald, *John Webster* (Boston: Twayne Publishers, 1989), p. 5; June Schlueter, "Who was John Wobster? New Evidence Concerning the Playwright/Minstrel in Germany," *Medieval and Renaissance Drama in England* 8 (1996), 165–75. Nevertheless, in light of his possible authorship of the Overburian character "An Excellent Actor," his various treatments of print in relation to performance are particularly interesting. See Douglas Brooks, for instance, on the preface to *The White Devil* [*From Playhouse to Printing House*, pp. 45–52]. See also Mary Bly's important reconsideration of Will Barksted's career as a boy player/ingle with the King's Revels company [*Queer Virgins*, pp. 121–6].

10 The critics working in this vein include Richard Helgerson (*Forms Of Nationhood*, ch. 5). In many ways these studies take their cue from Muriel Bradbrook: "The clown was losing his independence as an entertainer; he was no longer a challenger but a servant" ["Robert Armin and *Twelfth Night*," in *Shakespeare*: Twelfth Night: *A Casebook*, ed. D. J. Palmer (London: Macmillan Press, 1972), pp. 222–43; p. 232]. See also Colin MacCabe, "Abusing self," pp. 3–17, and Daryl W. Palmer, "William Kemp's *Nine Daies*," pp. 33–47.

11 See Richard Dutton's contention that Armin's roles may never have been intended to replace Kemp's style of performance [*Licensing, Censorship and Authorship in Early Modern England: Buggeswords* (Houndmills: Palgrave, 2000), pp. 34–5]. Indeed, though the scholarly consensus is virtually universal, even the notion that Armin played the role of Feste is based in conjecture.

12 See above, pp. 21–3.

13 *Forms of Nationhood*, pp. 199–204.

14 See, for instance, Bradbrook, "Robert Armin," p. 223; and Peter Thomson [*Shakespeare's Theatre* (London: Routledge and Kegan Paul, 1983), pp. 90–2]. Though Weimann reads Armin as more or less incorporated into his dramatic roles, he sees some of the fundamental changes as occurring before Kemp [*Shakespeare and the Popular Tradition*, p. 192].

15 *Faultlines*, ch. 3.

16 William Shakespeare, *Twelfth Night or What You Will: Texts and Contexts*, ed. Bruce R. Smith (Boston: Bedford / St. Martin's Press, 2001), 2.4.1–12, 1.5.1–57.

17 *Shakespeare's Festive Comedy*, p. 259.

18 Wiles, *Shakespeare's Clown*, p. 9.

19 Ibid, pp. 43–60.

20 *Author's Pen*, especially chapter 6.

21 Annabel Patterson, *Shakespeare and the Popular Voice* (Oxford: Basil Blackwell, 1989); Leah Sinanoglou Marcus, *Unediting the Renaissance: Shakespeare, Marlowe, Milton* (New York: Routledge, 1996), chapter 5.

22 Wiles, *Shakespeare's Clown*, pp. 16–17, 138–9. See also David Mann's insistence on a "juxtaposition of rapport and hostility" in Tarlton's performances (*Elizabethan Player*, p. 62).

23 The sentences following this remark in "What is an Author?" are also instructive: "In our culture (and doubtless in many others), discourse was not originally a product, a thing, a kind of goods; it was essentially an act – an act placed in the bipolar field of the sacred and the profane, the licit and the illicit, the religious

and the blasphemous. Historically, it was a gesture fraught with risks before becoming goods caught up in a circuit of ownership" (*The Foucault Reader*, p. 108).

24 On Armin as Dogberry, see Wiles, *Shakespeare's Clown*, p. 144.

25 *Virgidemiarum* (1597) 1.3.35, 43–4. Quoted in Weimann, *Author's Pen*, p. 101.

26 I am grateful to Akiva Fox and the Underground Shakespeare Company, Harnwell College House, University of Pennsylvania, for calling this fact to my attention.

27 Robert Weimann, *Shakespeare and the Popular Tradition*, pp. 253–60.

28 See Richard Dutton's description of Armin's "licensed fool" roles as reflections of the work of the acting companies themselves (*Licensing*, p. 35).

29 *Greene's Groatsworth of Wit. Bought With a Million of Repentance (1592), Attributed to Henry Chettle and Robert Greene*, ed. D. Allen Carroll (Binghamton: Medieval and Renaissance Texts and Studies, 1994), p. 84.

30 *Licensing*, pp. 90–113.

31 *Our Theatres in the Nineties*, 3 vols., (London: Constable and Company, 1932), vol. 2, pp. 267–9. I am grateful to Cynthia Marshall for suggesting this review to me.

32 Sinfield, *Faultlines*, p. 78.

33 *The Making of the National Poet: Shakespeare, Adaptation and Authorship*, 1660–1769 (Oxford: Clarendon Press, 1992), p. 134.

34 Dobson, *National Poet*, pp. 141, 146.

35 Bristol, *Shakespeare's America, America's Shakespeare* (London and NY: Routledge, 1990), p. 23.

36 Marjorie Garber, *Shakespeare's Ghost Writers: Literature as Uncanny Causality* (New York and London: Methuen, 1987), p. 11.

37 "Bardolatry: or, The cultural materialist's guide to Stratford-upon-Avon," in *The Shakespeare Myth*, ed. Graham Holderness (Manchester University Press, 1988), pp. 12–13.

38 There are important exceptions to this description. See, among others, Douglas Brooks on the development of authorship before Jonson (*From Playhouse to Printing House*, chapter 1); Richard Wilson's contention that the logical end of materialist scholarship is the return of the author [*Will Power: Essays on Shakespearean Authority* [(Detroit: Wayne State University Press, 1993), p. 18]; David Scott Kastan's assertion that a properly historicized Shakespeare will avoid both "the mystifications of idealist criticism [and] ... the no less mystifying moves of poststructural theory" [*Shakespeare After Theory* (New York: Routledge, 1999), p. 38]; and see Michael Bristol, *Big-Time Shakespeare*, for an attempt to theorize past the death of the author (London: Routledge, 1996), pp. 49–58.

Select bibliography

Alfield, Thomas, *A True reporte of the death... of M. Campion Jesuite*, London, 1582.

Anon., *The Copy of a Dovble Letter sent by an Englishe Gentilman from beyond the seas*, 1581.

Armin, Robert, *True Discourse of the Practices of Elizabeth Caldwell*, London, 1604.

Aspinall, Dana E., "Robert Armin," in Vicki K. Janik, ed., *Fools and Jesters in Literature, Art, and History: A Bio-Bibliographical Sourcebook*, Westport, Connecticut: Greenwood Press, 1998, pp. 41–9.

Ayres, Philip J., *Anthony Munday: The English Roman Life*, Oxford: Clarendon Press, 1980.

Babbage, Stuart Barton, *Puritanism and Richard Bancroft*, London: SPCK, 1962.

Baines, Barbara, *Thomas Heywood*, Boston: Twayne Publishers, 1984.

Bancroft, Richard, *Dangerous Positions and Proceedings*, 1593, Netherlands: Theatrum Orbis Terrarum, 1972.

Suruay of the Pretended Holy Discipline, London, 1593.

Barish, Jonas, *The Antitheatrical Prejudice*, Berkeley: University of California Press, 1981.

Brome, Richard, *Five New Playes, By Richard Brome*, London, 1653.

Bentley, Gerald Eades, *The Profession of Dramatist in Shakespeare's Time, 1590–1642*, Princeton University Press, 1971.

The Profession of Player in Shakespeare's Time, 1590–1642, Princeton University Press, 1984.

Billington, Sandra, *A Social History of the Fool*, New York: St. Martin's Press, 1984.

Blayney, Peter, "*The Booke of Sir Thomas Moore* Re-examined," *Studies in Philology* 69 (1972), 167–91.

Bly, Mary, *Queer Virgins and Virgin Queans on the Early Modern Stage*, Oxford University Press, 2000.

Bowers, Fredson, "Ben Jonson the Actor," *Studies in Philology* 34 (1937), 352–406.

Bradbrook, Muriel C., *The Rise of the Common Player*, Cambridge MA: Harvard University Press, 1962.

"Robert Armin and *Twelfth Night*," in D. J. Palmer, ed., *Shakespeare*, Twelfth Night: *A Casebook*, London: Macmillan, 1972, pp. 222–43.

Braunmuller, A. R., "Chapman's *Bussy D'Ambois* and Field's *Amends for Ladies*," *Notes and Queries* 26, 5 (1979), 401–3.

Brinkley, Roberta Florence, *Nathan Field, the Actor-Playwright*, New Haven: Yale University Press, 1924.

Brook, Nicholas, ed. *Bussy D'Ambois*, London, Methuen, 1964.

Brooks, Douglas A., *From Playhouse to Printing House: Drama and Authorship in Early Modern England*, Cambridge University Press, 2000.

Callaghan, Dympna, *Shakespeare Without Women: Representing Gender and Race on the Renaissance Stage*, New York: Routledge, 2000.

Chambers, E. K., *The Elizabethan Stage*, 4 vols., Oxford: Clarendon Press, 1923.

Clark, Arthur Melville, *Thomas Heywood, Playwright and Miscellanist*, Oxford: Basil Blackwell, 1931.

Collinson, Patrick, *The Elizabethan Puritan Movement*, Berkeley: University of California Press, 1967.

"John Field and Elizabethan Puritanism," in *Godly People: Essays on English Protestantism and Puritanism*, London: The Hambledon Press, 1983, pp. 335–70.

"The Theatre Constructs Puritanism," in David L. Smith, Richard Strier, and David Bevington, eds., *The Theatrical City: Culture, Theatre and Politics in London, 1576–1649*, Cambridge University Press, 1995, pp. 157–69.

Corbin, Peter, and Sedge, Douglas, eds., *The Oldcastle Controversy*: Sir John Oldcastle, Part I *and* The Famous Victories of Henry V, Manchester University Press, 1991.

Crockett, Bryan, *The Play of Paradox: Stage and Sermon in Renaissance England*, Philadelphia: University of Pennsylvania Press, 1995.

Cromwell, Otelia, *Thomas Heywood: A Study in the Elizabethan Drama of Everyday Life*, New Haven: Yale University Press, 1928.

Dawson, Anthony B., and Yachnin, Paul, *The Culture of Playgoing in Shakespeare's England: A Collaborative Debate*, Cambridge University Press, 2001.

de Grazia, Margreta, "The Ideology of Superfluous Things: *King Lear* as Period Piece" in Margreta de Grazia, Maureen Quilligan, and Peter Stallybrass, eds., *Subject and Object*, pp. 17–42.

Shakespeare Verbatim: The Reproduction of Authenticity and the 1790 Apparatus, Oxford: Clarendon Press, 1991.

de Grazia, Margreta, Quilligan, Maureen, and Stallybrass, Peter, eds., *Subject and Object in Renaissance Culture*, Cambridge University Press, 1996.

Dutton, Richard, *Licensing, Censorship and Authorship in Early Modern England: Buggeswords*, Houndmills: Palgrave, 2000.

Ellyot, George, *A Very true report of the Apprehension of Edmond Campion*, London, 1581.

Eutheo, Anglo-phile, *A second and third blast of retreat from plaies and theatres*, London, 1580.

Farmer, Alan B., and Lesser, Zachary, "Vile Arts: The Marketing of English Printed Drama, 1512–1600," *Research Opportunities in Renaissance Drama* 39 (2000), 77–109.

Farmer, John S., ed., *The Valiant Welshman*, Tudor Facsimile Texts, New York: AMS Press, 1913.

Feather, J. P., *The Collected Works of Robert Armin*, New York: Johnson Reprint Corporation, 2 vols., 1972.

Forker, Charles R., and Candido, Joseph, "Wit, Wisdom, and Theatricality in *The Book of Sir Thomas More*," *Shakespeare Studies* 13 (1980), 85–104.

Foucault, Michel, "What is an Author?" in *The Foucault Reader*, ed. Paul Rabinow, New York: Pantheon Books, 1984, pp. 101–20.

Gabrieli, Vittorio, and Melchiori, Giorgio, eds., Sir Thomas More, *A Play by Anthony Munday and Others. Revised by Henry Chettle, Thomas Dekker, Thomas Heywood and William Shakespeare*, Manchester University Press, 1990.

Gosson, Stephen, *Plays confuted in five actions*, London, 1582.

Gregory, Brad, *Salvation at Stake: Christian Martyrdom in Early Modern Europe*, Cambridge, MA., Harvard University Press, 1999.

Gurr, Andrew, *The Shakespearean Stage 1574–1642*, Cambridge University Press, 1992.

Halasz, Alexandra, *The Marketplace of Print: Pamphlets and the Public Sphere in Early Modern England*, Cambridge University Press, 1997.

Halasz, Alexandra, " 'So beloved that men use his picture for their signs': Richard Tarlton and the Uses of Sixteenth-Century Celebrity," *Shakespeare Studies* 23 (1995), 19–38.

Halliwell, J. O., ed. *Tarlton's Jests and News Out of Purgatory*, London: Shakespeare Society, 1844.

Halliwell-Phillipps, J. O., ed., *The Remonstrance of Nathan Field*, London, 1865.

Hanson, Elizabeth, *Discovering the Subject in Renaissance England*, Cambridge University Press, 1998.

Hawkes, David, "Idolatry and Commodity Fetishism in the Antitheatrical Controversy," *Studies in English Literature 1500–1900* 39: 2 (1999), 255–73.

Hedrick, Donald, " 'Be Rough With Me': The Collaborative Arenas of *The Two Noble Kinsmen*," in Charles H. Frey, ed., *Shakespeare, Fletcher, and* The Two Noble Kinsmen, Columbia: University of Missouri Press, 1989, pp. 45–77.

Helgerson, Richard, *Forms of Nationhood: The Elizabethan Writing of England*, University of Chicago Press, 1992.

 Self-Crowned Laureates: Spenser, Jonson, Milton, and the Literary System, Berkeley: University of California Press, 1983.

Herford, C. H., and Simpson, Percy and Evelyn, eds., *Ben Jonson*, 11 vols., Oxford: Clarendon Press, 1938.

Heywood, Thomas, *The Brazen Age*, London, 1613.

 The English Traveller, London, 1633, Amsterdam, Da Capo Press, 1973.

 The Four Prentices, London, 1615.

 The Golden Age. Or the lives of Jupiter *and* Saturne, *with the defining of the Heathen Gods*, London, 1611.

 Gunaikeion or Nine Bookes of Various History Concerning Women: Inscribed by the names of the Nine Muses, London, 1624.

 The Hierarchie of the blessed Angells, London, 1635.

 If you Know not Me, you Know Nobody, ed. Madelein Doran, Malone Society Reprints, Oxford University Press, 1934.

The Iron Age, part 1, London, 1632.

Love's Mistress, or The Queen's Masque, ed. Raymond C. Shady, Salzburg: Institut für Englische Sprache und Literatur, 1977.

Pleasant Dialogues and Dramma's, London, 1637.

The Second Part of the Iron Age, London, 1632.

The Silver Age, London, 1613.

Troia Britanica, or Great Britaines Troy, London, 1609.

Hillebrand, Harold Newcomb, *The Child Actors: A Chapter in Elizabethan Stage History*, Urbana: University of Illinois Press, 1926.

Hirschfeld, Heather, "Collaborating across Generations: Thomas Heywood, Richard Brome, and the Production of *The Late Lancashire Witches*," *Journal of Medieval and Early Modern Studies* 30:2 (Spring 2000), 339–74.

Holaday, Alan, "Heywood's *Troia Britannica* and the Ages," *Journal of English and Germanic Philology* 45 (1946), 430–9.

Thomas Heywood's The Rape of Lucrece, Urbana: University of Illinois Press, 1950.

Howard, Jean, *The Stage and Social Struggle in Early Modern England*, London: Routledge, 1994.

Irigaray, Luce, *This Sex Which is Not One*, trans. Catherine Porter with Carolyn Burke, Ithaca: Cornell University Press, 1985.

Kastan, David Scott, *Shakespeare After Theory*, New York: Routledge, 1999.

King, T. J., *Shakespeare's Clown: Actor and Text in the Elizabethan Playhouse* (review), *Shakespeare Quarterly* 39:4 (1988), 518–19.

Liddie, Alexander, *An Old-Spelling, Critical Edition of* The History of the Two Maids of More-Clacke, New York: Garland Publishing, 1979.

Loewenstein, Joseph, *The Author's Due: Printing and the Prehistory of Copyright*, University of Chicago Press, 2002.

Ben Jonson and Possessive Authorship, Cambridge University Press, 2002.

"For a History of Literary Property: John Wolfe's Reformation," *English Literary Renaissance* 18 (1988), 389–412.

"The Script in the Marketplace," *Representations* 12 (1985), 101–14.

Lyly, John, *Galatea*, ed. George K. Hunter, *Midas*, ed. David Bevington, Manchester University Press, 2000.

Lynch, Kathleen, "The Dramatic Festivity of *Bartholomew Fair*," *Medieval and Renaissance Drama in England* 8 (1991), 128–45.

MacCabe, Colin, "Abusing Self and Others: Puritan Accounts of the Shakespearian Stage," *Critical Quarterly* 30:3 (1988), 3–17.

Mann, David, *The Elizabethan Player: Contemporary Stage Representations* (London and New York: Routledge, 1991).

Marcus, Leah S., "Of Mire and Authorship," in David L. Smith, Richard Strier and David Bevington, eds., *The Theatrical City: Culture, Theatre and Politics in London, 1576–1649*, Cambridge University Press, 1995.

The Politics of Mirth: Jonson, Herrick, Milton, Marvell, and the Defense of Old Holiday Pastimes, University of Chicago Press, 1986.

Puzzling Shakespeare: Local Reading and Its Discontents, Berkeley: University of California Press, 1988.

Marotti, Arthur, *Manuscript, Print, and the English Renaissance Lyric*, Ithaca: Cornell University Press, 1995.

"Southwell's Remains: Catholicism and Anti-Catholicism in Early Modern England," in *Texts and Cultural Change in Early Modern England*, ed. Cedric C. Brown and Arthur F. Marotti, London: Macmillan, 1997, pp. 37–65.

Masten, Jeffrey, *Textual Intercourse: Collaboration, Authorship, and Sexualities in Renaissance Drama*, Cambridge University Press, 1997.

Maus, Katharine Eisaman, *Inwardness and Theater in the English Renaissance*, University of Chicago Press, 1995.

McLuskie, Kathleen, *Dekker and Heywood: Professional Dramatists*, New York: St. Martin's Press, 1993.

"The Poets' Royal Exchange: Patronage and Commerce in Early Modern Drama," *Yearbook of English Studies* 21, (1991), 53–62.

McMillin, Scott, *The Elizabethan Theatre and* The Book of Sir Thomas More, Ithaca: Cornell University Press, 1987.

"Jonson's Early Entertainments: New Information from Hatfield House," *Renaissance Drama* 1 (1968), 153–66.

McMillin, Scott, and MacLean, Sally-Beth, *The Queen's Men and their Plays*, Cambridge University Press, 1998.

Meagher, John C. ed., The Downfall *and* The Death of Robert, Earl of Huntingdon, PhD thesis, University of London (1961).

"Hackwriting and the Huntingdon Plays," *Elizabethan Theatre*, Stratford-Upon-Avon Studies 9, New York: St. Martin's Press, 1967, pp. 197–219.

Montrose, Louis, *The Purpose of Playing: Shakespeare and the Cultural Politics of the Elizabethan Theatre*, University of Chicago Press, 1996.

"Spenser's Domestic Domain: Poetry, Property, and the Early Modern Subject," in Margreta de Grazia, Maureen Quilligan, and Peter Stallybrass, eds., *Subject and Object*, pp. 83–103.

Mowat, Barbara, "Constructing the Author," in R. B. Parker and S. P. Zitner, eds., *Elizabethan Theater: Essays in Honor of S. Schoenbaum*, Newark: University of Delaware Press, 1996, pp. 97–110.

Munday, Anthony, *A Breefe Aunswer Made unto two seditious Pamphlets*, London, 1582.

A Breefe discourse of the taking of Edmund Campion and divers other papists, London, 1581.

A Breefe and true reporte, of the Execution of certaine Traytours at Tiborne, London, 1582.

The Death of Robert Earl of Huntingdon, ed. John C. Meagher, Oxford: Malone Society, 1964.

The Discovery of Edmund Campion, London, 1582.

The Downfall of Robert Earl of Huntingdon, ed. John C. Meagher, Oxford: Malone Society, 1965.

A Watch-woord to Englande To beware of traytours and tretcherous practises, London, 1584.

Nungezer, Edwin, *A Dictionary of Actors and of Other Persons Associated with the Public Representation of Plays in England before 1642*, New Haven: Yale University Press, 1929, pp. 362–3.

Orgel, Stephen, ed., *Ben Jonson: The Complete Masques*, New Haven: Yale University Press, 1969.

Impersonations: The Performance of Gender in Shakespeare's England, Cambridge University Press, 1996.

"What is a Text?" in David Scott Kastan and Peter Stallybrass, eds., *Staging the Renaissance: Reinterpretations of Elizabethan and Jacobean Drama*, New York: Routledge, 1991, pp. 83–7.

Palmer, Daryl W., "William Kemp's *Nine Daies Wonder* and the Transmission of Performance Culture," *Journal of Dramatic Theory and Criticism* 5:2 (1991), 33–47.

Paster, Gail Kern, *The Body Embarrassed: Drama and the Disciplines of Shame in Early Modern England*, Ithaca: Cornell University Press, 1993.

Patterson, Annabel, *Censorship and Interpretation: The Conditions of Writing in Early Modern England*, Madison: University of Wisconsin Press, 1984.

Peele, Albert, *Tracts Ascribed to Richard Bancroft*, Cambridge University Press, 1953.

Peery, William, ed., *The Plays of Nathan Field*, Austin: University of Texas Press, 1950.

Perkinson, Richard H., ed. *An Apology for Actors (1612) by Thomas Heywood, A Refutation of the Apology for Actors (1615) by I. G.*, New York: Scholars' Facsimiles, 1941.

Poole, Kristen, *Radical Religion from Shakespeare to Milton: Figures of Nonconformity in Early Modern England*, Cambridge University Press, 2000.

Porter, H. C., *Puritanism in Tudor England*, London: Macmillan and Co., 1970.

Ringler, William, *Stephen Gosson: A Biographical and Critical Study*, Princeton University Press, 1942.

Roach, Joseph R., *The Player's Passion: Studies in the Science of Acting*, Ann Arbor: University of Michigan Press, 1993.

Rose, Mark, *Authors and Owners*, Cambridge, MA: Harvard University Press, 1993.

Rowe, George, *Distinguishing Jonson: Imitation, Rivalry, and the Direction of a Dramatic Career*, Lincoln: University of Nebraska Press, 1988.

Rowe, Katherine, "Memory and Revision in Chapman's *Bussy* Plays," *Renaissance Drama* 31 (2002), 125–52.

Rowley, William, *A tragedy called* All's lost by lust, London, 1633.

A New Wonder, A Woman Never Vext, London, 1632.

Saunders, David, *Authorship and Copyright*, London: Routledge, 1992.

Saunders, J. W., "The Stigma of Print: A Note on the Social Bases of Tudor Poetry," *Essays in Criticism* 1 (1951), 139–64.

Schlueter, June, "Who was John Wobster? New Evidence Concerning the Playwright/Minstrel in Germany," *Medieval and Renaissance Drama in England* 8 (1996), 165–75.

Shakespeare, William, *Twelfth Night or What You Will: Texts and Contexts*, ed. Bruce R. Smith, Boston: Bedford / St. Martin's Press, 2001.

Shaw, George Bernard, *Our Theatres in the Nineties*, 3 vols., London: Constable and Company, 1932.

Shell, Alison, "Campion's Dramas," in *The Reckoned Expense: Edmund Campion and the Early English Jesuits*, ed. Thomas McCoog S. J., Woodbridge, Suffolk: The Boydell Press, 1996, pp. 103–18.

Shershow, Scott Cutler, *Puppets and Popular Culture*, Ithaca: Cornell University Press, 1995.

Shohet, Lauren, "Interpreting *The Irish Masque* at Court and in Print," *Journal for Early Modern Cultural Studies* 1,2 (Fall/Winter 2001), 42–65.

Sinfield, Alan, *Faultlines: Cultural Materialism and the Politics of Dissident Reading*, Berkeley: University of California Press, 1992.

 "*Poetaster*, The Author, and the Perils of Cultural Production," *Renaissance Drama* 27 (1996), 3–18.

Skura, Meredith, *Shakespeare the Actor and the Purposes of Playing*, University of Chicago Press, 1993.

Sturgess, Keith, *Jacobean Private Theatre*, London: Routledge, 1987.

Thomas, Max W., "*Kemps Nine Daies Wonder*: Dancing Carnival into Market," *PMLA* 107:3 (1992), 511–23.

 "Eschewing Credit: Heywood, Shakespeare, and Plagiarism before Copyright," *New Literary History* 31:2 (2000), 277–93.

Thomson, Peter, "Rogues and Rhetoricians: Acting Styles in Early English Drama," in *A New History of Early English Drama*, ed. John D. Cox and David Scott Kastan, New York: Columbia University Press, 1997, pp. 321–36.

 Shakespeare's Theatre, London: Routledge and Kegan Paul, 1983.

Turner, Celeste, *Anthony Munday: An Elizabethan Man of Letters*, Berkeley: University of California Press, 1928.

Wall, Wendy, *The Imprint of Gender: Authorship and Publication in the English Renaissance*, Ithaca: Cornell University Press, 1993.

Watt, Tessa, *Cheap Print and Popular Piety 1550–1640*, Cambridge University Press, 1991.

Wayne, Donald E., "*Drama and Society in the Age of Jonson*: An Alternative View," *Renaissance Drama* 13 (1982), 103–29.

Weimann, Robert, *Authority and Representation in Early Modern Discourse*, ed. David Hillman, Baltimore: Johns Hopkins University Press, 1996.

 Author's Pen and Actor's Voice: Playing and Writing in Shakespeare's Theatre, ed. Helen Higbee and William West, Cambridge University Press, 2000.

 "Bifold Authority in Shakespeare's Theatre," *Shakespeare Quarterly* 39:4 (1998), 401–17.

 "Performing at the Frontiers of Representation: Epilogue and Post-Scriptural Future in Shakespeare's Plays," in Murray Biggs, Philip Edwards, Inga-Stina Ewbank, and Eugene M. Waith, eds., *The Arts of Performance in Elizabethan and Early Stuart Drama: Essays for George Hunter*, ed., Edinburgh University Press, 1991, pp. 96–112.

 Shakespeare and the Popular Tradition in the Theater: Studies in the Social Dimension of Dramatic Form and Function, ed. Robert Schwartz, Baltimore: Johns Hopkins University Press, 1978.

Welsford, Enid, *The Fool: His Social and Literary History*, London: Faber and Faber, 1935.

White, Helen C., *Tudor Books of Saints and Martyrs*, Madison: University of Wisconsin Press, 1963.

Wiles, David, *Shakespeare's Clown: Actor and Text in the Elizabethan Playhouse*, Cambridge University Press, 1987.

Williams, Owen, *Trials of Conscience: The Criminalization of Religious Belief*, Dissertation, University of Pennsylvania, forthcoming 2003.

Wilson, Richard, *Will Power: Essays on Shakespearean Authority*, Detroit: Wayne State University Press, 1993.

Wilson, Robert, *Three Lords and Three Ladies of London*, London, 1592.

Woodmansee, Martha, *The Author, Art, and the Market: Rereading the History of Aesthetics*, New York: Columbia University Press, 1994.

Woodmansee, Martha, and Jaszi, Peter, eds., *The Construction of Authorship: Textual Appropriation in Law and Literature*, Durham: Duke University Press, 1994.

Worthen, William B., *The Idea of the Actor: Drama and the Ethics of Performance*, Princeton University Press, 1984.

Shakespeare and the Authority of Performance, Cambridge University Press, 1997.

Wright, James, and Flecknoe, Richard, *Historia histrionica an historical account of the English stage by James Wright 1699. A short discourse of the English stage by Richard Flecknoe 1644*, Introductory notes by Peter Davison, New York: Johnson Reprint Corporation, 1972.

Yachnin, Paul, *Stage-Wrights: Shakespeare, Jonson, Middleton, and the Making of Theatrical Value*, Philadelphia: University of Pennsylvania Press, 1997.

Index

actor(s)
 boy, recruitment/treatment of 64, 65, 179
 hostility towards 6, 11, 97, 184
 personal attributes 6
 relationship with authors 80, 122
 role in relation to text 4–6, 7–8, 10, 55–56, 96,
 124, 132, 133, 134, 149, 150, 179
 social role/status 6, 7, 14, 21, 172
 see also audiences; *names of individual*
 performers
Admiral's Men 109
Agnew, Jean-Christophe 7
Alfield, Thomas 11, 85
 A True reporte of the Death . . . of M Campion
 Jesuite 97, 98, 105
Alleyn, Edward 6
Altman, Joel 174
Armin, Robert 3, 9, 14, 16–17, 20, 23, 43, 172,
 174
 acting career 17, 18, 29–30, 45, 132, 154, 155,
 160, 175
 allegory, use of 41, 42
 authorial voice 1–2, 7, 17, 20–21, 23, 26, 29,
 32–34, 36–39, 40, 42–43, 52–53, 174
 comparisons with other performer/writers 21,
 22, 23, 25, 53, 112, 113, 121, 124, 125, 153, 161,
 162, 163
 "discovery" 27–28, 29, 34–35, 37
 multiple voices, use of 1, 12, 25, 29, 30–31, 33,
 37, 39, 173
 performance style 24, 25, 151, 154, 156, 157,
 159–60, 161, 171, 172, 173
 qualities as playwright 49–50, 52, 172
 self-promotion 12, 13, 17, 23, 96–97, 162, 173
 Shakespearean roles 155, 156, 157, 158, 159–60,
 161, 192
 Foole upon foole, or Six sortes of sottes 1, 12,
 17–18, 19, 33, 34–37, 39–41, 44–45, 175
 The Italian Tailor and his Boy 175
 Nest of ninnies (revised version of *Foole upon*
 foole) 41–43, 51
 Quips upon Questions 1–2, 12, 30–34, 41, 168,
 171, 175
 The Valiant Welshman 44, 50–52
 Two Maids of More-clacke 1, 6, 12, 34, 44,
 45–51, 149, 162, 175, 176
Aspinall, Dana 174
Atkins, Richard 103, 105, 185
audience(s)
 performers' interaction with 5, 20, 21, 25, 29,
 150–51 (*see also* Field, Nathan)
 response to humor 24–25
 tastes in entertainment 2–3, 19, 150–51, 185
Austin, Henry 142
authorship
 and absolutism 9–11, 18, 55, 82, 132, 134, 135,
 143, 171, 175
 commodification of 6, 7, 151
 contradictions of 78–79
 contrasting approaches (early vs. modern) 3,
 4, 37–38, 43, 56, 119, 125, 151, 163, 166
 early models 3–4, 6–7, 19–20, 21, 26, 43–44,
 54, 55, 65, 79–80, 82–83, 87, 113, 118, 121,
 125, 133–34, 152, 166–67, 189
 folio model 2, 7, 8, 130, 139
 hierarchy/community of 66–68, 74, 79–80,
 139–40, 180
 modern theories 2, 16, 82 (*see also* Foucault,
 Michel)

Bancroft, Richard 60, 61, 178
 Dangerous Positions and Proceedings 60, 61
 A Survey of the Pretended Holy Discipline
 60
Barber, C.L. 156
Barish, Jonas 54, 170, 191
Barker, Francis 169
Barksted, Will 192
Barthes, Roland 2
Barton, Anne 180
Beaumont, Francis 79, 122, 139
Beckett, Samuel 2

Belsey, Catherine 169
Bentley, Gerald Eades 54, 65
Bevington, David 128
Beza, Theodore 148
Bly, Mary 175, 192
Bloom, Harold 152, 154, 161
Bradbrook, Muriel 170, 174, 187, 192
Braunmuller, A.R. 81, 180
Brinkley, Roberta F. 176, 177, 178, 180
Bristol, Michael 165, 173, 193
Brome, Richard 153–54, 182, 191
 The Damoiselle 153
Brooks, Douglas 130, 132, 133, 170, 188, 193
Browne, Robert 190
Burbage, Richard 58, 79, 80
Busby, Olive Mary 173–74

Callaghan, Dympna 179, 181
Campion, Edmund 11, 86, 87, 100, 101, 103, 107,
 184, 185
Chamberlain's Men 1, 17, 22, 154, 161, 172
Chapman, George 74, 122
 Bussy d'Ambois 80–81, 180, 182
 dedication to *Woman is a Weathercock* (Field)
 66, 69, 70, 71–72
Charles I 125, 130
Chettle, Henry 111, 113, 161
Clarke, Arthur 127
Clifton, Henry/Thomas 64
clown(s) 18–20, 24
 authorial role 19–20, 26, 31–32, 39
 physical performance skills 24–25
 public following 25–26
 as public property 29–30, 52
 see also Shakespeare; *names of individual
 performers*
Cocke, J. 97, 184
collaboration, role in development of authorship
 118–19, 166
Collinson, Patrick 57, 59
companies, theatrical
 competition between 109–10
 internal organization 65
 role in text production 6–7
Condell, Henry 7, 161
copyright 16, 53, 119, 132
Cottam, Thomas 101
Crewe, Jonathan 88

de Grazia, Margreta 7, 169
Dekker, Thomas, *Satiromastix* 77, 78
Dictionary of National Biography 51
"discovery" (of fools), tales of 34–37
 see also Armin, Robert; Tarlton, Richard
Dobson, Michael 164–65

Donaldson, Ian 148
Dorset, Earl of 125, 188
Dover, Earl of 129, 130
Dutton, Richard 161, 172, 192

Edmunds, Thomas 60, 61, 179
Edwards, Philip 81–82
Elizabeth I, Queen 21, 61
Ellyot, George 184
executions, public 187

Field, John
 establishment attacks on 60–61
 referenced in *Bartholomew Fair* 59, 60, 61–62,
 150, 178
 writing/preaching career 59–60, 63, 178
Field, Nathan 9, 13, 14, 15, 43
 acting career 55, 56, 59, 68, 181, 182
 appeal to female audiences 57, 58, 68–70, 72,
 180–81
 attitudes towards women 70, 71–73
 authorial voice 2, 55, 63, 68, 74, 79, 82–83
 in *Bartholomew Fair* 14, 57–58, 61–63, 73,
 76–77, 80, 149, 150, 153, 179
 collaborations 55, 81–82, 176
 comparisons with other performer/writers
 53, 55, 72, 74, 112, 113, 121, 124, 125, 128,
 163
 critical commentary 55, 63, 66, 79, 80, 81–82,
 83, 163, 177, 179
 dealings with authority/senior figures 63–65,
 66–68, 74, 76, 80
 early life 59, 64–65
 family connections 179
 prefatory poems (for Jonson/Fletcher) 65–66,
 67
 relationship with Jonson 13, 14, 55, 56–57, 63,
 65, 79, 80, 150, 153
 self-promotion 97, 161, 163
 view of authorial role 9–10, 13, 72, 76
 Amends for Ladies 55, 63, 69, 70, 73–76, 81, 82,
 163, 180, 181
 Woman is a Weathercock 55, 66, 67–68, 69–73,
 75–76, 181
Fincham, Kenneth 61
Flecknoe, Richard, *A Short Discourse on the
 English Stage* 79–80, 81
Fletcher, John 65, 68, 74, 79
 The Faithful Shepherdess 65–67, 68, 80
fool(s) *see* clown(s); "natural fool"
Foucault, Michel, theories of authorship 2, 3, 12,
 16, 30, 37–38, 52, 86, 108
 shortcomings of 6, 11, 87, 106, 113, 118, 159
 summarized 2–3, 26, 192–93
Fuller, Robert 28

Garber, Marjorie 165
Gibson, Colin 81–82
Giles, Nathaniel 64
Gosson, Stephen 85
Greene, Robert 161
Gurr, Andrew 137

Halasz, Alexandra 6, 25, 40, 168, 173
Hall, Joseph, *Virgidemiarum* 160
Halliwell, J.O. 24
Hanson, Elizabeth 92
Hegel, G. W. F. 5
Helgerson, Richard 21, 54, 107, 155, 176, 192
Heminges, John 7, 161
Henrietta Maria, Queen of England 125, 130
Henry VIII 88, 110, 113, 184
Henslowe, Philip 13, 65
Heywood, Thomas 9, 13–15
 acting career 13–14, 124
 authorial voice 2, 124, 125, 128–29, 132, 134,
 135, 139, 151, 188
 comments on authorial role 3–4, 8–9, 122–24,
 127–28, 129–30, 133–34, 139–40, 143, 161, 170
 comparisons with other writer/performers 113,
 124, 125, 126–28, 141
 influences 128
 pedagogical qualities 141–43
 significance in development of authorship
 124–25, 132
 Age plays (general comments) 13, 124, 134–35,
 140, 141–43, 148, 188–89, 190
 Apology for Actors 137, 148
 Challenge for Beauty 145
 The English Traveller 8, 130, 189
 The Escapes of Jupiter 141
 The Fair Maid of the West 129
 The Four Prentices 141
 The Golden Age 135–39, 140, 189
 Gunaikeion, or Nine Bookes of Various History
 Concerninge Women 13, 14, 122–24, 126, 127,
 128, 133, 148, 150
 Hierarchie of the Blessed Angells 139–40, 141
 If you Know not Me, you Know Nobody 130,
 132, 135
 The Life of Merlin 129
 Love's Mistress, or the Queen's Masque 13,
 125–28, 187–88
 Pleasant Dialogues and Dramma's 13, 129,
 130–34, 140, 141, 145, 148, 188
 The Rape of Lucrece 13, 124, 134, 143–50, 190–91
 The Silver Age 140–41
 Troia Britanica 138–39, 141
Hill, Janet 173
Hirschfeld, Heather 180, 187–88, 191
Holaday, Allan 190

Holderness, Graham 166
Howard, Jean 10, 181

Irigaray, Luce 181
Isidore, St. 102

James I 179
 approaches/dedications to 9, 13, 18, 54–55, 57,
 65, 135, 153
 religious outlook 61
 jest-books 24, 30
 see also Tarlton, Richard
 Jesuits 11
John in the Hospital (Blue John), historical
 figure 1, 12, 34, 44–45
Jones, Inigo 127–28, 188
Jonson, Ben 55, 63, 74, 79, 82, 122
 attitudes to authorship 9, 10, 13, 14, 15, 43, 54,
 56, 57, 68, 78–79, 82, 124, 129, 134, 139, 166,
 177
 career (outside theater writing) 64, 77
 comparisons with other writer/performers 54,
 55, 126–28, 132, 140, 141, 154, 155, 161–62, 164
 dealings with James I 9, 54, 57, 65, 76
 family history 179
 Folio publication 2, 7, 9, 64
 modern critiques of 54–55, 83, 182
 relations with contemporaries 13, 56–57, 63,
 127, 153–54, 170, 180, 182, 187–88 (*see also*
 Field, Nathan)
 remarks on boy players 65
 Bartholomew Fair 13, 14, 57–63, 64, 68, 71, 73,
 74, 76–78, 79, 80, 149, 150, 153, 182
 Catiline 68
 Epicoene 72, 74, 181
 Every Man Out Of His Humour 33, 182
 Hymenaei 127
 The Masque of Blackness 127
 Poetaster 182
 Volpone 65, 74

Kastan, David Scott 110, 193
Kemp, Will 1, 12, 21, 22, 155, 169, 174, 186
 acting approach/technique 5, 156, 157, 172, 192
 comparisons with other performers 21, 23, 171
 "expulsion" from Globe 21, 22–23, 154, 160,
 172–73
 "jig" (London-Norwich) 5–6, 19, 22, 23
 Nine Daies Wonder 5, 22, 23, 169
King's Men 55, 81, 108, 109
Kirby, Luke 101
Kyd, Thomas, *The Spanish Tragedy* 48, 77, 176

Lady Elizabeth's Men 55, 57, 58
Lake, Peter 61

Leech, Clifford 5
Leicester, Earl of 28–29
Livy 145
Loewenstein, Joseph 16, 54, 168, 176, 188, 190
Lord Chandos's Men 35, 175
Lusty Juventus (anonymous) 94, 149
Lyly, John, *Midas* 128

Mann, David 173, 184, 192
Marcus, Leah 61, 77–78, 192
Marlowe, Christopher, *Hero and Leander* 58, 62
"Marprelate, Martin" 60
Marston, John 122
Massinger, Philip, *The Fatal Dowry*
 (collaboration) 81–82
Masten, Jeffrey 18, 56, 135, 171, 175, 180, 182,
 188
Maus, Katharine Eisaman 92
MacCabe, Colin 21
MacLean, Sally-Beth 184, 186, 191
McMillin, Scott 65, 183, 184, 186, 191
Meagher, John Carney 111
Middleton, Thomas 152
Miller, David Lee 180
Miller, Jack 34–36, 175
Montrose, Louis 10–11
Munday, Anthony 9, 13, 14–15
 acting career 97–98
 anti-Catholic work/writings 11, 88, 96, 117, 185
 (*see also individual titles below*)
 attribution of doubtful pieces 85, 183
 authorial voice 2, 11–12, 13, 109, 118, 119, 121
 commercialism 13, 86–87, 96, 105–6, 107–8,
 117–18, 119
 comparisons with other performer/writers
 124, 125
 contemporary attacks on 97–98, 107, 119–21,
 153, 161, 184
 contradictions 85–86, 88, 96, 100–1, 102–5,
 107, 108–9, 118, 183
 involvement in controversy 98, 118
 martyrdom, treatment of 86–87, 95–96, 98,
 100–6, 114–18
 as playwright 105–6, 107–8, 118–19 (*see also
 individual titles below*)
 self-promotion 86, 87, 163
 *A Breefe and true reporte, of the Execution of
 certaine Traytours at Tiborne* 98
 *A Breefe Aunswer Made unto two seditious
 Pamphlets* 97
 *A Breefe discourse of the taking of Edmund
 Campion and divers other papists* 97
 Discovery of Edmund Campion 97, 98
 *The Downfall/Death of Robert Earl of
 Huntingdon* 105, 110–18, 119, 186, 187

English Roman Lyfe 11, 87, 98–105, 106–7, 109,
 118, 119, 184, 185
John a Kent and John a Cumber 89, 105
Sir John Oldcastle 105, 108–10, 185, 186
Sir Thomas More 87–96, 105, 112, 149, 183,
 184
*A Watch-woord to Englande To beware of
 traytours and tretcherous practises* 108,
 119–21
Musarum Deliciae (Minnes/Smith) 14

names, importance as signifiers 26
Nashe, Thomas 139
"natural fool," social role/exploitation 29, 34, 50
 see also "discovery"
New Historicism 10
Nowell, Alexander 44

Oldcastle, Sir John (historical figure) 87, 108,
 109
Orgel, Stephen 54, 171
Ovid, translations from 130–31, 142, 188
ownership *see* authorship: modern theories of;
 copyright
Oxford, Earl of 99

Palmer, Daryl W. 21
Paris Garden, collapse of 59
Parrott, Thomas Marc 80–81
Paster, Gail Kern 24
Pavy, Salathiel 65
Peacham, Henry 19, 24
Peel, Albert 61
Peery, William 81, 181
plays within plays 93–95, 149, 184
Poole, Kristen 110
Pope, Alexander 164
printer(s), role in collaborative process 39–40
Privy Council, *English Roman Lyfe* dedicated to
 106–7
profit motive (of actors/authors) 7, 14, 15, 118–19,
 143, 150
 authorial comments on 40, 67, 68
 see also Munday, Anthony: commercialism
puritans
 religious controversy surrounding 60–61
 theatrical depiction/caricature 58–59, 60, 78,
 110

Quilligan, Maureen 7

Ringler, William 183
Roach, Joseph 24, 170
Rose, Mark 16, 108, 175
Rowe, George 54

Rowley, William 152–53
 All's Lost By Lust 153
 A Woman Never Vext 153

Saint Lawrence 102
*A second and third blast of retreat from plaies and
 theatres* (anonymous) 84–85, 88, 90, 107, 119
 debate on authorship 85, 183
Shady, Raymond 125, 187
Shakespeare, William 15, 26, 79, 173
 absence of personal testimony 154, 161,
 162–63, 165–66, 167
 critical approaches 3, 4–5, 20, 152, 154, 161–62,
 163–64, 165, 166–67, 172, 173, 192, 193
 echoes in Armin 47
 editorial approaches to 80
 First Folio 7–8, 20, 161
 monument (in Westminster Abbey) 164–65
 plays misattributed to 108
 social status 6, 7
 use of clown figure 4–5, 154–61
 As You Like It 155, 162
 Hamlet 19, 22, 23, 47, 122, 145, 146, 154–55,
 159, 163
 Henry IV 21, 22–23, 108, 109, 110, 154–55
 Henry V 174
 King Lear 47, 169
 Macbeth 47
 The Merchant of Venice 156
 A Midsummer Night's Dream 146
 Pericles 91
 The Taming of the Shrew 157
 Twelfth Night 21, 25, 33, 155–61, 192
 Two Gentlemen of Verona 4–5, 149, 156
Shaw, George Bernard 162
Shershow, Scott 76–77, 181
Shert, John 101
Sidney, Sir Philip 19, 48, 146
Sinfield, Alan 155, 163–64, 169, 177
size (of volumes), significance of 129–30
Skelton, John (historical figure) 110, 186–87

Skura, Meredith 169, 170
Stallybrass, Peter 7
Statute of Anne 2, 168
Sturgess, Keith 58, 62
Surrey, Earl of (historical figure) 88

Tarlton, Richard 19, 20, 21, 152, 160, 168, 172, 173
 comparisons with other performers 21, 23, 25,
 29, 33, 171
 influence on Armin 27–28, 174
 origins (alleged) 28–29, 35
 performance style 21–22, 23, 24–25, 159, 172
 public following 25, 26, 27, 28
 Jests 24, 28
 The Seven Deadly Sins 22, 23
Tarlton's News out of Purgatory (anonymous) 27
Taylor, Joseph 58
theater
 ideological attacks on 84–85
 power to shape reputation 70–71, 78
Thomas, Max W. 169, 175
Topcliffe, Richard 88, 96, 99
Tricomi, Albert 81
Turner, Celeste 183, 184

University Wits 166
Ure, Peter 81

Wall, Wendy 180
Walpole, Robert 164
Webster, John 191–92
 The Duchess of Malfi 3, 169
Weimann, Robert 4–5, 22, 122, 149, 159, 160,
 169, 171, 179, 183
Wiggington, Giles 59, 61
Wiles, David 5, 19, 20, 21, 24, 33, 50, 156, 157,
 159, 168, 171, 172, 173, 177
Willeford, William 173
Wilson, Richard 193
Wilson, Robert 152, 191
Worcester, Earl of 122